American Painting

AMERICAN PAINTING

From the Colonial Period to the Present

Introduction by

JOHN WALKER

Text by

JULES DAVID PROWN

and

BARBARA ROSE

New updated edition

SKIRA

RIZZOLI
NEW YORK

First published in two volumes in 1969.

New updated edition in one volume 1977.

© 1977 in Switzerland by Editions d'Art Albert Skira S.A., Geneva.

This edition published in the United States in 1977 by:

RIZZOLI INTERNATIONAL PUBLICATIONS, INC.
712 Fifth Avenue/New York 10019

Library of Congress Catalog Card Number: 70-80455
ISBN: 0-8478-0049-0

PRINTED IN SWITZERLAND

Contents

Introduction 7

Part One: From the Beginnings to the Armory
 Show by Jules David Prown

The Colonial Period 13

The Federal Period: Americans at Home and
 Abroad 33

The Search for Identity 51

Art for the People 75

From Art for the Sake of Art to the Ashcan School 107

Part Two: The Twentieth Century by Barbara
 Barbara Rose

The Armory Show and its Aftermath 131

The Crisis of the Thirties 151

The New York School 181

The Sixties 207

The Seventies 235

Select Bibliography 255

List of Color Plates 265

General Index 273

Introduction

*T*he history of American painting falls conveniently into triads. There were three main movements: Realist, Romantic, and Primitive art. There were three outstanding colonial painters: West, Copley, and Stuart. No artist measured up to them until the second half of the nineteenth century, when America produced three more masters of the first rank who worked in Europe: Mary Cassatt, Whistler, and Sargent. That same generation brought forth three artists equally distinguished who remained at home: Eakins, Homer, and Ryder. The text of this book brilliantly proves that these nine painters make the American School illustrious by any standards.

Though born in a colonial or a provincial society the first three were among the most advanced artists of their time. West, Jules Prown shows, was a prophet of David and neoclassicism, and both West and Copley were precursors of Géricault and Delacroix. To these I might add Stuart who in theory and to some degree in practice anticipated the Impressionists.

The expatriates at the end of the nineteenth century were equally inventive. Mary Cassatt, working with the Impressionists, reintroduced the mother and child theme and imbued this subject with a dignity not seen since the Madonnas of the Renaissance. Whistler single handed started a movement in Europe and America, Aestheticism, and in Jules Prown's words helped "to establish the theoretical basis for abstract art." Sargent set the standards for fashionable, cosmopolitan portraiture, creating a style which found imitators everywhere.

Though the three masters who remained in this country, Eakins, Homer, and Ryder, had fewer followers, they were in some ways more original. The realism of Eakins was the most intellectual, the most scientific, the most uncompromising among painters of his generation. Homer's studies of hunting and fishing are the best descriptions in art of the pleasures, dangers, even tragedies of men who live out of doors, the various aspects of their contest with nature for pleasure or for existence; just as his studies of waves as they beat relentlessly on the shore or as they gently swell, muffled

in fog, show uniquely both the power and the loneliness of the sea. Ryder, too, in his own way reaches a limit of art. His dream-shrouded world finds no parallel in American painting and few in European art. His style is as original and idiomatic as the poetry of Edgar Allan Poe.

Henry James was fond of pointing out that "the best things come, as a general thing, from the talents that are members of a group; every man works better when he has companions working in the same line, and yielding the stimulus of suggestion, comparison, emulation." This was not the good fortune of those nineteenth-century American painters who remained in this country. The lives of Homer, Eakins, and Ryder reveal loneliness, isolation, and a failure to communicate with their contemporaries, whether artists or patrons. Nevertheless, in a period of artistic decline, which marked the nineteenth century except in France, solitude may prove a vaccine against the virus of bad taste. Thus the solitary artist may work more healthily when quarantined from his fellows. Partly for this reason it can be asserted, I believe, that from 1860 to 1900 America produced more distinguished painting than any other Western country excepting only France.

But there were factors other than solitude which affected American artists. Their styles were determined by problems uniquely American. There was, for instance, the geographical separation of the New World from Europe. This had an important result especially for young artists. Traditionally painters during their apprenticeship have seen nature through the eyes of their instructors, or if self-taught, through masterpieces available to them in private collections or public museums. Neither the masters nor the models were to be found in America. Even as late as the second half of the nineteenth century Mary Cassatt summed up the situation when she said to an interviewer, "When I was young. . . our museums had no great paintings for the student to study." Thus among American artists there was always a European complex—a longing first for London, and later for Paris or Munich.

Owing to the lack of masters and masterpieces and to the predominantly rural nature of eighteenth- and nineteenth-century America, an exceptional number of American painters were itinerant, self-taught, and unaffected as were European artists by metropolitan fashions. These "primitives" were modest craftsmen, devoid of all pretentiousness. They executed their commissions as skillfully as they could, retaining always an innocence of vision and a strong sense of decoration. They were as far from the bohemian geniuses of the last century we associate with the Left Bank in Paris as they were from the fastidious aesthetes we think of in Chelsea. In this respect they were closer to the artisans of the early Renaissance or those of the late Middle Ages. Perhaps because their work lies outside the mainstream of art, just as they themselves do not fit into our romantic idea of the painter, they have not until now been adequately appreciated.

Apart from the lack of an artistic tradition the American painter was affected in other ways by the New World. He was confronted, for example, by a terrain as

unexplored artistically as it was geographically. When he left the Eastern seaboard he was overwhelmed by the vastness of nature. Making a virtue of necessity, he praised the sublimity of this primeval wilderness. But even a genius as great as Turner was unable to express satisfactorily the grandeur of the Alps; what hope was there for the American landscapist to render the stupendous splendor of the Rockies? Nevertheless, he tried repeatedly, and his failures are not without their own magnificence.

In America, light too is less paintable than in Europe. Though the North American continent is so vast that generalization is difficult, still it is apparent that nature has not afforded artists in the New World the equivalent of the broken, dappled sunlight of England and the Low Countries, or the caressing, soft bluish light of France, or the tangible gold of sunset in Italy. Instead, light in America tends to be strong, hard, and sharply brilliant. It brings out local color and exaggerates value contrasts. Perhaps for this reason America has never produced distinguished colorists until the advent of the Abstract Expressionists, who were totally indifferent to natural illumination.

Thus lack of models, lack of a humanized scenery, lack of a painterly light were disadvantages. But there was, on the other hand, the excitement of a new society. Painters were inspired by the spirit which caused Whitman to write in his preface to Leaves of Grass, "The United States themselves are essentially the greatest poem. In the history of the earth hitherto the largest and most stirring appear tame and orderly to their ampler largeness and stir. Here at last is something in the doings of man that corresponds with the broadcast doings of the day and night." Such boasting may now seem to us unattractive, perhaps because we realize how far a hundred years has taken us from Whitman's dream. Nevertheless, it describes the nineteenth-century atmosphere in which American painters thrived.

The dangers facing artists in this country were chauvinism and parochialism. These appear to some degree in the so-called "Ashcan school," which followed the generation of Eakins and Homer. To quote Jules Prown, "Their art dealt with real life and real people. It was democratic art depicting not the aristocratic classes who populated the paintings of the 'genteel tradition' but the lower middle classes, the great mass of the American populace." They believed with Whitman that "the genius of the United States is . . . always most in the common people."

In the 1930's Barbara Rose shows how this populist strain in American painting was encouraged by the Roosevelt WPA programs, but it eventually dwindled into Regionalism and Social Realism. The seeds of its destruction had been sown much earlier by the Armory Exhibition of 1913 where for the first time American artists saw the new movements taking place in Europe. The roots of abstraction were planted. During the First World War and the Great Depression the more progressive painters gradually assimilated these new ideas. During the Second World War whatever was parochial, whatever was provincial, vanished from American art; and at the same time American artists lost a certain innocence, a certain ingenuousness. Ended were those

misjudgments in taste, such as Eakins' admiration for Gérôme, or that insecurity before the Old Masters, which may explain Homer's wish to ignore them, or the lack of a studio tradition, which made Ryder such a weak craftsman. The gain in knowledge meant not only that innocence was lost but that something of more significance disappeared: an unselfconscious integrity, exemplified by Homer's and Eakins' refusal to compromise, by their plodding search for reality, or by Ryder's indifference to popular taste, by his detachment from all that was extraneous to his private vision. In the nineteenth century a blunt honesty was a major characteristic of the native American style, as distinct from the sophistication of the American expatriates. It was a style brusque, awkward, naive at times; but there was on the one hand a heartfelt struggle for actuality, and on the other a brooding, Romantic vision.

In our day American painting has become more subtle, more inventive, more cosmopolitan. With the emergence of Abstract Expressionism the torch of artistic revolution has burnt in New York and not in Paris. Pollock, de Kooning, and Motherwell led the "action" painters of the 1940's; they were followed by the "color field" painters: Still, Newman, Rothko, and Reinhardt. These in turn were succeeded by the hard-edge or post-painterly abstractionists: Frankenthaler, Noland, Olitski, Stella, Kelly, and others. There has also been a return to figurative painting in the pop-art movement, a combination of the comic strip and Madison Avenue advertising.

When one considers this extraordinary development of the School of New York it can be argued convincingly that leadership in painting has passed to this continent. The question remains, and only time will tell, whether these new American leaders are going in directions as significant as did their more innocent forebears.

JOHN WALKER

PART ONE

From the Beginnings to the Armory Show

by JULES DAVID PROWN

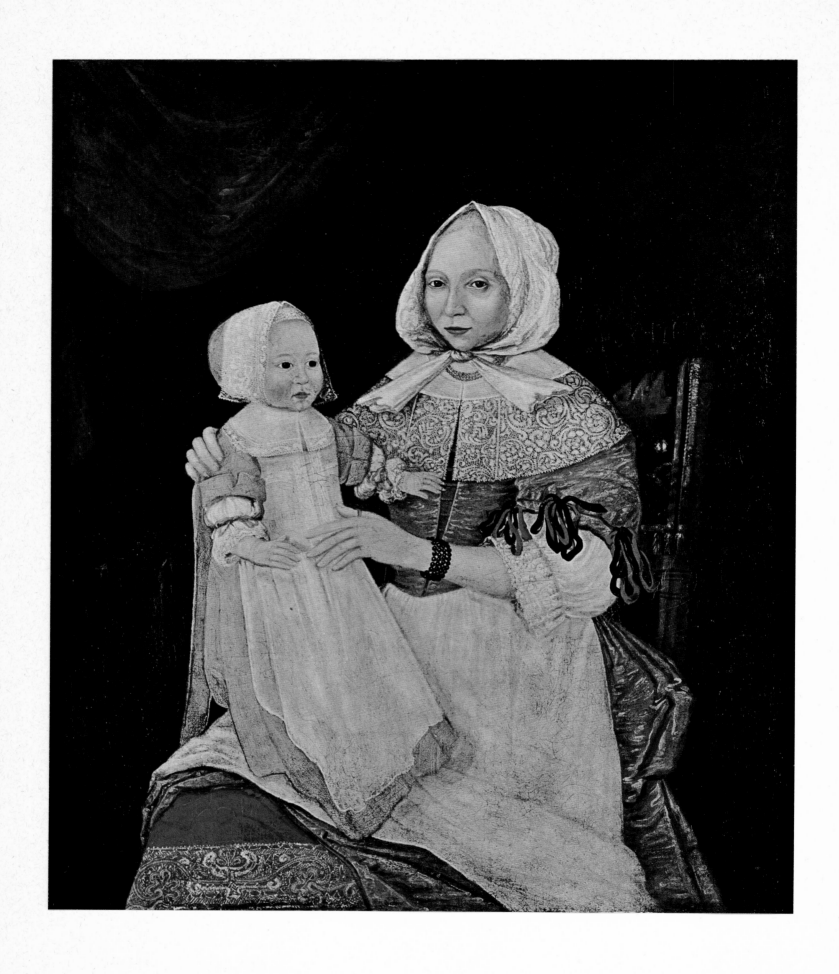

Anonymous. Mrs. Elizabeth Freake and Daughter Mary, about 1674. (42½×36¾")
Owned by the Worcester Art Museum, Worcester, Massachusetts. Gift of Mr. and Mrs. Albert W. Rice.

The Colonial Period

THE most obvious fact about early American painting is that there was so little of it. When European colonists began to establish permanent settlements on the eastern flank of North America, they had other things on their minds than the painting of pictures. Faced with a pressing necessity to satisfy their primary life needs—food, shelter, clothing—they adopted a way of life and a view of the world that was necessarily pragmatic. For them the arts seemed dangerously irrelevant, a distraction from the serious tasks at hand. As an anonymous writer in Boston put it: "The Plow-man that raiseth Grain is more serviceable to Mankind, than the Painter who draws only to please the eye. The hungry man would count fine Pictures, but a mean entertainment. The Carpenter who builds a good House to defend us from the Wind and Weather, is more serviceable than the curious Carver, who employs his Art to please his fancy. This condemns not Painting, or Carving, but only shows, that what's more substantially serviceable to Mankind, is much preferable to what is less necessary." That pragmatic attitude has characterized American culture from its inception to the present day, and has profoundly affected the trajectory of American art.

The earliest surviving American colonial painting, a portrait of *Elizabeth Eggington* (Wadsworth Atheneum, Hartford, Connecticut), inscribed with the date 1664, was painted long after the establishment of the first permanent English settlements at Jamestown in Virginia (1607) and Plymouth in Massachusetts (1620). Although it may be said that American art began with *Elizabeth Eggington*, it must at the same time be pointed out that a considerable body of pre-colonial, non-colonial and neighboring-colonial art might make the same claim. For example, early expeditions of exploration before the period of settlement often carried artists among their complement to record the physical facts of America. Curious Europeans wanted to see pictures of the New World and its inhabitants. Artists also participated in several of the abortive sixteenth century attempts at settlement in North America; notably Jacque Le Moyne de Morgues (d. 1588) who arrived in 1564 with a Huguenot settlement in Florida and fortuitously escaped when that settlement was wiped out by the Spanish the following year, and John White (active 1584-1593) who joined Sir Walter Raleigh's ill-fated venture at Roanoke in Virginia in 1585. However the pictures made by explorer-artists, fascinating as they are, were in fact the work of Europeans who happened only by circumstance to be working briefly in America. Their art belongs to the New World only in its subject matter, and even the *reportage* was affected by European modes of seeing. Sixteenth century American Indians often are given distinctly Mannerist proportions.

Also antedating *Elizabeth Eggington* is a corpus of provincial art, much of it religious, limited in quality as well as quantity, produced in the Spanish colonial areas of Florida, Louisiana and the American Southwest within the borders of the present continental United States. However this peripheral art properly belongs to the history of Central and South American painting. Similarly the French colonial art of Detroit and the Mississippi River Valley fits in more appropriately with the history of Canadian art. The artistic production of the Dutch in New York and the Swedish along the lower Delaware in colonies soon overrun by the British was, unfortunately, limited and minor.

It is more difficult to justify not beginning our study with the art of the American Indian, the art of the peoples resident here before the Europeans came. Yet this elimination is in fact consistent with what actually happened in the development of American art and American civilization. Whereas Spanish colonies in Central and South America absorbed local cultures, converting the natives to Catholicism in the process, the English settlers in North America disdained the Indian, annihilated his civilization whenever it got in the way, and absorbed virtually nothing from the culture of the American Indian.

Thus the tentative and halting beginnings of what eventually broadened into the mainstream of American painting are found in those pictures painted during the seventeenth century in the English colonies strung along the Atlantic seaboard from Maine to Georgia, the colonies that eventually banded together to form the United States of America. Extraordinarily little is known about painting in America in the seventeenth century; almost no documentation exists. The primary evidence is provided by perhaps half a hundred surviving paintings, all of them portraits. Artists are for the most part unidentified, although pictures have been tentatively assigned to discrete hands on the basis of style and sitter groups. It is obvious, if only from the paucity of surviving pictures, that these were not full-time artists, but perhaps unspecialized painters who wielded their brushes on walls and wagons, signs and portraits alike, as opportunities arose. The compositions used in the portraits are few and mannered. Children are shown at full-length, standing on checkered black-and-white tile floors, clutching a glove, fan, bird, cane, flower or piece of fruit. Men are half or three-quarters length; clergymen clutching a Bible and laymen toying with gloves. Women are seated, often holding a child in their laps. Heads are shifted slightly to left or right, the eyes staring forward. Both hands are invariably shown.

The portrait of *Elizabeth Eggington* presaged a sudden and still unexplained flurry of artistic activity in Boston about 1670. Undoubtedly a major factor must have been the arrival of one or more able artists, the best of whom, identified today only as the Freake limner, painted what is perhaps the most beautiful of all seventeenth century American paintings, *Mrs. Elizabeth Freake and Daughter Mary*. Mrs. Freake sits on a Cromwellian sidechair upholstered with turkeywork, her daughter standing on her lap. A curtain is pulled back to the upper left. The subjects in most of the earliest portraits were endowed with a similar appearance by the limners—small faces, almond-shaped eyes, high foreheads, wide cheekbones. Here the faces of mother and child are drawn with unusual sensitivity by the artist, but even so, they are devoid of personality and no more important than the stuffs that surround them, the dresses, petticoats, lace, hoods, ribbons and jewelry. The palette of black, white, yellow, green, red, and brown is limited but strong. Indeed color is a primary pictorial element. The traditional view of seventeenth century Americans as dour, ascetic, puritanical, and unresponsive to the sensuous pleasures of life is contradicted by the evidence before our eyes of people who enjoyed bright colors, finery and material comfort.

Although as our eye moves from the bright red embroidered petticoat in the lower left through the child to Mrs. Freake, the chair, and the background, we comprehend a recession in space, no real illusion of space is in fact presented. The picture is constructed of precisely outlined areas of strong local color juxtaposed to form a two-dimensional pattern in relief against the dark background. The picture surface is all-important, strongly affirmed by areas of intense color and embroidered with linear detail. The planar emphasis and bright color, normal in unsophisticated or primitive art, would not be unexpected in the work of

anonymous limners who painted signs as well as portraits. Yet the quality of the drawing suggests that the style may reflect conscious esthetic selection fully as much as, or even more than, insufficiency of technique.

The brilliant color, the determined linearity and the insistent emphasis of the picture surface recalls both Elizabethan portraiture, as in the miniatures of Nicholas Hilliard, and an older medieval tradition of manuscript illumination. Indeed *Elizabeth Freake and Daughter Mary* is a distant provincial echo of the courtly style that had developed in Northern Europe during the sixteenth century, a style that blended playful, colorful, linear, anti-classical Mannerism flowing northward from Italy with the indigenous and stylistically compatible Gothic tradition. The new stylistic amalgam reached a high point of development on the courtly level in England in the works of Hans Holbein. Filtering down through provincial strata, it finally arrived at this distillation in *Mrs. Freake and Daughter Mary* a century and a half later in Boston. Long after the European Baroque masters—Rubens and Rembrandt, Velasquez and Poussin—had lived and died, a flickering flame of the Middle Ages, fueled by Mannerism, still burned in the art as it did in the life of Colonial America.

The fragile early flowering of colorful decorative painting in Colonial America soon disappeared as more advanced styles became fashionable, although it was sufficiently durable to survive underground in American folk painting for two hundred years. Toward the end of the seventeenth century a group of portraits very different from those produced in Boston around 1670 appeared, including a *Self-Portrait* by Captain Thomas Smith, one of the masterpieces of early Baroque portraiture in America. The artist has learned something of chiaroscuro, and with a rather clumsy hand has brushed in shadows to give the head weight and substance. Gone are the delicate features of the earlier portraits. Not only does Smith employ modeling to define solid forms, but he also creates a three-dimensional ambience in which to set them. If we read this composition diagonally upwards, as we did with *Mrs. Freake and Daughter Mary*, our eye does not simply travel from area to area on the surface plane, but moves back step by step into pictorial space. A piece of paper inscribed with a poem is bent over the table edge in the lower left, serving as a space-defining device to lead the viewer into the composition. Smith's right hand is cupped over a skull, and the viewer's eye moves from it to the sitter's lace collar, his heavy head, the brass-studded upholstered chair, and a curtain. The background is no longer simply an abstract plane setting off the figure, but contains a window punched through the wall that allows the eye to proceed deeper into space to a scene of a harbor, fortress and battling ships.

The painting has gained a new dimension thematically as well as spatially. The man Thomas Smith is clearly more important than the costume and accouterments. The background scene presumably refers to an event in his career. The poem in the lower left ruminates on the fact that while we read the poem and study the likeness, Thomas Smith, creator of painting and poem who appears in the illusion of life before us, is in fact long dead, his well-fleshed head a skull like that on which his hand rests. The painting is a *Vanitas* portrait, a humbling reminder of our inevitable fate. Thomas Smith's *Self-Portrait*, with its solid forms and convincing space, marks the arrival of the Baroque style in America at the end of the century that had given it birth in Europe. Although Rubens and Van Dyck had worked in England during the 1620's and 30's, the general infusion of the Baroque into English art itself was long deferred by the Civil War and Puritan interregnum at mid-century. However with the return of Charles II and his court from continental exile in 1660, with the diffusion of Huguenot craftsmen and designers throughout the Protestant countries of Northern Europe after the Revocation of the Edict of Nantes ended religious toleration for Protestants in France in 1685, and finally with the Glorious Revolution of 1688 which brought William and Mary and their retinue from Holland to England, continental Baroque fashions and designs became naturalized in England, particularly on the court level. Transmission of the Baroque, diluted but recognizable, westward to the American colonies was facilitated when the restored English monarchy revoked the original commercial charters of the American colonies and issued new royal charters, setting up royal governors

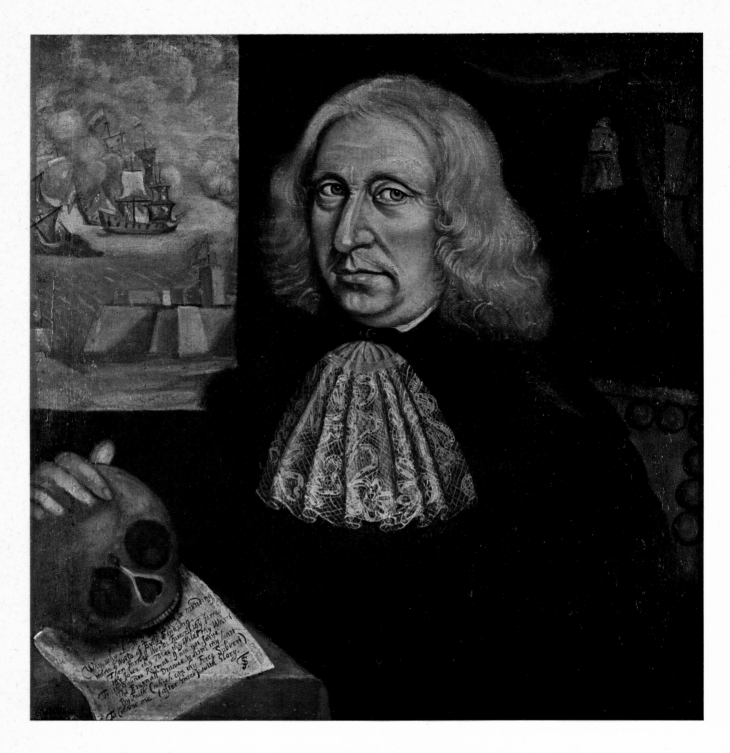

Thomas Smith (active last quarter of 17th century). Self-Portrait, about 1690. (24½×23¾″)
Owned by the Worcester Art Museum, Worcester, Massachusetts.

in provincial courts where the latest London fashions were introduced. In the colonies conditions were ripe for the acceptance of stylistic innovations as second and third generation Americans, bored with the Puritan rigidity of their forebears, wanted to begin to enjoy the fruits of the economic success they had gained.

In English painting a tradition of continental, especially German and Flemish, influence had been established by a succession of court painters from Holbein early in the sixteenth century through Rubens and Van Dyck early in the seventeenth century to Sir Peter Lely, an artist who appears to have been directly influential on Thomas Smith, at the end of the seventeenth century. However some continental stylistic influences came directly to the American colonies, by-passing England. For example, the Dutch had maintained their New Amsterdam colony until 1664, and a strong Dutch influence lingered long after the British

took it over and renamed it New York. Moreover one of the earliest trained Baroque artists to work in the American colonies was Justus Engelhardt Kühn (active 1708-1717), a German who emigrated to Annapolis, Maryland. Artists in the southern colonies, where the unit of settlement was the plantation rather than the town, were often itinerant. In about 1710 Kühn painted portraits of *Eleanor Darnall* and her brother, *Henry Darnall and His Colored Servant* (Maryland Historical Society, Baltimore, Maryland) at "The Woodyard," their family plantation in Prince George's County, Maryland. *Eleanor Darnall* stands on a checkered floor recalling seventeenth century children's portraits. Despite Baroque spatial pretensions, notably in the elaborate formal garden in the background, the girl and her dog are as flat as cardboard firescreens. Nevertheless such characteristic Baroque concerns as space, movement, contrast and rhythm, pervade the painting—the opening up of the background, the drapery and vine curving around the thick column, the bold turning of the balusters, the mask applied to the plinth, and the heavy massing of the floral arrangement. The large two-handled vase is an archetypal Baroque object, with the thick gadrooning pulsating as it marches around the body of the vessel, breaking up the surface into alternating and contrasting smooth and worked areas. Rhythmic echoes reverberate throughout the picture—two masks, a flower outside of the floral arrangement, the shape of the balusters, the movement of the gadrooning around the vase paralleling that of the drapery and vine around the column, and the repetitive balustrades and conical trees in the background.

During the years 1720-1740 an active school of portrait painters flourished in the Hudson River Valley of New York. As with the Boston limners a half century earlier, most of these itinerant artists remain anonymous. Although their portraits of members of patroon families use the vocabulary of Baroque painting, the bright color and emphasis on surface design recall the work of the earlier limners. This is evident in the charming anonymous portrait of *John Van Cortlandt*. At one time it was tempting for antiquarians to think of this scene as depicting a provincial American idyll, the fawn wandering out of the woods to be petted by a young American. However the entire composition is, in fact, based directly on a mezzotint after a painting by Sir Godfrey Kneller *(Lord Buckhurst and Lady Mary Sackville)*, a German who was the last and most influential of those continental artists who dominated English painting from the time of Holbein.

Engravings in general and mezzotints in particular were the dominant artistic influence on American painting in the eighteenth century, transmitting European designs to the colonies. This should not automatically condemn eighteenth century American art as imitative. According to eighteenth century artistic standards, still untouched by Romanticism's stress on individuality, adherence to tradition and the quotation from accepted sources was considered appropriate and desirable. The reliance upon European prints by American artists during the eighteenth century is of course a measure of their dependence, but also an index of the intensity of their aspirations. They wanted not only to produce pictures, but to produce the best possible pictures, to remain *au courant* with European art.

Despite the obvious advance represented by Captain Thomas Smith's Baroque *Self-Portrait* beyond the work of the earlier limners, subsequent stylistic advances in the first quarter of the eighteenth century were erratic. However, as the portrait of *John Van Cortlandt* already suggests, some of the best pictures were not the work of sophisticated artists but of provincials who used European sources as points of departure, and through a marriage of technical innocence and innate sensibility created fresh and striking images. The anonymous portrait of *Anne Pollard* is a case in point. As in the portrait of *John Van Cortlandt* the artist employs the outer forms of Baroque portraiture. Broad shadows are stroked in to model forms in space. The device of a painted oval or spandrel is used, its lower inside edge shadowed to interpose a painted wall between the viewer and the subject, making the illusion of pictorial space more convincing and relating it to the real space of the viewer. But despite the use of these space-enhancing devices, this delineation of a wizened centenarian, who had arrived in America as a child with the earliest Pilgrim settlers, is a surface arrangement of triangular and other shapes into a taut abstract pattern.

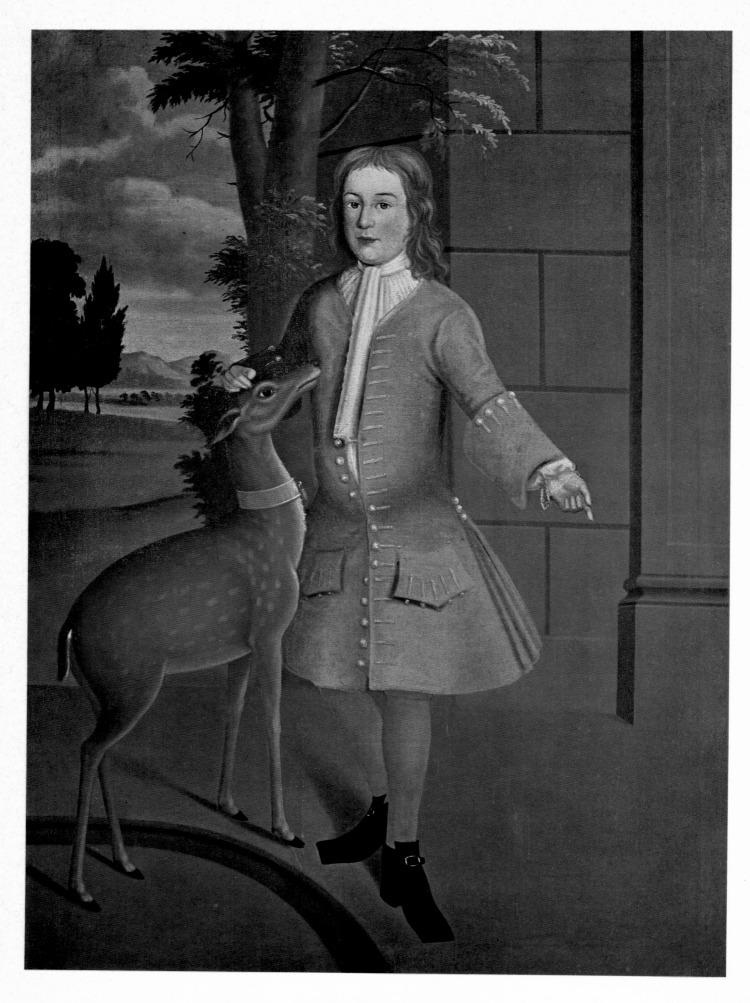

Anonymous. John Van Cortlandt, about 1731. (57×41″)
The Brooklyn Museum, Brooklyn, New York. Dick S. Ramsay Fund, 1941.

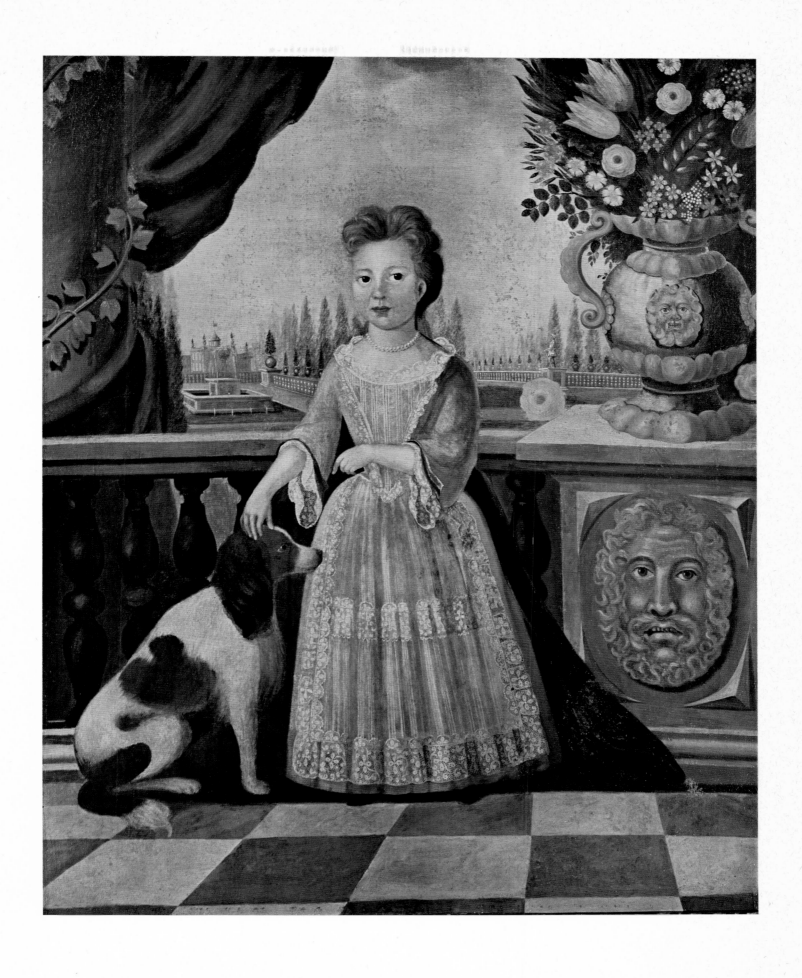

Justus Engelhardt Kühn (active 1708-1717). Eleanor Darnall, about 1710. (54×44½″)
Collection of the Maryland Historical Society, Baltimore, Maryland.

Anonymous. Mrs. Anne Pollard, 1721. (28¾×24″)
Massachusetts Historical Society, Boston, Massachusetts.

One of the most important events in the history of American art was the arrival in the colonies early in 1729 of the first well-trained European artist, John Smibert (1688-1751). Smibert had been born in Edinburgh. After an early apprenticeship to a house painter, he went to London at the age of twenty-one to study art, supporting himself as a coach painter and by copying old master paintings. He subsequently spent more than three years in Italy (1717-1720), and from 1720-1728 was a competent if not outstanding London portraitist working in the manner of Sir Godfrey Kneller. Many of his commissions came from fellow Scots, and he apparently catered to a provincial clientele. When in 1728 Dean George Berkeley, later Bishop of Cloyne, embarked on a venture to found a new college in Bermuda, he persuaded Smibert to come along as professor of art and architecture. Smibert took with him his collections of prints, copies of old master paintings, and plaster casts of antique sculpture.

Berkeley's expedition landed at Newport, Rhode Island, and while it paused there to await further funds, Smibert painted a large group portrait of Berkeley and his party. The *Bermuda Group* was the first major painting produced in the American colonies, and one

which exerted a significant and continuing influence upon American colonial painting during the ensuing years. In the painting Berkeley is posed at the right, as if in the act of dictating to the seated figure at the left, Richard Dalton. Berkeley's wife and child and another woman are seated between them. Smibert himself, gazing at the viewer, stands in the extreme left rear next to his nephew, Dr. Thomas Moffatt. Docile as it appears today, the *Bermuda Group*, in the complexity of its formal organization, in its technical competence, and in its convincing realization of solid figures in space was an esthetic bombshell in the art-starved American colonies.

As delays continued to plague the Bermuda expedition (finally abandoned in 1731), Smibert traveled to Boston to survey the art scene. He found a few local artists of limited ability, such as the painter Nathaniel Emmons and Peter Pelham, a mezzotint engraver who had arrived several years earlier from London where Smibert had probably known him. In Boston Smibert exhibited the *Bermuda Group* and several other recent portraits, along with a few of his old master copies. He was warmly welcomed as the prophet of culture to a city in the wilderness. In July 1730 he married wealthy and socially prominent Mary Williams, twenty years his junior, and settled down to spend the rest of his life in snug little Boston. Apparently Smibert found this small provincial capital, similar to the Edinburgh of his youth, a sympathetic milieu for the exercise of his talents. It was much more pleasant to be the best artist in Boston than a painter of the "third rank" in London. Smibert's studio in what later became Scolley Square was in effect the first art museum in America, where the artist not only painted portraits but exhibited them along with the art collection he had brought from Europe.

Despite Smibert's ability and his complete domination of the art scene, Boston did not generate sufficient patronage to enable him to support himself through painting alone. Perhaps this reflected a lingering local anti-image prejudice inherited from the iconoclastic Puritans; perhaps it reflected even more the low priority placed on painting by a pragmatic mercantile society. But Smibert, a provincial Scot, knew how to swim in these waters. He sold art supplies and prints to enlarge his income; he painted portraits that were engraved in mezzotint by Peter Pelham and sold for their mutual profit in Smibert's shop; and he had a wealthy wife. His only lack of success, of which he may not have been aware, was in sustaining the quality of his own work. With the passing of years he relied more and more slavishly on mezzotints for compositional ideas, and faulty drawing increasingly affected adversely the proportions of his figures. During the last years of his life Smibert suffered from failing eyesight. He was forced to give up portraiture, although he continued to divert himself "in a landskip way."

In 1740 twenty-two year old Isaac Royall, who had recently graduated from Harvard, taken a wife, fathered a child, and inherited a substantial estate from his father, a young man on the rise, decided to have a group portrait painted of himself and his young family to celebrate his new eminence. Probably because Smibert at the time was incapacitated by illness, the commission was given to Robert Feke (born 1705/10-after 1750), an artist whose background and career is still shrouded in mystery. Perhaps born and raised in Oyster Bay, Long Island, and perhaps having traveled to Europe in his youth as a mariner, Feke was from the start an artist of considerable sensitivity, particularly as a colorist, despite his apparent lack of professional training. Whether by Feke's design or Royall's orders, the large group portrait of *Isaac Royall and His Family* derives directly from Smibert's *Bermuda Group*. The figures are similarly gathered about a table covered with an oriental carpet. The principal figure stands to the right, holding a book in his right hand. Seated next to him is his young wife, holding an infant, followed to the left by a woman pointing across her body to the left, with landscape and sky in the background. A seated figure at the left end of the table closes the composition.

Compared with the *Bermuda Group*, which Smibert had painted fresh from his career as a competitive portrait painter in London, Feke's early effort seems naive, although hauntingly effective. The color areas float on the surface, and the modeling is not convincing,

John Smibert (1688-1751). Dean George Berkeley and His Party (The Bermuda Group), 1729. (69¾×94½″)
Yale University Art Gallery, New Haven, Connecticut. Gift of Isaac Lathrop of Plymouth, Mass., 1808.

especially the heads of the women and the doll-like child. Whereas Smibert after leaving
London became more provincial in America with the passage of time, Feke started out as an
untutored provincial and sought increasingly to achieve London standards of sophistication.
He too relied on prints, using them as a way of becoming more up to date, choosing those
produced by leading contemporary London portraitists such as Thomas Hudson and Joseph
Highmore. However, despite his aspiration to be a fashionable portraitist, Feke could never
divest his art of the highly developed sense of the surface plane at the expense of solid forms
and space that betrays his provincial origin. In Feke's portraits, figures dominate the
composition, and the landscape background is little more than a theatrical backdrop, a
painted setting. Figures are related to the landscape not by the subtle modeling of solid
forms in space but by the interaction of lines in the figure plane with lines in the landscape
plane, and by the complementary color play of foreground and background. Despite some
stylistic advance in his later work, Feke remained wedded to the two-planar concern with
surface design and background that had characterized American art from the start, as in
Mrs. Elizabeth Freake and Daughter Mary. In Feke's gifted hands this limitation became an
asset, not a liability, as he achieved extraordinarily appealing results in color, line and
surface design. As a portraitist, Feke was more interested in the decorative possibilities of

the picture surface than in the character of the subject. He portrayed Isaac Royall as an icon, a person of a particular social position, a handsome, well-bred, self-confident, wealthy young man. There is little or no indication of character, of personality, of a human being with a sense of humor, a person ever racked by emotion or tormented by self-doubt.

During the mid-1740's Feke settled in Newport, Rhode Island, painting portraits there and on several occasions in Philadelphia. In 1748-1749 he reappeared in Boston, where he enjoyed an extraordinary spurt of artistic activity, producing a number of handsome three-quarter length portraits that rank among his most brilliant work. At mid-century Feke disappeared, quite inexplicably, and the field was left to a new generation of artists.

Painting in the southern and middle colonies was not altered by the appearance of a single major artist as was New England painting by the advent of Smibert. One of the earliest southern artists identifiable by name was Henrietta Johnston (active 1708-1728/29), a female pastelist in Charleston, South Carolina, the largest city in the South. Her small Baroque pastel portraits on paper have charm if not great artistic merit. Her successor as the leading Charleston artist during the colonial period was a Swiss, Jeremiah Theus (1719-1774), who painted sugary portraits, especially of women with pursed lips and pouter-pigeon poses, such as *Elizabeth Rothmaler* (Brooklyn Museum, Brooklyn, New York). The leading painter in Virginia was a London artist, Charles Bridges (active 1735-1740 in Virginia), who

Robert Feke (1705/10-after 1750). Isaac Royall and His Family, 1741. (56¼×77¾")
Courtesy of the Harvard Law School, Cambridge, Massachusetts.

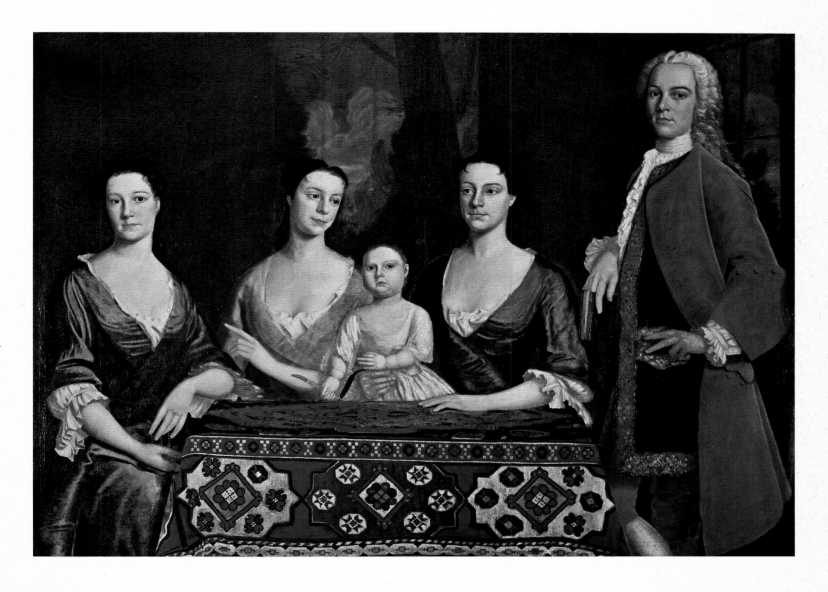

came to the colonies in his old age and received patronage from wealthy plantation families. In Maryland, Kühn was succeeded by a Swedish artist, Gustavus Hesselius (active 1711-1755) who departed from the usual restriction to portraiture to paint some interesting if not particularly attractive religious and mythological scenes. He also painted a few unusually sensitive portraits of Indians, *Tishcohan* and *Lapowinsa* (Historical Society of Pennsylvania, Philadelphia, Pennsylvania). His son, John Hesselius (1728-1778) became one of the most active portraitists in the Philadelphia-Annapolis area, but his style seems to have been influenced less by his father than by John Wollaston (active 1749-1767), a facile British artist who dominated the artistic scene in the middle and southern colonies at mid-century. Moderately skilled at painting drapery but woefully inept as a face painter, Wollaston nonetheless brought to the colonies firsthand experience of the contemporary Rococo style of Hudson and Highmore, sprightly and more colorful than Kneller's ponderous Baroque. Wollaston flattered his sitters through the decorative handling of drapery and landscape settings, but failed to convey a sense of the person portrayed. Indeed his art relied so heavily on stock pictorial devices that his sitters with their repetitive features all seem related.

A more pleasing, though less influential and productive, painter of Rococo portraits was William Williams (c. 1710-c. 1790) of Philadelphia who painted a delightful portrait of *Deborah Hall*, the daughter of Benjamin Franklin's printing partner. Although not much is known about Williams, the portrait speaks for his ability. In comparison with the Kühn portrait of *Eleanor Darnall* with its Baroque compactness of forms, tight curving movements, and repetitive rhythms, this Rococo portrait is much more linear, open and irregular. The sinuous descent of a tendril vine in front of a delicate plinth relief sculpture, and the free and asymmetrical pattern of the roses make a revealing stylistic contrast to the Baroque massing of flowers in Kühn's *Eleanor Darnall*.

Williams may have made a more significant contribution to American art through his early recognition and support of a young artist, Benjamin West (1738-1820). West was born and raised outside of Philadelphia, the son of a Quaker innkeeper. Williams, admiring West's youthful artistic precocity, loaned him books on art by Charles du Fresnoy and Jonathan Richardson which influenced West much more than did Williams' paintings. Unhappily the most obvious direct artistic influence on West's early style was exerted by John Wollaston. Fortunately West soon outstripped the superficial Wollaston. Even the early *Thomas Mifflin* (Historical Society of Pennsylvania, Philadelphia, Pennsylvania), painted in 1758 when West was only twenty, which reflects Wollaston's manner in the full jowls, almond eyes and dusky landscape setting, is far superior in its drawing, color, handling of space and light, and the balance of the composition to Wollaston's more static and pedestrian portraits.

West quickly achieved success as a portrait painter in Philadelphia, and his fame spread. But he was not satisfied with the prospect of a career as a portraitist in the American colonies. He had read glowing descriptions of the great art and artists of Europe in the books on art and art theory that Williams had given him. He learned that not all branches of painting were considered to be of equal importance, and that historical, religious and mythological pictures were the most highly regarded. Isolated in colonial America, his values shaped by his reading rather than by first-hand experience of great art, West burned with ambition to become a major artist. In response to his aspirations, a group of Philadelphia and New York businessmen sent West abroad to study in 1760, hoping to nourish the spark of artistic genius kindled in their country. West spent three years in Italy, and then settled in London where he soon achieved artistic eminence as history painter to George III and, eventually, President of the Royal Academy. Even though West never went back to America to yield a direct cultural return on the investment of his countrymen who had sent him abroad, he contributed enormously to the development of American painting. Throughout his long and distinguished career his London home and studio were at all times open to American artists, and as friend and teacher he exercised an important influence on several generations of American artists (see next chapter).

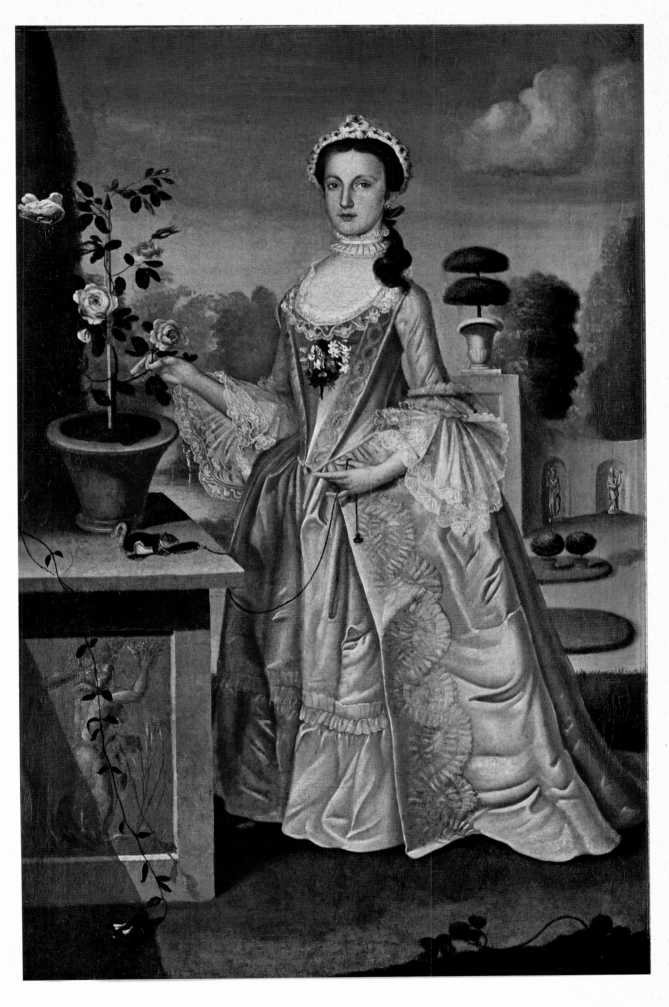

William Williams (about 1710-about 1790). Deborah Hall, 1766. (71¼×46½″)
The Brooklyn Museum, Brooklyn, New York. Dick S. Ramsay Fund.

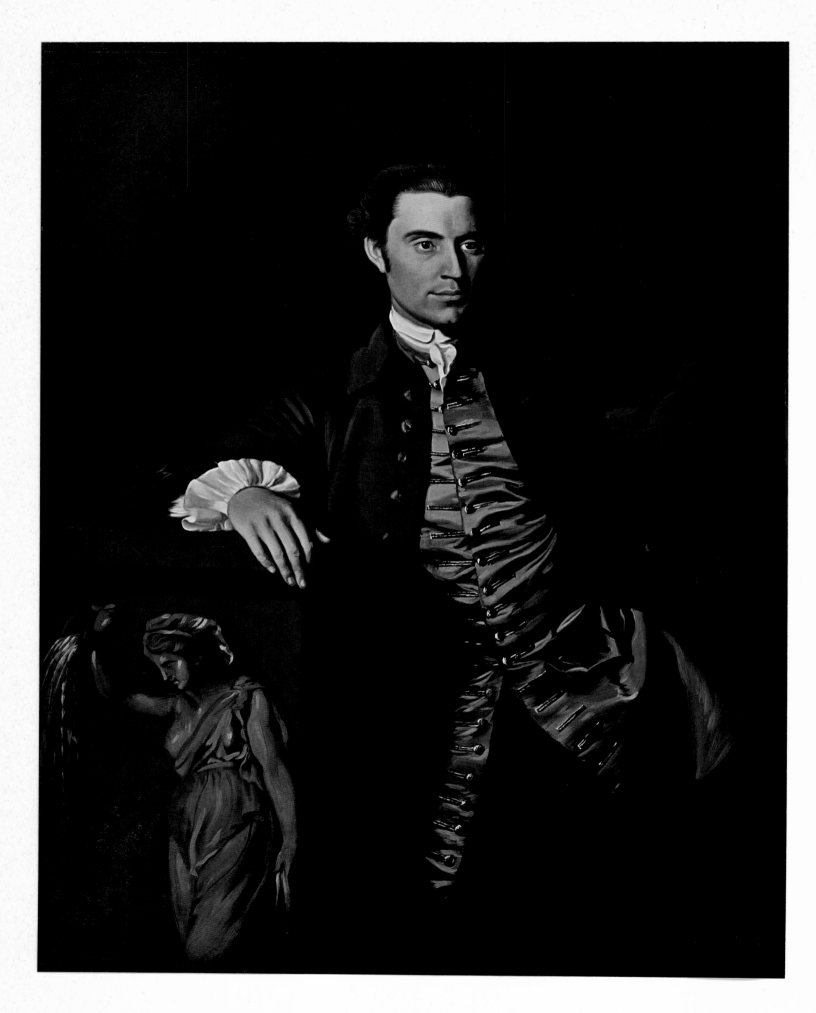

John Singleton Copley (1738-1815). Thaddeus Burr, 1758-1760. (50⅝×39⅞″)
City Art Museum, St. Louis, Missouri.

America's greatest colonial artist and a major artist by any standards, was John Singleton Copley (1738-1815). An exact contemporary of West, Copley was born in similarly modest circumstances, the son of a Boston tobacconist and his wife, recently arrived from Ireland. Copley grew up in Boston on Long Wharf, which jutted into the harbor. After his father's death on a trip to the West Indies, Copley's widowed mother, who continued to run the tobacco shop, married Peter Pelham, the engraver, in 1748. Through Pelham young Copley became familiar with the world of art and artists. He undoubtedly knew Pelham's friend, the aging Smibert, who lived nearby. He must have been aware of the recent work of Robert Feke, just then in a final blaze of productive glory in Boston. He may even have worked alongside of a promising young artist, John Greenwood (1727-1792), creator like Smibert and Feke of a large family group portrait, the *Greenwood-Lee Family* (Henry L. Shattuck, Brookline, Massachusetts), who may have been spending some time in Pelham's studio to learn the art of mezzotint engraving. Unfortunately for Copley, these stimulating halcyon days ended quickly. Pelham died in 1751, as did Smibert; Feke disappeared in 1750; and Greenwood for reasons as yet unknown departed in 1752 for Surinam, where he painted *Sea Captains Carousing at Surinam* (City Art Museum, St. Louis, Missouri), before proceeding to Holland and England and a career as an art dealer and auctioneer.

When Copley began his own career in 1753 at the age of fifteen, he faced little competition from such local artists as Smibert's son Nathaniel, who died in 1756 before his talent matured, or Joseph Badger (1708-1765), whose charming but unskilled paintings such as the portrait of his grandson, *James Badger* (Metropolitan Museum of Art New York, N.Y.) stand between the limners of the seventeenth century and the primitives of the nineteenth century in a continuing folk tradition. Copley's first major test arrived from England in the person of Joseph Blackburn (active 1753-1764 in America), an accomplished Rococo portraitist. Far from dismayed, Copley took advantage of the opportunity, learning all that he could from Blackburn, and like West with Wollaston, soon surpassed him. His portraits became increasingly deft and expressive, the Rococo style liberating his innate capabilities as a colorist. The bold and tasteful portrait of *Thaddeus Burr* with its spectacular brown-blue color harmony, painted when Copley was just over twenty, shows clearly why he rapidly achieved pre-eminence among American colonial artists. Although his success was guaranteed by technical competence alone, his real secret lay in his knowledge of his sitters and their requirements. Copley understood that what New Englanders valued in a portrait above all else was a good likeness. This was a pragmatic society, wedded to the facts of life, more concerned with the material realities of this world than the spiritual potentialities of the next. For this society portraiture was the one acceptable art form because it had a practical social application. A portrait could be sent to family far away as a token of the physical presence of a loved one, or it could descend to family distant in time, providing a kind of material immortality. In either case a good likeness was required, and Copley was able to produce just what his clients wanted. For example, early in his career he received a commission from Thomas Ainslie, Collector of the Port of Quebec, to paint portraits of Ainslie and his wife which, when completed, were sent to their respective parents in Scotland. Shortly thereafter the Ainslies' infant son went to Scotland to visit his grandparents. While having tea upon his arrival, the lad spotted his father's portrait on the dining room wall. He ran to it, and tried to grasp his father's hand. He called to the painted image, and when it did not respond, he stamped his foot and scolded it. The story, related by the delighted clients to Copley, testified to his accomplishment. Throughout the history of western art the feat of causing a viewer to believe that painted reality is actual reality has been the popular hallmark of artistic perfection. Conscious of his patrons' taste for realism, and able to satisfy it, Copley was flooded with commissions, especially from prosperous merchants like young Thaddeus Burr. As a result Copley himself grew wealthy. At the time of his marriage in 1769 to Susanna Clarke, daughter of a well-to-do Boston agent of the East India Company, Copley purchased a large estate on Beacon Hill adjoining the home of John Hancock, one of the richest men in New England.

Despite his success, Copley was not satisfied. It was all well and good to be the best artist in Boston, or even in America, but Copley, like Benjamin West, had read about great European artists. Never having seen their works, he yearned to know how his work stood in comparison. How did his art rate with that produced by the best contemporary artists in London? Consumed with curiosity and ambition, Copley sent the marvelous portrait of his half-brother, Henry Pelham, *The Boy with the Squirrel* (private collection) to London for exhibition at the Society of Artists in 1766. To his relief and pleasure, the painting was warmly received and won considerable praise. Benjamin West, delighted to discover the work of an American on exhibition in London, and Joshua Reynolds, the leading artist in Great Britain, sent helpful criticism and advice. They both encouraged Copley to come to Europe for at least a brief period of study. However Copley, pinned down by family responsibilities in Boston, felt unable to follow West's example and advice and go abroad.

In 1771 Copley received a letter from his former acquaintance and fellow artist, John Greenwood, now resident in London, commissioning a portrait of Greenwood's mother as she now appeared "with old age creeping upon her." Copley's portrait of Greenwood's mother, *Mrs. Humphrey Devereux*, is a masterpiece of his dramatic late American style. The subject is seated at a highly polished dropleaf table, a space-defining element between the viewer and the subject that is considerably more subtle and effective than the traditional painted oval spandrel. A flood of light illuminates the figure, casting part of the scene into deep shadow. Copley's art is marked by elements of style that characterize much provincial American art, although in his hands they are carried to unprecedented heights. For example, his light-dark contrasts are strong and crisp. American artists, far removed from collections of great master paintings and academies of art, received much of their awareness of art, their artistic training as it were, through the medium of black and white prints, especially mezzotints. In these, contrasts of light and dark are inevitably more pronounced than in the more subtly modulated original paintings. Carrying over the chiaroscuro of prints into their paintings, American artists often produced pictures marked by strong value contrasts. This seems to be one of the stylistic differences between American provincial painting and its European prototypes. Similarly Copley's notable sensitivity to color and his assertive use of line to demarcate color areas reveal a primary concern with the picture surface. Whether because of the lack of technical training to create the illusion of solid forms in real space or because of esthetic preference, it is a fact that much provincial art emphasizes surface design rather than three-dimensional illusion, and Copley's art, despite its impressive technical competence, is marked by this provincial mode of depiction. His work is clearly stamped by the general as well as artistic values of his society. Copley lovingly delineates textures; not since the Dutch masters of a century earlier had artists lavished as much care on the stuffs depicted. Like his Dutch predecessors, Copley was painting for a Protestant, mercantile, materialistic society, and his art was surely responsive to that society. Indeed Copley's great success as a portraitist lay not only in his ability to depict realistically the external appearances of people and their material surroundings, but also to capture the more profound realism of people as sentient human beings living out their lives in specific social contexts, whether as wealthy merchants, intellectual ministers, fruitful housewives, or characterful elders.

Despite Copley's great success, his American career was dramatically terminated by events beyond his control. Friend as well as painter of patriots like Paul Revere, Samuel Adams and John Hancock, and a man of genuinely democratic instincts, Copley nonetheless had risen into lofty social and economic circles. His family by marriage and most of his newer friends were distinctly loyalist. As the tension grew between England and her American colonies, Copley found it increasingly difficult to maintain a firm straddle on the political fence. Bad times politically meant bad times for the artist, as potential clients were diverted to other concerns. In 1774, after the Boston Tea Party, portrait commissions having fallen off sharply, Copley finally sailed from the American colonies to fulfill his long-cherished dream of a trip to Europe and a chance to study the works of old and modern

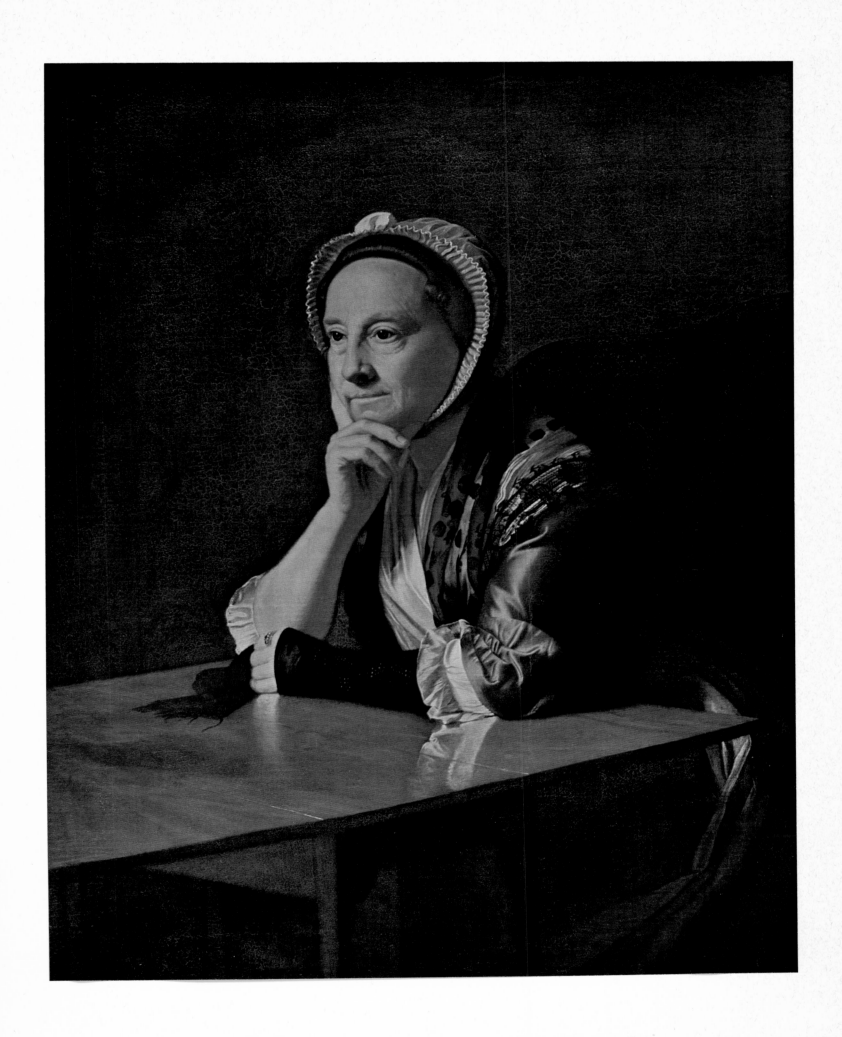

John Singleton Copley (1738-1815). Mrs. Humphrey Devereux, 1771. (40⅛×32″)
National Art Gallery, Wellington, New Zealand.

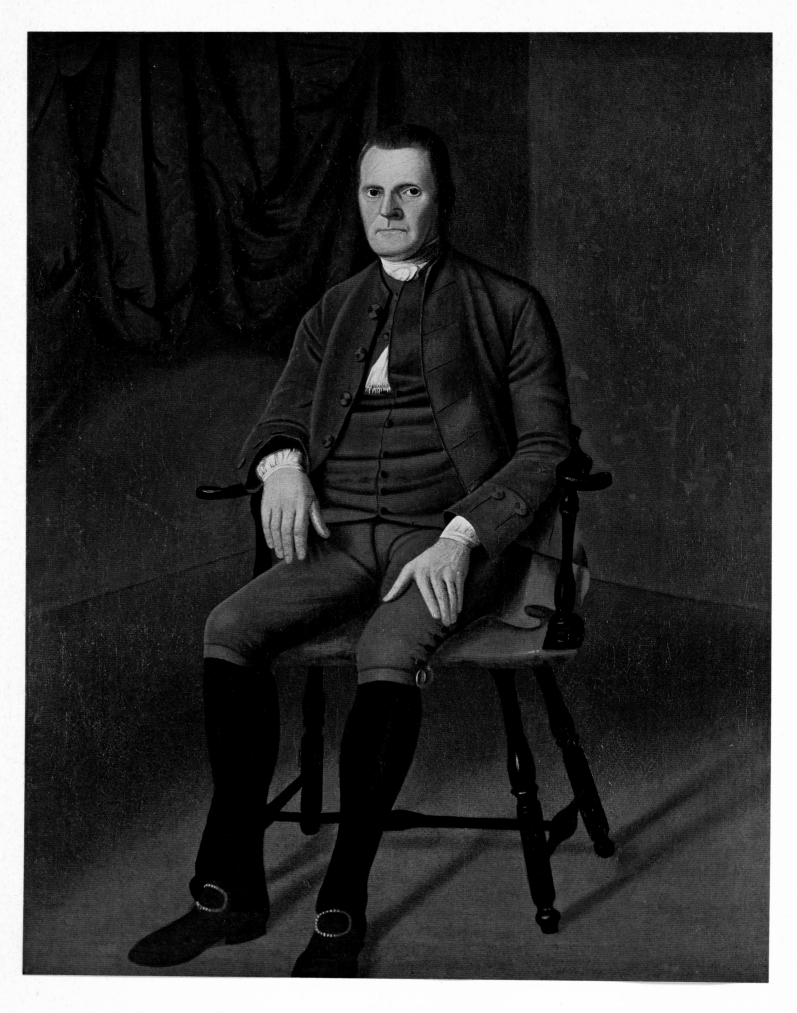

Ralph Earl (1751-1801). Roger Sherman, about 1777. (64¾×49½″)
Yale University Art Gallery, New Haven, Connecticut. Gift of Roger Sherman White, January 1918.

masters. While he was in Italy, war broke out at home at Lexington and Concord. Copley was reunited with his family in London, and there soon gained considerable success as a history painter (see next chapter). He never returned to his native land.

Although Copley left America, the paintings he left behind exercised a marked influence on subsequent painting in New England. The one picture known to have been produced by the Connecticut artist, Ralph Earl (1751-1801), before he left for England in 1778, a portrait of *Roger Sherman*, is Earl's masterpiece, one of the most impressive of all American paintings, and clearly reflective of the benign influence of Copley. Tastefully subdued in color, the painting depicts Sherman sitting in a painted Windsor chair, a compositional device occasionally used by Copley in his late American paintings. However Copley never invoked such an open composition, the sitter facing the viewer, and only rarely would he portray a full figure seated; his seated figures are usually shown at three-quarters length. In *Roger Sherman* the composition is supported firmly by the sitter's legs thrust in one direction balancing two chair legs that splay out in the other. The arms of the Windsor curving back in space echo the movement of Sherman's arms and shoulders. The relationship between foreground and background planes is established linearly as was common with Feke; here the lines where walls meet floor are picked up by the lines of the bottom of Sherman's waistcoat. The triangles formed by thumb and forefinger on each hand and the similarly shaped wedge of white cravat peeking through the waistcoat, along with the edges of the jacket and the rows of buttons and buttonholes, march one's eye irresistibly to Sherman's stern but kindly face, the focal point of the portrait. The sober and restrained style reinforces awareness of the character of the sitter, a self-made man who worked his way up as shoemaker, surveyor, and lawyer to become Judge of the Connecticut Superior Court. He was a delegate to the Continental Congress, attended the Constitutional Convention, and served in the United States Congress as both a Representative and as a Senator. He was one of only two men (the other was Robert Morris of Pennsylvania) to sign the Declaration of Independence, the Articles of Confederation, and the Federal Constitution, the three major documents of American independence. The slightly primitive quality of the angular portrait enhances rather than detracts from the impression of strength, spare toughness and moral rectitude. *Roger Sherman* is an unforgettable symbol of the spirit of independence and the will to achieve and preserve it that marked the establishment of the United States of America as a self-reliant federal republic, and the end of the colonial period.

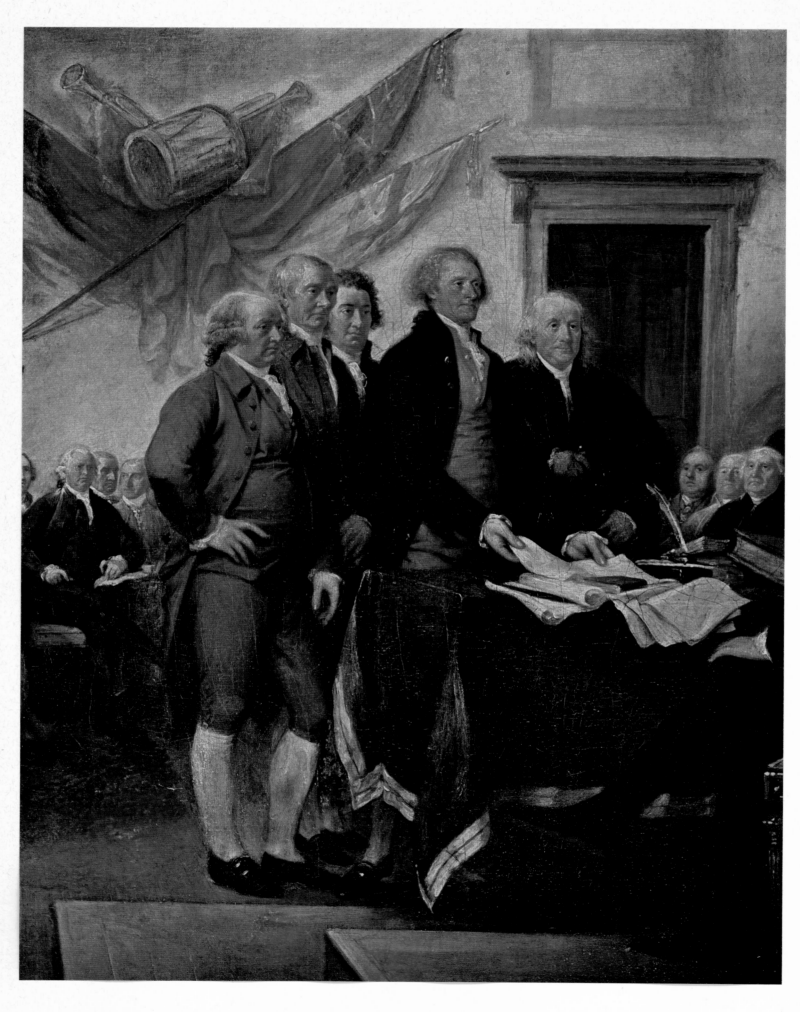

John Trumbull (1756-1843). The Declaration of Independence (detail), 1786-1797.
Yale University Art Gallery, New Haven, Connecticut.

The Federal Period:
Americans at Home and Abroad

EIGHTEENTH century Americans who thought about art were of two minds about it. On the one hand feelings of national pride disposed them to believe that America would one day become a center for the arts. Early in the century Bishop Berkeley had formulated a theory, repeated later by Benjamin Franklin, that the arts move westward. This theory noted that art had first been centered in the Eastern Mediterranean basin, then flowered in Greece, moved to Rome and, after the hiatus of the "dark ages," continued on from Renaissance Italy to France. Now, in the eighteenth century, England was arriving at pre-eminence, and it was logical to assume that the next step to the West would make the new world the next center for the arts.

In opposition to this chauvinistic confidence that the arts would someday flourish in America was a deeply-rooted pragmatic American attitude that relegated the impractical arts to the periphery of American life. After the American Revolution the tendency to dismiss the arts as irrelevant was reinforced by a positive conviction that art, which in its sensual appeal stimulated the emotions rather than the intellect, was corrupting, and therefore to be avoided.

American artists were whipsawed between these two points of view. Again and again the situation recurred in which a promising young American artist, wishing to travel to Europe to study art, would be sent abroad by public-minded citizens intending their subsidy of the artist as an investment in America's cultural future. The artist would spend years in Europe studying, expanding the range and vocabulary of his art. On his return to America he would find that despite his early encouragement, there was in fact no patronage for the ambitious art that he now wished to produce—history pictures, mythology, landscapes. Portraiture was the only art form for which there was a continuing demand in pragmatic America, and through the first third of the nineteenth century, the artist who hoped to make a living by painting anything other than portraits was tilting at windmills.

Despite the discouraging obstacles that artists faced in the new world, scores and eventually hundreds of young Americans still wanted to become artists and found the financial support necessary to get to Europe to study. Many remained there as expatriates, from Copley and West to James McNeill Whistler, John Singer Sargent and Mary Cassatt. But more returned to America, their work enriched by what they had learned in Europe.

For over half a century the dominant influence on American artists abroad was that of Benjamin West. When West arrived in London in 1763 after three years of study in Italy, he decided to make his career there rather than return to America, and sent to Philadelphia

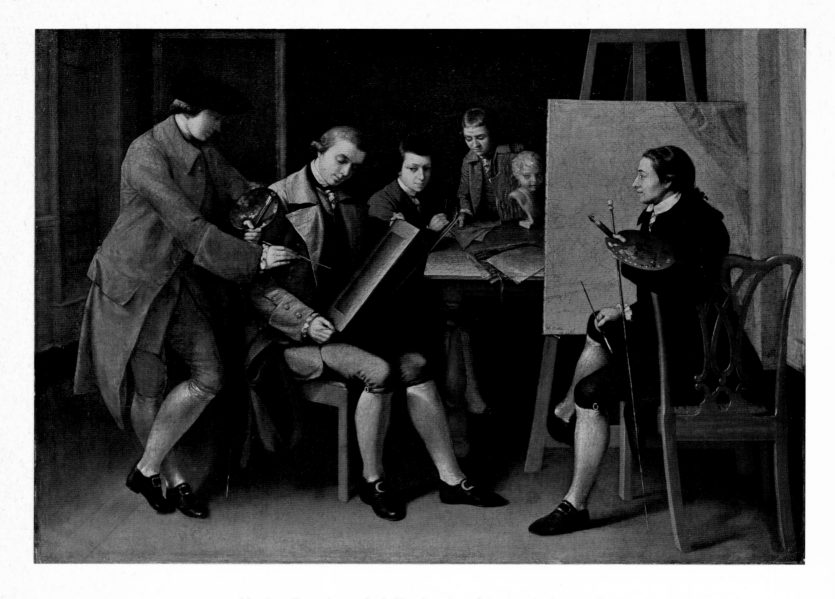

Matthew Pratt (1734-1805). The American School, 1765. (36×50¼")
The Metropolitan Museum of Art, New York. Gift of Samuel P. Avery, 1897.

for his fiancée, Elizabeth Shewall. Among the friends who escorted her to London for the wedding was a young Philadelphia artist, Matthew Pratt, who remained to become one of West's first American pupils. West's studio rapidly became an important training center for American artists, a fact celebrated in Pratt's memorable *The American School*, a view of the studio in 1765. Most of the figures, other than West standing at the left, are unidentified, although one, probably the artist at the easel, is Pratt himself and another may be the New York artist, Abraham Delanoy, also one of West's early pupils. They were soon followed by Charles Willson Peale, Gilbert Stuart, John Trumbull and a host of others.

While West's effectiveness as a teacher resulted from his magnetic and kindly personality, his importance flowed from his perceptive view of art and its meaning in his time. If to twentieth century eyes his paintings seem static, dull, and occasionally pompous, it is obvious from the fact that so many young artists found his art and his thinking provocative and stimulating that he requires careful study, particularly within the context of the artistic values of his own day.

As a youth in America, his imagination stimulated by the books on art he had read, West was stirred by a desire to become not just an artist but a master of the highest branch of art, a painter of historical subjects. In Italy he was caught up in the powerful surge of interest in classical antiquity that pervaded the intellectual climate of the day. Influential writings of the rationalist philosophers of the Enlightenment were suggesting that man, in

opposition to the traditional Christian belief in taint by original sin, was essentially pure, and had simply been debased over the centuries by corrupt institutions of church and state. If eighteenth century man could divest himself of these corrupt institutions, he could then construct a better society. As living proof of the inherent purity of man, writers like Rousseau pointed to natural man, man in a savage or uncivilized state, such as the American Indian. With some prodigious misreading of available evidence, philosophers of the Enlightenment found in the American Indian an example of a society of naturally good men practicing all of the civic and family virtues. They also postulated that history provided similar evidence of the creative potential of unspoiled man; in classical Greece and Rome, before corrupt institutions had arisen, man had created ideal societies where the highest standards of justice, virtue, courage, beauty, morality and every imaginable social good obtained. Civilization had declined ever since, but classical antiquity demonstrated what man could achieve when free of corruption, providing a model for eighteenth century man as he worked to rebuild his own society. It was therefore obviously important to discover as much as possible about antiquity. As a result the eighteenth century turned to the classical past not out of a dry and dusty antiquarian curiosity, but out of an intense desire, born of potent social and political ideas that before the end of the century would bring revolution in America and France, to reach back across the centuries and touch hands with the past. At Pompeii and Herculaneum the earth was scraped away to reveal the remains of the Roman world beneath; the Greek temples at Paestum claimed new attention; the *Ruins of the Palace of the Emperor Diocletian at Spalato* were carefully measured and published in 1764 by Robert Adam; James Stuart and Nicholas Revett published precise and beautiful measured drawings of *The Antiquities of Athens* in 1762; and even earlier Robert Wood published the *Ruins of Palmyra* (1753) and *Balbec* (1757). In Rome itself a prime mover behind the whole classical vogue was the German Johann Joachim Winckelmann. Through such writings as *Gedanken über die Nachahmung der griechischen Werke in der Malerei und Bildhauerkunst* (1755), translated into English by Fuseli in 1765, and *Geschichte der Kunst des Altertums* (1764), and through his artistic protégé, Anton Raphael Mengs, he exercised enormous influence.

And there in Italy from 1760 to 1763, right in the midst of this exciting rediscovery of the past, was Benjamin West, an alert and receptive young provincial from Philadelphia. A few years later West began to weave these new ideas and discoveries into the fabric of his art. *Agrippina Landing at Brundisium with the Ashes of Germanicus* (1768) asserts the importance of classical antiquity as a model for the eighteenth century. Germanicus was a Roman hero, treacherously assassinated by a political rival. On one level the picture is a tribute to a hero who has sacrificed his life for his country—*dulce et decorum est pro patria mori*. But more importantly it dramatizes the admirable performance of Agrippina carrying her husband's ashes in a cinerary urn and followed by grieving children. Her courage, stoicism and dignity in the face of tragic circumstances, normative behavior in classical times, is presented here to inspire emulation.

The presentation of a Roman subject and a moralizing message is not unusual in eighteenth century painting; what is significantly new and different is that West attempts to depict the Roman subject in accurate Roman terms, making the painting as realistic as he could. The central cortege, obviously based on relief sculpture in its flat disposition of figures and its monochromy, following the injunctions of Winckelmann to the letter, was in fact specifically based on a published detail of the procession of senators and their wives from the *Ara Pacis*. The arcaded façade in the background was taken directly from Robert Adam's recent *Ruins of the Palace of the Emperor Diocletian at Spalato* (1764). The triangularly composed grieving group on the left is obviously reminiscent of classical pedimental sculpture.

West also used a dramatic theatrical composition to communicate his didactic message to maximum effect. The main action in the center of the stage is strongly lit, with supporting groups in the wings to frame and define the action. A secular sermon in paint to

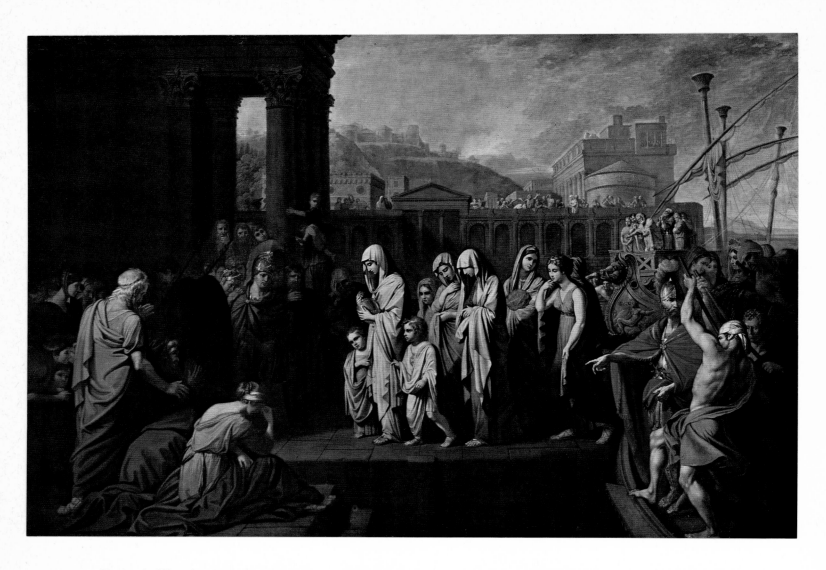

Benjamin West (1738-1820). Agrippina Landing at Brundisium with the Ashes of Germanicus, 1768. (64½×106½″)
Yale University Art Gallery, New Haven, Connecticut. Gift of Louis M. Rabinowitz.

an eighteenth century audience, *Agrippina* prefigures French Neo-classicism, notably the paintings of Jacques-Louis David, in the political implications of its call for a change in the values and standards of contemporary society, in its concern for historical accuracy and realism, and in the new classicism of its sculptural, coloristically muted style.

Like *Agrippina*, *The Death of General Wolfe*, exhibited by West in 1771, treats the theme of the death of a hero. However in this case the death scene is actually represented, and the subject is taken from the recent past rather than from classical antiquity. General Wolfe died on September 13, 1759, on the Plains of Abraham, outside of Quebec, in the war against the French. The innovations in thematic seriousness and pictorial realism initiated in *Agrippina* are here carried forward to achieve what has been termed a "revolution in history painting," as West depicted the figures in contemporary dress (against the advice of Joshua Reynolds and George III). Although contemporary subject matter was not unusual, modern dress was. History paintings as a matter of course treated contemporary themes allegorically, with the figures draped in togas, amidst soaring angelic choirs or the shades of heroic predecessors. Classical dress and details helped to demonstrate that the hero and his deeds transcended ordinary life and were worthy of the ancients. In *The Death of Wolfe* West inverted the emphasis, stressing the contemporaneity of it all. This man who heroically gives his life for his country, is an eighteenth century Englishman; the heroism, courage and dignity he demonstrates, these classical virtues, are in fact eighteenth century realities.

West is preaching again, using a variety of devices to help deliver his sermon. The composition remains theatrical, with highlighted drama in the center stage supported by flanking groups. A knowledgeable eighteenth century connoisseur would have found this painting suffused with subtle pictorial references. The placement of the figure of Wolfe with a draped flag behind him recalls countless compositions of the descent of Christ from the cross. Wolfe's comrades mournfully support his body in a compositional echo of a traditional "Lamentation" over the body of Christ. On the right a young officer wrings his hands in the pose of a youthful St. John the Evangelist at the Crucifixion, while on the left a wounded officer recoils into a pocket of figures like a swooning Virgin Mary. *The Death of Wolfe* thus invokes a rich substratum of Christian iconography, subtly using compositional Crucifixion, Deposition and Lamentation echoes to imply parallels between the death of Wolfe and the martyrdom of Christ.

In the left foreground a seated Indian contemplates the scene. A natural man, a noble savage, he seems most fully aware of the meaning of Wolfe's sacrifice. West, pulling out all of the stops to intensify the contemporary viewer's response to the painting, was very much aware of European fascination with Indians. Earlier, in Italy, a young artist fresh from the land of the noble savages, West had been taken by a group of Roman *cognoscenti*, including Cardinal Albani, to view the *Apollo Belvedere*. As his eyes fell on the famous antique sculpture, West gasped, with apparent but unlikely spontaneity, "My God, how like a

Benjamin West (1738-1820). The Death of General Wolfe, 1770. (59½×84″)
The National Gallery of Canada, Ottawa, Ontario. Canadian War Memorials Collection.

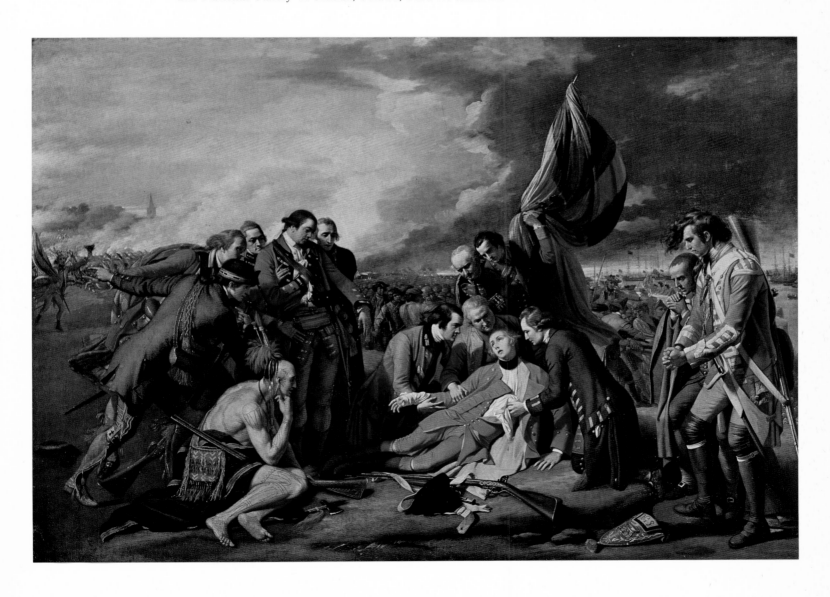

Mohawk warrior." Perfect! The youth from the forests of the new world seemed to grasp instinctively the parallel between the godlike classical figure and natural man, the noble savage unspoiled by civilization. West capitalized on European interest in the American Indian in a number of paintings, notably in his next major modern history painting, a depiction of William Penn's *Peace Treaty with the Indians* (Independence Hall, Philadelphia, Pennsylvania), exhibited at the Royal Academy in 1772. Turning to advantage his own Pennsylvania Quaker background as well as his first-hand knowledge of Indians, he presented Penn's "Holy Experiment" in Pennsylvania as evidence in fulfilment both of Rationalist philosophy and biblical prophecy that men of good will could create a new society, that the lion and the lamb, here in the persons of white man and red man, could lie down and dwell together in peace and harmony, and had done so on the banks of the Delaware.

West's innovations and accomplishments as a history painter greatly impressed his fellow colonial, John Singleton Copley. When Copley arrived in England in 1774, aspiring like West before him to go beyond portraiture and become a history painter, he perceived that West had significantly advanced the course of history painting with his realism. Copley first won recognition as an artist in England with his exhibition of *Watson and the Shark* in 1778 at the Royal Academy. Instead of the death of a hero, *Watson and the Shark* represents the bizarre maiming of a youth. Brooke Watson, a prosperous shipper and later Lord Mayor of London, as a boy had served as a midshipman aboard an English ship. On one occasion, while the vessel was anchored in Havana harbor, Watson went swimming and was attacked by a shark. On its first strike the shark had stripped all of the flesh from Watson's leg below the knee. It then returned and snapped off his foot at the ankle. As the shark closed once more to devour its helpless victim, Watson's shipmates came to the rescue. This is the climactic moment that Copley depicts. Like West in *The Death of Wolfe*, Copley portrays a scene that is recent in time but distant in setting, cushioning the impact of the straightforward presentation of a contemporary event in contemporary costume on English viewers unaccustomed to such immediacy. But Copley goes beyond West in heightening the realism by not only using modern dress but also presenting an actual view of Havana harbor, based on engravings, so that such landmarks as Morro Castle, the cathedral, and the convent towers are readily identifiable.

Watson and the Shark is more directly *reportage* than *The Death of Wolfe*, without complex classical, religious or philosophical overtones, although the figure of Watson is based on the *Borghese Warrior*, evocative of gladiatorial combat between warrior and beast. The painting may not be profound, but it is effective. The composition is held together by a zigzag movement through the shark and boy, boat and background, both on the picture surface and plunging deep into pictorial space. Dramatic lighting emphasizes the boy, the shark, and the man with the boathook. It calls specific attention to the tip of the hook, reinforced by a triangular wedge of light on the stem of the boat, and to the nose of the shark. There is a sense of pending but uncertain impact. Will the men in the boat grasp the boy before the shark gets him? Will the boathook stop the shark? All is held in suspense. The scene is tautly bound within a pyramidal arrangement, and despite its transitory nature, is locked in place forever.

This monumental painting has sometimes been considered an important example of proto-Romanticism, anticipating such later works as Géricault's *Raft of the Medusa*. *Watson* does indeed reflect that eighteenth century fascination with the exotic and the horrible that forms part of the root structure of Romanticism, but the picture is quite orthodox in its composition. Nineteenth century artists may well have been aware of the painting, but Copley exercised more influence on David and French Neo-classicism through his realistic, portrait-filled history pictures. Instead it was Benjamin West, always sensitive to artistic novelty, who painted romantic pictures as early as the 1770's with *Saul and the Witch of Endor* (Wadsworth Atheneum, Hartford, Connecticut) and the *Cave of Despair* (Mr. and Mrs. Paul Mellon), and whose *Death on a Pale Horse* (Philadelphia Museum of Art, Philadelphia, Pennsylvania), exhibited in Paris in 1803, directly influenced French romantic painters.

In *The Death of the Earl of Chatham* (1779-1781, Tate Gallery, London), Copley carried realism a step further by depicting an important event that was local as well as contemporary. Fifty-five portraits of individuals present at the event, accurately set in the House of Lords, are woven into a complex composition. Although the picture may seem static now, filled with so many portraits, it was produced in a pre-camera era when people were eager to see pictures of important events. Today's viewer is no longer familiar with the people portrayed or the complexities of their relationships, but to Copley's contemporaries the painting represented a rich interplay of political positions, party antipathies, personal scandals, and family backgrounds.

Copley's next history painting, *The Death of Major Peirson* (1782-1784) marked the zenith of his career. On the night of January 5/6, 1781, a French detachment of nine hundred troops had invaded the Channel isle of Jersey. Aided by surprise, the French quickly gained control of the capital city of St. Helier. However before they could secure the island, a twenty-four year old British officer, Major Francis Peirson, rallied the local militia and the remaining British forces and launched a counterattack that swept back into St. Helier. In a bloody pitched battle the English regained the city and the island. At the moment of victory, Major Peirson was slain.

The Death of Major Peirson achieved considerable popular success when it was exhibited in 1784. The spirited character of the scene is enhanced by the vigor of the composition, the brilliance and boldness of the color, and the surface flicker of light and dark contrasts. Years later the Duke of Wellington observed that this exciting picture, smoke-obscured and filled with the sounds, smell and stir of combat, with troops marching, banners flying, and civilians fleeing, was the only painting that he had ever found convincingly evocative of the real feel of battle. The subject of the painting also contributed greatly to its popular success. England had endured a long period of war marked by few victories. News from America was not good, and even success in the colonies involved Englishmen killing Englishmen. But a victory over a traditional continental foe, the French, was a different matter, and on Jersey the triumph was made all the more gratifying in that it had been snatched from the jaws of defeat. The poignant death of a youthful hero cut down at his moment of glory, the retribution exacted by a faithful Negro servant, and the selfless devotion of the mortally wounded drummer who ignores his own wounds to turn toward his lost leader, all added to the picture's appeal. Modern viewers may find this arrangement of figures in costume theatrical; indeed a creative act of imagination is required to comprehend the impact this picture had in its own day. Within the context of a time when visual images were still uncommon, one must imagine this as a contemporary street scene with soldiers and civilians in modern dress, with death and destruction all around, and terrified civilians fleeing. Copley stressed the immediacy of the terror by using members of his own family for the group on the right, including his wife with upraised arms and a son, John Singleton Copley, Jr., the little boy with the hat, later Lord Chancellor of England.

The Death of Major Peirson, like *Watson and the Shark,* has a realistic setting; the town square of St. Helier is accurately depicted, including the statue of George II in front of city hall and Town Hill on the left. The painting also follows *Watson* in the incorporation of a Negro as a dramatic central figure. As in *The Death of Chatham*, the composition centers around a death group and includes portraits of people who participated in the event.

In his large history paintings Copley completed the "revolution" begun by West, recording contemporary events with increasing realism of dress, setting, action and the portrayal of individuals present. The innovative impulse of West and Copley toward realism, not to be found in the work of their English contemporaries, may have reflected pragmatic and materialistic values of the provincial society from which they had sprung (the realism of Copley's American portraits as responsive to the values of his society has already been noted). If so, their achievement as history painters in England may stand as perhaps the earliest instance of an identifiable American contribution to the development of European art, and indeed one of the earliest American contributions to European culture.

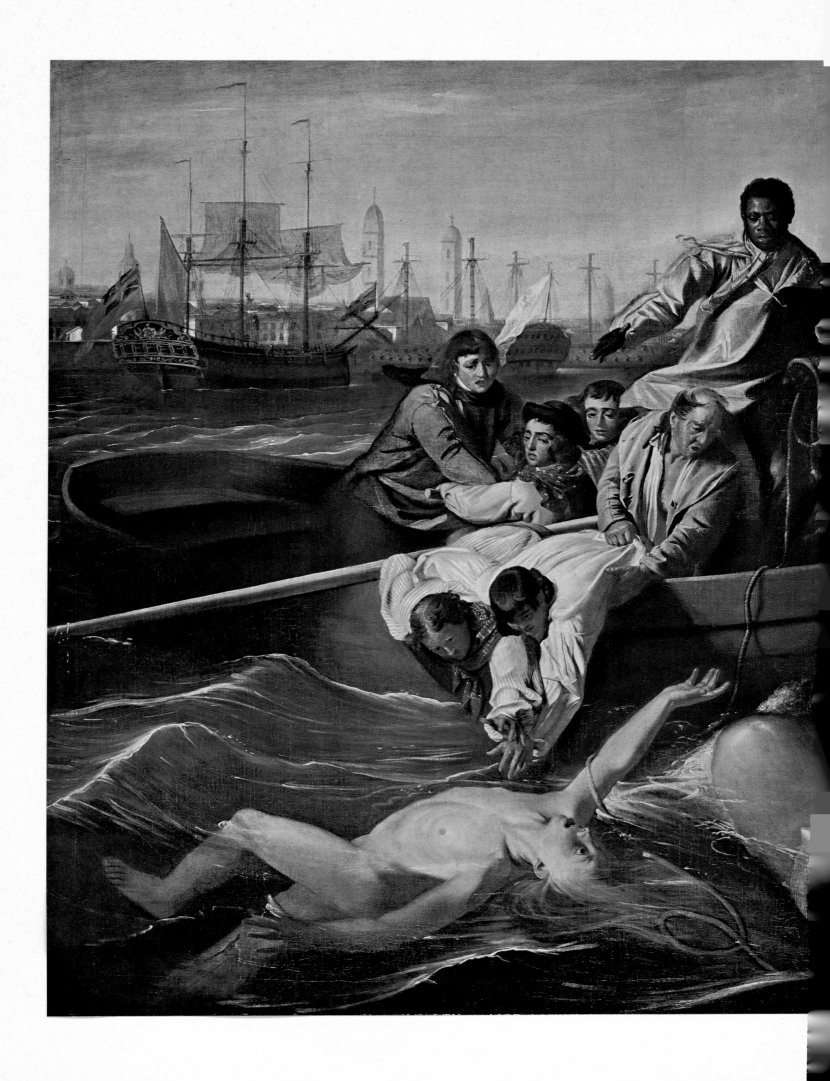

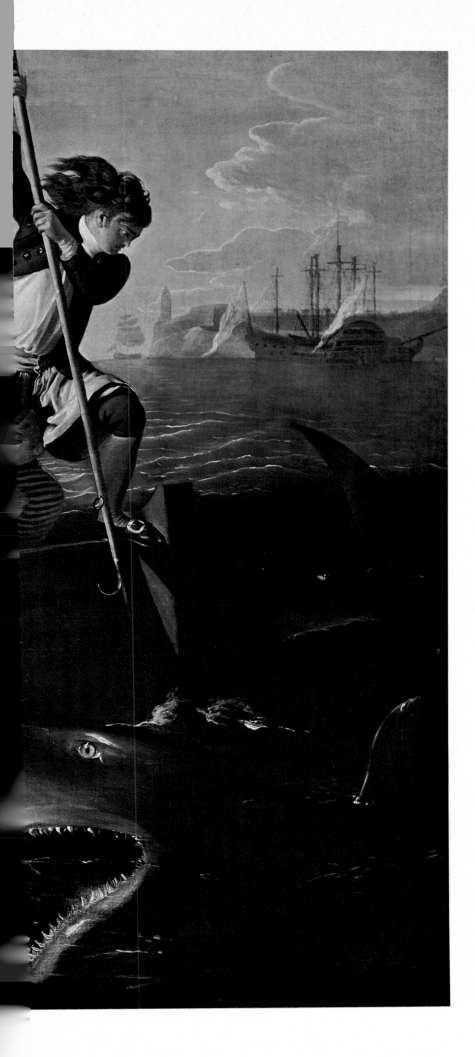

John Singleton Copley (1738-1815).
Watson and the Shark, 1778. (72×90⅛″)
Courtesy, Museum of Fine Arts, Boston, Massachusetts.
Gift of Mrs. George von Lengerke Meyer.

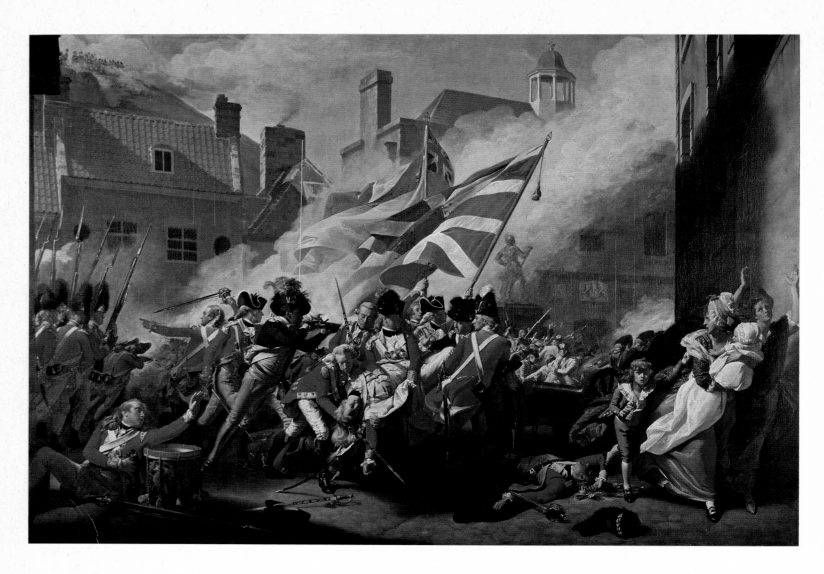

John Singleton Copley (1738-1815). The Death of Major Peirson, 1782-1784. (97×144″)
By Courtesy of the Trustees, The Tate Gallery, London.

Copley's one artistic descendant, although not his pupil, was John Trumbull (1756-1843). Trumbull was born in Lebanon, Connecticut, to a prominent, well-to-do family (his father became Governor of Connecticut during the Revolution). His youthful desire to study with Copley in Boston and become a painter was frustrated by his family. While at Harvard College he did meet Copley and was strongly influenced by his work. He graduated from Harvard in 1773. When the American Revolution began, Trumbull joined the Continental Army, using his artistic talent to draw maps and sketches of British positions. He served briefly as aide-de-camp to General George Washington, a fact of which he boasted until his dying day. After a petty dispute over the date of his commission, he quit the army. Renting John Smibert's old studio in Boston, he copied some of Smibert's copies of old master paintings and also painted portraits and history pictures that reflect the influence of Copley. In 1780 he went to London to study with Benjamin West. However upon the arrest and execution in America of the British spy, Major John André, Trumbull, an ex-officer in the Revolutionary Army, was jailed in reprisal. He was released in 1781 (Copley and West posted his bail), and deported to America. When hostilities ended, he returned to London to resume his study, arriving just as Copley's *Death of Major Peirson* was exhibited to popular acclaim. He realized that West and Copley had moved the most important branch of art, history painting, into new ground with their increased realism. He also realized that there was an important category of contemporary history, the American Revolution, inappropriate for use by West and Copley as Americans living permanently in England. With the

encouragement of West and Copley, Trumbull undertook a series of Revolutionary War scenes. The first of these, *The Death of General Warren at Bunker's Hill* (Yale University Art Gallery, New Haven, Connecticut), with its central death group, waving banners, diagonal shafts of fire and smoke, a prominently placed Negro servant, and a fleeing group on the right, is clearly derived from Copley's *Death of Major Peirson*. The second, *The Death of General Montgomery at Quebec* (Yale University Art Gallery, New Haven, Connecticut) is patterned on West's *Death of General Wolfe*, which earlier represented a general's death at Quebec, and includes an Indian, a grieving figure holding his wrist and other similarities. In 1785 Trumbull was invited by Thomas Jefferson, the first American minister to France, to visit Paris, where Trumbull was obviously influenced by French Neo-classicism. The third picture in the series, *The Declaration of Independence*, which he began in Paris, assisted by factual advice from Jefferson who was a participant, is much more neo-classical in its balance and order than the earlier, intensely movemented battle scenes. This results in part, of course, from the subject itself which, like Copley's *Death of Chatham*, involves an interior setting with lots of figures, necessarily leading to static rows of heads. However the scene represents one of the crowning moments of the Enlightenment, as new world men declared themselves independent from an old and unresponsive regime, affirming their resolve to construct a new society based on reason rather than on tradition and empty forms. The balance, repose and stability of the painting echoes the rationality of the enterprise.

In all Trumbull completed a total of eight Revolutionary war scenes, traveling extensively throughout America to sketch the sites and to take life portraits of participants. Since West and Copley never returned to America, it was Trumbull who applied their innovations to American subjects, and re-introduced the accomplishments of these American artists into the mainstream of American art.

When Trumbull had first arrived in London in 1780 he was welcomed and introduced to the mysteries of West's studio by a young American painter, Gilbert Stuart (1755-1828), West's apprentice and principal assistant. Stuart was born in Narragansett, Rhode Island. His father had come from Scotland to establish a snuff mill for Dr. Thomas Moffatt, John Smibert's nephew and a member of Berkeley's expedition, depicted next to Smibert in *The Bermuda Group*. When the snuff venture failed, the Stuart family moved to Newport, where young Stuart became exposed to art in the small private collections of Moffatt and William Hunter. In 1769 a Scottish portrait painter, Cosmo Alexander (c. 1724-1772), arrived in Newport. After a brief stay he returned to Scotland, taking Stuart with him. Upon Alexander's sudden and untimely death, Stuart was cast loose in Edinburgh. He managed to work his way back to America, but the experience at sea was brutal; in subsequent years the normally loquacious Stuart never touched upon the subject.

Upon the outbreak of the American Revolution, Stuart's loyalist family left Newport for Nova Scotia. Stuart himself went to London in 1775 to pursue his artistic career. Intending like Ralph Earl to paint, not to study, he almost starved to death before he swallowed his pride after a year and applied to Benjamin West for help. West took him in as a pupil and assistant. In 1777 Stuart began to exhibit at the Royal Academy, and during the next few years, while he continued to work with West, he exhibited regularly. Stuart attracted little attention at the Academy until 1782, when he exhibited four paintings that were well received, especially a splendid full-length portrait of a Scottish client, Mr. Grant of Congalton, a painting more popularly known as *The Skater*.

Stuart differed from West, Copley and Trumbull in that he had no wish to paint history pictures. Portraits were his forte. He loved to paint faces, to "pin the sitter's head to the canvas," to capture the aspect and personality of the subject. The remaining parts of painting bored him as hack work to be discharged as expeditiously as possible. As a result he painted very few full-length portraits, which led to allegations that he could not paint below the shirt buttons. However *The Skater* provides convincing proof that Stuart could paint superb full-length portraits when he chose. *The Skater* is painted in a cool harmony of gray,

green-gray, black and white with touches of red in the background. The head, a strong area of flesh color framed by a jaunty black hat and silhouetted against the light gray winter sky, serves as the focal point for the entire composition. The arrangement invokes a precarious formal balance between stability and movement that subtly suggests the essence of skating. The skater glides away from the stable verticals of the tree and leaning figures on the right. A small figure in a red jacket, sitting on the bank of the frozen river to tie his skates, makes the transition between tree and skater, between land and river, between stability and motion. On the left the clockwise movement of circling skaters imparts a pull to the left, away from the shore, on the main figure. The composition is at rest at the top and on the right, in motion to the left and at the bottom. The primary movement from right to left is bracketed by a counterpoint of movements curving into space; the bend of the road away from the scene in the background, and the curl cut in the ice as the skater turns toward the viewer. With arms folded as he glides, the skater evokes an allegorical image of Winter as one of the Four Seasons, arms buried in a muffler, hugging his body against the cold. After *The Skater* was exhibited, it disappeared from view until 1878 when it was again shown at the Academy. In the interim the name of Stuart had become dissociated from the picture. In a flurry of attributions it was first suggested that the painting was by Gainsborough, then Romney, then Raeburn, until Stuart was finally identified as the artist through connection with the original exhibition record.

In 1783 Stuart moved out of West's studio to pursue his own career. He soon achieved a rank among the leading portraitists of the day just behind Reynolds, Gainsborough and Romney. Commissions flowed in, and Stuart, who had known intense poverty and deprivation, plunged himself into an orgy of self-indulgence. He was a dandy in dress, and delighted in lavish entertainments where, over quantities of food and drink, he amused his friends as a brilliant raconteur. Although he earned a substantial income, his expenses rose even more rapidly, especially after his marriage in 1786, and his extravagance induced constant and severe financial strain. As with most portrait painters, Stuart's procedure on receipt of a commission was to collect half of his fee in advance. His need for money tempted him to begin more pictures than he could hope to finish, a procedure to which he was further inclined by the fact that it was the initial phase of portrait painting, the taking of the likeness, that interested him most. It became increasingly difficult for him to finish a portrait.

Stuart suddenly resolved his problems in 1787 by leaving London, going to Dublin where he worked for five years. In Ireland he followed the same pattern of extravagant living. Despite the flood of commissions that came his way as the best portrait painter in Ireland, Stuart's financial situation deteriorated to the point where he saw the inside of a debtor's prison. However the canny Stuart was not without hope or resources. As an American with a detached view of America, he saw clearly that George Washington, as commanding general of the victorious Continental Army and as first President of the United States, had achieved legendary stature in his own lifetime. Stuart reasoned that there would be an endless demand for likenesses of Washington, and if he could only get access to the President and persuade him to sit, he could secure a steady income by selling copies of his portrait and by publishing an engraving of it. As for the moral question of abandoning a large number of unfinished paintings in Ireland, paintings begun in order to collect the initial half fee, Stuart rationalized that he would in fact be performing a good deed since completing the portraits would provide welcome employment for local Irish artists who had suffered from his competition.

Stuart returned to America early in 1793, establishing a studio in New York. At the time of his return, the arts in America were at a low ebb. Several of the best American artists, including West and Copley, had left before the war and never returned. Those who did return found that patronage was severely limited by a depressed economy. Times were difficult, and even such good artists as Matthew Pratt in Philadelphia were reduced to painting signs. However among the social elite in America, especially those associated with Washington's new regime who formed a Federalist aristocracy, there continued to be a

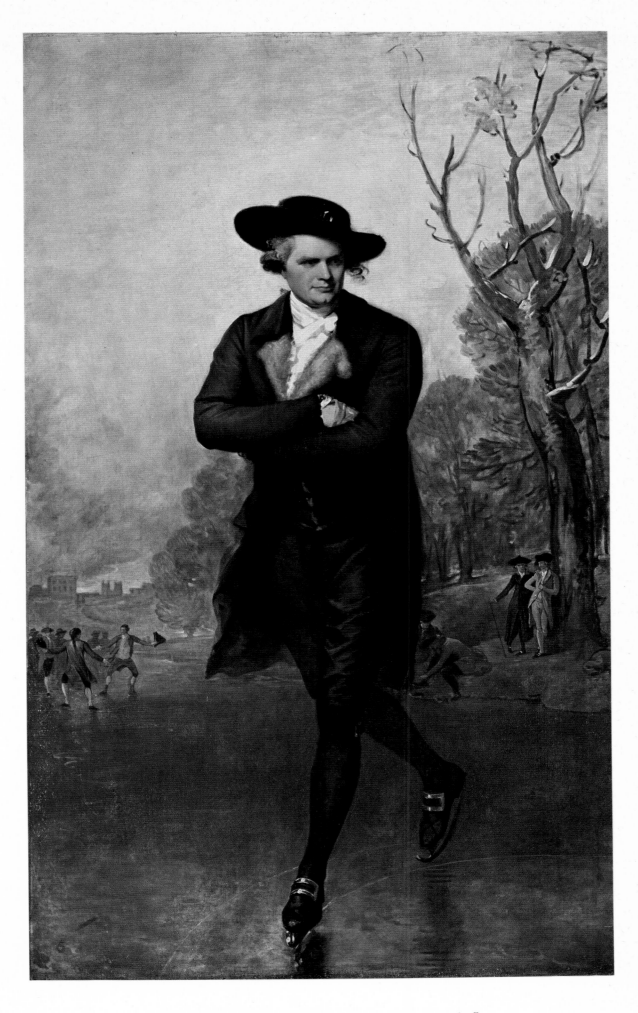

Gilbert Stuart (1755-1828). The Skater, 1782. (96⅝×58⅛″)
National Gallery of Art, Washington, D.C. Andrew Mellon Collection.

demand for portraits. Moreover Stuart was a far more accomplished painter than any of his American rivals. His early New York portraits, such as *Mrs. Richard Yates* (National Gallery of Art, Washington, D.C.), were the equal of high style London portraits, and established Stuart's artistic primacy. In 1795 Stuart followed the federal government from New York to Philadelphia. Armed with a letter of introduction from John Jay, a satisfied client, Stuart gained access to President Washington and painted his first portrait of him. This was the so-called "Vaughan" portrait which shows Washington facing right. Although the "Vaughan" Washington is thought to have been destroyed, the version at the National Gallery of Art, Washington, D.C., may be the original version, and many other replicas survive. Stuart, while painting a portrait, would utilize his conversational brilliance to engage the interest of his sitters, and animate their expressions. However he was unable to arouse any response from Washington who, apparently in pain from ill-fitting false teeth, sat in stony silence while Stuart enthusiastically but futilely turned the one-sided conversation to horses, war, farming and other subjects of possible interest.

Dissatisfied with the "Vaughan" portrait, Stuart was happy to receive a commission the following year from Lord Lansdowne in England for a full-length portrait of Washington. Shortly afterward, commissioned by Martha Washington to paint a portrait of her husband, Stuart produced a bust-length variant of the "Lansdowne" picture. Known as the "Athenaeum" *Washington*, this is the finest of the three Washington portraits Stuart painted, and is the likeness by which Washington is best known to posterity. Having finally gotten a good likeness, Stuart was reluctant to complete the portrait and deliver it to Martha Washington. Instead he used it as the source for an endless stream of copies, jokingly referred to by Stuart as his "hundred dollar bills," that he cranked out to meet the demand for Washington portraits. By the time of Stuart's death, when his widow sold the painting to a committee which presented it to the Boston Athenaeum, it still had not been completed. Stuart had "pinned the likeness to the canvas," and that was what he cared about.

One reason why Stuart was so reluctant to surrender the profitable "Athenaeum" portrait was his disappointment in regard to an engraved likeness of Washington. He had planned to publish an engraving after one of his Washington portraits anticipating that it would yield a considerable income. Without Stuart's knowledge, Lord Lansdowne gave permission to a London engraver, James Heath, to engrave the "Lansdowne" *Washington*. Heath's engraving could not have been more timely; it was published at the beginning of 1800, immediately following Washington's death in the final month of the old century. It capitalized on a surge of interest both in America and Europe in portraits of the lamented leader, and Stuart, with no copyright laws to protect him, gained not a penny.

Despite this disappointment, Stuart enjoyed considerable patronage and prospered. The fashionable flocked to his studio in Germantown, outside of Philadelphia. In 1803 he moved to Washington, again following the seat of government, and painted there such important political figures as James Madison, John Adams and Thomas Jefferson. Chronicler of the faces of the founding fathers, Stuart is perhaps the best known of all American painters.

Stuart returned to his native New England in 1805 at the age of fifty, settling in Boston to spend the rest of his life. Stuart liked Boston and Boston liked him. Still addicted to good food, good drink and good conversation, although less extravagantly than in earlier days, the convivial Stuart became the grand old man of American painting. He welcomed a steady stream of young artists who came to Boston to seek his advice and his instruction, and his influence dominated American portraiture deep into the nineteenth century.

If Stuart painted the best and most familiar portraits of George Washington, he lagged far behind Charles Willson Peale (1741-1827), in the number of Washington life portraits. Washington sat for Peale no less than seven times. During his early years in Annapolis, Maryland, Peale was a saddler, a watch and clock maker, and a silversmith. In 1763, convinced upon seeing the uninspired work of an itinerant portrait painter that he could do better, Peale exchanged a saddle for some painting lessons from John Hesselius. Later he

Gilbert Stuart (1755-1828). The Athenaeum Portrait of George Washington, 1796. (39⅝×34½″)
Courtesy, Museum of Fine Arts, Boston, Massachusetts. Courtesy of the Boston Athenaeum.

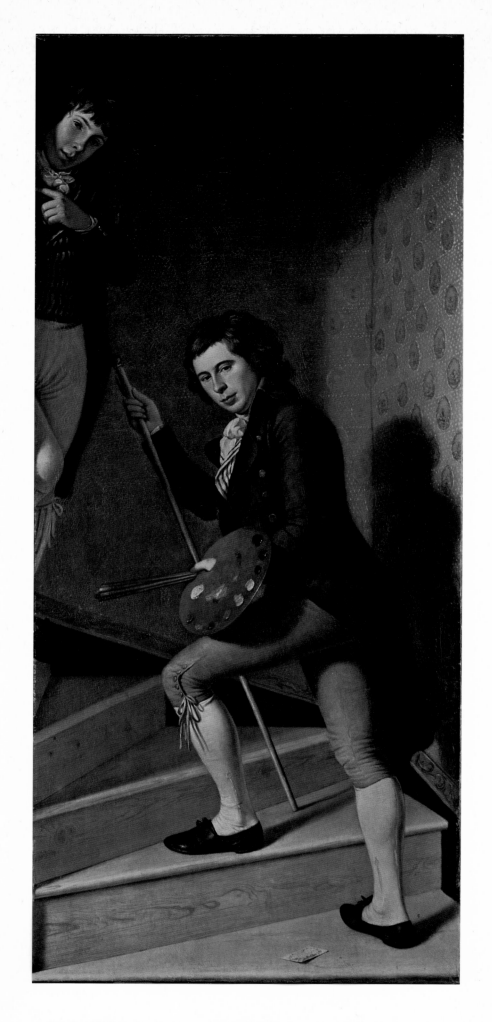

Charles Willson Peale (1741-1827). The Staircase Group, 1795. (89×39½″)
Philadelphia Museum of Art, Philadelphia, Pennsylvania. George W. Elkins Collection.

traveled to New England where he visited Smibert's studio and met Copley. In 1766 he was sent by a group of Maryland patrons to London, spending three years in West's studio. West and Peale became firm friends, corresponding after Peale's return to America, and years later West sent artistic advice to Peale's sons as they launched their own careers as painters.

Back in America, Peale painted cool, pleasant portraits that reflect the coloristic influence of Joshua Reynolds, the leading portrait painter in London while Peale was there. Although many artists departed from the colonies for Europe on the outbreak of the Revolution, either from loyalist convictions or economic necessity, Peale was an ardent patriot who served in the Continental Army throughout the war. In a memorable 1779 portrait of George Washington (Pennsylvania Academy of Fine Arts, Philadelphia, Pennsylvania), he depicted the victorious general at full length, exaggeratedly attenuated, legs crossed, leaning jauntily against a cannon, with captured Hessian flags representing the Battle of Trenton stacked at his feet and British prisoners from the Battle of Princeton being marched past Nassau Hall in the background. Confidence pervades the portrait, as a relaxed Washington, a smile playing about his lips, with New England, New Jersey and Pennsylvania now cleared of the enemy, seems ready to mount up and ride off to strike another victorious blow elsewhere.

Peale was a man of varied interests, an inveterate tinkerer and inventor, as devoted to science as to art. He established one of the first American museums in Philadelphia in 1786, exhibiting paintings and specimens of natural history cheek by jowl. He was also deeply interested in art instruction, and a leader in the formation of the Columbianum Academy in Philadelphia in 1795, forerunner of the oldest art academy still in existence in America today, the Pennsylvania Academy of Fine Arts, founded in 1807. For the initial exhibition at the Columbianum in 1795, Peale painted *The Staircase Group*, a remarkable double-portrait of two of his sons, Raphaelle and Titian (Peale at this point named his children after artists, including Rembrandt and Angelica Kauffmann; later he named children after scientists, Linnaeus and Franklin). The painting is a "deception." *Trompe l'œil* paintings have enjoyed particular appeal throughout the history of American art. Perhaps this reflects the materialism and pragmatism of American life, its firm commitment to the real world. *The Staircase Group* elicited the same kind of admiration as Copley's portrait of *Thomas Ainslie*, which the sitter's young son had attempted to grasp by the hand. Years later Rembrandt Peale recalled that when President Washington went to see the Columbianum exhibition, *The Staircase Group* caught the corner of his eye. The painting had been intentionally framed in a door jamb and a step had been built out from the base of the picture to the floor, continuing the painted staircase on which the illusion of a dropped ticket of admission to the Columbianum had been painted out into the room itself. As Washington passed the picture, according to Rembrandt, he turned to it and doffed his hat, making a polite little bow to the painted image. The "deception" was a success!

In later years Peale's interest in science overshadowed his interest in art, although he never abandoned the latter completely. In 1806 he painted the fascinating *Exhuming the Mastodon* (Peale Museum, Baltimore, Maryland) which recalled Peale's 1801 expedition to recover dinosaur's bones discovered in a swamp on a New York farm. It shows a large wheel and bucket chain operated by a human treadmill dredging water from the pit in which the bones had been located. Peale's *The Artist in His Museum* of 1822 (Pennsylvania Academy of Fine Arts, Philadelphia, Pennsylvania) is a final monument to a long career, a self-portrait of the artist standing in his museum on the second floor of Independence Hall. His dual interest in art and science is indicated by the juxtaposition of a palette and mastodon bones in the foreground, and echoed in portraits of Revolutionary War heroes, a dinosaur skeleton and various stuffed specimens in the background.

Toward the end of his long and productive career, Peale produced a series of charming landscape views showing scenes around his farm in Germantown. Peale, ever experimental, was dabbling late in life with the kind of artistic expression that was to become dominant in American art in the nineteenth century, paintings of the American landscape.

Asher B. Durand (1796-1886). Kindred Spirits, 1849. (46×36″)
The New York Public Library, New York. Astor, Lenox and Tilden Foundations.

The Search for Identity

IN addition to such familiar obstacles as unsettled political and economic conditions inhibiting patronage of the arts, and the lack of demand for art other than portraiture, American artists in the first half of the nineteenth century faced some new problems. These grew out of two related issues: what kind of art was appropriate for a democracy and what were to be the sources of artistic support in a democracy? Was art *au fond* undemocratic, as John Adams suspected it was, appealing to base primitive instincts, to undemocratic feelings of personal and family pride, to the sensuous rather than the rational nature of man? And from what segment of a democratic society was patronage to come? There was no formal aristocracy, although a *de facto* aristocracy of wealth and political power, especially in Federalist circles, existed. There was no dominant state church to support the arts; indeed Congregationalism and the other large Protestant denominations in America were literally iconoclastic. Moreover the state itself, in contrast to European monarchies, showed little inclination to commission works glorifying the nation and its leaders.

The problems faced by artists in America went beyond rampant philistinism. That could be overcome through education, increased affluence, and the growing awareness that a great nation must achieve world leadership in all areas, including the arts. But assuming adequate support for the arts, what should an American art be? What styles and subjects were appropriate to this unprecedented democracy? The distinctive character of earlier American art had resulted in part from technical inadequacies of the artists, which together with esthetic preference led to emphasis of the surface plane, and in part from the pragmatism of American life, which manifested itself in a taste for realism. Yet the armature on which these national, or rather provincial, characteristics were hung, was European. America was an outpost of European civilization, artistically serviced by itinerant European painters of varying but rarely impressive abilities, and kept at least monochromatically abreast of contemporary developments in European art by means of engravings. After the middle of the eighteenth century American art was further Europeanized by American artists who studied abroad. This dependence on Europe for artists, art ideas and art training had been acceptable in America when it had been a European colony, a place where the synonym for England was "home." It was quite unacceptable in an independent country, determined to stand on its own feet culturally as well as politically. As a result the history of American art during the first seventy-five years of nationhood was in essence a quest for an art expressive of American identity.

Thomas Sully (1783-1872). Lady with a Harp: Eliza Ridgely, 1818. (84⅜×56⅛″)
National Gallery of Art, Washington, D.C. Gift of Maude Monell Vetlesen.

John Neagle (1796-1865). Pat Lyon at the Forge, 1829. (94½×68½″)
Courtesy of the Pennsylvania Academy of the Fine Arts, Philadelphia, Pennsylvania.

Progress, such as it was, came slowly. Portraiture continued to be the primary artistic activity in America during the first half of the nineteenth century. The leading portrait painter in the wake of Gilbert Stuart, following very much in the same tradition of stylish English portraiture, was Thomas Sully (1783-1872). Born in England, Sully was brought to this country before he was ten. He grew up in Charleston, South Carolina and received his first artistic training there. He traveled north in 1807, went to Boston to visit Gilbert Stuart, and finally settled in Philadelphia. A few years later a group of Philadelphia merchants advanced Sully money for a trip to England, to be repaid in copies of old master paintings. In England Sully, like most aspiring American artists, went first to see Benjamin West, a fellow Philadelphian, now over seventy but still active and influential as President of the Royal Academy. Sully, like Stuart earlier, was only interested in painting portraits, and since West had become almost exclusively concerned with historical and religious paintings, he referred Sully to Thomas Lawrence, the leading English portrait painter of the generation after Reynolds and Gainsborough. The strong influence of Lawrence is clearly evident in Sully's full-length portrait of *Eliza Ridgely, the Lady with a Harp.* At his best in idealized portraits of women, Sully, like Lawrence, combines high color and free brushwork to create sleek, occasionally sentimental, prettified images of boneless figures. His portraits of men are somewhat more vigorous, particularly the dramatic portraits of heroes of the War of 1812 painted early in his career, but these are also idealized. Sully's flattering confections earned him great popularity. During his long career he produced about 2600 paintings, almost all of them portraits.

In later years Sully shared his dominance of Philadelphia portraiture with his son-in-law, John Neagle (1796-1865), whose soft, idealizing portraits resemble Sully's. However his masterpiece, a portrait of *Pat Lyon at the Forge,* is strong and impressive. At the time of the portrait Pat Lyon was a large independent-minded man of fifty-seven. In his youth he had been falsely imprisoned on a robbery charge, and after the real culprit was apprehended Lyon had not been immediately released. For some years he lived in poverty and disgrace, resentful of the upper class, whose members he felt had caused his troubles and failed to right the wrong that had been done him. Gifted with a creative intelligence, Lyon the blacksmith eventually became Lyon the wealthy hydraulic engineer, inventor of a successful fire-engine. When he subsequently commissioned this portrait, he specifically wanted to be shown as a smithy at his forge rather than as a gentleman of the class he disdained. Looking the viewer in the eye, Lyon stands by his forge in a leather apron, hammer on anvil, an assistant behind him leaning on the bellows. Through an opening on the left the cupola of Walnut Street Prison is visible, a reminder of Lyon's false imprisonment. This *portrait d'apparat,* a view of a man within the context of his work, hews close to the grain of the American taste for realism in art.

Although many American artists like Sully and Neagle were content to make their living by painting portraits, others struggled against the straight-jacket of limited patronage and, like West and Copley earlier, wanted to try their hand at something more ambitious. As young Samuel F. B. Morse (1791-1872) wrote from England to his father, Jedidiah Morse, minister and author of the first American geography book, a practical man who was opposed to his son's artistic inclinations and skeptical of his ability to make a living as an artist in America by painting anything but portraits: "Had I no higher thoughts than being a first-rate portrait-painter, I would have chosen a far different profession. My ambition is to be among those who shall rival the splendor of the fifteenth century; to rival the genius of a Raphael, a Michael Angelo, or a Titian; my ambition is to be enlisted in the constellation of genius now rising in this country; I wish to shine, not by a light borrowed from them, but to strive to shine the brightest."

After graduating from Yale College, Morse had gone to England in 1811. He studied at the Royal Academy and before returning to America in 1815 painted several history pictures, including *The Dying Hercules* (Yale University Art Gallery, New Haven, Connecticut), a clay model for which won a gold medal for sculpture at the Adelphi Society (only a

plaster cast at the Yale University Art Gallery survives). However, as his father had predicted, Morse found patronage only for portraits on his return to America. Out of necessity he became an itinerant portraitist, spending the winters in Charleston, South Carolina, and working at other times in Boston, New Haven, New York and Washington. A man of many interests, Morse tinkered with inventions (as did the miniature painter, Robert Fulton, inventor of the steamboat); painted large realistic depictions of the interior of the House of Representatives and of the interior of the Louvre which he took on unprofitable traveling exhibitions; led an artistic revolt against the American Academy of Fine Arts in New York, run in a dictatorial manner by aging John Trumbull, becoming first President of the rival National Academy of Design on its founding in 1826; served as first professor of art at New York University; and in 1832 discovered the principles of the telegraph. Morse found his inventions a more promising path to prosperity in this materialistic democracy than his art, and completely abandoned art during the latter half of his life.

John Vanderlyn (1775-1852) resisted the siren song of portraiture more stubbornly than Morse, and in the end experienced much greater frustration. Born in Kingston, New York, Vanderlyn was the grandson of Pieter Vanderlyn, one of the group of artists including the anonymous painter of *John Van Cortlandt* that had worked in the Hudson River Valley early in the eighteenth century. At the age of sixteen Vanderlyn went to New York City, supporting himself by working in an art supply and engraving shop while he studied at one of the earliest academies for art instruction in America, Archibald Robertson's Columbian Academy (not to be confused with Charles Willson Peale's contemporaneous Columbianum Academy in Philadelphia). Gilbert Stuart, a customer at the shop, allowed young Vanderlyn to copy several of his portraits. One of these copies, a portrait of *Aaron Burr*, caught the attention of Burr himself. Burr inquired about the artist, and learned to his dismay that young Vanderlyn had found it necessary to leave New York and return to Kingston for want of support. Moved by the same public spirit that had led Americans of means to send West, Peale, Sully and other aspiring young artists to Europe, Burr undertook to support Vanderlyn financially for as long as might be necessary for him " to cultivate his genius to the highest point of perfection." Burr arranged for Vanderlyn to live and study briefly with Stuart, who had meanwhile moved to Philadelphia, and in the following year, 1796, sent him to Europe. Since Burr's interests lay not in England, where virtually all previous American artists had gone, but France, Vanderlyn became the first major American artist to study in Paris. He enrolled in the studio of André Vincent at the Ecole des Beaux-Arts, where he learned the basic principles of neo-classical art, with its emphasis on drawing and anatomy. Neo-classicism, although it had germinated three decades earlier in the politically potent paintings of Benjamin West, did not come to fruition in England (West as principal painter of history pieces to the king had abandoned in the 1770's impolitic paintings which proclaimed that men could create new and more perfect societies), but in France, where the style was well-suited to the political needs of the French Revolution.

When Vanderlyn returned to America at the turn of the century, Burr advised him to paint a view of Niagara Falls, one of the wonders of the New World, since an engraving of Niagara would find a ready market in Europe. Vanderlyn, determined not to become a portrait painter, accepted the advice. After completing his sketches he returned to Europe in 1803 to arrange for an engraving. He also carried with him a commission from the newly established American Academy of Fine Arts in New York to purchase plaster casts of antique sculpture and copies of old master paintings that could be used for the instruction of young artists. Shortly after his return to Europe Vanderlyn painted *The Death of Jane McCrea* (Wadsworth Atheneum, Hartford, Connecticut) as an illustration for *The Columbiad*, an epic poem written by his American friend in Paris, Joel Barlow. A scene from the time of the American Revolution, the painting shows Indians scalping an American girl. If the behavior of the Indians was not quite what Rousseau had led Europeans to expect from noble savages, the figures themselves were at least based on classical relief sculpture, echoing in a way the analogy between natural and classical man observed by West in his

John Vanderlyn (1775-1852). Marius Amidst the Ruins of Carthage, 1807. (87×68½″)
M. H. de Young Memorial Museum, San Francisco, California. Gift of M. H. de Young.

comparison of the antique *Apollo Belvedere* with a Mohawk warrior. The composition itself bears a generic resemblance to the Parthenon metopes depicting *The Battle of the Centaurs and the Lapiths*.

In 1805 Vanderlyn went to Rome to study antiquity at first hand. There he painted his most important history picture, *Marius Amidst the Ruins of Carthage*. The painting depicts a defeated Roman general, Caius Marius, seated in front of the ruins of Carthage in a pose borrowed from a classical statue of *Ares*, the god of war (after Scopas). A man who had enjoyed power but now defeated in a civil war and disappointed in his ambition, Marius, his world in ruins about him, meditates revenge. The painting received a gold medal at the Academy Exhibition of 1808 in Paris, and is said to have been admired and selected for the prize by Napoleon, who himself would one day sit on Elba amidst the ruins of his ambition like Marius, and plot his return.

Neo-classical art is humanistic, concerned with what man has accomplished and what he can accomplish. Human actors invariably dominate the scene. *Marius Amidst the Ruins of Carthage* is neo-classical in subject and treatment, although atypical in that no action occurs. Marius is not doing anything; he just sits and broods. The picture cannot simply be read as a story. It requires the active emotional as well as intellectual involvement of the viewer. The viewer must, if he is to approach the essence of the painting, try to imagine what is going on in the mind of Marius. The empathetic participation required of each individual perceiver of the painting is a step beyond Neo-classicism in the direction of Romanticism. Neo-classicism, the artistic arm of the Enlightenment, focused attention on man in society, natural and perfectible, and this led, perhaps unexpectedly but directly, to Romanticism wherein the interest in man in general became interest in individual man, his feelings and emotions rather than his behavior.

Continuing to drift away from pure Neo-classicism, Vanderlyn, on his return to Paris, was less influenced by the classical exercises of his French contemporaries than by the glowing color and subtle chiaroscuro of paintings by Titian and Correggio in the Louvre. Trying his own hand at an original composition in this mode, he painted *Ariadne* (Pennsylvania Academy of Fine Arts, Philadelphia, Pennsylvania), a sensuous representation of ideal female beauty. Ariadne, daughter of Minos, the King of Crete, had fallen in love with Theseus, a prisoner in her father's labyrinth. Unraveling a thread to trace a path to freedom, Ariadne rescued Theseus and they escaped to the idyllic Isle of Naxos. Eventually fickle Theseus became restless and deserted Ariadne. The painting depicts his desertion, nude Ariadne sleeping in the foreground, Theseus sneaking off in the distance.

Vanderlyn wished to return to America, but since he was not a portrait painter, he faced the problem of earning a living. He decided that there was money to be made by combining art and entertainment, exhibiting large panorama paintings to the public. Before leaving France in 1815 he sketched the gardens of Versailles, and when he arrived in America he transferred the sketches to three thousand feet of canvas. He constructed a solid little rotunda in New York where he exhibited this and other panoramas quite successfully. During the winter months he took the panoramas on tour to the South. Within a few years, however, the novelty of the panoramas wore off and public interest withered. Vanderlyn became bitter over the failure of Americans to support art. Toward the end of his life he finally received a commission from Congress to paint *The Landing of Columbus* for the Capitol Rotunda, but his spark was gone. Vanderlyn returned to Paris and with the help of French assistants produced a pedestrian picture. Having failed to find adequate support for his art after his return to America, Vanderlyn never fulfilled his early promise.

During the second half of the eighteenth century the cutting edge of artistic innovation had been a new classicism, the characteristics of which included clarity, order, rationality, a dominance of line over color, sculptural modeling of the human form, an overriding humanistic concern with man, and didacticism. Vanderlyn was the one American artist steeped in French Neo-classicism, but he caught it at ebb tide, and in retrospect appears an anachronism in his own time, although the brooding intensity of Marius seems to catch

something of the spirit of the new Romantic movement. If Vanderlyn was artistically *retardataire*, his progressive mirror image was Washington Allston (1779-1843). Born in Charleston, South Carolina, during the American Revolution and named after the national hero, Allston was very much a product of the new generation, eager for fresh experiences. At Harvard he studied the classics but was more profoundly affected by early romantic literature, notably Schiller's *The Robbers* and the gothic novels of Ann Radcliffe, and such melodramatic pictures as Fuseli's illustrations for Boydell's *Shakespeare Gallery*. After his graduation in 1801, Allston and his friend, the Charleston miniature painter, Edward Malbone, sailed for London. Unlike previous American artists who were eager to sit at the feet of Benjamin West, Allston anticipated that West's works, which he knew through prints, would be static, pretentious and dull. He sought more exciting stuff. However when he arrived in London he found to his surprise that West was creating highly romantic pictures, such as *Death on a Pale Horse* (Philadelphia Museum of Art, Philadelphia, Pennsylvania), and soon counted West among his artistic heroes.

Whereas French painting during the last quarter of the eighteenth century had become increasingly neo-classical, painting in England, after an early flirtation in the work of West and others, veered away from Neo-classicism because of its radical political overtones. Subsequent English painting, particularly portraiture, became deeply concerned with color as opposed to the linear stress and muted palette of Neo-classicism, and was strongly influenced by Rubens and by the great Venetian colorists of the sixteenth century. Allston absorbed this in London, and when he went to Paris in 1803 via the Low Countries in the company of Vanderlyn, whom he had met in London, it was not to absorb Neo-classicism but to immerse himself in the art of the past at the Louvre. Copying Rubens, he used a rich glazing technique that perplexed his French contemporaries who were accustomed to flat, opaque surfaces. He studied intently the work of Titian, Tintoretto, and, above all, Veronese, in whose color Allston found an abstract appeal analogous to music. Color, not the events displayed, was for Allston the true subject of Veronese's paintings.

In such early pictures as *Thunderstorm at Sea* (Boston Museum of Fine Arts, Boston, Massachusetts), Allston deployed broad tonal masses of sea and sky, linked closely in hue but with strong contrasts of light and dark, creating a deep space markedly different from the surface immediacy of neo-classical painting. Touches of bright color carry the eye to tiny figures in the pilot boat, and only then does the viewer become aware of the human participants in the dramatic scene. In contrast to neo-classical art, man does not dominate the natural world here; he is at its mercy. The viewer identifies himself with the threatened figures, empathetically experiencing their terror. The participation of each individual perceiver is an essential part of the esthetic experience. The viewer cannot read the picture as a narrative but must become personally involved with it to grasp its meaning.

In 1804-1805 Allston traveled to Rome, making sketches of Swiss scenery on the way, which he subsequently combined into imaginative landscapes, such as *Diana in the Chase* (Fogg Art Museum, Harvard University, Cambridge, Massachusetts). These paintings, built up of washes of translucent glaze which successively modify the color beneath, are reveries on the timeless grandeur and beauty of nature, on the endless cycle of life and death in the natural landscape.

Allston returned to Boston in 1808, but rather than paint portraits for a living, he went back to England several years later. Settling in London, he painted highly imaginative subjects such as *The Dead Man Revived by Touching the Bones of the Prophet Elisha* (Pennsylvania Academy of Fine Arts, Philadelphia, Pennsylvania), with its complex interplay of gesture and expression as the human actors become aware of and respond variously to the miracle that occurs.

Allston went to Paris again in 1817, and was once more enchanted by the Venetian paintings at the Louvre. *Elijah in the Desert*, painted shortly afterwards, reflects his renewed interest in color. It strikes a harmonious chord of warm brown earth and cool blue mountains and sky. The small, solitary figure of Elijah kneels in the foreground, a dead tree

Washington Allston (1779-1843). Elijah in the Desert fed by the Ravens, 1818. (43¾×72½″)
Courtesy, Museum of Fine Arts, Boston, Massachusetts. Gift of Mrs. Samuel and Miss Alice Hooper.

towering above him. As opposed to Vanderlyn's neo-classical paintings in which foreground figures dominate the composition, the figure here is dominated by the landscape. The brown earth is sere. Dry stones and dead trees predominate over a few foliate elements to the left. It is a realm of death, not life. Yet the cool, distant sky and mountainscape seem to hold forth a promise of spiritual refreshment. The starving prophet kneels in the barren desert and prays, reaching out to the world of the spirit which lies beyond. The blue of his robe, echoing the color of mountains and sky, implies his identification with the spiritual world. His prayers have been heard and answered; the ravens, normally scavengers who would pick his dead bones clean, fly down to deliver life-giving bread.

The huge *Belshazzar's Feast* (Detroit Institute of Arts, Detroit, Michigan), a "sublime" conception, very different in character from the dreamy *Elijah*, was almost complete when Allston returned permanently to the United States in 1818. He hoped to finish the picture promptly, but found it financially expedient to paint a number of small pictures for immediate sale. To alleviate this necessity and allow Allston to devote himself uninterruptedly to his master work, a group of Bostonians formed a trust and put up ten thousand dollars to buy the picture in advance. This generous patronage, unprecedented in America, unhappily became an albatross around Allston's neck. Accepting Gilbert Stuart's advice to change the perspective in the picture, Allston undertook extensive and time-consuming alterations to please his patrons. By this time, his esthetic interests had progressed from "sublimity" to a completely different kind of painting, tranquil and meditative. Yet he was

trapped by his obligation to complete *Belshazzar*. He kept at it, painting and repainting, sometimes rolling up the canvas and putting it away for awhile, but always returning, working on it to the very day of his death. A humiliation to the artist and an embarrassment to the good citizens of Boston who had tried to be helpful, the painting became such a sore subject that friends of the gentle Allston could not mention the picture in his presence.

Whereas most creative artists in America suffered from neglect and lack of support, Allston's creative spark had been smothered by an excess of helpfulness. The "Allston Trust" failed in its purpose, but it was a hopeful indication of the potential for art patronage in America. Wealthy Americans had in the past assisted young artists by subsidizing European travel and study, and, in the nineteenth century, became active in organizing academies such as the American Academy of Fine Arts in New York (1803) and the Pennsylvania Academy of Fine Arts in Philadelphia (1807) where artists could receive instruction in this country. However support of art and artists was not effectively continued to the essential final step, the purchase of pictures. American collectors of art, few in number at best, preferred European works, old and new; they did not "collect" American art. American paintings as a rule entered American collections only incidentally, as when portraits of the collector or members of his family were commissioned. However by the end of the eighteenth century a small market for topographical landscapes, that is for portraits of places, began to develop.

Throughout most of the seventeenth and eighteenth centuries the American landscape had been considered a source of danger, a sheltering darkness from whence came Indian attacks, an inconvenient wilderness that blocked the way from place to place and that had to be obliterated to create fields and meadowlands. Although the wilderness supplied wood for building and fuel, essential for life support in the New World, it was to be conquered and used rather than admired. John Smibert spoke of painting some landscapes at the end of his life, when failing eyesight ended his career as a portrait painter, but by and large landscape painting was virtually non-existent in America until the last decade of the eighteenth century. A small group of minor English landscapists, the most important of whom was Francis Guy (1760-1820), came to America and painted views of gentlemen's estates in Maryland and Northern Virginia. The most ambitious early landscape was the large *Landscape: Looking East from Denny Hill* (Worcester Art Museum, Worcester, Massachusetts), a prospect painted in the 1790's by the Connecticut portrait painter Ralph Earl as a remembrance for a patron who was moving from his lifetime home. At the turn of the century William Birch (1755-1834) and his son Thomas (1779-1851) made numerous topographical views of Philadelphia for publication. By the 1820's increasing interest in the American landscape for its own sake surfaced in the works of Thomas Doughty (1793-1856), perhaps America's first real landscape painter. A sportsman who loved to hunt and fish, Doughty painted quiescent and somewhat stylized views that record his personal affection for nature. Another early landscapist, Asher B. Durand (1796-1886), began as a highly skilled engraver (his reputation was greatly enhanced by a successful engraving of John Vanderlyn's *Ariadne*, which he owned). Active in New York artistic life, Durand was a founding member and second president of the National Academy of Design.

In 1825 three landscapes of unusual quality appeared in a shop window in New York. Durand bought one, as did John Trumbull, president of the American Academy of Fine Arts, and William Dunlap, painter, theatrical producer, and in 1832 author of the earliest book on American art, *The History of the Rise and Progress of the Arts of Design in the United States*. These three landscapes, recognized immediately as remarkable works by the most knowing eyes in New York, were painted by Thomas Cole (1801-1848). Cole had come to New York from Ohio, where he had gone with his family as a boy of seventeen after their arrival in America from England. In New York Cole quickly established himself as America's leading landscape painter. During the good weather he would travel throughout New England and along the Hudson River, making drawings and oil sketches which he

worked up into finished canvases during the winter in his studio. Soon a whole throng of artists, popularly known as the Hudson River School, literally followed in Cole's footsteps.

Cole and Allston stand as the two major American painters of the first half of the nineteenth century. Their eminence results not so much from their mastery of the craft of painting, although this they had, as from the powers of mind which they brought to their art. Author of a treatise on art theory entitled *Lectures on Art*, of a number of poems including the substantial *Sylphs of the Seasons*, and of *Monaldi*, a gothic romance, Allston was the intimate friend of major literary figures in England and America, notably Samuel Taylor Coleridge and Washington Irving. Cole's literary and philosophical counterpart was the poet William Cullen Bryant. The parallel between Cole as painter and Bryant as poet, particularly in their sensitive response to nature, was fully appreciated in their own day. In commemoration of Cole's death Durand painted *Kindred Spirits* depicting Cole and Bryant on a rocky ledge in a picturesque forest setting.

Cole went to Europe in 1829 for three years of intensive study. He was particularly interested in the work of the great seventeenth century landscapist, Claude Lorrain. Among moderns he was most profoundly influenced by J. M. W. Turner, another Claudian, and John Martin, whose visionary art struck a responsive chord with Cole's similar taste for melodrama on a gargantuan scale.

Cole was greatly affected by the surviving ruins of classical antiquity in Italy, not for the moral and social lessons that earlier generations had found there, but in themselves as mute testimonials to the impermanence of the human condition, to the inescapable fact that life is change, that everything rises and falls, lives and dies; as reminders of the transience of one's own moment in time. Ruins also suggested to Cole that the surface appearance of a place is deceptive, affording only a slight clue to the historical richness of all that had transpired there. The roll of years over a site left behind deep substrata of history, out of which the artist's imagination could dredge the secrets of the past. Two early paintings representing a scene from James Fenimore Cooper's 1826 novel, *The Last of the Mohicans* (Wadsworth Atheneum, Hartford, Connecticut; New York State Historical Association, Cooperstown, New York), reveal Cole's predisposition for this type of thinking, depicting the event as a transient flicker in the timelessness of a mountain landscape. The *Titan's Goblet* (Metropolitan Museum of Art, New York), painted just after Cole's return from Europe, deals with the theme of time and place in a bizarre vision. A gigantic drinking vessel rests on the surface of the earth, its rim enclosing a lake so lofty that it touches the clouds. Along the rim of the goblet, a civilization thrives, its ships scuttling back and forth across the lake. Lacking a true perspective on themselves, the people who live in this place are presumably unaware that their physical environment is not a natural part of the landscape, but rather the result of some incredible titanic event.

As Cole rambled in Italy amidst ruins surviving from ancient civilizations that had played out their brief dramas on the permanent stage of the natural landscape, contemplating time, change and the transience of civilizations as artistic themes, he began to think in terms of series of paintings rather than single canvases. The result was *The Course of Empire* painted on his return from Italy for his New York patron, Luman Reed. The series consists of five large canvases, each depicting the same scene, although the viewpoint shifts. In the first painting, *The Savage State*, a storm moves off to the left and the break of day reveals the dawn of civilization under a clear sky. Man, the hunter, tracks his prey in a wild and uncivilized landscape. The second picture, *The Pastoral State*, represents an idyllic arcadian scene under a fresh mid-morning sun. Simple roads traverse the hunter's former path. Wild animals have been replaced by domestic herds of sheep guarded by their shepherd. An old man draws geometric patterns in the dust with a stick, suggestive of the beginnings of mathematics and science. Ships traverse the lagoon, as commerce springs forth. In the distance a temple with monolithic stone columns suggests an emergent spiritual nature and the growth of religion. The third painting presents *The Triumph of Empire*. The scene has now shifted to the shores of the lagoon. A horned mountain on the right, which had

Thomas Cole (1801-1848). The Course of Empire: The Savage State, 1833-1836. (39¼×63¼″)
The New-York Historical Society, New York.

appeared in the distance in the earlier views, guards one entrance to the harbor. A lighthouse stands on the other side. A noonday sun pours down on a fantastic architectural complex, a great white city like the imaginative views of Dido's Carthage painted by Turner and Claude. In the fourth scene, *The Destruction of Empire*, the point of view retreats to the head of the lagoon, exposing a panoramic view of unchecked carnage and destruction, perhaps inspired by John Martin's *Fall of Babylon*. The time is late afternoon. A sublime stormy sky provides an appropriate backdrop for the turbulent scene below. In the fifth and concluding scene, *The Desolation of Empire*, the viewpoint retreats still further. Beneath a calm moonlit sky, growth-covered ruins of the expired civilization moulder back into the earth. Only the great natural forms, the mountain and the lagoon, persist. Yet the implication is that all is not ended. After a stormy night to complete the ruin, dawn will bring a new life, a fresh savage state, and the cycle will be repeated, raising up a new civilization unaware that all of this had transpired before. Only the mountain and the lagoon will share the secret.

The essence of what Cole said melodramatically in *The Course of Empire* is distilled in his best single natural landscapes, such as *Schroon Mountain*. Slanting trees enframe a panoramic opening that draws the viewer as if he were a disembodied spirit down into the valley where the river flows, then around to the right beyond the foreground mountain to a widening of the river, perhaps a lake, and then up the slope to the mountain peak that dominates the composition, its point piercing through the clouds to a clear blue opening in a stormy skyscape. No living being is seen, yet the picture throbs with life. One of the two

prominent trees in the left foreground is alive while the other is dead and blasted, a skeletal thing; the tree on the right has both living and dead limbs. These tree forms, their limbs extended like arms, stand in the natural landscape as human surrogates. Their fate is man's fate. The landscape is decked with autumn foliage, its fiery beauty a prelude to death. But beneath the death is life. All is change, process, flux. A great civilization may have flourished on this very spot, or perhaps someday will, but for the moment the life cycles of unspoiled nature pulse regularly, the sky fills with storm and clears, day is replaced by night which is replaced by day, the river flows, and the mountains endure. Like Bryant in *Thanatopsis*, Cole saw the physical world as the handiwork of God and pervaded by Him. It is a glorious tomb, where dead heroes dwell and where we and our children and our children's children will join them in the bosom of the Divine Spirit. This is what Durand implies, a little stiffly, by the juxtaposition of Cole and Bryant in *Kindred Spirits*, and what Cole actually achieves in *Schroon Mountain*, a painting palpitating with life force and infused with Divine immanence.

Another of Cole's series is *The Voyage of Life* of 1839. In the first of four scenes, *Childhood*, a small boat with a golden figurehead, bearing a child and his guardian angel, issues from the circular opening of a dark cave (a remarkable pre-Freudian image). In one of Cole's early landscapes, *The Expulsion from the Garden of Eden* of 1827 (Boston Museum of Fine Arts, Boston, Massachusetts), the tiny figures of Adam and Eve depart fearfully from a sunny paradise to enter a dark, terrifying craggy landscape. In terms of romantic art theory they were moving from the Beautiful to the Sublime. In *Childhood* the situation of Adam

Thomas Cole (1801-1848). Schroon Mountain, the Adirondacks, 1833. (39⅜×63")
Cleveland Museum of Art, Cleveland, Ohio. Hinman B. Hurlbut Collection.

and Eve is reversed; the figures come out of the "sublime" unknown to enter the "beautiful" natural world. In *Youth* the young man in his boat sets out from the shore, reaching toward a vision of the heavenly kingdom. His guardian angel bids him farewell. The boat is tossed about in *Manhood*, a storm-filled scene, shooting past rock-spiked rapids and yawning chasms. The young man stands calmly in his boat, his hands clasped in prayer, trusting to divine guidance. In *Old Age* all is again placid. An old man sits in his boat, the figurehead worn down to a burnished nub. The angel flies ahead to lead the way across calm waters to the reward that lies beyond. The voyage is almost ended.

Thomas Cole brought new respectability to a previously neglected branch of American painting, landscape, demonstrating that it could incorporate philosophical and religious content worthy of the attention of artists and the support of patrons. Nationalistic pride also stimulated the domestic market for these works. Spurred by Cole's achievement, many younger artists turned to the American landscape as an appropriate subject. And when interest in New England and Hudson River landscapes inevitably began to pall, westward expansion opened new vistas to paint. The interest of Americans in the western territories was intensified by a sense of "Manifest Destiny," a belief that divine will coincided with national interest in the American push to the Pacific. This worked to the advantage of Albert Bierstadt (1830-1902), an artist of the West who achieved great popularity during the third quarter of the century. Bierstadt traveled extensively through the Rocky Mountains and Northern California, making drawings and oil sketches on paper from which he painted enormous canvases on his return. Paintings such as the *Rocky Mountains* (Metropolitan Museum of Art, New York) and *Mount Corcoran* (Corcoran Gallery of Art, Washington, D. C.) dwarfed most Hudson River canvases and effectively conveyed a sense of the magnitude of the western landscape to awed Eastern viewers. Even such delightful small canvases as *Lake Tahoe* have an inherent monumentality, suggestive of the grand scale of the West. Although Bierstadt did not use his art as a forum to express his views, he clearly expressed a sense of the unspoiled perfection of the West as it stood. When Indians are shown, as in *Rocky Mountains*, they, like the deer, bear and other forms of animal life depicted, exist in harmony with the magnificent natural setting. There is an obvious implication that the coming of the white man will change all of this, and the viewer frequently is aware of playing the role of an intruder, an interloper in a natural paradise.

Last of the Buffalo (Corcoran Gallery of Art, Washington, D.C.) is a memorable image of a dramatic clash between Indians and buffalo on the prairie. For centuries the Indian had relied upon the buffalo for food, shelter, and clothing, hunting him relentlessly. In the painting, a mounted Indian drives his spear deep into a buffalo, who glares with reddened eye and lowers his horns to charge with a ferocity born of desperation. Around these ancient adversaries locked in combat lie the dead and dying, Indians and buffalo. This tragic encounter will be their last, as the coming of the white man dooms them both.

Although Bierstadt stands in the same dominant position in relation to Western landscape as Cole in the East, he was not really Cole's artistic kinsman. A native of Germany who later returned to Düsseldorf for four years of art study, Bierstadt reflects a more sentimental and less metaphysical tradition. Cole's one major direct descendant was Frederick Edwin Church (1826-1900), his only pupil during the last few years of his life. Church's earliest New England landscapes continue the type of panoramic outlook that Cole was developing in his own late work. His subsequent dramatic canvases painted in far-flung corners of the globe rival Bierstadt's in scale, but their philosophical content comes directly from Cole. Church carried Cole's concern with the ebb and flow of history over a fixed site in the natural landscape back a step further to the history of the landscape itself. Much influenced by Alexander von Humboldt's *Cosmos* (1847), he combined a scientific interest in geology and the history of the earth with a theological belief that the best avenue for an approach to God could be found through the most dramatic natural phenomena of the earth itself. If God made the earth and is immanent in it, then certainly He reveals Himself most clearly in the earth's most spectacular and awesome displays. Church's monu-

Albert Bierstadt (1830-1902). Lake Tahoe, 1868. (13×16⅛″)
Courtesy of the Fogg Art Museum, Harvard University, Cambridge, Massachusetts. Gift of Mr. and Mrs. Frederic H. Curtiss.

mental canvases frequently contain Christian references, whether overt, as in the shrine in *The Heart of the Andes* (Metropolitan Museum of Art, New York) of 1859, or implied, as in the cruciform golden reflections of the sun on the surface of a crimson lake in the several views of *Cotopaxi*.

Church traveled all over the world in search of dramatic subject matter, to South America, Labrador, Europe and the Near East, but he also found it close at home. He made his early reputation in 1857 with *Niagara* (Corcoran Gallery of Art, Washington, D.C.). Church believed Niagara Falls to be meaningfully symbolic in nationalistic terms for America. If one were closest to God in the most dramatic parts of nature, surely Niagara Falls was an American blessing. God's immanence in natural phenomena implied presence, which by extension implied divine favor on the place or country in which the phenomenon was located. For a country caught up in the full flood of western expansion, imbued with nationalistic fervor and convinced of "Manifest Destiny," the evidence that God was on our side was undoubtedly popular. Church carried his chauvinism to a mawkish extreme in a

Frederick E. Church (1826-1900). Twilight in the Wilderness, 1860. (40×64")
Cleveland Museum of Art, Cleveland, Ohio. Mr. and Mrs. William H. Marlatt Fund.

chromolithograph, *Our Banner in the Sky*. It depicted a star-studded blue firmament and bars of white cloud in a sunset sky streaked with red, beyond a bare tree on which an eagle perched, creating an incredible natural simulation of a fluttering American flag. Published shortly after the outbreak of the Civil War, the message of the picture was clear; God stood with the Union.

In *Niagara* a rainbow is formed by the spray from the Falls. Often used in symbolic connection with the New World, the rainbow represents promise, a fresh start, which was what the New World was all about. As a natural spectrum, the rainbow also exercised for Church the same kind of scientific appeal coupled with symbolism as did dramatic geological phenomena. Another symbol for a new start in the New World was Adam; the American was Adam, a new man. In the symbol-infused landscapes of Church, large trees in the foreground, rooted in the American soil, their leafy arms twisting in space, stand as man's proxy in the natural landscape, as new men in the New World. Nowhere is this symbolism more overt or more moving than in Church's thundering *Twilight in the Wilderness*. Fiery red clouds surge across the sky in bold diagonal rhythms. Nature is the manifestation of God, and here divine purpose moves in echo of the westward movement of Manifest Destiny. A purple mountain crowns the composition in the distance, at the end of the flowing carmine river. The trees stand like sentinels; they are us and we are they, surveying this vast and moving new world landscape that belongs to us, Americans, the new men.

Church's combined interest in art and the earth sciences places him partly within one of the most venerable traditions in America, that of the artist-naturalist. From the time of the earliest explorations, artists had depicted the natural phenomena of America, often in

engravings published for broader distribution to Europeans curious about the strange flora and fauna of the New World. More than with most other categories of artists, the artist-naturalist made pictures with an eye toward publication. Early practitioners, such as Mark Catesby (1679?-1749), William Bartram (1739-1823) and Alexander Wilson (1766-1813), traveled extensively throughout eastern North America, plunging into unspoiled areas, recording their observations in pictures and publishing the results on their return to civilization. The artist-naturalist is the counterpart of the artist-inventor in his scientific curiosity about the real world. The archetypal figure in American art was Charles Willson Peale, who was both artist-inventor and artist-naturalist. One of his sons, the second Titian Ramsey Peale (born after the death of the lad with the same name who appears at the top of the steps in *The Staircase Group*) was an artist-naturalist who sailed on several voyages of geographical exploration to the South Pacific.

The most justly famed of all American artist-naturalists is John James Audubon (1785-1851). Born in Haiti of French parents and educated in France, he came to the United States in 1804. He returned briefly to France in 1805-1806. At one point Audubon studied drawing with Jacques-Louis David, and if he is to be fitted into any artistic tradition, it is French Neo-Classicism. However Audubon defies categorization by the originality of his creative power. He traveled extensively, recording the birds and later the mammals of North America. Rendering the various species in beautiful drawings and watercolors, Audubon was not satisfied with accuracy of surface description. He sought to capture the character as well as the external appearance of each living thing. Brilliantly introducing sparse but graphic settings suggestive of the habits of each creature, he would indicate the ferocity of a predator by showing it with a small creature clutched in its bloody claws, or the nocturnal habits of an owl by depicting it wide-eyed on a branch while all else drowses along a moonlit river, or the world of the turkey cock by observing him from his own eye level, providing a turkey's-eye view of the world. Audubon possessed an almost oriental interest in the essence of things, and like a Chinese painter he disposed his forms, notably in such watercolors as *Purple Grackle*, with a precise and perfect sense of design, achieving balance, or sedate movement, or nervous agitation, or whatever the character of the subject required.

Martin Johnson Heade (1814-1904) combines aspects of both Audubon and Church in his art. Like Audubon he was so attentive to nature that he is in some regards as much a naturalist as an artist. Like Church, he traveled to South America, although not to paint the dramatic Andes. Heade painted innumerable intimate studies of the flora and fauna of the rain forests of Brazil, such as the exquisite *Orchids, Passion Flowers and Hummingbird* intended as an illustration for a projected but never completed book on the hummingbirds of South America. Heade also worked in Florida, where the tropical conditions appealed to him. However he most frequently chose as subject matter the marshlands of New England and New Jersey. Although marshes are less familiar as a subject for art than the sea, the mountains or the forest, Heade knew the marshes as a dramatic and enchanting part of the world, quickened by animal, bird and insect life; by moving patterns of land, grass and water; and above all by their dramatic response to light, especially at dawn and dusk. Heade's long horizontal marsh scenes present a panorama of swiftly changing atmospheric effects. Heade shared with Bierstadt and Church, more evident in the latter two's delightful small oils and sketches based on direct observation of nature than in their large canvases, a strong interest in the transitory effects of nature—the appearance of clouds, the visual effect of light filtering down upon the landscape under varying atmospheric conditions, the approach of a storm, the fleeting brilliance of the sunset. Indeed many landscape painters in the third quarter of the century had this concern, and produced some of the most beautiful American landscapes. Unaccountably neglected until recent times, these artists included second generation Hudson River School figures like John F. Kensett (1818-1872); highly individualistic painters such as Fitz Hugh Lane (1804-1865), overlooked like Heade until recently, a master of the effects of light on water; and sophisticated artists like Sanford R. Gifford (1823-1880) who was aware of the atmospheric innovations of Turner in England,

Martin Johnson Heade (1819-1904). Orchids, Passion Flowers and Hummingbird, 1880. (20×14″)
Collection of Mr. and Mrs. Robert C. Graham, New York.

John James Audubon (1785-1851). Purple Grackle, 1822. Watercolor. (23⅞×18½″)
The New-York Historical Society, New York.

and pioneered a peculiarly American movement known as Luminism. Contemporaneous with Impressionism in France, American Luminism was less adventurous coloristically, never breaking the palette into dabs of pure color. Luminist canvases are gentle, often suffused with a golden glow as sunlight pervades a mist-filled atmosphere.

Whereas for Cole nature had been the constant against which the parade of civilizations and the passing life of man provided change, for Heade and his contemporaries the observer is constant, and nature is in flux, ever shifting in its moods and appearance. Heade's mastery of the transient effects of nature is evident in his tender landscape, *Spring Shower*,

Attributed to Ammi Phillips (1788-1865). Portrait of Harriet Leavens. (56¼×27″)
Courtesy of the Fogg Art Museum, Harvard University, Cambridge, Massachusetts. Gift, Estate of Harriet Anna Niel.

Connecticut Valley (Boston Museum of Fine Arts, Boston, Massachusetts) of 1868. The sky is suddenly filled with clouds. An approaching rain shower will pass quickly, leaving behind a freshly washed landscape to delight the senses. Puffs of blossoms on the fruit trees dot a spring landscape mantled in light green. The viewer is flooded with the sweet recognition of a magical moment in the natural world, the kind of moment that, once experienced, dwells ever after in the subconscious and brings delight upon recollection.

While most American artists in the nineteenth century were more or less conscious participants in an attempt to found a national school that would achieve world stature, there existed in America a vigorous, unself-conscious tradition of folk art practiced by artists who cared little about rivaling Europe. Actually the earliest American painters, the anonymous unschooled limners of *Elizabeth Freake and Daughter Mary* or *John Van Cortlandt*, were folk artists. Aware at second or third remove of high style European art, they reduced it to a flat pattern of line and areas of bright color. Untutored eighteenth century artists like Joseph Badger worked in the same vein, but the heyday of folk painting was in the nineteenth century.

The boundaries of folk art, or primitive art, are difficult to define. It was (and is) practiced by artists more or less innocent of academic training. Some are amateurs painting for the sheer joy of it, and others are unskilled professional artisans who do their best despite technical limitations. Their limitations, largely the result of a lack of training depriving them of skill in the use of linear perspective, atmospheric perspective or chiaroscuro to model solid forms in convincing space, mean that folk art is relentlessly two-dimensional, with the surface often asserted by strong color. The result is a pronounced abstract patterning that appeals strongly, perhaps even disproportionately, to twentieth century

Anonymous. Meditation by the Sea, about 1850-1860. (13½×19½")

Courtesy, Museum of Fine Arts, Boston, Massachusetts. M. and M. Karolik Collection.

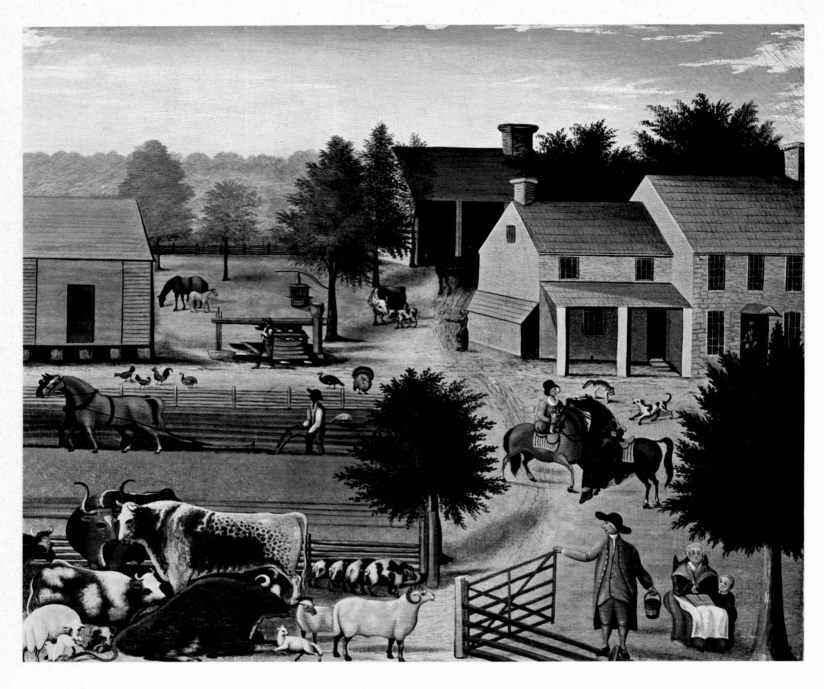

Edward Hicks (1780-1849). The Residence of David Twining 1787. Painted about 1846. (27×32″)
Abby Aldrich Rockefeller Folk Art Collection, Williamsburg, Virginia.

tastes. A case in point is the charming portrait of *Harriet Leavens*, ascribed to an itinerant artist of the New York-Massachusetts area at times identified as the Border Limner and the Kent Limner but now pinpointed as Ammi Phillips (1788-1865). The bold use of heavy black outlines to band color areas, familiar in twentieth century paintings from Mondrian to Bernard Buffet, is here the naive accomplishment of an artist who weaves line and color into a design that operates on one level as a recognizable likeness but much more vitally as a sense-delighting abstraction.

Folk art flourished with particular vigor among sectarian groups, such as the various Pennsylvania German sects and the Shakers, but it also manifested itself in the work of highly individualistic, often anonymous artists such as the one who created the memorable *Meditation by the Sea*. As in so many nineteenth century paintings, the scene is set along the littoral, the line where the earth meets the sea. A small bearded figure stands on the beach and contemplates the ocean. The quick air causes the clouds to scud across the sky, and its

breath propels sailing ships over the water. Waves pulsating with the life force of the sea move rhythmically toward the shore until they are stopped by an abrupt cliff. The incessant sea laps at the immovable shore, and between these forces, amidst stones and rocks and dead branches that are mute testimony to past conflicts between sea and land, a small, perishable human ponders the meaning of it all.

Perhaps the best known of all American folk painters is Edward Hicks (1780-1849). An active Pennsylvania Quaker, Hicks devoted much of his art to the service of his faith. He took the general theme of William Penn's "Holy Experiment," painted much earlier by another Quaker artist from Pennsylvania, Benjamin West, and explored it in a series of memorable representations of the *Peaceable Kingdom*. These invariably depict a menagerie of beasts lying down in peace and harmony with a child in their midst, often in combination with a river landscape and the scene of William Penn receiving the charter for the colony of Pennsylvania or the scene of Penn's treaty with the Indians, reproduced from West's painting. Hicks belonged to the professional or artisan end of the folk art scale, having been apprenticed to a coachmaker, for seven years painting decorative panels, and later he carried on the craft as a painter of tavern and shop signs. Among his most handsome works are several farm scenes, such as *The Residence of David Twining*, a delightful echo of the early tradition of plantation views. The gathering of animals in the left foreground is reminiscent of a *Peaceable Kingdom*, and indeed this is a peaceable kingdom, albeit domestic rather than social or theological. The fruits of industry and domestic harmony are evident in the prosperity and tranquility enjoyed by this Quaker family in America.

William Sidney Mount (1807-1868). The Painter's Triumph, 1838. (19½×23½")
Courtesy of the Pennsylvania Academy of the Fine Arts, Philadelphia, Pennsylvania.

Art for the People

THE turn to the American landscape in the nineteenth century constituted a major step toward the development of an essentially American art. However for most artists landscape painting did not resolve the problem of insufficient patronage. With such notable exceptions as John Vanderlyn's panoramas and the large canvases of Church and Bierstadt, specifically produced for public exhibition, the taste for landscape was limited to a restricted circle of collectors and connoisseurs.

Widespread support in the nineteenth century was gained not by depictions of the American landscape, but of American life. Genre painting, the representation of scenes of everyday human activity, was the natural counterpart to landscape painting in that both were concerned with the world as it is. An art for and about people, genre painting became literally popular in America simultaneously with the rise of Jacksonian democracy. In so doing, it resolved the problem of artistic support and the development of an appropriate art for a democracy.

William Sidney Mount's *The Painter's Triumph* explains the success of genre painting. The scene represents the interior of an artist's studio. Color, except in the costumes, is muted. Details are carefully drawn. The floorboards converging on the far wall provide a perspective setting for the careful placement of objects, creating a convincing illusion of real space. The broad flow of light from the front right casts shadows that further define and locate physical objects. It seems to enter through much of the wall, suggesting that the studio is a small converted barn with an open sliding door, such as Mount often used as the setting for his genre scenes. The studio is sparsely furnished. Two figures, an artist and a rustic visitor, face a painting on an easel. The artist points to the canvas with his right hand, at the same time brandishing his brushes and palette aloft in a fencer's pose, as if elated that through the brilliance of his brushwork he had scored a touch. The visitor leans forward, resting his hands on his knees, and examines the painting. His clothing and buggy whip suggest that he is a local farmer or teamster, rather than a knowing connoisseur, who has stopped in to visit his friend, the artist, in his barn-studio. As he studies the picture, particularly that portion toward which the artist points, his face creases in a smile. Since the painting elicits a spontaneous response from the unsophisticated visitor, it must obviously be readily comprehensible. Like *The Painter's Triumph* itself, the painting must represent something familiar, some aspect of the real world in realistic terms.

An appreciation of realism in art is the most widespread and the least sophisticated of all the criteria of excellence. It is, indeed, the lowest common denominator of artistic taste.

Admiration is elicited by the artist's technical ingenuity, his wizardry with the brush, in achieving realistic pictorial effects that rival reality itself. Art that permits the viewer to recognize what he knows in life, that evokes admiration for the artist's skill at replication, requires no special training or skill to comprehend. Through it the artist can communicate directly with the ordinary public, as in *The Painter's Triumph*. In America the potential public for this sort of art was considerable. The penchant for realism, deeply rooted in the American character, reflecting a pragmatic and materialistic value system, has already been noted.

As in *The Painter's Triumph*, genre paintings often tell some kind of simple story, and the viewer simply reads the picture in literary terms. Indeed genre scenes often were illustrations taken from literature rather than life. Painters found increasing artistic inspiration in American literature as it flowered in the nineteenth century. The dramatic narratives of James Fenimore Cooper and the richly textured stories of Washington Irving inspired artists like John Quidor (1801-1881), just as the poetry of William Cullen Bryant inspired Thomas Cole. Born in Tappan, New York, a small village that still bore the imprint of its early days as a Dutch settlement, Quidor studied art in New York City with the portrait painter, John Wesley Jarvis. However when he launched out on his own, it was as a painter of literary illustrations rather than portraits. Quidor differed from most literary illustrators in that his pictures were not intended to accompany published editions of literary works. The written words simply provided him with the inspiration for the visual recreation of a scene. Each picture is inevitably literary, meant to be read like a story, and its effectiveness hinges on its success in communicating that story. Formal characteristics serve not their own ends but the ends of the plot.

In Quidor's *The Money Diggers*, a scene taken from Washington Irving's *Tales of a Traveller*, Wolfert Webber, with the aid of the nefarious Dr. Knipperhausen, attempts to retrieve a hoard of buried pirate gold. Just as the digging uncovers a treasure chest, the ghost of the drowned buccaneer, "grinning hideously," rises over a rocky embankment behind them. Sam the Negro scampers out of the hole in terror; Dr. Knipperhausen's knees knock together in fear at this unexpected development and he begins to pray in German; Wolfert, in surprise and horror, raises his arms to ward off the apparition. The frantic movements of the figures are echoed by the expressive and tortured gestures of the branches on the trees around them. The scene is dramatically lit by firelight, with secondary illumination from Wolfert's forgotten lantern in the foreground and the ghostly moon that rises behind the embankment. Color, used sparingly in the flames, Wolfert's cape, Sam's vest, and the pirate's cap, effectively leads the eye through the composition. The picture amusingly conveys comic confusion and the cowardice of these inept villains caught out in their wickedness.

The most effective and important genre paintings in the nineteenth century, whether humorous or serious, were derived from actual aspects of American life. The two major artists in this vein were William Sidney Mount (1807-1868) in the East and George Caleb Bingham (1811-1879) in the West. William Sidney Mount was born and raised on Long Island, not far from New York City. He entered the school of the National Academy of Design during its first year, 1826. Although he admired history painting and made some early efforts in that direction, he soon recognized that his peculiar gift was for "comic pictures." He was advised to study the work of the Dutch seventeenth century masters of everyday life, especially Jan Steen. When his period of study was ended, Mount moved back to his beloved rural Long Island where he spent the remainder of his life. However he remained active in the affairs of the National Academy of Design, and exhibited there annually until his death. Despite constant offers from New York patrons and dealers to send him abroad, Mount always demurred, saying "I am contented to remain a while longer in our own great country."

Mount was a slow and painstaking artist, and his production was limited. However his work became widely known through engravings and lithographs. Prints enabled Mount to

tap that broad popular market which was the potential source of extensive patronage in democratic America. Mount consciously directed his art toward the esthetic level of his audience. His artistic dictum was "paint pictures that will take with the public—never paint for the few, but for the many." His goal may not have been lofty, but it was appropriate to America in the nineteenth century.

Another important but short-lived means by which American artists reached a broad public was the American Art Union. Organized in 1838 as the Apollo Association, the Art Union used membership fees to publish a news letter, to distribute to each member an engraving of a work by a distinguished American artist or an illustrated book, and to purchase a number of paintings which were distributed by lot at the annual meeting. The Art Union thus became an important source of patronage, with a pool of cash available each year for the purchase of representative works by American artists. This assured patronage fostered interest in art as a viable career, and a noticeable increase in the number of young Americans becoming artists paralleled the life-span of the Art Union. Through the lottery, American paintings were distributed to lucky winners throughout the country. Although this seemed an ideal way for art to achieve broadly based popular support appropriate for a democracy and to develop a wider interest in art, moral scruples about lotteries led to legislation that closed down the Art Union in the early 1850's. One result was financial hardship for artists who lost a dependable source of patronage.

John Quidor (1801-1881). The Money Diggers, 1832. (16¾×21½")

The Brooklyn Museum, Brooklyn, New York. Gift of Mr. and Mrs. A. Bradley Martin, 1948.

Mount was sufficiently popular not to suffer greatly from the demise of the Art Union. He had many important patrons who were happy to have his work. *Eel Spearing at Setauket*, painted in 1845 for a wealthy New Yorker, George Washington Strong, reflected the stylistic lessons Mount had learned from Dutch genre painting of the seventeenth century. The color is restrained, as in *The Painter's Triumph*. The pervasive sepia monochrome avoids strong coloristic assertion of the picture plane and permits a more realistic illusion of solid forms in space. The picture is a rural echo of Copley's *Watson and the Shark* with a Negro as a main character, a spear about to be thrust into the water, and a dominant triangular composition. However the modest artistic intent here is quite different. There are no aspirations toward history painting, no echoes of the *Borghese Warrior*, no striking innovations in dress or setting. The young boy and the Negro woman are on an eel-catching excursion. The day is clear, the water calm, the landscape tranquil. The task at hand is simply an excuse for a delightful outing, more sport than work, as the picnic basket and the pet dog in the boat further suggest. However at the moment everything is concentrated on the business at hand. The boy uses his oar as a rudder to steady the boat on its slow course. He and the dog are motionless. The woman stares down and ahead, focussing the entire composition on the unseen target.

Mount frequently used a Negro as a central figure, and invariably the Negro is presented sympathetically, never caricatured or lampooned. Quite often the Negro appears in conjunction with music. In *The Power of Music* (1847, The Century Association, New York)

William Sidney Mount (1807-1868). Eel Spearing at Setauket, 1845. (29×36")
New York State Historical Association, Cooperstown, New York.

George Caleb Bingham (1811-1879). Fur Traders Descending the Missouri, about 1845. (29×36½")
The Metropolitan Museum of Art, New York. Jesup Fund, 1933.

a handsome Negro leans against the door of a barn, separated from the fiddler and his audience within, yet rapt by the music and, like the thoughtful Indian in West's *Death of Wolfe*, apparently more in tune with the essence of the moment than the active participants.

George Caleb Bingham, who depicted life along the Mississippi River, Mark Twain's world of Huckleberry Finn and Tom Sawyer, was Mount's Western counterpart. Bingham grew up in Franklin, Missouri, on the banks of the Mississippi. Self-taught, he began his career as an itinerant portrait painter. His early portraits are quite primitive, but in the late 1830's he worked in Philadelphia and his style grew more sophisticated under the influence of Sully and Neagle. Simultaneously he began to paint genre scenes depicting the life of boatmen on the Mississippi River which attracted interest when they were exhibited at the National Academy of Design. In the mid 1840's Bingham turned almost exclusively to genre, partly enabled to abandon portraiture through the purchase of his genre pictures by the American Art Union. In 1844-1845 he sold four paintings to the Art Union, including his masterly *Fur Traders Descending the Missouri* which brought seventy-five dollars. The painting is almost exactly contemporaneous with Mount's *Eel Spearing at Setauket*. Each

depicts a characteristic scene of local life, has a hunting theme, and includes an older figure, a boy and a pet. In both pictures the boat, moving laterally over the calm water, is held steady by an oar. *The Fur Traders* is set early in the morning, as the mist slowly lifts from the river. Although it lacks the classical device of a pyramidal composition, the figures and the background are cleverly knit together. The head of the young half-breed is placed against a break in the trees, while the French trapper's cap marks the point where the lower level of trees on the distant shore meets the higher trees on what appears to be an island. The silhouette of the bear cub in the bow is bracketed diagonally between the motionless shapes of snags breaking the surface of the water in the foreground and middle distance. As in *Eel Spearing*, reflections in the water play an important role in completing the composition. The picture seems to capture the spirit of the river perfectly. During his career Bingham, the first major American artist to develop beyond the Alleghenies, created memorable images of the West that catch the essence of the locale and the character of the people, paralleling the achievement of Mount in the East.

Bingham's depictions of raftsmen, flatboatmen, and western politicians became widely known, especially through the engravings of his works distributed by the American Art Union. In a sense Mount and Bingham were history painters recording their own time. However they did not depict all aspects of their society. They chose leisure subjects, life's happy moments, and never dealt with the harsh severities of work or the less pleasant aspects of American existence. Bingham's raftsmen, for example, always appear at ease, dancing or fishing or playing cards, never at their arduous labor or pitting themselves against the elements.

Although Bingham's constant subject is life, a kaleidoscopic pattern of people and events, he usually presents it in quiescent, monumental images, with individual figures based on carefully worked drawings. The early *Fur Traders*, in which the direction of the action is parallel to the picture plane, appears motionless. However in his later river views, street scenes, and even the target range in *Shooting for the Beef* (1850, Brooklyn Museum, Brooklyn, New York) there are powerful diagonal recessions into space, conveying a sense of flux, of process. Bingham creates tension between the stasis of individual figures and the sweep of the composition that implies much about Americans, their rootedness and movement, in the nineteenth century.

To the student of American art Eastman Johnson (1824-1906) seems in retrospect to break like a false dawn in mid-nineteenth century painting, holding forth the promise of combining that grasp of the essence of American life found in the popular genre paintings of Mount and Bingham with a high degree of technical training and skill. Born in Maine and apprenticed at an early age to a Boston lithographer, Johnson made his initial reputation with highly realistic, almost photographic, pencil and crayon portraits of political and literary notables. In 1849 he went to Europe, studying, as did a number of American artists at mid-century (Bierstadt, Leutze, Whittredge) with Lessing in the Academy at Düsseldorf. He also worked at The Hague and Paris before returning to America in 1855. On the eve of the outbreak of the Civil War, Johnson painted in Washington, D.C. a scene of "negro life in the South," which now parades under the popular title *Old Kentucky Home*. The painting, marked by the tight handling and muted color that reflect his Düsseldorf training, was well received, and Johnson was elected an Academician of the National Academy of Design the following year. Whereas earlier paintings by artists as diverse as Copley and Mount had occasionally included a Negro as a picturesque figure, here the "different" figure is a white woman. She comes through an opening in the garden wall, leaving her elegant quarters to enter this picturesque place occupied by handsome, happy black people. One suspects that it contrasts favorably with her more genteel existence. The painting is reminiscent of Mount in its idealization of the Negro and the identification of the Negro with music. When Johnson settled in New York City in 1858, Mount was the old master of American genre painting, and still active in the academy. It seems extraordinary but nonetheless clear that

Mount, who never strayed far from rural Long Island, exerted a strong influence on the sophisticated Johnson. For example Johnson's *Corn Husking* of 1860 (Everson Museum of Art, Syracuse, New York) is obviously influenced by Mount's barn interior scenes, especially the *Banjo Player* of 1858 (Detroit Institute of Arts, Detroit, Michigan).

During the next few years Johnson produced a number of Civil War pictures, and after the war painted a colorful series of views of maple sugaring in his native Maine followed by some impressive mood-infused landscapes of Nantucket. During the latter part of his life Johnson abandoned genre painting entirely for a popular brand of comfortable portraiture. His early war and rural scenes are reminiscent of the work of his contemporary, Winslow Homer, and the later portraits resemble those of Thomas Eakins. But the resemblance is superficial, and Johnson's work never consistently rivaled the quality attained by Homer and Eakins, who between them carried the promise of an American art held forth by Mount and Bingham to fruition in the second half of the century. Standing midway in the history of American art between the towering figures of John Singleton Copley in the eighteenth century and Jackson Pollock in the twentieth century, Homer and Eakins are the twin peaks of American nineteenth century painting.

Eastman Johnson (1824-1906). Old Kentucky Home, 1859. (36×45″)
The New-York Historical Society, New York.

Winslow Homer (1836-1910) was raised in Cambridge, Massachusetts, then a delightful country village across the Charles River from Boston. At the age of nineteen he was apprenticed to John Bufford, a successful Boston lithographer. Young Homer soon began drawing pictures for publication (usually as wood engravings), sending the better ones to *Harper's Weekly* in New York. In 1859 he moved to New York as a freelance illustrator.

Homer covered Abraham Lincoln's inauguration for *Harper's* in 1861. When the Civil War broke out, he spent quite a bit of time as a correspondent at the front sketching. However few of his illustrations actually show military action. Homer preferred to concentrate on camp life, and his scenes are generally humorous or sentimental rather than stirring. As the war dragged on Homer became less concerned with it and more interested in his own artistic development. He was elected a member of the National Academy of Design in 1865 at the unusually early age of twenty-nine, and the following year exhibited his first popular success, *Prisoners from the Front* (Metropolitan Museum of Art, New York), a sympathetic representation of Southern prisoners standing before a young Union officer.

After the war Homer took up the pattern of artistic life familiar since the days of Thomas Cole and the Hudson River painters. When the weather turned fair, he traveled through New England, along the Hudson River, or down into Pennsylvania—hunting, fishing, camping and sketching. Back in New York he would develop his summer sketches into finished works during the winter. Although he lived in the city, the city itself was never his theme. His subjects were invariably rural, usually pleasant scenes involving women and children. Homer's early palette was subdued. The color areas on the picture surface are opaque, with dark background areas setting off a few brilliant touches of color in the foreground. Compositions revolve around a limited number of elements, the design simplified to large masses laid out in a flat decorative pattern, unmarred by niggling detail.

Although Homer, like Eastman Johnson, developed out of the genre tradition of Mount, he was more original in his response to it. Moving in a direction akin to Courbet and Naturalism, Homer divested his paintings of anecdote, choosing pictorial material for its own sake, free from the requirements of message or meaning.

Homer went to France for a year in 1866-1867, but the experience seems to have exerted remarkably little influence on him. Such influence as there was is more evident in the magazine illustrations on which he concentrated during the next six years than his paintings. His style became gayer and more fashionable, and marked by increased compositional daring that reflected increased awareness of Japanese prints. In 1873 Homer began to work in watercolor. Rarely have artist and medium been so well-suited. Watercolor permitted Homer to record direct observations of nature with freshness and immediacy, and he possessed the technical gifts to make the capricious medium increasingly responsive to his hand and his will. Watercolor demands sureness; when color touches paper, it is fixed. Homer reveled in the irreversible commitment of watercolor painting. Indeed watercolors became the cutting edge of his artistic growth. At first he simply used watercolors in place of pen and ink drawings as an improved method of preparing illustrations for publication, but increasingly he used them as initial sketches for oil paintings. Homer fought his artistic battles in watercolor skirmishes, carrying the resultant hard-won knowledge and skill over into his oils.

Homer's early paintings are generally sunlit scenes, often of young women playing croquet, or promenading along the seashore, or riding on horseback in the mountains. The women are invariably attractive, healthy, and fashionable, although aloof and impersonal. Figures are isolated from each other and from the viewer, and this isolation is sometimes intensified by anonymous male figures introduced in minor roles, their faces averted or hidden in shadow.

Although the adults in Homer's world seem isolated, his children frolic together in a cheerful world of laughter and mutuality. For Homer, growing up seems to imply a loss, a fall from paradise, removal from happy, carefree innocence and high spirits to a serious, lonely existence in which each man is an island unto himself. Homer's *Snap the Whip* (1872, Butler

Winslow Homer (1836-1910). Breezing Up, 1876. (24×38″)
National Gallery of Art, Washington, D.C. Gift of the W. L. and May T. Mellon Foundation.

Art Institute, Youngstown, Ohio) stands as a memorable image of childhood in rural America. If Bingham's scenes of life on the Mississippi caught the external appearance of the world of Huckleberry Finn, Homer's exuberant children at play convey the character of the boyhood days of Huck and Tom Sawyer. *Snap the Whip* is set in a sun-drenched valley, its bold diagonal recession echoed by the slanting line of the mountains and the roof of the schoolhouse. With thoughts of school far from their minds, the children hold hands to form a moving line anchored firmly at one end that snaps off at the other to send youngsters tumbling amidst the wildflowers.

Breezing Up is a seagoing version of *Snap the Whip*. The boys exert a mutual effort for their common delight. One adult is present, briefly privileged to share their pleasure. The day is sunny; the air and the water are alive. Wind fills the sails, and the boat fairly shudders as it drives through the choppy sea. The thrust of air against the canvas pulls every line taut, and all hands work to hold this living machine, quick with the breath of nature, under control. Lines are grasped firmly, the rudder is locked in place, and the figures throw their weight against the heave of the gunwhales to hold the boat under control as it skims along its course. In the right background a ship in full sail moves along the line of the horizon in serene counterpoint to the diagonal thrust of the foreground boat.

A salient characteristic of Homer's greatness as an artist is the capacity for change and growth manifested throughout his career, both in increased mastery over his artistic means and, more importantly, the artistic ends he made them serve. In the late 1870's one of Homer's periodic artistic transformations began. Homer spent greater amounts of time in close rapport with nature on fishing and hunting trips in the Adirondack Mountains and in

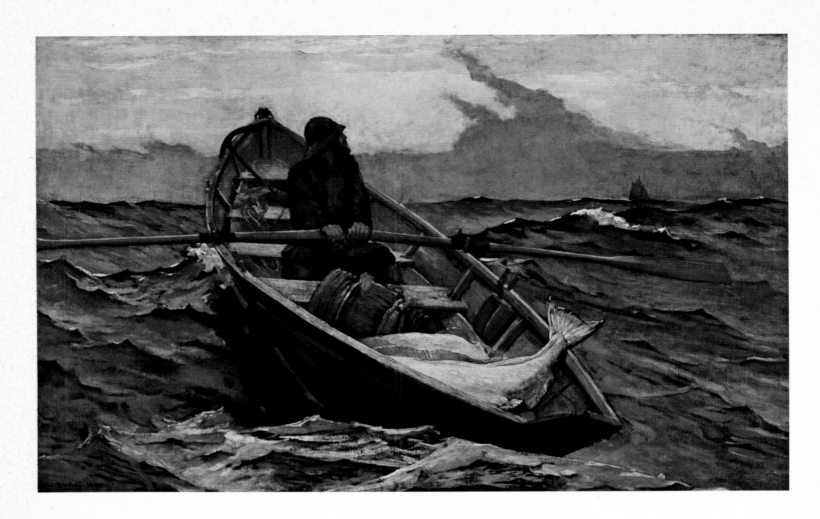

Winslow Homer (1836-1910). The Fog Warning, 1885. (30×48″)
Courtesy, Museum of Fine Arts, Boston, Massachusetts. Otis Norcross Fund.

Canada. The pattern of his existence seems in some ways a prolonged vacation, an attempt to perpetuate boyhood pleasures. Paintings of forest and mountain scenes became frequent. Homer devoted himself increasingly to watercolor, to a direct recording of nature, achieving ever more subtle atmospheric effects, the softening play of reflected lights, the coloristic linking of all parts into a pictorial unity replacing the clear separation of parts that characterized his earlier work.

In 1881 Homer, who had become increasingly anti-social, left America to spend two years in the English fishing village of Tynemouth on the North Sea. Life in Tynemouth was completely oriented toward the sea. The men fished; the women repaired the nets, raised the children, kept the house, and waited stoically on the strand for their men to return. Homer chose to concentrate on monumental figure studies of these sturdy and courageous women on the shore, rather than the perilous existence of the men at sea. He worked mostly in watercolor, seeking to master the dull diffuse atmosphere of the English coast. The sober tonality of these watercolors and the few oils of the period invoke an ominous feeling of the threat of the sea, which lurks behind every picture. From this time forward the sea becomes the dominant theme in Homer's work. On his return to America in 1883, he moved to Prout's Neck, a desolate fishing village on the coast of Maine, where he built a studio with a large balcony breasting the sea like a ship's bridge. This studio provided the solitude for which he felt an increasing need, and served as a base from which to launch his frequent excursions.

On his return to America Homer became intrigued with the subject of rescue from the sea, as his attention seemed to move slowly from the shore out to the sea itself. In *Lifeline* (1884, Philadelphia Museum of Art, Philadelphia, Pennsylvania), an unconscious female is

transported to shore on a breeches buoy stretched between a foundering boat and a rocky coast, cradled in the arms of a man rendered anonymous by a red scarf that blows across his face. In *Undertow* (1886, Sterling and Francine Clark Art Institute, Williamstown, Massachusetts), two half-drowned young girls are dragged from the sea by lifeguards. The discipline Homer had developed in the Tynemouth watercolors strengthens the powerful and monumental oils of this period in which restrained, even dreary, color heightens the dramatic impact.

In 1884 Homer probably sailed with a fishing fleet, perhaps to the Grand Banks, and during the next two years he painted fishermen at sea in such monumental oils as *The Herring Nets* (1885, Art Institute of Chicago, Chicago, Illinois), *Eight Bells* (1886, Addison Gallery of American Art, Phillips Academy, Andover, Massachusetts) and *Fog Warning*. In *Fog Warning* a fisherman is alone at the end of the day on the open sea in a dory, his catch at his feet. He looks back over his left shoulder across the rolling waves at his ship, and gauges the intervening distance. Night is falling, and the fog is beginning to roll in. Will he have time to reach the safety of the ship before darkness and danger overtake him? His hands firmly grasp the oars, and his knowing glance makes it clear that he is in control of the situation. He pits his physical strength, his knowledge, his experience and his courage against the sea with the calm heroism that is a component part of his daily existence. The picture compositionally echoes *Breezing Up*. The boat moves diagonally into space to the left while a sailing ship moves to the right along the background horizon line. As in *Breezing Up* the boat is firmly under control, but there is a new seriousness of purpose. This is work, not play. This is a matter of life and death. The heroic theme demands and receives a monumentality of form that echoes the magnitude of the concept.

Winslow Homer (1836-1910). The Gulf Stream, 1899. (28⅛×49⅛″)
The Metropolitan Museum of Art, New York. Wolfe Fund, 1906.

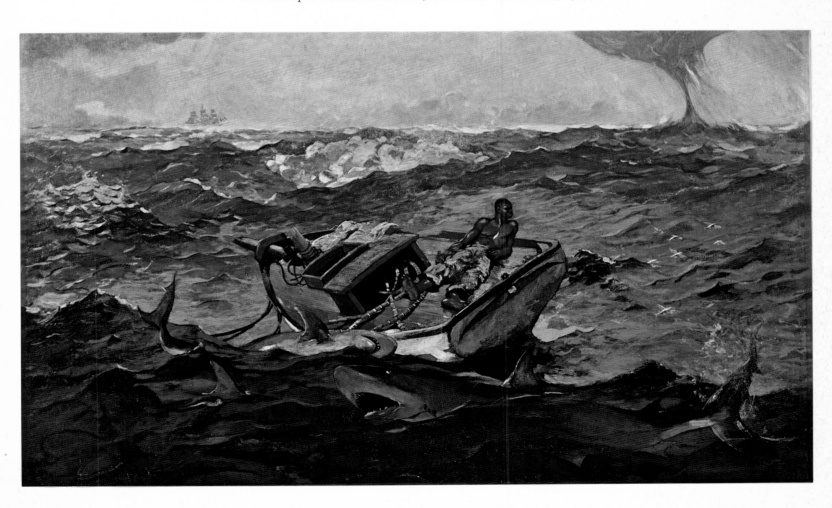

As the years went by Homer continued to explore the theme of the relationship between man and nature. Each major painting required considerable thought and gestation, and his production of oils was limited to a few pictures each year. Almost all of Homer's previous *œuvre* seems pointed toward the climactic *Gulf Stream* of 1899. In this great painting Homer takes an unrelievedly grim view of existence in a deterministic universe. A Negro is adrift on the open sea. The mast of his sailing vessel has snapped. The rudder is gone. The composition echoes *Breezing Up* and *Fog Warning* but the theme has altered substantially. Here the human occupant exercises no control over the boat. It lies slack in the water, subject only to the will of the waves. In the right distance a menacing waterspout replaces the comforting sailing ships of the earlier pictures. There is a sailing vessel on the horizon, but to the left, moving beyond the listless Negro's line of vision. The ship and the solitary figure remain unaware of each other. Sharks circle the boat. A few touches of red color in the water at the stern, and dirty brown flotsam around the boat, add to the ominous mood of the scene. This man, this anonymous spark of life, is a pawn of forces beyond his control. He is at the mercy of an impersonal nature that does not care about him one way or the other. It may snuff him out, or it may not. The painting, produced one year after Stephen Crane's short story *The Open Boat*, is an exact pictorial counterpart to Crane's Naturalism. It echoes the view of the world expressed by Crane in a short poem in the same year, 1899.

> A man said to the universe:
> "Sir, I exist!"
> "However," replied the universe,
> "The fact has not created in me
> "A sense of obligation."

Although the final outcome of the scene in the painting is uncertain, the odds seem hopelessly stacked against the Negro. A contemporaneous watercolor by Homer (*After the Tornado*, 1899, Art Institute of Chicago, Chicago, Illinois) shows the body of a shipwrecked Negro thrown up on a sandy beach while the storm passes out to sea.

Gulf Stream marked the finale of an extended sequence of thematic paintings in which, consciously or unconsciously, Homer expressed his world view. The earlier paintings spoke of joyful commonality in the world of children, and hinted at adult loneliness made all the more poignant and bittersweet by the contrast. His paintings of the 1880's and 90's depicted men involved in cooperative efforts to earn a living or even simply to survive in the face of the dangers of the natural world. In these paintings Homer seems to imply that man's struggle with nature is what in fact establishes his humanity. It is what gives his life meaning. In a deterministic universe that is unconcerned about man or his fate, cooperation, the brotherhood of common effort, is what makes man human. Homer is not concerned with specific individuals. His people are anonymous, often to the point of having their faces hidden from view. The Negro in *Gulf Stream* is Everyman. He has no name, like Crane's characters—the cook, the oiler, the correspondent, the captain—in *The Open Boat*. A man joins the community of men not through peculiarly personal experiences, but through individually encountered common experiences.

Gulf Stream apparently drained Homer of what he had to say, and subsequently he concentrated on making pictures rather than statements. As Homer grew older his capacity for sustained growth did not end. Although he remained much of the time in relative isolation at Prout's Neck, remote from the centers of artistic life, his art during the first decade of the twentieth century was surprisingly advanced. He revealed an increasing interest in the formal possibilities of paintings, particularly color relationships, and the development of expressive forms which seem to parallel developments in German Expressionism during the same period. He was fascinated with unusual atmospheric effects, such as accompany a sunrise after a storm, and produced haunting visions of strangely colored seascapes with spume rising in wraithlike forms to dance along the rocky shore. His compositions became eccentric, reflecting a continuous, indeed increasing, responsiveness to Japanese prints. This is evident in his eerie *Kissing the Moon* (1904, Addison Gallery of

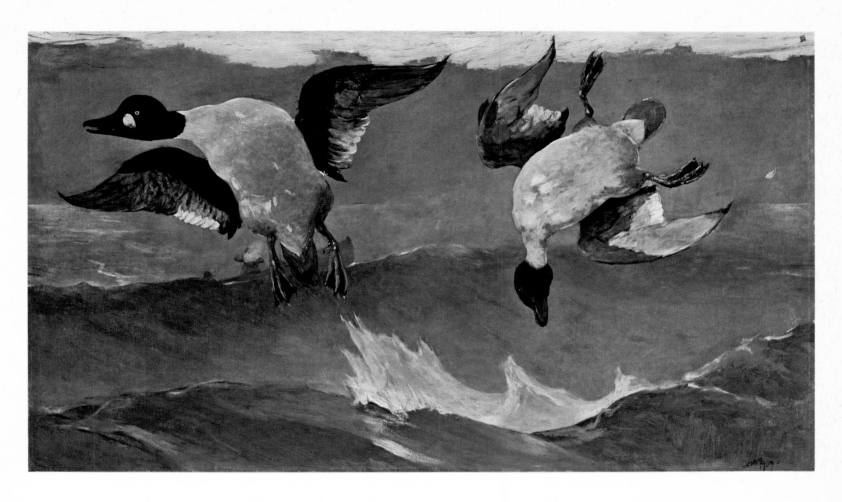

Winslow Homer (1836-1910). Right and Left, 1909. (28⅛×48½″)
National Gallery of Art, Washington, D.C. Gift of the Avalon Foundation.

American Art, Phillips Academy, Andover, Massachusetts) in which figures sit stiffly and without expression in a canoe dropping into the trough of an enormous wave which reaches up and almost seems to touch a low-hanging moon, echoing Hokusai's *Wave*.

Right and Left is one of Homer's oddest compositions. The point of view places the viewer floating free over the ocean, flying as it were in the company of ducks. In the distance a tiny figure in a boat, shrouded in mist, rises up and fires a double-barrelled shotgun blast in our direction. Before our eyes two ducks, one hit by each barrel, are splattered against the plane of their death, frozen momentarily in an ungainly sprawl. They resemble a naturalist's study, but Audubon would have shown the ducks in life, not death. Homer's subject is once more life and death, but here it seems to serve only as the point of departure for picturemaking. The startling result bears witness to the fact that Homer, despite his age, entered the twentieth century as a twentieth century artist.

Winslow Homer was an objective Realist, painting with detachment aspects of the real world that interested him and themes that embodied his thoughts on the meaning of life. His paintings rarely include his friends and never himself. Thomas Eakins (1844-1916) was, by contrast, a subjective Realist, passionately involved with the world in which he lived and which he painted. His art is a record of his life. Eakins was born in Philadelphia. His grandfather had been a weaver; his father was a drawing master. From them he inherited a tradition of craftsmanship, of precision, and, specifically from his father, a sense of drawing and its importance. Eakins shared his father's love of outdoor activities—sailing on the Delaware, rowing on the Schuylkill, swimming, hunting rail birds in the New Jersey marshes. Although he had a strong scientific inclination, he was primarily interested in art, and enrolled at the Pennsylvania Academy of Fine Arts. The Academy, with its collection of

old history paintings by West and others, and plaster casts of antique statuary, was an unexciting place in which to study. However it did provide an opportunity to draw from living models. Surviving charcoal drawings by Eakins show nude female models masked to shield their identity, graphic witness to the local prudery that later blighted his career. Interested in learning all that he could about the human figure, Eakins concurrently studied anatomy at Jefferson Medical College, witnessing and participating in dissections.

In 1866, after the Civil War had ended, Eakins went to Paris to study. He enrolled in the Ecole des Beaux Arts, and chose to work in the studio of Jean-Léon Gérôme. Eakins' methodical artistic preparation—penmanship and mechanical drawing from his father, free drawing at the Pennsylvania Academy, anatomy at Jefferson Medical College—stood him in good stead at the conservative Ecole, still dominated by the shade of Ingres and his insistence on the primacy of draftsmanship. Eakins studied with Gérôme for over three years, and then in 1869 left Paris for Spain to paint on his own. There among the old masters he was deeply impressed by Ribera and Velasquez who, along with Rembrandt, he admired as forceful artists who painted "big work" with breadth and freedom.

Upon his return to Philadelphia in the summer of 1870, Eakins painted a number of intimate family portraits; dark, glowing images free of flattery and with emphasis on character and presence rather than specific detail. He resumed a vigorous outdoor life, and expanded his artistic subject matter to include this aspect of his days. In *Max Schmitt in a Single Scull* (1871, Metropolitan Museum of Art, New York), Eakins himself appears in a scull in the middle distance. These outdoor scenes, while informal in appearance, are in fact carefully structured distillations of the world in which the artist lived and breathed. Eakins often used preparatory drawings to establish a perspective grid on which every solid form could be locked in place. He brilliantly invoked the geometry of his compositions to heighten their pictorial impact. In his oil sketch of *John Biglin in a Single Scull* (1874, Yale University Art Gallery, New Haven, Connecticut) the horizon passes directly behind the rower's head. A vertical line drawn at right angles to the horizon at the vanishing point would pass just at the back of Biglin's profiled head, and directly through the oarlock. The oarlock is the fulcrum of the entire composition, the point at which all lines of arms, oars and struts converge, as well as the literal fulcrum for the rowing action depicted. Biglin, about to unleash his stroke, seems to brace his head against this invisible line, the curve of his back behind the line bent like an uncoiled spring, the arms and oars to the left of the line a rigid zigzag from shoulders to oarlock ready to execute the mechanics of the pull.

The 1876 painting of *Will Schuster and Blackman Going Shooting for Rail* is divided into three horizontal bands of sky, marsh and river, and three vertical strips, separated by the two standing figures, to form a gridlike "tic-tac-toe" composition. Upon this a triangle is superimposed, with the boat as the base and the Blackman's pole as one of the sides. The other side is an invisible line stretched tautly between the upper tip of the pole and the bow of the boat, passing through the lock of Will Schuster's cocked gun (reminiscent of the unseen vertical coordinate that passes through the oarlock in *John Biglin in a Single Scull*). The composition is knit tightly by a series of contrasts that begin with the juxtaposition of black man and white man. The value contrast of black trousers on the white man and white shirt on the black man is criss-crossed coloristically by the contrast of Will Schuster's red shirt and the black man's blue trousers. The vertical pole held by the black man balances the horizontal line of Schuster's gun.

A perspective grid supports this composition, permitting the major pictorial elements to be located with precision. Although the line of Will Schuster's gun and the gaze of the two figures run parallel to and assert the picture plane, the boat diverges into pictorial space, stretching open the composition. The heft of the Negro presses the back of the boat into the water and raises the bow. As he leans his weight against the pole to hold the boat motionless, the boat tips toward the picture plane. The accurate response of the boat to the physical forces acting upon it emphasizes dramatically that the base of the dominant compositional triangle, the boat, is a skitterish thing held steady on the water for a

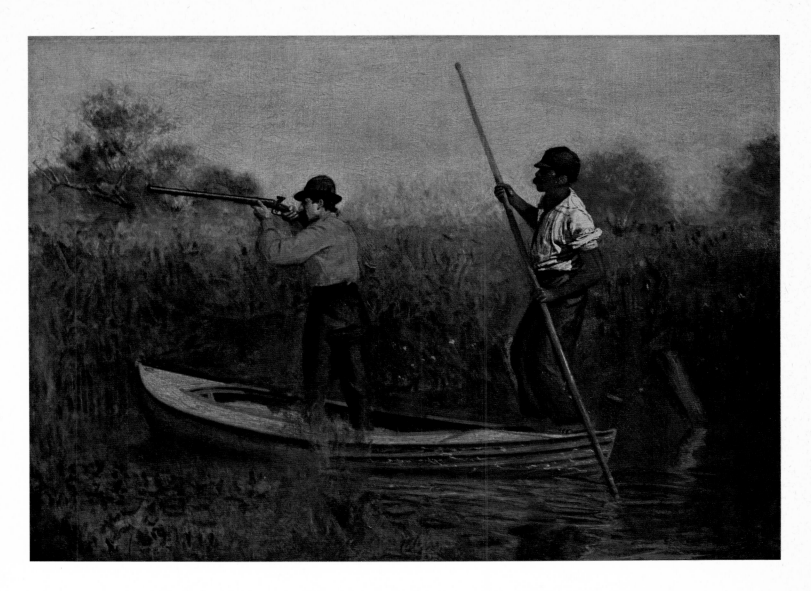

Thomas Eakins (1844-1916). Will Schuster and Blackman Going Shooting for Rail, 1876. (22⅛×30¼″)
Yale University Art Gallery, New Haven, Connecticut. Bequest of Stephen Carlton Clark, B.A. 1903.

breathless moment while Schuster takes aim. Anticipation is screwed to an excruciating pitch by the viewer's awareness that the whole taut equilibrium is precarious. The least twitch or jostle will throw the gun out of line, and the shot will miss. The hammer is back, attention is focused on the unseen target to the left, everything awaits the release that will come when the trigger is pulled. The release is implied visually by the puff of green foliage near the mouth of the gun and the brown tree limb tracing the trajectory of the shot. Eakins caught, or one might say constructed, the synthetic moment that sums up all that has gone before—the movement of the boat through the marshes, the flushing of the bird, the balancing of the boat, the sighting of the gun—and implies what is to follow. This is the moment of potency. Thus Eakins perceives, imparts order to, and records his world. It is very different from the more purely pictorial concern of Homer's *Right and Left*, where the results of a shot are orchestrated into a remarkable image free from thematic overtones.

Eakins had resumed his study of anatomy at Jefferson Medical College upon his return to Philadelphia. Just as mechanical drawing permitted him to construct an armature for his realistic views of the world around him, so knowledge of anatomy led to more realistic delineations of human beings. His study led directly to the painting of *The Gross Clinic*, one of the major monuments in the history of American art. The painting represents Dr. Samuel Gross, the dominant figure at Jefferson Medical College, in his dual role as surgeon and teacher. Standing as Eakins had often seen him in the somber amphitheater, light flooding

down from a skylight above, Gross is operating on the leg of a patient. He has made an incision, and while his associates hold the cut open, he turns to his students to explain what has been done and what he is about to do. His bloodied hand grasps the scalpel, the cruel cold fact of its work more than balanced by the compassion and objective professionalism of the man.

The Gross Clinic immediately recalls *The Anatomy Lesson of Dr. Tulp* by Rembrandt, one of Eakins' artistic heroes. Both paintings are portrait groups on the theme of medical instruction, although *The Gross Clinic* represents an operation on a live patient rather than the dissection of a cadaver. *The Gross Clinic* also contains echoes of several of the more popular paintings of gladiatorial combat and Christian martyrdom by Eakins' erstwhile teacher, Gérôme, in which spectators similarly witness a bloody scene of laceration, pain and possible death in a circular arena. However, Eakins' picture is neither anecdotal nor sentimental. It is a frank record of a drama of contemporary life. It is not pleasant to watch, and the viewer sympathizes with the mother of the patient seated on the left who shields her eyes with her arms, her hands clutching at the air in anguish. But the picture is humane too. The figure of Gross, kindly and knowing, dominates the scene, making it clear that dispassionate science and technical skill are servant to humane wisdom and compassion.

The blunt honesty of *The Gross Clinic* shocked and offended Eakins' contemporaries. The painting was rejected for the art section of the Philadelphia Centennial Exhibition of 1876, for which it had been painted, and Eakins was forced to exhibit it in the medical pavilion. The public, comfortable with anecdotal paintings, able to gaze with equanimity at the bloodiest *Massacres of the Innocents* or the most revolting scenes of flayed, crucified, beheaded or roasted martyrs as long as the event took place long ago and far away, was shocked and offended by a representation of bloodshed, suffering, pain and grief in contemporary Philadelphia. Outraged critics objected to what they felt was gratuitous brutality. This kind of picture was not elevating to the morals, instructive to the mind, enlightening to the spirit, or even divertingly anecdotal. What could be the justification of brutal realism for its own sake? Few understood that Eakins had taken American painting an important step further along its traditional path of realism, opening up increased possibilities for the honest and free recording of the realities of contemporary life.

In *The Gross Clinic* Eakins sought the synthetic moment, just as in *Will Schuster and Blackman Going Shooting for Rail*. Gross, turning from his operation to talk to his students, is characterized both as gifted surgeon and magnetic teacher. The dual emphasis on the bloody hand and the intelligent, compassionate face, weathered by experience, captures the essence of the man.

The negative public response to *The Gross Clinic* marked only the beginning of Eakins' troubles. As teacher of the life classes at the Pennsylvania Academy of Fine Arts from 1877, Eakins stressed the importance of drawing from undraped models. He believed that a thorough understanding of anatomy was prerequisite to the accurate picturing of pose and locomotion. Unfortunately his enthusiastic and graphic instruction in the facts of comparative anatomy, using live models, shocked some of the more conventional female pupils. A devoted and inspired teacher, loved by his professional students, Eakins suffered a great blow when he was dismissed from his post at the Academy because of his insistent use of nude models before mixed classes.

As a realist who was interested in anatomically correct depictions of the nude human figure, Eakins was hard put to find subject matter in contemporary life which included undraped figures. His choice of scenes of rowing, boxing and surgical operations partially reflects his interest in anatomy. Even his depiction of a *Crucifixion* (1880, Philadelphia Museum of Art, Philadelphia, Pennsylvania) resulted from his interest in an anatomical study of the human body under stress rather than any religious sentiments. Opportunities to depict nude or partially nude females were particularly limited in Victorian Philadelphia. However, perhaps motivated by the general climate of retrospective historical awareness that accompanied the centennial celebration, Eakins did discover a pretext for painting a

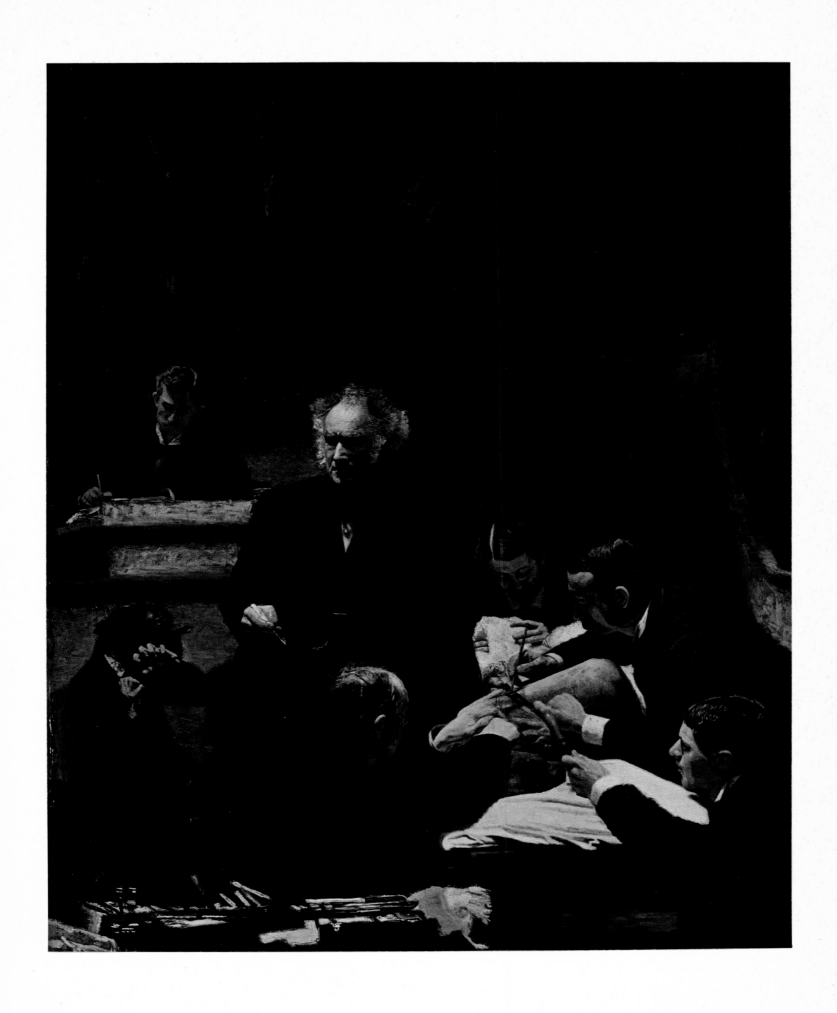

Thomas Eakins (1844-1916). The Gross Clinic, 1875. (96×78″)
Courtesy of the Jefferson Medical College, Philadelphia, Pennsylvania.

nude female in a subject taken from the artistic history of Philadelphia itself, *William Rush Carving His Allegorical Figure of the Schuylkill River* (1877, Philadelphia Museum of Art, Philadelphia, Pennsylvania). When Rush, a Philadelphia sculptor of the late eighteenth and early nineteenth centuries, had required a model to pose nude for an allegorical statue commissioned by the City of Philadelphia, and encountered the same prudery that later frustrated Eakins, he resolved the problem by getting the daughter of a local merchant to pose with a chaperone in constant attendance. Eakins ingeniously resolved his problem by painting an historical reminiscence of Rush at work, a subject that was local and factual, if not contemporary, and afforded him an opportunity to paint a female nude. Eakins subsequently returned to this pictorial device several times, treating the same subject in a variety of compositions.

Eakins' interest in anatomy led to an increasing concern with motion. In the *Swimming Hole* of 1882 (Fort Worth Art Center, Fort Worth, Texas), Eakins depicts a group of friends diving and swimming in the nude, while he himself treads water in the lower right hand corner and looks on, the constant observer. Eakins was also interested in animal loco-motion. For the picture of *Fairman Rogers' Four-in-Hand* (1879, Philadelphia Museum of Art, Philadelphia, Pennsylvania), he made extensive studies, including wax models, of horses in motion (one of a number of interesting parallels between Eakins and Degas). An expert photographer, he became interested in Eadweard Muybridge's experiments in motion photography, and experimented himself with multiple exposure photographs of athletes in motion.

During his later years, although generally recognized as an important American artist, Eakins received few honors and few commissions. His battles over realism of subject matter and nudity in art made him, in Lloyd Goodrich's phrase, something of "an artistic outlaw." Although his art was neglected by the public, Eakins' artistic thinking, abetted by his warm personality, became the dominant influence on the next generation of American realists, notably the artists of the so-called "Ashcan School." His friend Walt Whitman recognized his potency when he said, "Tom Eakins is not a painter, he is a force." The basic thrust of Eakins' art and his teaching was in the direction of heightened realism. He strove for accuracy in reproducing external reality through his mastery of perspective drawing, human anatomy, and locomotion, and in capturing internal reality as well, probing for essences, whether in the representation of the synthetic moment of a scene or in rendering probing character studies that reveal the record of a life lived in lines and wrinkles, glance and pose.

Although both Homer and Eakins spent a few years in Europe, almost all of their major work was done in America. A third American painter, Albert Pinkham Ryder (1847-1917), although representing the opposite end of the artistic spectrum as a non-realist, must be classified with Homer and Eakins as a major native artist who hammered out solutions to his artistic problems in America rather than in Europe. Like them too, Ryder dealt with significant artistic problems, although his output was limited and his paintings generally small. Ryder was born in New Bedford, Massachusetts, on Cape Cod, then the largest whaling port in the world. As a self-taught artist, Ryder was frustrated in his early attempts to record the myriad details of the natural world. An infinitude of leaves and branches perplexed him. Suddenly, one day, he saw natural objects in terms of their essential form, and, working more with palette knife than brush, he re-created these forms on canvas in a way that was more satisfying and in essence more accurate than his more detailed previous attempts.

In 1870 Ryder moved to New York where he continued to paint landscapes, often not from nature but from recollection of the scenes he had known in Massachusetts. These landscapes were usually bathed with the soft golden sunlight of late afternoon or silvery moonlight, rather than the full light of midday, yielding a serene, dream-like quality to the results. Although he exhibited occasionally at the National Academy, and was a founding member of the Society of American Artists in 1877, Ryder was largely ignored by public and

critics alike. After 1880 his paintings became increasingly imaginative. His paintings on biblical themes, with their expressive distortions, revealed a genuine, if unorthodox, religious sensibility. Often a literary or poetic theme provided the point of departure. The great English poets were a major source of inspiration, notably Chaucer (*Constance*, before 1876, Boston Museum of Fine Arts, Boston, Massachusetts) and Shakespeare (*Macbeth and the Witches*, 1890, Phillips Collection, Washington, D.C.; *The Forest of Arden*, 1877, Metropolitan Museum of Art, New York; *The Tempest*, before 1891, The Detroit Institute of Arts, Detroit, Michigan). He admired contemporary Romantic poets like Byron, Moore, Campbell and Tennyson, and also found inspiration in Romantic music. Several of his paintings were inspired by the operas of Richard Wagner, including *The Flying Dutchman* (1887, National Collection of Fine Arts, Smithsonian Institution, Washington, D.C.), and *Siegfried and the Rhine Maidens* (1875-1891, National Gallery of Art, Washington, D.C.) which he began late one night after hearing the opera, and worked on for forty-eight hours without sleep or food until he had it largely done (although as with many of his paintings he later reworked it).

Perhaps the strongest influence on Ryder was exerted by Edgar Allan Poe, whose fevered imagination was akin to his own. *The Temple of the Mind* of 1885 (Albright-Knox Art Gallery, Buffalo, New York) was based on Poe's poem, *The Haunted Palace* from *The Fall of the House of Usher*. The painting was acquired immediately after its completion by the first major collector of American art, Thomas B. Clarke. This helped to establish Ryder's reputation, and created a demand for his work that he could not satisfy because of his slowness and his reluctance to relinquish his paintings. *The Temple of the Mind* depicts a temple in a state of ruinous decay. Outside, three graces, former occupants of the temple, wait for a "weeping love" to join them. A cloven-footed faun dances up the path to the ruined temple, snapping his fingers in glee at having dethroned the erstwhile ruling graces. Ryder's meaning here goes beyond a comment on the cycle of grandeur and decay such as is found in Thomas Cole's *The Course of Empire*. Here the temple symbolizes a body deserted by the mind, an empty shell, about to be occupied by demonic madness. In the second half of the nineteenth century the theme of madness engaged the attention of a number of the more imaginative painters (e.g. Elihu Vedder's *The Lost Mind*, 1864-1865, Metropolitan

Albert Pinkham Ryder (1847-1917). The Dead Bird, 1890-1900.
The Phillips Collection, Washington, D.C.

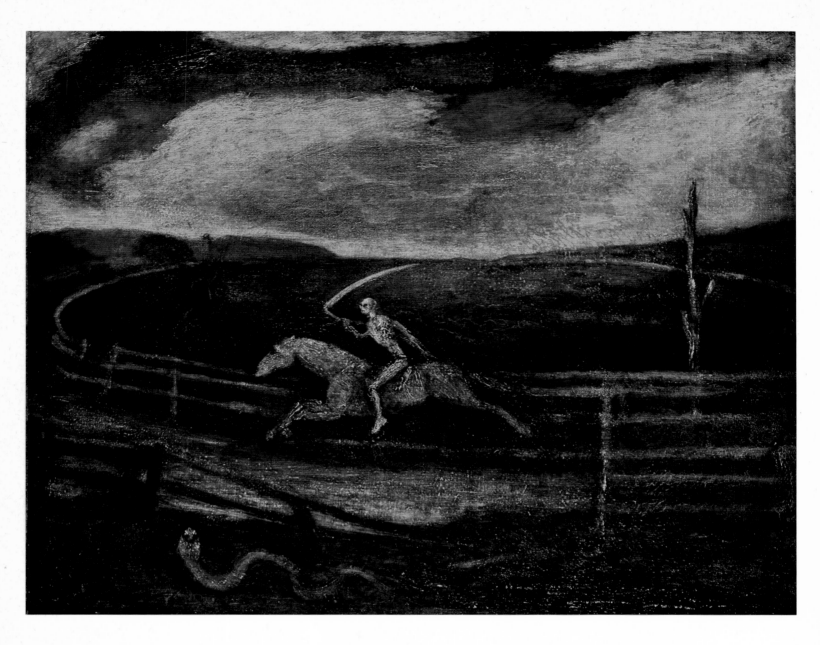

Albert Pinkham Ryder (1847-1917). The Race Track or Death on a Pale Horse, 1895-1910. (28¼×35¼")
Cleveland Museum of Art, Cleveland, Ohio. Purchase, J. H. Wade Fund.

Museum of Art, New York). The madman seemed to dwell in a different world, removed from our own. Ryder, an apparent Platonist, was similarly interested in the ideal world that lay behind the illusory screen of the physical real world. His remarkably fragile and lovely *The Dead Bird* of 1890-1900, atypical in theme and handling, depicts a lifeless yellow bird against a thinly painted yet textured background. The wood panel shows irregularly through the pigment, and gives the effect that the lifeless bird is literally lying crumpled on its surface. Around the bird a ridge of paint traces the outline of a larger, ghostly bird form, that seems to stand almost as a bird spirit behind the inert body. The painting is a still life of death, literally a *nature morte*, in which the composition is focused on a single object, an object with no life force of its own. The viewer is forced into an intimate confrontation with the lifeless form of the bird and the echoing bird shape behind, into inescapable speculation on the meaning of life and death.

To get at the underlying reality of the noumenal world that lurks behind phenomena, the world perhaps accessible through the conjectures of a madman, the memories of children, the vision of mystics, dreams, or the probing imagination of artists, Ryder strove to reduce forms to their essences. The natural world was important to Ryder not for its own

sake, but as a point of departure, the available evidence which had to be probed and pondered and made transparent. Ryder spent long hours in silent communion with nature, often walking late at night around New York and nearby New Jersey, soaking up the effects of moonlight on clouds. Images from the natural world were ingested by Ryder, steeped in his subconscious for long periods of time, their details falling away to leave only the essential form, divested of anything accidental or meaningless. This is what reappeared in his paintings—a tree that conveys the essential form of treeness, a boat that is the quintessence of boatiness, clouds that are archetypal clouds encircling the mooniest of moons. Sometimes dark and fuzzy, the forms are solid and irreducible at the core. *Toilers of the Sea* (Metropolitan Museum of Art, New York), exhibited in 1884, is free of all irrelevant detail. Sailboat, sea, clouds and moon are archetypal images. The picture bears a strong compositional similarity to Homer's *Fog Warning* of the following year, which also treats the theme of a fisherman on the open sea returning home at the end of the day. However the two pictures are completely different conceptually. One is detailed and realistic, with the situation clearly stated; the other is obscure, mysterious and dreamlike.

Ryder's own creative symbolism came into play in an extraordinary painting, *The Race Track* of 1895-1910. It was evoked by the suicide of an acquaintance, a waiter in his brother's Brooklyn hotel, who had foolishly plunged all of his life's savings in a wager on a horse race, lost, and committed suicide. Ryder combines the theme of a horse running on a deserted country track with the more profound image of a mounted grim reaper who rides as one of the Horsemen of the Apocalypse. There are prototypes for this kind of apocalyptic vision in American art, notably Benjamin West's *Death on a Pale Horse* (final version, 1817, Pennsylvania Academy of Fine Arts, Philadelphia, Pennsylvania) and Rembrandt Peale's *Court of Death* (1820, The Detroit Institute of Arts, Detroit, Michigan), but these are large pictorial machines very different from Ryder's more personal conception. Although the barren setting of *The Race Track* seems hauntingly familiar, it is more like a dreamscape than a natural landscape. A skeletal tree behind the rider attests to the fruitlessness of this place. The serpent slithering along the ground is a reminder of the temptation that lures man into foolishness. Everything appears an inversion of normalcy, yielding an image of a dreamworld, actually a nightmare world, that lies behind the familiar world of phenomena. It appears to be night, the time of dreams, although the hour is uncertain and Ryder claimed that he never gave any thought as to whether it was day or night in the painting. The tree is leafless, the mounted figure fleshless, the track is deserted, the unearthly horse floats weightlessly above the turf, circling clockwise, against the grain of an American race course. All is inverted in this realm of unpleasant Ideas, this nightmare noumenal world.

Ryder's total production of paintings was limited. He let pictures develop over long periods of time. Painting often on small wooden panels, he laid layer upon layer, often working impatiently on wet surfaces to achieve a sensuous richness of effect. He at times introduced unstable media, such as wax, candlegrease and alcohol, and his uncraftsmanly practices have caused many of his paintings to deteriorate badly. In his late years Ryder became markedly eccentric, and much more of a recluse than Winslow Homer. His apartment in lower Manhattan was filled with debris, through which paths led to his easel, a window, a mat on the floor upon which he slept, a fireplace, with festoons of wallpaper hanging from the ceiling. Ryder's powers fell off in his later years, and he kept reworking a number of earlier paintings to their physical detriment. He was, however, befriended by and influential upon some younger artists, notably Marsden Hartley, who admired his highly personal creations.

Imaginative painting has been a constant companion to the stronger tradition of realism in American art. Indeed during the first half of the nineteenth century, under the pervasive influence of Romanticism, art of the imagination achieved qualitative, if not quantitative, pre-eminence in the works of Allston and Cole. Although Mount, Bingham, Homer and Eakins subsequently reasserted the dominance of Realism, imaginative painting

continued to flourish in the second half of the century in the hands of Ryder, William Page (1811-1885), Elihu Vedder (1836-1923), Thomas W. Dewing (1851-1938), George Fuller (1822-1884), and John La Farge (1835-1910).

One of the most gifted of the imaginative artists in the nineteenth century was the landscape painter George Inness (1825-1894). Born in Newburgh, New York, Inness began to paint in 1842 in the late Hudson River School landscape tradition, instructed briefly by the little known Regis Gignoux (1816-1882), but influenced primarily by Durand and Cole. In 1847 he traveled to England and Italy, and in subsequent years returned to Europe regularly. His artistic development is clearly marked by influences of contemporary European painting, especially the landscapes of the Barbizon School. His early landscapes were quite detailed and naturalistic. Later his scenes became progressively more moody and atmospheric. His brushwork became softer, outlines more fluid, and forms less architectural. In this sense, the pattern of this work follows that of the great French landscapist J. B. C. Corot, whom he admired. After 1875 Inness gained increasing fame and prosperity, particularly through the patronage of the first great collector of American art, T. B. Clarke.

In his late years Inness' style became still more vaporous and unworldly, largely as a result of his increasingly intense religious mysticism and his involvement with Swedenborgianism. In the *Home of the Heron* (1891, Art Institute of Chicago) and *Indian Summer*, painted in the last year of his life, misty forms float rootlessly over a landscape vaguely reminiscent of the natural world, suggesting some sort of transcendent Swedenborgian vision.

George Inness (1825-1894). Indian Summer, 1894. (45¼×30″)
Mr. George M. Curtis Collection, Clinton, Iowa.

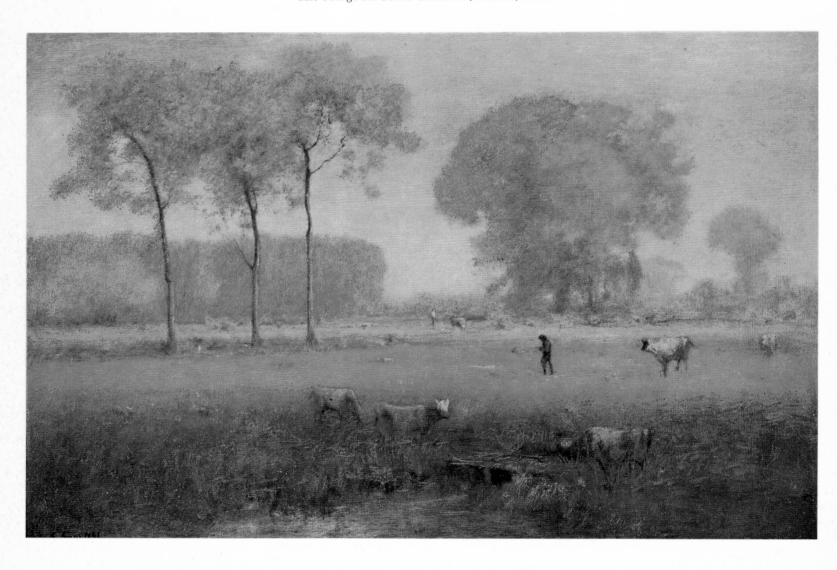

Another artist working in a more imaginative vein was Ralph Albert Blakelock (1847-1919), who has often been understandably but inaccurately linked with Ryder because of stylistic similarities. Although Ryder and Blakelock were exact contemporaries in New York City, they worked quite independently. Born into comfortable circumstances in New York, the son of a physician, Blakelock began to exhibit landscapes at the National Academy of Design in 1867. He was in the West between 1869 and 1872, and his subsequent artistic career was profoundly affected by this experience. Indian life and its landscape setting became his recurrent theme. Subsequently he almost invariably traced an arrowhead outline around the signature on his paintings. Unlike many painters of the American Indian, Blakelock's interest was not anthropological or factual. For Blakelock the Indian was the ancient and natural inhabitant of America; this place belongs authentically to the Indian, and his spirit and the spirit of the land are one. During much of the nineteenth century, after Enlightenment theories about the "Noble Savage" had faded in the face of real experience and national priorities, the Indian was considered a vile threat that had to be annihilated as America expanded westward to fulfil her "Manifest Destiny." But later in the century, rendered harmless, the Indian began once more to be appreciated. Blakelock was in the van of this revised view, along with Bierstadt who suggested the same sort of harmony between the Indian and the western landscape. The process of idealization was carried further in the work of Thomas Moran (1837-1926) and George De Forest Brush (1855-1941) at the end of the century. It became pervasive in the work of such diverse twentieth century artists as Robert Henri, John Marin, Georgia O'Keeffe, Frank Lloyd Wright and an entire school of painters at Taos, New Mexico, all of whom found meaningful American roots in the Indians and their land.

Blakelock, like Ryder, rarely depicted scenes in full daylight, and often painted moonlight scenes. Blakelock's range of themes was much more restricted than Ryder's. He dealt with landscape almost exclusively, drawing little or no inspiration from literature. However he was even more responsive to music. Ryder was inspired more by operatic themes than by the music, whereas Blakelock, a skilled pianist, often improvised on the piano, searching for color compositions and pictorial ideas. This kind of synesthesia, in which sounds suggested pictorial possibilities, was to become an important element in opening the way to pure abstraction in the late nineteenth and early twentieth centuries, from the "Nocturnes" and "Symphonies" of Whistler to the "Synchromies" of Morgan Russell and Stanton Macdonald-Wright.

Like Ryder, Blakelock also had a strongly developed sense of the physical properties of the material with which he worked. He was particularly conscious of the surfaces of his pictures, working them over and scraping them to achieve desired textural effects. Again like Ryder he used unstable materials, mixing varnish and bitumen with his pigments, which has caused his paintings to darken and crinkle over the years.

As is evident in his masterly *Moonlight*, Blakelock was concerned with the decorative treatment of the picture surface and did not share Ryder's preoccupation with the creation of solid irreducible forms. A decorative veil of trees frames an opening in the center of the picture through which the eye proceeds from the warm foreground to the cooler tonalities in the distance.

Blakelock married in 1877, and his family grew rapidly. With nine children eventually to support, he was under increasing pressure to secure income. Prices for his pictures were low, and he began to crank out repetitive images to earn a few dollars. Rebuffed by patrons and ignored by critics, Blakelock began to crack under the strain. It is said that in 1891, with a child about to be born, Blakelock went with a recently completed picture to a patron who had previously bought his work. The man offered Blakelock one half the asking price for the picture, and admonished Blakelock that if he did not accept the offer, it would be lower later on. Blakelock declined, was then unable to sell the picture elsewhere, and ultimately returned to the original patron and was forced to accept the lower price for the picture. Shortly afterward, Blakelock was found wandering in the streets tearing up one

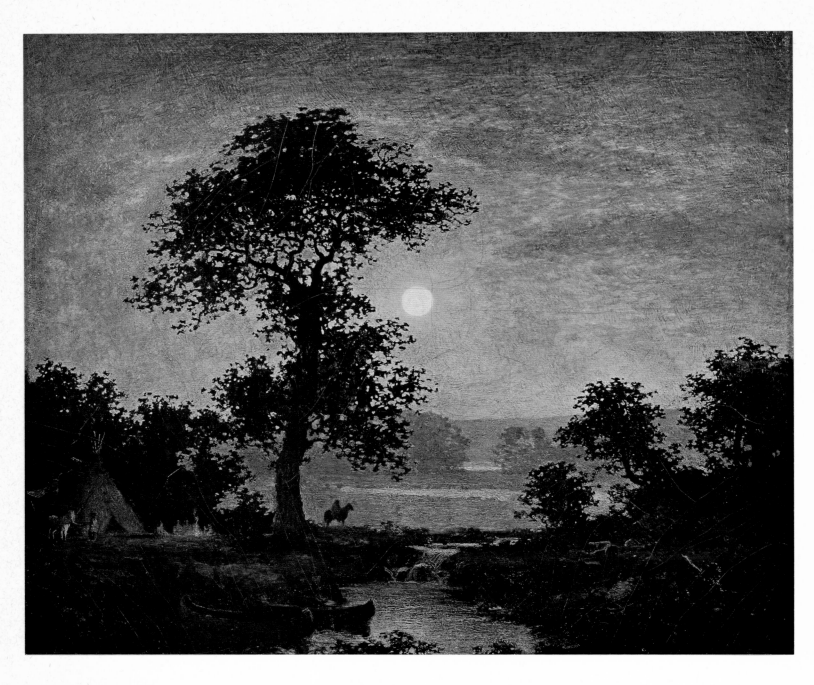

Ralph Albert Blakelock (1847-1919). Moonlight, about 1885. (27¼×32¼″)
The Brooklyn Museum, Brooklyn, New York.

hundred dollar bills. He was temporarily placed in an asylum. After his release he became increasingly eccentric, affecting Indian dress of sashes, beads and richly embroidered belts, along with long hair and beard. When he was incarcerated permanently in 1899 he had delusions of great wealth. Indeed prices for his paintings did rise sharply thereafter, but no benefit accrued to him or to his family. In 1912 *Moonlight*, which Blakelock was originally going to sell for $50 but for which an artist friend had gotten $600, changed hands for $13,900, the highest price paid up to that time for the work of a living American artist. As prices rose, Blakelock's paintings, like those of Ryder, were extensively forged, and the problem of Blakelock attributions has been a serious one for subsequent scholars.

Several specialized categories of nineteenth century painting stand outside of the mainstream of American art, and yet are important constituent parts of the total artistic enterprise in America. A few of these special categories, for instance folk art and the work of artist-naturalists, have already been discussed. Another discrete realm of American nine-

teenth century painting, shaped, indeed created, by the taste for realism, is *trompe l'œil* painting. An interest in hyper-realism, in paintings so real that they deceive the viewer into confusing painted reality with actual reality, has already been noted in connection with Copley's American portraits and Charles Willson Peale's *Staircase Group*. *Trompe l'œil* painting flourished in America during the nineteenth century, especially in Philadelphia, in a tradition shaped and furthered by the Peale family. Charles Willson Peale's son, Raphaelle Peale (1774-1825), was a master of *trompe l'œil* painting, and indeed one of the best of all American still life painters.

Apparently Raphaelle Peale had a termagant wife who kept poking around his studio. In a delightful attempt to teach his wife a lesson, and to keep her out of his studio, Peale painted the amusing and extraordinarily effective *After the Bath* of 1823. One can almost imagine Peale's wife entering his studio in his absence to find unframed on the easel a canvas apparently representing a nude drying her hair after bathing. A linen cloth hanging from a tape over the surface of the picture concealed everything but a partial view of arm and hair above and a foot poking out below. Her suspicions confirmed, did she attempt to snatch the towel off, only to find that it was all a painted illusion, linen, tape and all? Yes or no, it is a wonderful story and an effective painting.

The greatest master of American *trompe l'œil* painting was William M. Harnett (1848-1892). However a number of other extremely gifted *trompe l'œil* painters also worked during the latter part of the nineteenth century, notably John F. Peto (1854-1907) and John Haberle (1856-1933). Harnett's *Faithful Colt* of 1890, like Peale's *After the Bath*, is a superlatively beautiful as well as effectively deceptive painting. With extraordinary skill the artist has caught the exact appearance of the hammered, rust-flecked barrel of the gun contrasting with the more finely grained brass of the trigger guard and the cracked ivory handle. The painted vertical planks in the background are splintered, and beneath rusty nails and nailholes washes of rust stain drift down. A clipping pasted to the wall in the lower right undulates ever so slightly, and the viewer can hardly resist the temptation to pull it off by a curling corner. Unable to sign his name in a normal fashion on the picture surface without destroying the integrity of the image, Harnett inscribed it in the lower left so that his name and the date appear to have been carved into the surface of the plank with a penknife. Harnett's realistic depiction of things is not unrelated to Eakins' probing representations of people, places and events, similarly produced in Philadelphia at about the same time.

In addition to the dazzling competence of the technique, Harnett also achieved a perfect balance of pictorial parts in the sharply limited space, so that the abstract quality of the design is extraordinarily effective. In tribute to Harnett's remarkable ability and popularity, his work was not only imitated but industrious attempts were made to pass off as original Harnetts the work of other artists. Obviously technical requirements ruled out crude imitations. Some years ago the scholar Alfred Frankenstein noted that signed Harnett paintings tended to fall into two quite disparate categories: those painted in a "hard" style such as the *Faithful Colt* in which the forms are crisp, textures are clearly differentiated, details are recreated with microscopic accuracy, the image has a strong tactile appeal, space is severely limited, objects occasionally project into the spectator's space, and a clear spatial relationship of the parts obtains; all in contrast to a "soft" style in which all of these characteristics except limited depth are reversed, and in which textures are homogeneous and soft, colors strong, and light-dark contrasts more marked. These paintings have a moodier and more sentimental quality, showing objects evocative of human use and associations, such as a pile of old books, called *Discarded Treasures* (Smith College Museum of Art, Northampton, Massachusetts), or a littered desk entitled *After Night's Study* (Detroit Institute of Arts, Detroit, Michigan). Frankenstein's investigations revealed that the "hard" style was Harnett's own, but that the "soft" pictures were works by Peto to which Harnett's signature had been added.

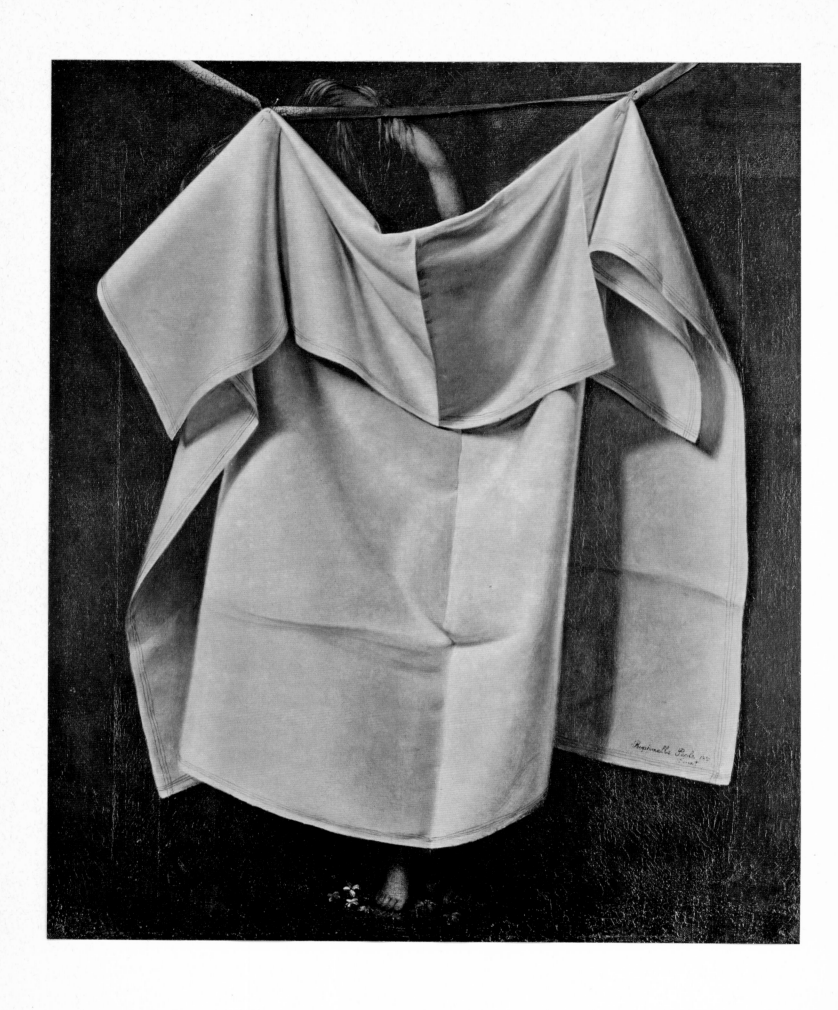

Raphaelle Peale (1774-1825). After the Bath, 1823. (29×24″)
Nelson Gallery-Atkins Museum (Nelson Fund), Kansas City, Missouri.

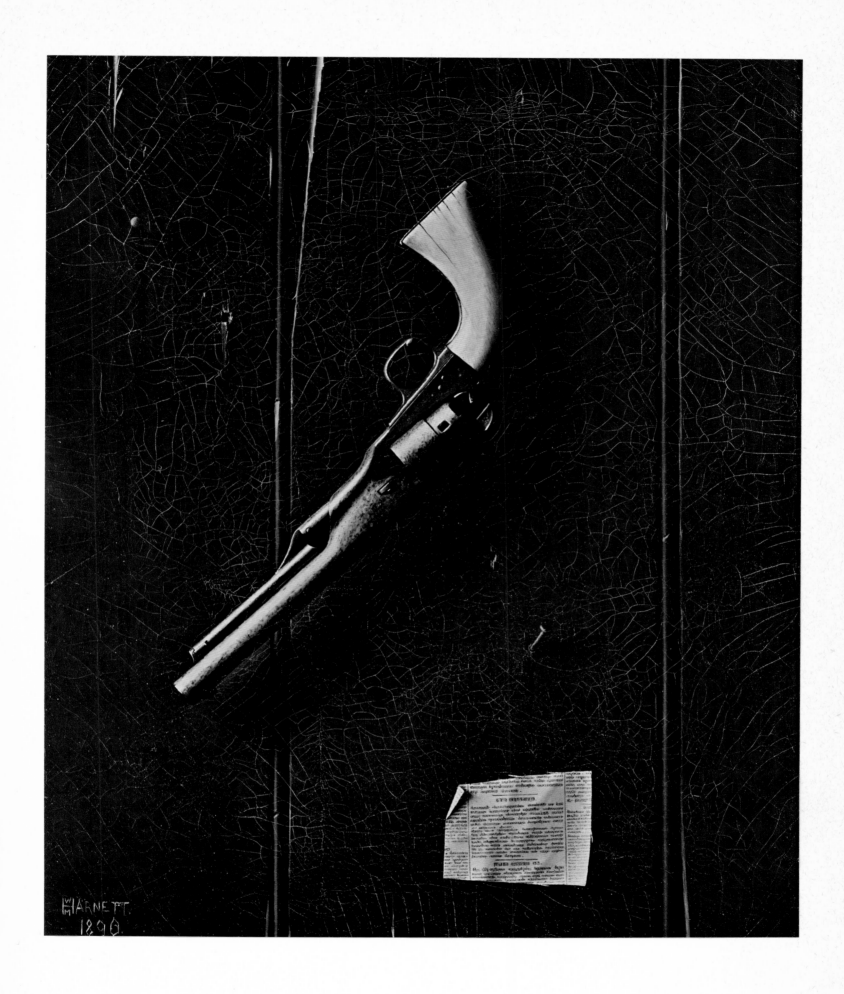

William M. Harnett (1848-1892). The Faithful Colt, 1890. (22½×19″)
Wadsworth Atheneum, Hartford, Connecticut. The Ella Gallup Sumner and Mary Catlin Sumner Collection.

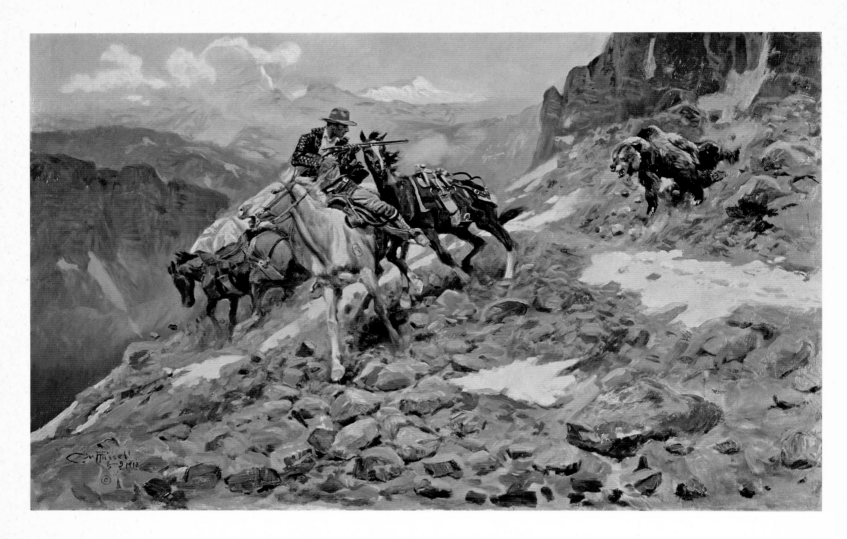

Charles Marion Russell (1864-1926). Crippled But Still Coming, 1913. (30×48″)
Amon Carter Museum of Western Art, Fort Worth, Texas.

Another special and definable classification, already briefly considered in the work of Bierstadt and Blakelock, is the art of the West. In the nineteenth century, as westward expansion of the United States compressed the Indians into limited land areas, it became increasingly apparent that their way of life, indeed perhaps their very existence, was doomed to extinction. After the Louisiana Purchase of 1803, and the Lewis and Clark Expedition the following year, which opened up the still largely unexplored territories between the Missouri River and the Pacific coast, ever-increasing numbers of Americans moved westward. Expeditions not infrequently included artists among their complement, and their pictorial records are often of extraordinary historic interest, even when low in artistic quality.

The first artist of real stature to go West was George Catlin (1796-1872). Born in Wilkes-Barre, Pennsylvania, he was educated as a lawyer and for several years practiced in Philadelphia. A self-taught artist, he painted at first only as an amateur, but by the time he was thirty he had established himself as a successful portrait painter and gave up the law. Sensing that the Indian was doomed, Catlin took it as his purpose "to rescue from oblivion the looks and customs of the vanishing races of the native man in America."

During the early 1830's Catlin traveled all over the West, often alone on horseback and by canoe, penetrating into unmapped territories and visiting forty-eight tribes. Living with them, acquiring their languages, familiarizing himself with their customs and way of life (which, as he foresaw, were on the verge of extinction), he made many portraits of Indians, such as the superb *The White Cloud, Head Chief of the Iowas*, and countless sketches of Indian life. Subsequently he exhibited his collection of Indian paintings and paraphernalia

in the cities along the east coast of America, and in the 1840's took the exhibition to London and Paris, lecturing on Indians and championing their cause. Several of his Indian portraits were shown at the Paris Salon of 1846, where they were seen by Charles Baudelaire, the most discerning art critic of the day, who commented on them admiringly: "Catlin has rendered superlatively well the proud free character and noble expression of these splendid fellows; the structure of their heads has been thoroughly understood. With their fine attitudes and easy movements, these savages make antique sculpture comprehensible. As for the coloring, there is something mysterious about it that delights me more than I can say." The bulk of Catlin's great collection of Indian pictures is now preserved in the Smithsonian Institution and the National Gallery of Art in Washington.

The greatest of all western artists, and indeed the most valuable visual source for the history of the West, despite his late appearance on the scene was Frederic Remington (1861-1909). Extraordinarily accurate in his depictions, and uniting a genuine artistic talent with deep understanding of his subject, Remington produced over 3000 pictures that, more than the work of any other artist, shape our memory of the Golden West. *A Dash for Timber* of 1899 is an extraordinary example of the vitality of his art, reflecting something of Eakins' concern with reality, but overlaid with a sense of excitement and energy that Eakins intentionally filtered out of his static and synthetic images. Indeed many of the western artists themselves were vigorous outdoor types who lived what they painted. The archetype of the artist-cowboy was Charles Marion ("Charlie") Russell (1864-1926) of Montana. Lured to the far west from his boyhood home in St. Louis by the romantic appeal of a life of high adventure and freedom from the restraints of civilization, the doughty and colorful Russell made his way first by punching cattle and then increasingly by painting pictures such as *Crippled But Still Coming* of 1913. Actually, with few exceptions, the art of the West falls

Frederic Remington (1861-1900). A Dash for Timber, 1899. (48¾×84⅜″)
Amon Carter Museum of Western Art, Fort Worth, Texas.

George Catlin (1796-1872). The White Cloud, Head Chief of the Iowas. (27¾×22¾")
National Gallery of Art, Washington, D.C. Paul Mellon Collection.

into the broader category of American realist painting, and the overriding concern of most artists of the West with accuracy in the depiction of Indians and Indian life is a manifestation of the deeply rooted American predilection for realism. This new realism of immediacy and motion combined with the Philadelphia tradition of realism reaching from the Peales to Harnett and Eakins to inspire what came to be called the "Ashcan School," a group of artists who aggressively projected the tradition of realism in American art into the twentieth century, expanding the thematic limits of their art to encompass the immediate feel of contemporary American life. However other American artists working abroad were simultaneously pursuing very different ends, concerning themselves more with the formal properties of art itself than with its relevance to real life. The ultimate confrontation between these opposed concepts of art was to become the lead story in the history of American art during the twentieth century.

James Abbott McNeill Whistler (1834-1903). Nocturne in Black and Gold: The Falling Rocket, about 1874. (23¾×18⅜″)
The Detroit Institute of Arts, Detroit, Michigan.

From Art for the Sake of Art to the Ashcan School

I HAVE seen, and heard, much of Cockney impudence before now; but never expected to hear a coxcomb ask two hundred guineas for flinging a pot of paint in the public's face," wrote John Ruskin about James A. McNeill Whistler (1834-1903) and his *Nocturne in Black and Gold: The Falling Rocket* when the picture was exhibited in 1877 in London at the Grosvenor Gallery. The peppery Whistler, not one to take such an assault lying down, sued for libel. In the trial that followed, Whistler explained his artistic aims and his choice of the descriptive term "Nocturne," by which he intended "to indicate an artistic interest alone in my work, divesting the picture from any outside sort of interest which might have otherwise attached to it. It is an arrangement of line, form and color first, and I make use of any incident of it which shall bring about a symmetrical result." Whistler, following Théophile Gautier's esthetic theory of *l'art pour l'art*, felt that an art object should exist for its own sake, apart from outside relationships, and should be judged a success or a failure only in terms of its internal esthetic requirements.

A century earlier Benjamin West had come to Europe and stepped into the vanguard of a revolutionary artistic movement, one concerned with man and society, and in his early paintings had anticipated French Neo-classicism by several decades. Now Whistler, another American with sensitive artistic antennae, was among the first to grasp the revolutionary implications of *l'art pour l'art*. Through his work, his philosophy of art, and indeed his eccentric life style, Whistler led the way toward modernism in art, asserting the independence of the artist and helping to establish the theoretical basis for abstract art, the most revolutionary and dynamic stylistic innovation since the development of linear perspective.

Whistler was born in Lowell, Massachusetts. Between the ages of nine and fifteen young Whistler was in Russia, where his father was consulting engineer on the railroad being built between St. Petersburg and Moscow. On the death of his father, the family returned to America where Whistler attended Pomfret Academy in Connecticut and the United States Military Academy at West Point. He compiled an unimpressive record at West Point, and was finally expelled in 1854 for "a deficiency in chemistry." Whistler then worked briefly for the government on a coastal survey, preparing drawings of the coastline and learning the craft of etching.

In 1855 Whistler went to Paris, where he enrolled in the studio of Charles Gabriel Gleyre and enthusiastically launched upon a bohemian existence which undoubtedly suited his temperament much better than the rigors of military life at West Point. In 1858-1859 he

produced several superb sets of etchings of river scenes done along the Rhine and the Thames. Whistler soon treated the same themes in paintings such as *Wapping on Thames* (1861-1864, Mr. and Mrs. John Hay Whitney, New York, New York) and *The Last of Old Westminster* (1862, Museum of Fine Arts, Boston, Massachusetts). Influenced by his friend Courbet, Whistler began as an objective realist, recording the aspect and character of river life with heavy brushwork and a warm palette. In 1861 he painted *The Coast of Brittany* (Wadsworth Atheneum, Hartford, Connecticut), exhibited at the Royal Academy the following year under the title *Alone with the Tide*. The first of his major paintings of the sea, this work transcends simple realism in its emphasis on the formal juxtaposition of warm foreground tonalities of sand and rock against the cool blue of ocean and sky beyond. Whistler's drift toward more purely formal concerns is suggested in *Wapping*, as the head of his red-haired mistress Joanna Heffernan, his oft-painted Jo, re-worked as the painting progressed, reveals an abstract concern with form and color that contrasts with the realism of the other figures and the detailed background.

Jo was the model for Whistler's famous, indeed notorious, *The White Girl* (National Gallery of Art, Washington, D. C.) of 1862. A decade later, when Whistler adopted the musical terminology (Symphonies, Nocturnes, Arrangements) suggested by Baudelaire and others as better suited to his ideas of an abstract esthetic, the painting was re-titled *Symphony in White, No. 1. The White Girl* was rejected by the Royal Academy in 1862, and by the Salon in Paris the following year. Whistler therefore exhibited it at the Salon des Refusés, where it was a center of attraction along with Manet's *Déjeuner sur l'Herbe*. The daring placement of an all-white dress against a white drapery background which emphasized subtle textural modulations, the dramatic red splash of Jo's hair in a sea of white, and the tantalizing themelessness which provoked endless speculation about the "meaning" of the picture, all served and reflected Whistler's increasing preoccupation with the formal aspects of picture-making. This interest was advanced by his exposure to Japanese art. He became an active early collector of blue and white porcelain, and an admirer of Japanese color prints. Such works as *Rose and Silver: "La Princesse du Pays de la Porcelaine"* of 1864 (Freer Gallery of Art, Washington, D. C.), *Purple and Rose: The Lange Lijzen of the Six Marks* (Philadelphia Museum of Art, Philadelphia, Pennsylvania) of the same year, and the fragile *The Artist's Studio* of about 1867-1868 (Art Institute of Chicago, Chicago, Illinois) are notable among many pictures reflecting oriental attitudes toward line, perspective, subtle color relationships, and surface patterning, as well as actually introducing eastern dress. Whistler increasingly conceived of each work as a decorative entity. He designed his own molded gilt picture frames, and devised a butterfly monogram which he carefully placed on the canvas like a colophon on a Chinese or Japanese scroll, a positive element in the design.

Whistler painted his famous *Arrangement in Gray and Black No. 1: The Artist's Mother* (Louvre, Paris) in 1871. It was exhibited reluctantly the next year by the Royal Academy (Whistler never again exhibited at the Academy, and never became an Academician) and a year later at the Paris Salon. The portrait integrates the subject into a precise pattern of lines and muted color areas, devoid of any emotional involvement or sense of personality. Whistler's mother (who was something of a shrew) becomes an object among objects. The result may be impersonal, but it is a stunning picture. The painting was followed immediately by *Arrangement in Gray and Black No. 2: Thomas Carlyle* painted in 1872-1873. The famous Scottish author, philosopher, essayist and historian, who liked Whistler's portrait of his mother, is also dressed in black and silhouetted in profile against a gray background. His face, the single strong patch of color, is balanced by the rectangular shapes of pictures on the wall to the left, while Whistler's butterfly monogram perfectly completes the composition along the right edge. In addition to Whistler's almost oriental sense of design, the picture also reveals the influence of Velasquez in the restrained and harmonious color relationships. This painting, purchased by the Glasgow Corporation in 1891, was the first work by Whistler to be acquired for a public collection; immediately afterward the portrait of *The Artist's Mother* was purchased by the French government for the Luxembourg.

James Abbott McNeill Whistler (1834-1903).
Arrangement in Gray and Black No. 2: Thomas Carlyle, 1872-1873. (67⅜×56½")
Glasgow Art Gallery and Museum, Glasgow, Scotland.

Thomas Eakins (1844-1916). The Thinker (Louis N. Kenton), 1900. (82×42″)
The Metropolitan Museum of Art, New York. Kennedy Fund, 1917.

James Abbott McNeill Whistler (1834-1903). Arrangement in Flesh Color and Black:
Portrait of Théodore Duret, 1883. (76⅛×35¾″) The Metropolitan Museum of Art, New York. Wolfe Fund, 1913.

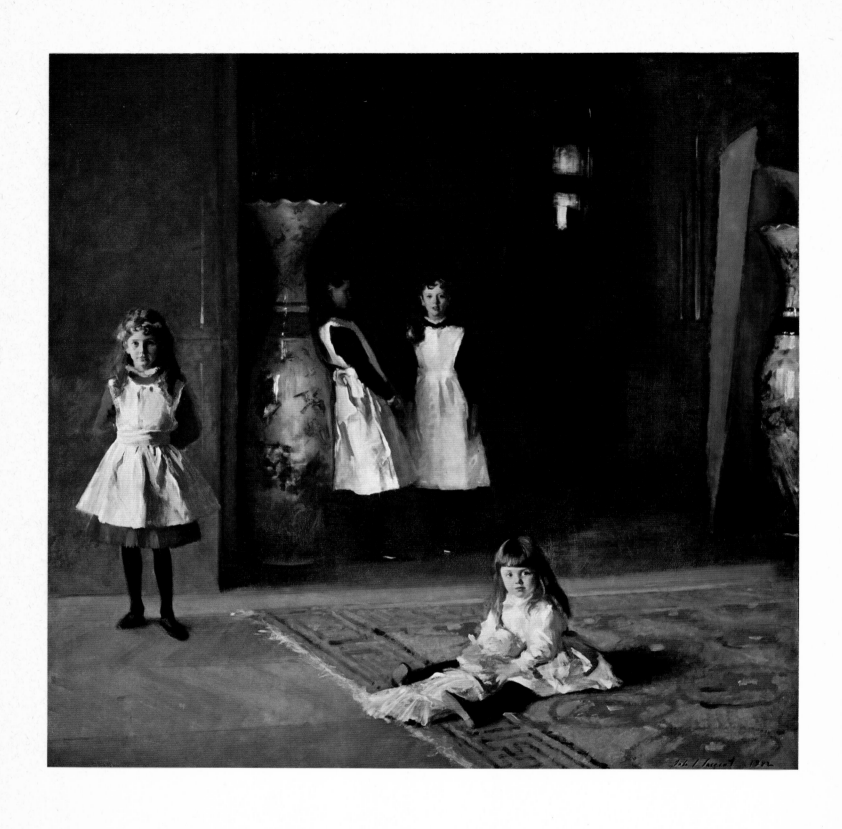

John Singer Sargent (1856-1925).

The Daughters of Edward Darley Boit, 1882. (87⅝×87⅝″) Courtesy, Museum of Fine Arts, Boston, Massachusetts.

Gift of the daughters of Edward D. Boit in memory of their father.

The uproar that greeted Whistler's nearly abstract *Nocturne in Black and Gold: The Falling Rocket* occurred at almost the same moment as the similarly outraged, but differently motivated, reaction to Eakins' realistic *Gross Clinic* in Philadelphia. Though their esthetic positions are almost diametrically opposed, Eakins and Whistler have much in common. Both were Americans, had studied in Paris, admired Courbet, and were affected by the art theories of the influential Lecoq de Boisbaudran. A comparison of Whistler's portrait of *Théodore Duret* (1882-1884) with Eakins' portrait of his brother-in-law Louis Kenton, *The Thinker* (1900), clearly shows that both were also influenced by the full-length portraits of Velasquez. Yet at the same time these two paintings and these two artists epitomize those two opposed views of art which have informed the development of modern American art.

Eakins' *Thinker* stands squarely in the American tradition of realism. Eakins is committed to reality, to the pictorial reconstruction of the real world. The subject, Kenton, is a solid mass in space modeled by light, a substantial reality that casts deep shadows. He stands in front of a wall that slants away from the picture surface to define a spatial ambient rather than to provide an abstract background. Eakins is interested in line, color, light, and other formal qualities, but not for their own sake. He does not pursue their perfection as an end, but uses them as means to achieve other pictorial goals. Yet his aim is more than the creation of an illusion of visual reality; it is more than the invocation of a mastery of anatomy to achieve an accurate and convincing impression of the physical existence of the weighty, slumping figure. Eakins has painted a man, a human being. The subject has a body, and that body contains a mind that thinks, contemplates, reflects, remembers. He has existed through time, has been weathered by experience. Eakins is more interested in this man than in art; at any rate his primary interest is not in art for its own sake but for its relevance to man and his existence.

Whistler, in his portrait of *Théodore Duret*, is more interested in the picture than in the man. He is intensely involved with the formal possibilities established by the subject; the esthetic disposition of the pattern of lights and darks, the flow of line, the exquisite harmonies of varying shades of black and halating pinks. The painting is to be judged on its internal pictorial merits, not on the fidelity of its relationship to visual reality. It is no accident that Whistler signed his picture with a butterfly monogram that floats on the surface as part of the decorative pattern, abstracting the presence of the artist into a symbol, whereas Eakins placed his actual name and the date in the lower right, tipping the signature backward through the use of perspective drawing to make it a real fact in the pictorial space. Whistler is primarily concerned with art, Eakins with reality. However just as Eakins was obviously not uninterested in the formal aspects of art, so Whistler was not uncaring about his subjects. It was simply a matter of emphasis. Duret, an art critic and early supporter of the Impressionists, and an oriental art scholar, had in fact been a close friend of Whistler's since the early 1860's, and in 1883 wrote one of the most important early biographies of the artist.

The final result of the Ruskin trial was exoneration for Whistler, who was awarded a farthing in symbolic damages, but it was a pyrrhic victory. The financial strain induced by the costs of the trial forced Whistler into bankruptcy the following year. Neither his art nor his personal fortunes ever returned to their previous heights.

Aristocratic, cultured and urbane, John Singer Sargent (1856-1924) typifies Henry James' image of the American expatriate. Whereas Whistler, born and educated in the United States, never returned to his native land, Sargent, who was born in Florence, Italy, to American parents, became increasingly involved with America in his later years. Sargent first visited the United States in 1876 at the age of twenty, having studied art briefly in Rome, and in the Paris studio of Carolus Duran. His reverse grand tour lasted for four months, and included a visit to the Centennial Exhibition in Philadelphia. On his return to Paris, Sargent began to exhibit at the Salon. During the next few years he traveled

extensively through Spain, Holland and North Africa. Like Eakins he particularly admired Hals and Velasquez, and emulated their free brushwork. His earlier works, pervaded by a characteristic pearly tonality, reveal an almost impressionistic concern with atmosphere and light. The influence of Velasquez and Spain is evident in his dramatic *El Jaleo* of 1880 (Isabella Stewart Gardner Museum, Boston, Massachusetts). A row of musicians and dancers is theatrically lit, the shadowy guitarists silhouetted against a light background and a highlighted dancer against a dark setting. The figures, and the guitars hanging on the wall, are clustered like notes in a bar of music, enhancing the visual impression of music being performed. In their staccato pairings they are evocative of the flamenco rhythm, which culminates in a "bang" as the dancer slams her foot down on the floor. Subsequently the composition, in contrast to the coloristic restraint and severely ordered tempo to the left of the dancer, resolves itself into a discharge of color in the costumes of the figures at the right. Sargent was himself an accomplished pianist, and his interest in music informed certain aspects of his art, although in a more objective way than Whistler's creation of musical equivalents or Blakelock's groping on the piano keyboard for compositional inspiration.

Sargent's superb group portrait of the *Daughters of Edward Darley Boit* of 1882, exhibited at the Paris Salon the following year, is similar to *El Jaleo* in its calculated groupings and the strong value contrasts induced by the flow of light from the left creating dramatic highlights and deep pools of shadow. The color is also similarly restrained, except for the dramatic orange-red slash of the screen at the right. The careful patterning of the

Mary Cassatt (1845-1926). Little Girl in a Blue Armchair, 1878. (35×51″)
From the Collection of Mr. and Mrs. Paul Mellon, Washington, D.C.

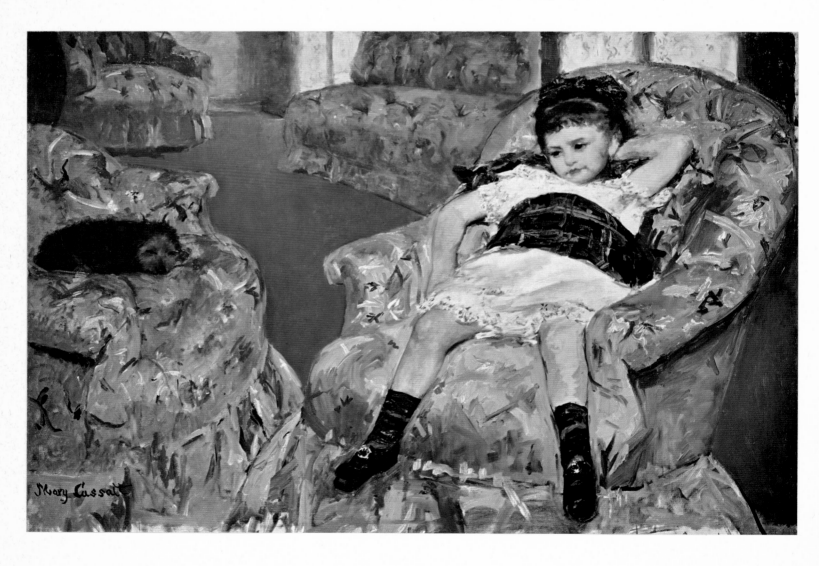

picture surface is reminiscent of Whistler's response to Japanese prints, while the enormous blue and white Chinese vases are like wildly exaggerated Whistlerian motifs. This intimate informal view of the daughters of an artist friend gathered in the dark hallway of their Paris apartment, retrieved from the passing current of time, conveys a sense of individuals within the surroundings in which they live their lives that is more satisfying and effective in its totality than an exact delineation of each individual would be.

In 1884 Sargent exhibited his daring and controversial full-length portrait of Madame Gautreau, the painting known as Madame X (Metropolitan Museum of Art, New York, New York), at the Paris Salon. The painting is an inverse silhouette. A blast of light isolates the curving contour of the figure and the outline of the face against the background, but erases facial detail and any sense of character or personality. The picture drew biting criticism, not least of all from the sitter and her family, in part for its handling and in part for the revealing décolletage. The attack provided one of the reasons for Sargent's subsequent remove to London, where he felt his work would be more sympathetically treated.

Sargent exhibited the *Boit Children* and *El Jaleo* in Boston in 1888. His work was well received, and a few years later he was commissioned to paint murals dealing with the evolution of religion for the Boston Public Library. Later he received commissions for murals for the Boston Museum of Fine Arts and Widener Library at Harvard. During the latter decades of his life Sargent also worked increasingly with watercolor, a medium well-suited to his extraordinary technical ability. His achievements in that medium place him with Winslow Homer, Maurice Prendergast and John Marin in the top rank of American watercolorists. Despite his achievements as a muralist and watercolorist, Sargent is primarily remembered for his portraiture, particularly those overblown Edwardian full-lengths which allowed an ample arena for his extraordinary manipulative facility with the brush. Sargent's reputation suffers to some extent from that very facility which has obscured the fact that many of his portraits reflect an awareness of human personality that, if not as probing as Eakins, goes well beyond the mere surface replication of appearances. And more profound images, such as the memorable *Gassed* (London War Museum, London), perhaps the most striking picture to come out of World War I, suggest the achievement of which Sargent was capable but only infrequently attained.

The third member of what may be conveniently considered as the expatriate triumvirate (as opposed to a native trinity of Homer, Eakins and Ryder) was Mary Cassatt (1845-1926). The most significant American female artist prior to the twentieth century, Mary Cassatt was born near Pittsburgh, Pennsylvania. Much of her childhood was spent abroad, but she received some early art training at the Pennsylvania Academy of Fine Arts in Philadelphia in 1864-1865, where she may well have been a fellow student of young Eakins. She later studied in Paris and in Parma at the academy of Carlo Raimondi, and traveled extensively throughout Spain and the Low Countries. Like so many artists in the second half of the nineteenth century, she was influenced by Hals and the great Spanish seventeenth century masters, and her early work reflects this in its dark colors and fluid brushwork. A friend of Degas, she began to exhibit with the Impressionists in the late 1870's. Under the influence of the Impressionists, her palette lightened, but her color remained assertive, and she relied heavily on texture and modeling for her effects. *Woman and Child Driving* of 1881 (Philadelphia Museum of Art, Philadelphia, Pennsylvania), depicting her sister Lydia and Degas' niece in a carriage, is clearly influenced by Degas both in subject and the arbitrary composition. When Eakins painted his contemporaneous and thematically similar *Fairman Rogers' Four-in-Hand*, he strove to attain an anatomically correct disposition of limbs in representing animal locomotion, and requested that the carriage be driven past him again and again in order to study the subject. Mary Cassatt, by contrast, devoted her attention to the design of the picture, caring little for anatomy or locomotion. Indeed, like Degas, she does not hesitate arbitrarily to trim off parts of the horse and carriage in order to achieve an effective composition.

The Little Girl in a Blue Armchair of 1878 reflects the same dominance of pictorial concern. The viewer's forcibly depressed line of vision eliminates the ceiling and much of the far wall, while the floor slopes up and almost reaches the upper framing edge of the picture. The windows and upholstered chairs are arbitrarily cut by the frame to form pleasing new shapes. The curving recession of the chairs diagonally to the left and the compressed space echo an arrangement familiar from Degas' ballet interiors. The picture is coloristically firm, and a variety of textured patterns enliven the surface. The painting seems to combine Degas' sense of space and composition, Renoir's color and Manet's assertive forms into an effective synthesis that marks Mary Cassatt's early style at its best.

During the 1880's Cassatt's style did not change markedly. However in 1890 she went with Degas to see the great exhibition of Japanese prints in Paris, which profoundly influenced her subsequent work. The following year she produced a set of ten colored prints in dry-point and aquatint, very Japanese in their sense of line and the careful arrangement of flat color areas, that are among the most beautiful works of graphic art ever produced by an American artist. The theme of mother and child began to dominate her work after 1890. One of her most effective paintings on the maternal theme is *The Bath* (c. 1891, Art Institute of Chicago, Chicago, Illinois), in which the figures are viewed sharply from above, creating an unexpected disposition of color areas on the picture surface that is extraordinarily Japanese in character. Less subtle, but more dramatic coloristically, is *The Boating Party* (National Gallery of Art, Washington, D. C.) in which, apparently under the influence of the Post-Impressionists, notably Gauguin, Cassatt divides the surface into broad flat areas of brilliant primary blue and yellow. The arbitrary viewpoint again raises the horizon line to

William Merritt Chase (1849-1916). In the Studio, about 1880 (?). (28½×40¼″)
The Brooklyn Museum, Brooklyn, New York. Gift of Mrs. C.H. DeSilver.

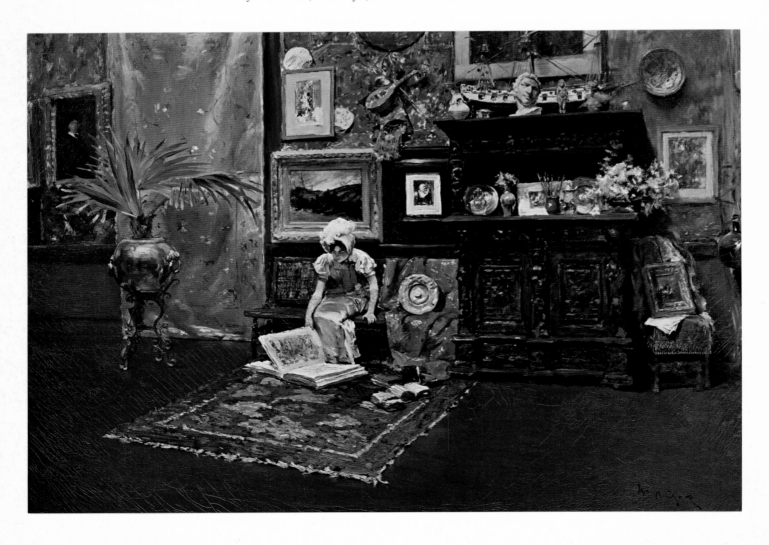

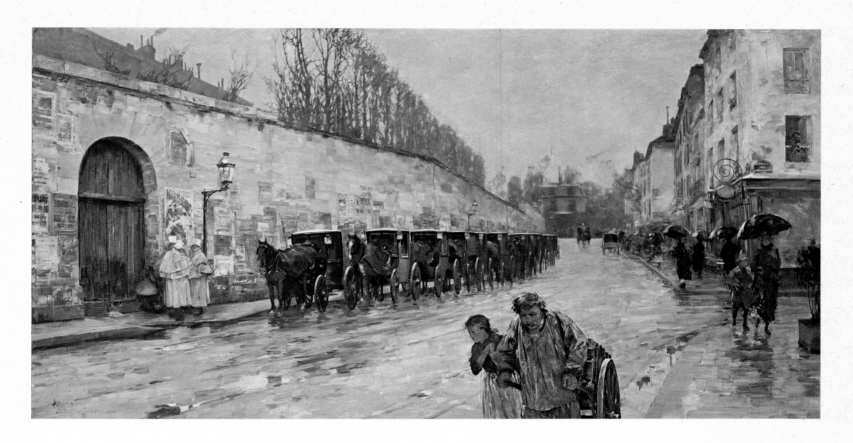

Childe Hassam (1859-1935). Rainy Day, Rue Bonaparte, Paris, 1887. (40¼×77¼")
Harry Spiro Collection, New York.

the top of the canvas, resulting in an inescapable emphasis upon the design. The maternal theme is present, although overwhelmed by the striking visual context. The relentless emphasis upon its formal aspects removes this picture a substantial distance from such antecedents as Mount's *Eel Spearing at Setauket* or Homer's *Fog Warning*.

Another American artist who enjoyed a direct link with a major French Impressionist was Theodore Robinson (1852-1896), who knew and worked with Claude Monet briefly at Giverny. However Robinson was not robust, and died prematurely without exerting much impact on American painting. Much more active and influential in transmitting aspects of Impressionist painting to America was William Merritt Chase (1849-1916) who, after his initial training in Munich, abandoned the dark palette of that school for the brighter colors of French Impressionism, which he applied, as in his impressive *In the Studio*, with facile brushstrokes in the manner of John Singer Sargent. An influential teacher after his return to America, Chase communicated a largely derivative emphasis on technical facility and rapid brushwork to many budding American artists.

A more distinctively American brand of Impressionism did develop, however, which occasionally led to remarkable, still under-appreciated, pictorial achievements. One of the best known, although not the most original, of the American Impressionists was Childe Hassam (1859-1935). Hassam was raised in the vicinity of Boston, and began his career with a number of remarkable scenes of city streets infused with moody atmospheric effects of rain, snow or twilight revealing Hassam's roots in the tradition of American Luminism. When he went to Paris in 1886, Hassam became aware of the innovations of the French Impressionists, especially Monet, Pissarro and Sisley. His large canvas of 1887, *Une Averse, La Rue Bonaparte*, marks the moment when the sensitivity to place and atmosphere that characterized his earlier American work was first informed by an Impressionist sense of color to produce an especially happy result.

John H. Twachtman (1853-1902). The White Bridge. (30¼×20¼″)
The Minneapolis Institute of Arts, Minneapolis, Minnesota. Martin B. Koon Memorial Collection.

Hassam's early city scenes almost invariably contain, as here, a deep perspective thrust into pictorial space, reminiscent of major paintings by Bingham or early Homer. However an important characteristic of American Impressionism is the replacement of this spatial concern by a commitment to the picture surface. Although American Impressionism derived from French Impressionism, it developed considerably later and was therefore also affected by Post-Impressionism, Art Nouveau, and eventually Neo-Impressionism. By virtue of its unrelieved concern with the decorative quality of the picture surface and its muted and restrained palette, American Impressionism is immediately recognizable as something different and distinct from its French counterpart.

A case in point is John H. Twachtman's *The White Bridge*. Twachtman (1853-1902) was one of the most gifted and sensitive American Impressionists, still not adequately esteemed in his own country. With rare exceptions, such as the sensitive and perceptive collector Duncan Phillips who acquired and hung paintings by Twachtman in the company of major French Impressionist works, few recognized the validity and importance of Twachtman's accomplishment. The true nature of his subtle art was perceptively described by Edgar P. Richardson who noted that it was more akin to French Impressionist music than painting. Twachtman disposes pools of color on the picture surface in writhing irregular shapes, and weaves a delicate tracery of lines into an "all-over" surface pattern that anticipates mid-twentieth century abstract art.

A group of American artists who can more or less be classified as Impressionists exhibited together in 1895 as the Ten American Painters. Hassam and Twachtman belonged to The Ten, as did J. Alden Weir (1852-1919). Weir came from a distinguished family of American painters. His father, Robert W. Weir (1803-1889), was professor of drawing at West Point (where he taught Whistler) for many years, and his brother, John Ferguson Weir, was a successful artist and the first director of the Yale School of Fine Arts. J. Alden Weir's brand of Impressionism was slightly bolder than Twachtman's, but embodied the same primary orientation toward overall decorative treatment of the picture surface. His

J. Alden Weir (1852-1919). The Red Bridge. (24¼×33¾")
The Metropolitan Museum of Art, New York. Gift of Mrs. John A. Rutherford, 1914.

Maurice Prendergast (1859-1924). Ponte della Paglia, Venice, 1899. (28×23″)

The Phillips Collection, Washington, D.C.

painting *The Red Bridge*, with its subtle and effective use of color, stands as one of the high points of American Impressionism. The flanking foreground trees, recalling a standard landscape device, are used here not so much to frame the composition as to complete the design with their sinuous movement.

For more than a century, from the time of Whistler to the present, a rapid succession of artistic developments have been powered by the liberating concept that an art object exists for the sake of art. Indeed, it is difficult to determine on other than strictly chronological grounds where to draw the line between nineteenth and twentieth century art. But if one had to find that moment in the history of American art, it might well occur in the work of Maurice Prendergast. Prendergast's *Ponte della Paglia* of 1899 combines the commitment to the picture surface that informs the work of American Impressionists with a more highly developed interest in pure color. Prendergast, whose delight in blobs of color manifested itself in a fascination with balloons, parasols and banners, shared that immersion in problems of color and color theory that marked the growth of western art during the last decade of the nineteenth century and the first two decades of the twentieth. Influenced by Vuillard and such arcane sources as Persian miniatures, Prendergast returned time and again, especially in his late oils, to the bold textural and coloristic surface effects found in the early *Ponte della Paglia*. As is evident in his *Central Park* of 1901, he was also one of the most gifted of all American watercolorists. His touches of limpid watercolor provide the viewer with a pure sensual delight not often found in American painting which, perhaps as the result of a Puritan heritage and a tradition of pragmatism, tends to pursue more serious ends.

Maurice Prendergast (1859-1924). Central Park, 1901. (14⅛×21¾″)
Pencil and Watercolor. Collection Whitney Museum of American Art, New York.

William Glackens (1870-1938) was another artist sensitive to developments in European art, especially in the realm of color. However he was simultaneously deeply involved with an important indigenous movement as a member of a vital group of artists that matured in Philadelphia during the last decade of the nineteenth century. This group, which also included John Sloan (1871-1951), George Luks (1867-1933), Everett Shinn (1876-1953), and Robert Henri (1865-1929), was to a greater or lesser extent in each case, influenced by Thomas Anshutz, who had succeeded Eakins as Professor of Drawing and Painting at the Pennsylvania Academy of Fine Arts. Anshutz conveyed to these young artists the Eakins tradition of art involved with life. Many of them began as journalists, producing illustrations for the *Philadelphia Press*. By the turn of the century they had all settled in New York. Glackens, although he shared the same background and orientation as the others, was atypical in his pronounced, if conservative, sensitivity to French painting. Gifted with an innate sense of color, Glackens, like Prendergast, produced paintings that are sources of visual delight rather than transmitters of messages. His early *Hammerstein's Roof Garden* of circa 1901 has an almost Whistlerian delicacy. Formal qualities of composition and color seem more important than the people or the event depicted. In subsequent paintings, such as his popular *Chez Mouquin* (1905, Art Institute of Chicago), Glackens was clearly influenced by Renoir, the greatest of all impressionist colorists. Indeed Glackens' affinity for Renoir is so pronounced that he is sometimes dismissed as a follower. However when his best work is seen in depth, as in the splendid collection in Philadelphia assembled by the artist's friend Dr. Albert C. Barnes, it is evident that Glackens may have been the most gifted painter of his whole circle.

The leader of the young artists who moved from Philadelphia to New York, although not the best painter among them, was Robert Henri. Senior in years and inspiring in person, Henri was the theoretician who gave voice and direction to the artistic concerns of the group in his influential book, *The Art Spirit*, infusing the realistic tradition of Eakins with new force and relevance. An admirer of Hals, Velasquez and Manet for their spirited brushwork which enabled them to record their perceptions with immediacy and verve, Henri's concept of painting as a means for a bold personal response to the real world stood diametrically opposed to the delicate estheticism of most American Impressionists, artists like The Ten, who worked in the "genteel tradition" during the closing years of the nineteenth century. Not all of the artists who admired Henri followed his teaching in their own practice. Glackens, for example, was much more concerned with pictorial effects, as were Prendergast and Shinn. But Sloan and Luks were active practitioners of Henri's brand of Realism—a Realism attuned to early twentieth century life.

A generation earlier, Homer and Eakins had carried American Realism to new heights. Taking as their point of departure the realistic genre scenes of Mount and Bingham, they had divested their realism of sentiment or narrative frosting, and offered reality alone, albeit structured, ordered and carefully selected reality. Homer concerned himself almost exclusively with non-urban life, while Eakins, although deeply involved in the life of the city himself, depicted rivers and marshes, or interior scenes that effectively conveyed no sense of an urban setting. Moreover, their images were fixed and static. Eakins, for example, strove for a distillation of the essence of the scene depicted. The younger artists, led by Henri, wanted to get much closer to the reality of life in their own time. They wanted to capture in their art the actual sensory feel of existence, the "spirit" of contemporary life. They wanted to be where the action was, and the action was in the city. These artists, for the first time in the history of American art, chose to paint the city, and did not restrict themselves to pleasing aspects of urban life. Impelled by a journalistic instinct to get at the truth, they, like such contemporary naturalist writers as Theodore Dreiser and Frank Norris, looked with fresh eyes at the realities of man and his world, and recorded what they saw. Often their paintings were charged with social consciousness. For example, few previous artists had dealt bluntly with the subject of man and his work. Early portraiture had occasionally

William Glackens (1870-1938). Hammerstein's Roof Garden, about 1901. (30×25″)
Collection Whitney Museum of American Art, New York.

hinted at this aspect of a man's life by introducing some element of the sitter's occupation into the decor—a desk, a Bible, a ship in the background. Neagle's *Pat Lyon at the Forge* anticipated mid-nineteenth century genre scenes by showing the subject within the context of his occupation. However Bingham's paintings of river life or Mount's farm scenes invariably represented the more leisurely and pleasant aspects of work. Eakins, in the *Gross Clinic*, made a daring move into new ground by opening up unpleasant parts of a man's

George Luks (1867-1933). The Miner. (60×51″)
National Gallery of Art, Washington, D.C. Gift of Chester Dale.

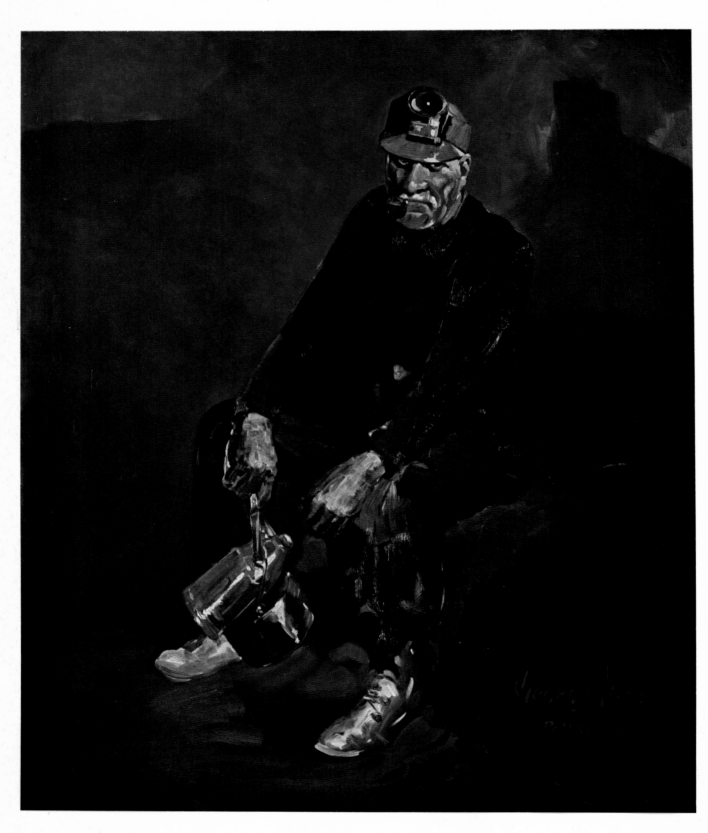

from the crowd. A row of heads in the foreground sets the stage for the action, putting the viewer in the audience where he can almost hear the roar and smell the smoke and the people, as he perceives the "feel" of the event. When a critic objected that Bellows had not depicted accurately the positions in which boxers hold their hands and plant their feet, Bellows replied: "I don't know anything about boxing. I am just painting two men trying to kill each other."

The young American painters were proud of their achievement. They had taken a brand of realism that was in the mainstream of traditional American art, and had moved it into new, adventurous and exciting ground. Their art, as in John Sloan's evocation of the ferry ride between Manhattan Island and Jersey City in his powerful *Wake of the Ferry* of 1907, dealt with real life and real people. It was democratic art, depicting not the aristocratic classes who populated the paintings of the "genteel tradition," but the lower middle classes, the great mass of the American populace. Their sense of artistic purpose was heightened by the fact that existing institutions for the education and encouragement of young artists such as the National Academy of Design, the places where art was exhibited and artists made contact with potential patrons, had become rigid and conservative, providing an authority against which to rebel, an enemy to fight. The young American artists were anxious to show off their art to their fellow Americans, sure that an appreciative public would give them the patronage they required. To this end they decided to hold a large independent exhibition in 1913, the exhibition that has become famous as the Armory Show, probably the most important single event in the history of American art.

In order to flesh out their undertaking, the Americans decided to include work by European contemporaries in the exhibition. They were anxious to prove that the novelty of their art was not eccentric or parochial, but part of a general wave of modernism throughout the world. The local manifestation was seen as a leading accomplishment of the new spirit that was liberating all art, something of which Americans could and should be proud. The major figure behind the Armory Show was the aristocratic Arthur B. Davies, a charter member of The Eight, but whose real interests, despite the deceptive conservatism of his own work, lay in the direction of European modernism. Approximately one third of the 1500 objects in the enormous exhibition were European works. The Armory Show opened in New York on February 17, 1913. As the American public gradually awoke to the existence of the show, it reacted violently. However the reaction was not against the works of the young American realists, who were ignored, but against the more advanced European works, notably those of Matisse and Marcel Duchamp, whose *Nude descending the Staircase* (Philadelphia Museum of Art, Philadelphia, Pennsylvania) became a symbol of the exhibition. American artists may have thought that the works of Ashcan painters like Luks, Sloan, or Bellows (who actually hung the exhibition) were novel and exciting in their realistic views of urban life, but when Bellows' boxers or Luks' city scenes were compared with a European-influenced abstraction such as Joseph Stella's *Coney Island*, the new realism suddenly seemed old hat and tame.

The ghost of Whistler and the doctrine of art for art's sake had returned in the form of abstract art, and the realist tradition in American painting would never recover from the shock of this confrontation. Although the public reviled modernism and abstraction, and made fun of Matisse and Duchamp, many of the younger American artists quickly became aware of the importance of what they saw at the Armory Show, realizing that here was a quicker and more exhilarating path to artistic independence. The battle between realism and abstraction was joined, and the ebb and flow of the contest has marked the history of American art ever since.

PART TWO

The Twentieth Century

by BARBARA ROSE

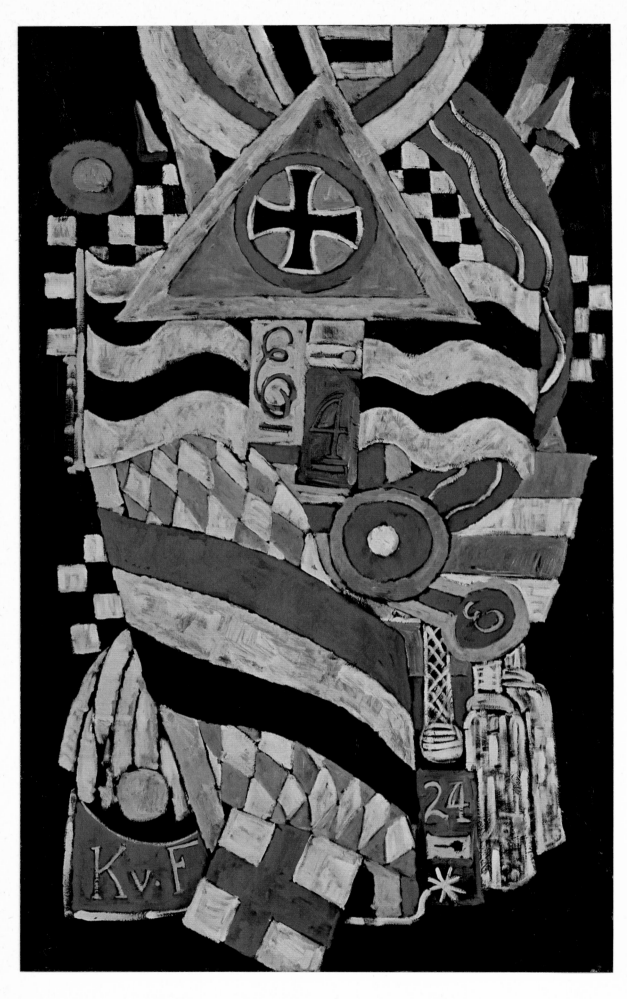

Marsden Hartley (1877-1943). Portrait of a German Officer, 1914. (68¼×41⅜")
The Metropolitan Museum of Art, New York. The Alfred Stieglitz Collection, 1949.

The Armory Show and its Aftermath

ALTHOUGH the success of the Armory Show—in terms of the thousands who jammed the exhibition, the glut of publicity and criticism, and the general aura of sensationalism that accompanied it—was unprecedented in the history of American art, the exhibition itself was more a *succès de scandale* than a *succès d'estime*. America was not, as it had vainly been hoped by some, immediately transformed into a nation of art lovers by virtue of its exposure to the greatest modern art. On the contrary, the crowds that flocked to the 69th Infantry Regiment Armory were looking for shock and titillation more often than for enlightenment or genuine aesthetic experience. The attitude of most Americans toward the hundreds of Post-Impressionist, Fauve and Cubist works in the show was that modernism was some kind of "new-fangled" crackpot invention of deranged minds; others like Royal Cortissoz, the leading critic of the time, were quick to detect a foreign conspiracy in the invasion of "Ellis Island art," as Cortissoz termed the new styles.

Many of the exhibition's original supporters, like William Glackens, had high expectations in the beginning for the showing American realism could make when set against European art; but they were depressed by the results of the confrontation, which only confirmed any suspicions that native American art might look immature and pale by comparison with the skilled technique and advanced ideas of the Europeans. For Europe, unlike America—a country according to one writer "born young into a late time"—had a long unbroken tradition of painting dating back to the Renaissance. Europe also had established state academies where the traditional skills and art theories, of which the majority of Americans were almost completely ignorant, were transmitted from one generation to the next.

Unfortunately, the discontinuities between advances in form and technique painfully exposed by the Armory Show continued to plague American art for several decades afterward. Moreover, this discontinuity, which prevented the logical progress toward a modern style that had taken place in Europe when post-Impressionism made a smooth and gradual transition to Cubism, was aggravated not only by the lack of a firmly established academic tradition but by the isolation in which American artists necessarily were forced to work. To better their lot, some banded together for mutual protection and understanding, forming a few loose-knit groups like the Eight. Occasionally artists organized themselves more formally. In fact it was such an artists' group, the Association of American Painters and Sculptors, which planned the International Exhibition of Modern Art, as the Armory Show was officially known.

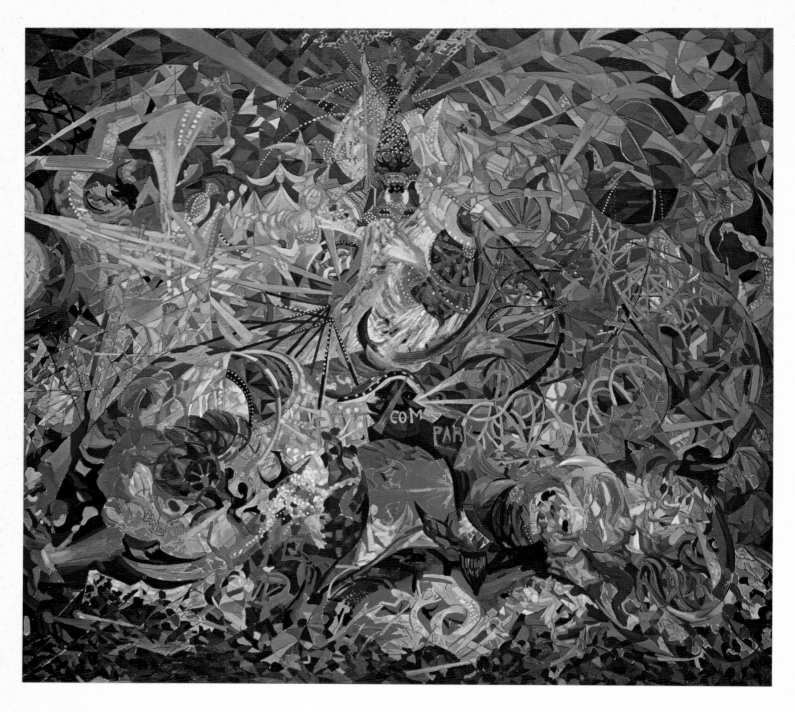

Joseph Stella (1877-1946). Battle of Lights, Coney Island, 1913. (75¾×84″)
Yale University Art Gallery, New Haven, Connecticut. Gift of the Société Anonyme.

The Armory Show obviously did not win the hoped for wide patronage for American art; on the contrary, it established even more securely the priority of the Europeans. But there were some gains: a few more converts to modernism like Stuart Davis were made; a few collectors like Duncan Phillips and Katherine Dreier, herself a budding artist who exhibited in the Armory Show, gained new insights; a few writers and critics became more sympathetic to modernism. Because the show was organized as a kind of capsule history of the new art, some notion of the continuity of the modern tradition and its roots may have been inferred by a few sensitive minds. Probably the most important single achievement of the Armory Show was the least evident. The circulation throughout America of many new images, through reproductions on post cards, in pamphlets sold at the exhibition and in reviews, caused Americans for the first time to become nationally conscious of such a queer thing as modern art.

Well represented at the Armory Show were members of the two most important groups of artists, the "Ashcan School," and those who exhibited at the modern art gallery known as 291, after its address on Fifth Avenue. These unofficial coteries were held together by the personal magnetism and evangelical sense of mission of two men, themselves artists, who defined the aesthetic stance of the group in general. Obviously one of these focal personalities was Robert Henri, teacher, writer, and leading member of the Ashcan School, if not its public standard bearer. At his own school near what is now Lincoln Center in New York, where John Sloan, George Bellows, Yasuo Kuniyoshi, Walt Kuhn and others studied, Henri preached a down-to-earth realism based on the objectivity of Dutch genre, the somber palette of Spanish tonal painting, and Manet's broad painterliness. To this traditional mixture Henri added the "slashing brushstroke" and vivid highlights of the Munich School. Such a formula, unfortunately, sometimes lapsed into the facile bravura and surface glitter of Salon painting, in imitation of the worst aspects of Sargent's manner, which had become extremely fashionable in America.

An opponent of art for art's sake as gutless and cerebral, Henri contended that an ugly subject might make a beautiful painting, providing that the brushstrokes were emphatic and lively enough to be suggestive of movement and vitality. Many of Henri's ideas regarding the virtue of a "lively" style remind one of certain passages in the writing of Henri Bergson, in which the French philosopher described the necessity for transmitting the *élan vital* or the life force in art. On the other hand, Henri's demand for direct experience and an art based on the observation of life links him prophetically to the pragmatist aesthetic articulated in the 1930's by the American philosopher, John Dewey. Henri's "realism," however, was relative; it was not based on the careful study of anatomy or the traditional canons of painting and plastic form creation that made Eakins an outstanding realist within the convention defined by Courbet and the French realists. The realism of Henri and the Ashcan School was largely a superficial affair; it was fundamentally more indebted to journalistic illustration than to fine art. Of the members of the Ashcan School, in fact, only Prendergast, America's first post-Impressionist, Glackens, a late convert to Impressionism, and Davies, an anachronistic romantic whose interest in Redon led him to organize the Armory Show, seemed to have much knowledge of or interest in modernism.

The exact opposite was true of that other circle of artists, which had as its center the enigmatic genius of photography, Alfred Stieglitz. American artists who showed at 291, Stieglitz' attic gallery on lower Fifth Avenue, were brought into direct contact with the European modernists whose work Stieglitz imported from Europe—many well before the Armory Show. So advanced was Stieglitz' taste, in fact, that he gave Brancusi his first show anywhere in the world! That 291 the gallery, as well as Stieglitz' publication *Camera Work* (which first printed Gertrude Stein, among other experimental writers) were equally dedicated to photography as an art form and modernism as an art style was natural, since it was precisely the invention of photography that tolled the death knell for realism. For if a photograph could capture reality that much more completely and accurately than the human eye and hand guiding a paint brush or chisel, what was the point of the painter or sculptor attempting to challenge the photographer in recording reality? Ironically, it was also the use of photographs to illustrate newspaper stories that put the artist-journalists of the Eight, like Sloan, Glackens, Henri and Luks out of work, and caused them to concentrate on painting rather than on illustration.

The polarity established between Henri and the realists on the one hand, and Stieglitz and the modernists on the other was in a sense the first twentieth-century recapitulation of the Whistler-Eakins art for art's sake vs. art for life's sake dichotomy. This opposition would express itself again in the split between American Scene painting and geometric abstraction in the thirties and forties, and later in the opposition between Pop art and hard-edge or color abstraction in the sixties. So chronic is this schism, in fact, that one might see it as an unavoidable recurrent polarization in American art, brought into play each time a clash between democratic and elite taste might occur.

Morgan Russell (1886-1953). Synchromy in Orange: To Form, 1913-1914. (135×123″)
Albright-Knox Art Gallery, Buffalo, New York. Gift of Seymour H. Knox.

Stanton Macdonald-Wright (1890-1973). Abstraction on Spectrum (Organization 5), 1914. (30 × 24″)
Nathan Emory Coffin Memorial Collection, Des Moines Art Center, Des Moines, Iowa.

That several of the artists who regularly visited 291 used straight-edged, sharply illuminated forms, close-up views and strong light-dark contrasts, as well as enlargements and "cropped" compositions may be at least partially explained by their constant exposure to the formal values of photographs. The most obvious and irrefutable case of course is that of Charles Sheeler, a great photographer and an interesting and influential painter, who is still better known for his painting of factories and skyscrapers than for his photographs of the same subjects. Sheeler's reduction of forms to their pure geometric volumes clearly connects his painting to his photography; in fact, we know that his photographs frequently served as points of departure for his paintings, particularly in his later work. In the thirties, Ben Shahn would likewise base paintings on scenes he had photographed.

Although the artists he most faithfully supported were the American-born landscape painters John Marin, Marsden Hartley, Arthur Dove, and Georgia O'Keeffe, whom he married in 1924, Stieglitz showed virtually all of the outstanding early American modernists. His eye, in fact, seems close to having been infallible. Besides the four painters just mentioned, he also exhibited the work of Alfred Maurer, a sensitive painter of still lifes in a style that married Fauvist color to Cubist composition; Max Weber, who produced the first Cubist painting by an American in 1909; and Gaston Lachaise, whose art challenged Puritanism with its honest and explicit eroticism. The art of the painters and sculptors who exhibited at 291 had this in common: it was intense, direct, and committed to the idea that art in itself and as itself represented a spiritual reality as potent, actual, meaningful as the material world. The relationship of this group of artists to European art was a complex affair. With the exception of O'Keeffe, all had travelled to Europe, and some had undoubtedly read Kandinsky's influential essay *Concerning the Spiritual in Art*, which appeared in an English translation around the time of the Armory Show. Yet in general their art had only a tangential relationship to the bright color art of the Fauves, or in Hartley's case, to the sharp angularity of the German Expressionists. In fact, they pointedly had no interest in becoming European artists. Like the members of the Ashcan School, they wished to express a distinctly American vision. What was remarkable and significant then about Dove, O'Keeffe, Marin and Hartley, above all, was their equal commitment to their experience as Americans as well as to the frankness and uninhibited freedom of modernism.

The painters and sculptors who exhibited at 291 were the first modern American artists. Often they did not look to European art for inspiration, but to sources outside fine art—to popular art, or applied art. Weber studied the vividly painted dolls of the Hopi Indians called Katchinas and copied the repetitive geometric patterns of restaurant floors. Hartley was interested in the decorative embroidery and archaic symmetry of Coptic textiles.

While the members of the Ashcan School recorded their observations of reality in a blunt urban art, the group who found Stieglitz such an inspiring moral force turned away from Puritanism toward another American tradition—Transcendentalism, the nature philosophy of Emerson and Thoreau. Wishing to capture the sensual core of life as it was expressed in nature, they looked for subjects not at the outside world, but within themselves, to their own dreams and imagination. While Henri, Sloan and the rest of the realists tried to elevate the lives of "quiet desperation" led by most Americans into a suitable because authentic theme for art, Dove, Marin, O'Keeffe and Hartley examined natural forms, searching for equivalents of their deepest inner experiences; in this search, they looked, as Thoreau and Emerson had, to nature for salvation. O'Keeffe and Dove observed natural forms like plants, clouds, and rocks, simplifying their shapes to conform with the demands of art. Like Thoreau himself, all eventually left the city: Marin to live among the evergreens and fishing boats of Maine; O'Keeffe to find peace of mind in New Mexico; Dove to anchor his houseboat on Long Island Sound; and Hartley to wander back and forth across country, to Mexico and Canada, only to settle finally near his New England birth place.

Each developed a very personal vision of the American landscape. In a sense the artists who exhibited at 291 and later at Stieglitz' other galleries, the Intimate Gallery and An American Place, were forced to paint landscapes as a result of their ambition and intensity.

Max Weber (1881-1961). Athletic Contest, 1915. (40×60")
The Metropolitan Museum of Art, New York. George A. Hearn Eund, 1967.

This was so because any art tied to human life in America had to take the form of genre, given that the democratic experience did not demand the glorification of heroes. "Heroic" themes for an American artist could never be related to classical or even Renaissance anthropomorphic humanism; the only truly "heroic" subject for an American artist had been and would continue to be the epic grandeur of the American landscape. Even when American art attained its fullest flowering, in the works of the Abstract Expressionists, its images evoked not the figure or still-life themes of Cubist painting, but the "sublime" force of nature. To the degree that the works of both groups are tied to nature, there is some connection, however vague, between Dove, O'Keeffe, Hartley and Marin, the first artists to paint American subjects in a modern style, and the Abstract Expressionists. One such similarity is that the Abstract Expressionists, like the artists who exhibited at 291, thought in terms of symbolic equivalents of natural forces and inner states.

That Alfred Stieglitz was one of the great revolutionaries in the history of American art is without question; that his vision was a prophecy of the future is becoming equally clear. Stieglitz and those around him, including writers like Lewis Mumford, Waldo Frank and Paul Rosenfeld, were aware of the deadening effects of industrialism and urbanization. As a photographer, Stieglitz was determined to subordinate the machine (in his case the camera) to man's domination. Most importantly, he and the artists around him, in their dedication

to the poetic and the spiritual, in opposition to the literal and the material, voiced a minority point of view. Dedicated to restoring the primacy of the instincts denied by a repressive Puritanism, they emphasized the direct, the sensuous, the organic, and the intuitive in their art. These were unusual but not unprecedented ideas in America: they had been espoused earlier by nineteenth century titans like the architect Louis Sullivan and the poet Walt Whitman in their writings.

Elizabeth McCausland, one of the few critics who understood the mission of 291, described the spirit of Stieglitz, Marin, Dove and O'Keeffe as a passionate, emotional romanticism, a commitment to honest work and craftsmanship as well as to inner freedom. For Marsden Hartley, who had his first exhibitions there, 291 was the place new values were established, as well as a sympathetic group spirit that allowed a few personalities to find their individual means of expression. Hartley remembers the day he saw the drawings of a young Texas art teacher, a student of Arthur Wesley Dow who taught an advanced method of design based on Notan, the light-dark patterning of Oriental art. "There was no name on these drawings," Hartley recalled, "and there has never been a name on any of the paintings that have followed, for this artist believes also, as I do, that if there is any personal quality, that in itself will be signature enough, and we have seen a sequence of unsigned pictures over a given space of years permeated with an almost violent purity of spirit." Many American artists felt and feel as Hartley did about Georgia O'Keeffe's work, so that to this day the paintings of many of America's greatest modernists bear no signature other than their extreme stylistic individuality. This dedication to individuality Hartley refers to is not only true of O'Keeffe and himself, but of the majority of American artists, who do not care for schools or theories. Typical of their point of view is John Marin's dismissal of the complexities of Cubist theory: "In the seethe of this, in the doing of that, terms, abstract, concrete, third dimension, fourth dimension—bah. Don't bother me." Because of this lack of involvement with theoretical matters and academic standards, American paintings often have a crude directness and unstudied spontaneity which is part of their fresh quality. On the other hand, this point of view had its limitations, too; it probably explains why Americans did not fully master the mechanics of analytic Cubism until they were able to assimilate them to something quite different from Cubism in the forties. Even around the time of the Armory Show, the American artist preferred action to words. He was dedicated, not to the slow process of artistic evolution within an established tradition, but to expressing his individuality at all costs—which may be seen as the only positive result of the isolation in which he was condemned to work. For in America there were no artists' cafés or free academies where everyone went to draw and converse. Communication was difficult, especially for those artists who lived in remote parts of the country.

Despite many obstacles, however, Stieglitz accomplished at 291 what the Armory Show had not: he showed Americans and Europeans together and proved that American artists could be modernists without sacrificing the originality or specifically American quality of their work. Even more important, the shows he carefully selected proved, as the more heterogeneous group of artists at the Armory Show perhaps had not, that Americans could stand up to European art on the level of quality. For Stieglitz, quality, not nationality, was the sole criterion. This explains why, while 291 was open from 1908 to 1917, Stieglitz showed such diverse works as Rodin and Picasso drawings, Japanese prints, Toulouse-Lautrec lithographs, Cézanne watercolors, Negro sculpture, and children's art, as well as paintings by Matisse, Picabia and Severini and photographs by himself, Steichen and other leading photographers. Paintings by Americans such as Max Weber and Stanton Macdonald-Wright, who had learned the essentials of Cubism in Paris, and works by Oscar Bluemner, Arthur B. Carles, Samuel Halpert, and Abraham Walkowitz, who were also aware of the new liberation of color and design required by modernism, were exhibited at 291 as well. By far the most significant exhibitions in terms of their originality, however, were those of John Marin, Marsden Hartley, Arthur Dove, and Georgia O'Keeffe.

Hartley's intense, brooding quality was evident even in the early colorful works he based on the closely knit "stitch" stroking of the Italian Impressionist Segantini. Later he painted deserted farms in Maine with a somber directness reminiscent of Ryder's dark palette, heavy impasto and forceful patterns based on natural formations. During his stay in Berlin in 1914, Hartley came into contact with the artists connected with the Blue Rider group. From that point on, he was decisively affected by the Expressionist distortions and their deliberately primitive drawing. Although he retained the embroidery-like stroke of his early landscapes, he began to paint abstractions based on religious symbols or still-life arrangements commemorating his friendship with a young German officer whose initials, K. v. F., appear in one of these Berlin paintings. Like many American artists, Hartley returned to the United States when World War I broke out. For a brief period he painted calm pastel abstractions, flirting with the decorative flatness of synthetic Cubism. In their rigorous two-dimensionality these paintings resembled those of Man Ray, an American Cubist who eventually left his native country (probably because of overt American hostility to modern art) to settle permanently in Paris, where he gave up painting to devote himself to making "rayographs," abstract images photographically recorded on sensitized paper.

In the twenties, Hartley returned to a moody expressionist style characterized by rich, dark colors outlined boldly in black. In these intense, dramatic works, as in his Berlin paintings, Hartley orients his stiffly hieratic images frontally; now, however, he accentuates the awkwardness and crudity of his drawing to an even greater degree to extract the most expressive statement from them. The paintings of the teens had been explicitly flat, but the New Mexico landscapes and still lifes of flowers and fruit Hartley painted in the twenties and thirties are plastically modeled into tense muscular forms. Toward the end of his life, Hartley, like Max Weber, who gave up Cubism to paint mystical Jewish themes, became exceedingly inward and spiritual. His paintings of New England fishermen done shortly before his death in 1943 express an intense religiosity. Some, like the *Fishermen's Last Supper—Nova Scotia*, even refer directly to religious paintings.

The denseness and opacity of Hartley's oils was in diametric contrast to the light, airy landscapes and cityscapes of John Marin, many of whose finest paintings are done in the transparent medium of watercolor. In fact, even in his earliest watercolors, done around 1887—hazy, tonal landscapes reminiscent of Whistler—Marin emphasized atmospheric qualities. Later on in Europe, he continued to paint brightly lit, atmosphere-drenched views of Alpine hillsides, Venetian canals and French cathedrals in a style that seemed to have more in common with the reticence of Chinese landscape painting than with the Fauves and Cubists he exhibited with in the Salon d'Automne of 1907, 1908 and 1909.

In Paris, Marin met his friend from student days at the Pennsylvania Academy, Arthur B. Carles, whose brilliantly colored still lifes and landscapes, flat space and free technique showed an obvious acquaintance with the art of Matisse and Derain. Carles was part of the sophisticated milieu of the American expatriates, Gertrude Stein, hostess to Picasso and Matisse, and her brother Leo, one of the first Americans to write approvingly of modern art. He introduced Marin to the photographer Edward Steichen; Steichen in turn brought Stieglitz to visit Marin's studio in Paris in 1909. The outcome of this meeting was a two-man exhibition of Marin and Alfred Maurer held at 291 later that year. Maurer, who had rejected Whistler's tonal painting for the intense, fully saturated palette of Fauvism was called the "Knight of the Burning Pestle" in a review by James Huneker, one of the leading art critics of the time, while Marin was seen as the "master of mists." Together, according to Huneker, they made "an interesting duet in fire and shadow." Fortunately, Marin had a stronger character and a happier and more productive life than the tragic Maurer, who took his own life in 1932, after a beleaguered career and virtually no recognition—the fate of many a misunderstood and ignored American modernist.

A year before his return to the United States in 1911 Marin painted several watercolors of the Brooklyn Bridge. The search for an explicitly American theme might in fact be seen as an indication of a new feeling of identification with his homeland. Between 1912 and

John Marin (1870-1953). Off Stonington, 1921. Watercolor. (16⅜×19½")
The Columbus Gallery of Fine Arts, Columbus, Ohio. Ferdinand Howald Collection.

1914, Marin painted many scenes of lower Manhattan, filling the page with a nervous tremulous image executed with a few rapid energetic brushstrokes. Beginning in 1914, Marin spent his summers in Maine. But whether painting the city or the Maine coast, Marin creates a similar world—a heaving, churning life-filled world in which literally nothing is settled, a world in which bright reflections bounce off choppy waves, and even buildings and bridges seem to bend in the wind. Capturing the electric, restless quality of urban life in America in his cityscapes, Marin sees Manhattan as he sees Maine, flooded with light and surrounded by water. One of America's greatest, if not its greatest marine painter, Marin is so enthralled by the lively movement of water that he often paints even New York as seen from the river, an island jutting abruptly from the water like some great blocky mountain of stone.

In at least one respect Marin was different from most American artists: alone among the painters of his day, Marin, perhaps because of his apparent appreciation of the delicate, elliptical quality of Oriental landscapes, was able to appreciate that what was left out—the

spaces between forms designating air—was often more important than the airless, heavy-handed clutter typical of most American paintings. Marin's openness thus stands as a happy antidote to the many over-worked American paintings of the period which are too full of details, narrative incident and laborious filling in. Marin understood, probably from Cézanne's example, when a few well placed lines and transparent patches of color would suffice to abbreviate a fuller picture.

Formally, Marin's paintings owe something to both Futurism and Cubism, although strictly speaking, they are neither Futurist nor Cubist works. From Futurism he borrows the slanting angular "lines of force" we see in Demuth's and Joseph Stella's paintings as well. These oblique lines, which he uses almost as masts around which to hang his airy forms, lend structural coherence as well as tension and energy to his compositions. From analytic Cubism he acquires the habit of floating his image buoyantly in the center of the canvas rather than pinning it to the frame, which he often re-echoes within the canvas as an internal rectangle that binds the explosive energies within together in a stable unity.

Marin's delicacy and sensitivity were not quite matched by Arthur Dove. Dove's color sense and bold patterning, however, are sufficient to distinguish him as a painter of an extraordinarily potent image and original lyrical vision of nature. A subscriber to the theory of synaesthesia promoted by the Symbolists, Dove believed that he could paint forms that would equal sounds, like his *Fog Horns*, which are supposed to depict visually the sound of fog horns. Like Kandinsky, Dove believed as well that colors and forms could be the equivalents of musical harmonies; to this end he, like Kandinsky, alternated rhythmic patterns, staccato and lento passages, in visually melodic—if one can use such a contradiction in terms—harmonies. Although there are many similarities between Dove's early work and Kandinsky's expressionist styles, the only painting by Kandinsky that Dove was likely to have seen was the single Kandinsky landscape in the Armory Show, which was bought by Stieglitz for $500. (One of the main criticisms of the Armory Show, in fact, was that the German and Austrian Expressionists were badly represented, and the Futurists, who quit in a moment of pique because they could not have their own booth, were not represented at all.)

Often Dove's free, spreading forms with their haloes of modulated colors are like the bursting forth of natural forms as they bud and grow. In Dove's pantheistic universe, even the inanimate is invested with life. Along with Max Weber and Abraham Walkowitz, Dove was one of the first abstract artists, not only in America, but in the world. His earliest abstract works have been dated 1910, the same year that Kupka and Kandinsky painted their first abstractions. Although Dove studied in France and Italy from 1908-1910, there is little or no reason to think he could have seen their works.

As his paintings were dissimilar from Cubist works, Dove's collages of bits and pieces of real materials were unlike Cubist collages. Contrasted with Cubist collage, they were bolder, freer, and more literal—a shape representing a shirt sleeve was literally a shirt sleeve, a piece of fabric being sewn on a sewing machine was literally a piece of fabric. They were different from Cubist collage, too, in that the shapes were generally larger and more irregular. In his paintings Dove used these simple large shapes to advantage to create sharply silhouetted patterns, his organically twisting and undulating forms carrying the eye across the surface in a strong rhythmic movement.

As Dove's aureoles and gently rolling motifs are based directly on nature, so are Georgia O'Keeffe's forms. Where Dove emphasizes flat patterning and sharp color contrasts, however, O'Keeffe never ceased to model her forms with light and shadow, giving them a sculptural plasticity and volume that she interprets as a ripely voluptuous swelling. O'Keeffe's compositions are monumental far beyond their actual dimensions. They are particularly impressive because of the assured manner in which she fills the pictorial field with a few dramatically placed austere, uncompromising forms. She achieves a sense of scale that is also beyond the size of her paintings by relating small elements to large forms, causing the latter to appear all the more vast by comparison. In one of her finest paintings,

Arthur G. Dove (1880-1946). Holbrook's Bridge, Northwest, 1938. (25×35″)
Collection Roy R. Neuberger, New York.

done during the first summer she spent in New Mexico, *Black Cross, New Mexico*, 1929, the great wooden cross of the Penetenti, an American Indian sect, looms dramatically in the foreground, asymmetrically dividing the canvas, its massiveness heightened by the relative smallness of the rolling hills in the distance.

In O'Keeffe's paintings, nature and things seen are always the point of departure, even if they are flattened, simplified, changed in color or otherwise interpreted by the unique sensibility of the artist. O'Keeffe transforms nature by ordering, smoothing out, regularizing—a word that seems more accurately descriptive of what she does than idealizing, which might raise a false issue of classicism with regard to a painter who is essentially a romantic, for all the severity and cleanness of her forms. Uninterested in atmospheric effects, O'Keeffe creates images that are as static and monumental as Marin's are fluctuating and evanescent. No classicist, still she rigorously constructs solid forms that suggest the durable and the timeless. For this reason, perhaps, her luminous Southwestern skies are filled with unmoving clouds, painted as solidly and opaquely as if they were made of marble. Hills, mountains, clouds, animal skulls and bones (a *vanitas* or *memento mori* motif common in O'Keeffe's work of the thirties)—all are painted with the same patient craftsmanship, brushstrokes blended together until they are barely if at all visible.

Still a powerful and important painter in the 1960's, O'Keeffe is working today on a new large scale with the same resoluteness that has characterized her work since 1940, when she bought the house she now lives in at Albiquiu, New Mexico, whose patio she has painted

Georgia O'Keeffe (1887). Black Cross, New Mexico, 1929. (39×30¹/₁₆″)
Courtesy of The Art Institute of Chicago, Chicago, Illinois. Art Institute Purchase Fund.

so often. O'Keeffe is a painter of such imagination that she can give the humblest subject a sense of mystery. Her paintings of animal skeletons, although not her best work, nevertheless have a haunting quality that invites an attitude of mystical contemplation. O'Keeffe seems constantly in touch with life's deepest secrets. Even a simple farmhouse, reduced to its elementary geometry, has a mysterious evocative presence when O'Keeffe paints it.

In a letter to a friend, O'Keeffe described the effect on her of the strange colors of the New Mexico twilight: "I climbed way up on a pale green hill and in the evening light—the sun under the clouds—the color effect was very strange—standing high on a pale green hill where I could look all around at the red, yellow, purple formations—miles all around—the colors all intensified by the pale grey green I was standing on." The colors she describes are her own colors too: mysterious combinations of the muted and the fiery.

Frequently in her New Mexico works, among which are her masterpieces, O'Keeffe emphasizes the vastness and the emptiness of the American landscape, paying homage in a sense to the spaciousness and generosity of the physical environment. Yet she lived in the city for some time too, painting skyscrapers in New York with the same care and craft she devoted to landscape. Although she was never officially part of the group who came to be known as the Precisionists because of their emphasis on fine workmanship and precise detail, O'Keeffe had much in common with them, specifically in her reductions of volumes to their simplest geometry, her lucid hard-edged forms, and her ability to monumentalize even the most ordinary subject. The Precisionists, or Cubist-Realists as they are more appropriately called, used Cubist methods of composition and reduced forms to simple geometry to interpret basically realistic subjects, and were more closely tied to European art than O'Keeffe, who never travelled to Europe. Although their themes were recognizably if not self-consciously American—the anonymous grain elevators, silos and factories that Lewis Mumford had singled out to praise for the honest quality of their modest simple forms—most of the Precisionists could not have painted without the example of Cubism as a point of departure. But the Cubist style Precisionism has most in common with is not the severe manner of Braque and Picasso, with its careful analysis of forms, but the "epic" Cubism of Gleizes and Metzinger, who, like the Futurists, painted urban themes in a style far more conservative than the radical art of Braque and Picasso. Weber's Cubist abstractions of 1912-1915, for example, with their repetitive forms and urban themes are obviously related to "epic" Cubism.

Not the analysis of forms, but their reduction and simplification was the aim of the Precisionists. The Precisionists, who included Charles Sheeler, Charles Demuth, Morton Schamberg, Preston Dickinson, and Ralston Crawford, to name the most prominent, searched, like Joseph Stella, whose work is also allied to theirs, for specifically American themes. They were the first artists perhaps to realize that the European grand manner could only produce an empty rhetorical art in America. In order to be true to their experience, they felt they would have to renounce any pretensions to grandeur, paint in a modest, careful style, and choose banal everyday themes. Like the pop artists who came after them, the Precisionists painted humble subjects—simple common objects or the machinery of American industry. Because craftsmanship was fast disappearing in the country where mass production was invented, they made a fetish of good careful workmanship and simple, well-made forms. Demuth admitted he learned his respect of craftsmanship from Marcel Duchamp; Sheeler, on the other hand, studied the clean, precise forms of the household objects and furniture made by the Shakers, an early American religious community, who saw the integrity of craftsmanship as a metaphor for moral integrity.

Like the majority of American artists, the Precisionists looked not to the major Cubists but to the minor figures in the movement, Gleizes, Picabia and Duchamp, all of whom were in New York around the time of the Armory Show—Gleizes to visit, Picabia to take up residence for some time, and Duchamp to remain, become an American citizen, and until his death in 1968, to be perhaps the most decisive single influence on the course of modern American art. Because his complex and controversial career has offended so many

Charles Sheeler (1883-1965). Upper Deck, 1929. (29 × 21³/₄″)
Courtesy of the Fogg Art Museum, Harvard University, Cambridge, Massachusetts. Louise E. Bettens Fund Purchase.

Charles Demuth (1883-1935). Buildings Abstraction, Lancaster, 1931. (27⅞×23⅝″)
From the Collection of the Detroit Institute of Art, Detroit, Michigan.

critics who admire traditional painting, Duchamp's contribution has not yet been assessed for its true importance. The star attraction of the salon maintained by the wealthy bibliophile and art collector, Walter Arensberg, Duchamp launched Dada in New York a year before it exploded in Zurich in 1916. He also painted machines reduced to elementary geometric volumes like his *Chocolate Grinder* of 1914. Their hard-edged mechanical style in turn provided the model for the first Precisionist paintings by Demuth, Sheeler, and Schamberg, painted shortly afterward. Later he served as an advisor to both Katherine Dreier, whose Société Anonyme, founded in 1920, was the first public collection of modern art in the United States, as well as to Peggy Guggenheim, who brought the best of European art to New York during World War II.

Creating scandals like submitting a standard urinal signed R. Mutt to the 1917 exhibition of the Society of Independent Artists, Duchamp constantly attacked aesthetic norms and canons of taste, extending the limits of art until it encroached upon everyday life. An aristocratic chess-playing aesthete who renounced painting in 1918 as a "dead" anachronism, Duchamp was more than anyone a symbol of the avant-garde for American artists, a concrete link between Paris and New York. The organizer of Dada events, Surrealist manifestations and environments, Duchamp attended every important avant-garde spectacle from the moment he and John Sloan proclaimed Greenwich Village an independent republic from the top of the Washington Square Arch to recent Happenings. His presence was a constant reminder of the connection between the Parisian avant-garde and the embattled and struggling New York experimenters. As the *éminence grise* of the New York art scene for half a century, Duchamp re-emerged as one of its heroes in the 1960's when painters like Jasper Johns and his progeny of pop artists took new interest in Duchamp's verbal and visual Dada punning. And one cannot overlook either the influence his literal use of industrial materials in *The Bride Stripped Bare by her Bachelors, Even* has had on the object makers of the sixties.

The Precisionists were indebted to Duchamp not only for their forms but for their iconography as well. Duchamp's claim that the only art America had produced were her plumbing and her bridges inspired Morton Schamberg to make a "sculpture" of a piece of plumbing and title it "God" long before the minimal artists of the sixties began making art that looked like industrial objects, or using simple clean forms reminiscent of the banal architecture and objects painted by the Precisionists. Since early in the century there has been the feeling among many artists that to make an authentic statement American art had to confine itself to the most standard forms and humble themes, because these were characteristic of the American experience. Duchamp, of course, was not the only one to make a negative assessment of American culture. For several decades following the Armory Show, Americans were to suffer from what amounted to a cultural inferiority complex whenever they saw themselves in relation to the European tradition. And this was inevitable, because despite the protestations of chauvinists like the American Scene painters, American art continued to live in the shadow of the School of Paris until the end of World War II, when it suddenly exploded as a great international force, and America became the leading power in world art as well as in world affairs.

The *détente* which followed the outbreak of World War I in Europe, causing many leading European artists like Derain and Matisse to take more conservative positions, had its effect on American artists as well. Abstract art was abandoned by former abstractionists such as Weber, Hartley, Maurer, Charles Burchfield, Thomas Hart Benton, Joseph Stella, and Andrew Dasburg. Of the dozens of abstract American artists, only Dove remained committed to abstraction in the twenties and thirties. In fact one of the difficulties in writing a history of the period between World War I and the Depression is that so much of the work was destroyed. Dasburg, Burchfield, Maurer, and Patrick Henry Bruce were some of the American artists who destroyed most if not all the work they produced during those years. The effect of the war and the lack of public interest in modernism seemed to create a general loss of conviction in abstract art that caused artists to desert its practice in droves.

Since they had never been abstract artists, the Precisionists were in a better position to progress in their work. There is something to be said for even the minor Precisionist painters such as Niles Spencer, Louis Lozowick and George Ault; but the paintings of Charles Demuth stand out from the others because of their elegant formality, and their surer grasp of the elements of Cubism. Demuth's subtle color sense and light touch, both especially remarkable in his many exquisite watercolors, distinguish his work. Moreover, the relatively shallow space his forms inhabit and their frontality identify Demuth clearly as a modernist, whereas, on the other hand, the other Cubist-Realists, with the exception of O'Keeffe and Joseph Stella, neither of whom was strictly speaking a Precisionist, continued to depict the deep space of traditional painting. If one compares works by Sheeler and Demuth, for example, it becomes immediately apparent that Sheeler is by far the more conventional artist. The lively, reflective, enamel-like quality of Demuth's surfaces make Sheeler's nearly monochrome palette look drab by comparison, for none of the Precisionists was the sensitive colorist Demuth was.

Related to Precisionism in terms of subject and style was one of the most interesting and bizarre figures in American painting, the Italian émigré Joseph Stella. Although he settled in New York in 1896, Stella made frequent trips to Europe. On one of these trips he must have come into direct contact with Futurism, because he first exhibited as an Italian Futurist. Like other poets and artists seeking an "epic" theme which would transcend the banality of the democratic experience, he focused on the Brooklyn Bridge as the symbol of America's power and creativity.

Like the Futurists, Stella sought to capture the dynamism and energy of modern urban life, locking its fragments into place with Futurist "lines of force." His shattered planes, like the figures in Severini's mad ballrooms, dance across the fractured surface of Stella's dazzling Cubist paintings like *Coney Island* with a whirling convulsive momentum. In the twenties, Stella's depictions of the bridges and structures of the New York skyline were more severely and statically organized along the lines of Precisionism. His late work, on the other hand, became, like the late paintings of Hartley, Weber and O'Keeffe, increasingly mystical, romantic and symbolic. Yet as full as they are of hermetic meanings, arcane references, and religious overtones, the simplified shapes of Stella's decorative flowers and exotic birds still contain references to Precisionist simplification.

Although Cubism was fully understood by few if any Americans working during the two decades after the Armory Show, a handful of American artists in Paris had a better grasp of its essentials. Attracted to the same neo-Impressionist color theories that inspired Delaunay to transform Cubism into a primarily lyrical statement about light and color, the Paris-based Americans, Stanton Macdonald-Wright and Morgan Russell developed an American (in the sense that American painters created and named it) form of "orphic" Cubism. Macdonald-Wright and Russell called their self-proclaimed movement *Synchromism*, which means "with color." Synchromism, then, was Cubism with color.

Macdonald-Wright was the brother of the distinguished American art critic, Willard Huntington Wright, who lost his objectivity in his enthusiasm for Synchromism, and predicted the end of painting and the beginning of a pure disembodied art of color and light, in which colors and forms could be "played" like music on special instruments. An intellectual and a theoretician like his brother, Macdonald-Wright used color with sensitivity in his superimposed transparent planes, which alternate complementary colors like blue and orange in harmonic combinations. But like the majority of American artists, Macdonald-Wright did not understand that the basis of Cubism was a reformulation of pictorial depth within a shallower space more like the space of a bas-relief than the three-dimensional space of fully modeled forms. Consequently his Synchromist abstractions represent a compromise—like virtually all the Cubist work done by Americans between the Armory Show and the Depression—with modernism; although their forms are abstract and their colors freely chosen from the extended spectrum of neo-Impressionism, their spatial organization is almost the same as that in old master paintings. This was not as true of the

opaque color volumes of Morgan Russell, and it was totally untrue of the flat, highly structured compositions of Patrick Henry Bruce, whose suicide after his return from Paris to New York in 1936 was one of the greatest losses suffered by American art in a generally depressing period.

Mixing a primary red with pastel blues, lavenders and white, Bruce, who like Max Weber had studied with Matisse, used Matisse's device of employing black and white as colors, rather than as chiaroscuro. The lack of any genuine connection of American art to the classical tradition felt by many was experienced in a particularly painful way by Bruce, who nonetheless sought a stable, architectonic order, and a geometric severity based on emphasizing the horizontal and vertical elements that repeat and reinforce the framing edges. Because of this, his paintings have an authentic monumentality lacking in the many disjointed and cluttered simulated Cubist works being produced by any number of "semi-abstract" American artists, who still believed that a fundamentally illustrational or academic art could be given a superficially modern look by applying a few of the conventional surface effects of the Cubist formula.

Unlike most of his contemporaries in that he destroyed himself and his work rather than swerve from his course as a modernist, Bruce was an extremist. His colleagues at home in the United States, on the other hand, searched for the middle of the road, for compromises between abstraction and representation, between formal values and illustrational subject matter, between modernism and academicism. Most of these efforts by artists like Henry Lee McFee, Maurice Sterne, Alexander Brook, Bernard Karfiol, et al., to adapt Cubism to American subjects were dismal, tentative affairs, as is usually the case in the first attempts of provincial schools to assimilate a mainstream style. Cubism was as French as the Renaissance was Italian; and the efforts of Americans to master its underlying premises resulted in the same kind of misconceptions of Cézanne, Picasso and Braque as those exhibited by provincial Renaissance masters in their often ludicrously misunderstood imitations of Raphael, Michelangelo and Leonardo. As the provincial Renaissance masters copied engravings and works by minor masters of the style, so, too, did the American Cubists look to reproductions and the work of less complex and developed painters rather than to those who had created Cubism. For the true Renaissance, the Americans would have to wait until the School of Paris masters themselves made their homes in New York, as the provincial centers of the Renaissance awaited the arrival of a traveling Italian.

Charles E. Burchfield (1893-1967). Church Bells Ringing, Rainy Winter Night, 1917. Watercolor. (30×19″)
The Cleveland Museum of Art, Cleveland, Ohio. Gift of Mrs. Louise M. Dunn in memory of Henry G. Keller.

The Crisis of the Thirties

IN 1929, the year the stock market crash plunged America into a bitter Depression, John Cotton Dana wrote that when he thought of American art, he thought of "tableware, cutlery, table linen, chairs and tables; draperies and wall papers; houses, churches, banks, office buildings and railway stations; medals and statues; books, journals, signs and posters; lamp-ware, clocks and lamps; carpets and rugs; laces, embroideries and ribbons; vases and candlesticks, etchings, engravings, drawings—and paintings." Significantly, Dana, organizer of the first museum show of a living American painter (a Max Weber exhibition at the Newark Museum in 1913), put paintings last in his listing of American art objects. He was not alone in this negative attitude toward American painting. For the general public as for many artists as well, painting, as opposed to the minor arts of craft and design, which had their roots in a solidly established indigenous popular tradition, represented a distinctly European and imported form. One explanation of the reluctance to accept painting as an American art may have been that, as opposed to the minor arts which served some purpose, painting was useless, and hence of little interest to utilitarian Americans.

There were other obstacles to the development of fine art in America which had to be overcome before American painting could develop. First of all, there was the Puritan work ethic, which caused people to see art as a form of play, at best irrelevant and at worst immoral. As a new country, always forced to devote its best energies to economic development, America had created a work rather than a leisure-oriented culture. Lacking an aristocracy, America had no tradition of cultivated amateurs who could hand down a love of the arts from generation to generation. Few Americans had either the time or the money to devote to art. Collectors were generally newly rich and wished therefore to use art to gain immediate social status; because more status and a higher pedigree were attached to older art and to European art, this is what they collected, to the neglect of American painting. One of the few exceptions to this rule was Gertrude Vanderbilt Whitney, a wealthy sculptress who founded the Whitney Museum of American Art in 1914, an event which signalled the first public acknowledgement of a consciousness that American art had a history and possibly even a future.

In his assessment of the state of American art at the beginning of the period in which the country would be transformed from a rural agricultural society to a fully industrialized world power, Dana maintained that the principal obstacle to the progress of American art was economic. If the money were available, he reasoned, the art would surely follow, as it had when the Medici poured money into art. Dana was, of course, at least partially correct

in his diagnosis of what was ailing American art. For it was virtually impossible for an American artist to live from art at that point. Those who tried, subsisted literally on the edge of starvation—to the extent that an artist like Max Weber was for a time forced to camp out in 291. Indeed, the lives of the American vanguardists had more of the desperation of the lower depths than the color of La Vie de Bohème. Many, like the abstractionist John Covert, renounced painting altogether; others, like Gerald Murphy, a Cubist still-life painter, remained in Europe where the climate was more favorable to the practice of modern art.

The embattled role of modernism in America was both exacerbated and alleviated by the events of the Depression years. On the one hand, the surge of popular feeling that characterizes any such period of social upheaval and change, demanded the expression of popular taste in art. Although government patronage did not exclude abstract art, it was heavily weighted in favor of more conservative and academic styles. The few museums, such as the Whitney, which showed American art, quickly capitulated to the demands for a sentimental, socially-oriented art that seemed expressive of the events of the time. Artists, too, like the American Scene painters, turned their backs on apolitical abstraction in favor of themes that addressed themselves to the immediate social and political realities. Others, like the Magic Realists, created a kind of buckeye Surrealism by painting American subjects in a bizarre fantastic manner.

Certain developments, however, like the emergence of a strong personality like Stuart Davis to take up the banner of abstraction after the Armory Show, aided its development. One might also mention the increased contact between Americans and the European avant-garde, including the spread of Synchromist theories of form and color by Arthur B. Frost on his return to New York in 1914 from Paris where he had known Macdonald-Wright and Morgan Russell. The gradual influx of Europeans that coincided with Hitler's closing of the Bauhaus in 1933, as well as the awareness of a common goal among American abstract artists themselves, which led to the foundation of the group who exhibited together as the American Abstract Artists in 1936, were also important. All these factors contributed to providing a firmer base for modernism in America. Most importantly, however, abstract artists also benefited, although not as much as American Scene painters, social realists and magic realists, from the far-reaching government program in the arts instituted by the Roosevelt Administration.

The original government art agency, created in 1933 to give artists work instead of just handing them a "dole," was modeled on the system of government patronage developed in Mexico. In a letter to Roosevelt urging him to set up such a program, the muralist George Biddle wrote: "The Mexican artists have produced the greatest national school of mural painting since the Italian Renaissance. Diego Rivera tells me that it was only possible because Obregon allowed Mexican artists to work at plumber's wages in order to express on the walls of the government buildings the social ideals of the Mexican revolution. The younger artists of America are conscious as they never have been of the social revolution that our country and civilization are going through; and they would be very eager to express these ideas in a permanent art form if they were given the government's cooperation."

With the example of the Mexicans and the Renaissance fresco painters in mind, Biddle maintained "that our mural art with a little impetus can soon result, for the first time in our history, in a vital national expression." Roosevelt was slightly less convinced than Biddle; disturbed by Diego Rivera's portrait of Lenin in the mural Rivera was painting at Rockefeller Center (later covered over by the Rockefeller family), Roosevelt said that he did not want "a lot of young enthusiasts painting Lenin's head on the Justice Building." Rivera's presence in the United States helped to draw attention to the art of the Mexican muralists, for which the Americans already felt considerable enthusiasm, since it appeared to solve the crisis plaguing American art: how to create an epic national style not necessarily incompatible with modernism, but not slavishly devoted to French models either.

Edward Bruce, a painter as well as a lawyer, was appointed director of the Public Works of Art Project. Regional directors were also appointed in order to spread the

government commissions all over the country. Nearly 4,000 artists produced over 15,000 works of art during the five months of 1933 that the Public Works of Art Project functioned. Naturally, government patronage did a great deal to solidify the position of the Regionalists and American Scene painters, because these were the artists commissioned to paint mural projects and to decorate the new public buildings in Washington such as the Justice Department and the U.S. Post Office. Selected for these commissions were American Scene painters Thomas Hart Benton, George Biddle, John Steuart Curry, Rockwell Kent, Reginald Marsh, Henry Varnum Poor, Boardman Robinson, Eugene Savage, Maurice Sterne and Grant Wood. All of these artists painted in a more or less realistic style whose sculptural illusionism was badly adapted to wall decoration. Many were influenced by the Mexican mural painters. Typical of the grandiose themes chosen were Boardman Robinson's pseudo-classical Menes, Moses and Hammurabi executed for one of the entrances to the Justice Building. Needless to say, neither the accomplishment of the Renaissance masters nor even those of the contemporary Mexicans were approached by such artists.

Of the several New Deal programs in the arts, the most important by far was the art project of the WPA. From 1935 to 1939, the Federal Art Project of the WPA provided work for thousands of artists. The director of the WPA Art Project was Holger Cahill, a critic and

Patrick Henry Bruce (1881-1937). Painting, 1930. (35×45¾″)
Collection Whitney Museum of American Art, New York.

authority on American folk art and former Museum of Modern Art curator. The great project inaugurated by Cahill to catalogue, classify and illustrate the minor arts in America, the Index of American Design, not only gave work to many artists hired to illustrate it, but drew attention to the high level of accomplishment achieved by American craftsmen. Obviously some artists like Peter Blume, whose early style was deliberately naive and primitive, and Grant Wood, who also cultivated an ingenuous manner, must have been impressed with the greater attention given to craft and simple folk art in the thirties, which seemed to many critics like Dana and artists like Sheeler to be the authentic art of America.

Over 2,000 murals were painted by artists commissioned by the United States government during the Depression. Most were mediocre compromises with academicism in a heavy-handed dull illustrational style that had neither the authority of academic art nor the unpretentious charm of illustration. Two of the few exceptions were Willem de Kooning's modest sketch for a Williamsburg housing project that was never executed, and perhaps the single substantial work to come out of the program, Arshile Gorky's mural *Aviation: Evolution of Forms Under Aerodynamic Limitations*, painted for the Administration Building at Newark Airport. Interestingly enough, Gorky's ten-panel work was not a true mural painting at all, but a series of oil on canvas easel pictures. Like Stuart Davis's *History of Communication* painted for the 1939 World's Fair in New York and Thomas Hart Benton's project for a cycle illustrating American history, Gorky's idea was to paint an epic theme, only he chose to do so as a pure abstraction. Painted in 1935-1936, the panels, which were destroyed during the war and exist only in sketches, took note of the special conditions of mural painting, even if actually they were nothing but an extended easel painting. Unlike the American Scene muralists, Gorky believed that the "architectonic two-dimensional surface plane of walls must be retained in mural painting." He found this a problem, since he wanted to represent the "unbounded space of the skyworld of aviation." Finally he decided to represent forms as if seen from an air view to achieve the desired degree of flatness, since seen from above, all objects look flat.

Artists accepted for the WPA program on the basis of an examination which certified their training and skill as painters were assigned to execute murals in various public places like bus and train stations, post offices, banks, schools and radio stations. Those whose styles were not appropriate to such commissions were attached to the easel painting project, and received an average of $95.00 a month to live on. In this way, many of the greatest modern American artists, such as Arshile Gorky, Willem de Kooning, Ad Reinhardt, Mark Rothko, Adolph Gottlieb and David Smith were assured of a living. For the first time, they were allowed to focus all their energies on their art and to paint full time. The importance of this possibility cannot be overemphasized. Jackson Pollock, for example, worked on the easel painting project as long as it was in operation, from 1935 to 1943. In those years, he was free to explore a number of styles, both representational and abstract, ranging from Benton's neo-Baroque style to an expressionist manner inspired by the Mexican muralists Orozco and Siqueiros, both of whom visited the United States and impressed Pollock with their virile monumental forms. By the time the WPA ceased to function, however, Pollock had begun seriously to study the Cubism of Picasso and the automatism of a Surrealist like André Masson, eventually to combine the two in paintings of mythic themes that seem, despite their obvious debt to French art, to be wholly original inventions.

Although the quality of the work produced by the WPA art project was not high in most instances, the program had many positive consequences. It allowed artists to paint full time, to think in ambitious terms about decorating large spaces, to feel themselves to be accepted members of society, rather than useless Bohemian outsiders in a utilitarian materialistic culture. Traveling shows organized by the WPA brought art to remote places in the country, where many had never seen a real painting or sculpture before. Like the publicity attending the Armory Show, the WPA program helped to disseminate art images throughout the country and to stimulate general interest in art among people who had never had the time or inclination to think about art before.

Despite the opportunity to devote themselves to painting, however, most abstract artists were in a desperate situation, not only in terms of little money and non-existent sales, but in terms of the limited and discontinuous development of modernism in the United States. Unable to believe in the sentimental, story-telling art of the American Scene painters, they could not look to the American tradition of realism either. As a result, they began to draw their inspiration directly from the works of the School of Paris painters they could see at A. M. Gallatin's Gallery of Living Art, installed at New York University, at the Museum of Non-Objective Painting founded by Solomon R. Guggenheim in 1937 to house his astonishing collection of works by Kandinsky, and at the Museum of Modern Art, where, beginning in 1929, the greatest European modern masters were exhibited. Realizing that their own tradition was not strong enough to build on alone, young American artists began to study the modernists like Picasso and Braque as the American Scene painters were studying the Old Masters in an attempt to emulate their forms and techniques. One must see both these efforts—that of the modernists to assimilate the advances of the School of Paris, and that of the Regionalists to imitate the compositions and meticulous detail of the Old Masters—as related, and as equally desperate reactions to the feeling that the American tradition in and of itself was inadequate to create a monumental style or a grand manner. For the aspiration toward a heroic style, a grand manner that could in its ambition and achievement rival the finest creations of European art, was the single common denominator among the heterogeneous groups of artists working in America during the Depression.

This aspiration is perhaps the most persistent and important single characteristic distinguishing artists of the thirties from earlier twentieth-century American artists who were dedicated to an intimate personal art, rather than to achieving a public style. There was the general feeling, although there was not yet the means to realize such a feeling, that it was time for American art to come of age, to take its place among the great national schools. But the maturation of American art that took place in the thirties in the context of massive social, political and economic unrest and change was a painful and slow process, which extracted an enormous price from the artists engaged in it. Often, they were discouraged.

Lee Krasner, who later married Jackson Pollock, one of the original members of the American Abstract Artists, recalls a meeting Gorky called in his Union Square studio in the late thirties. "We must admit we are defeated," she remembers Gorky saying to a group of avant-garde artists which included the young Willem de Kooning, who had arrived a decade earlier from Holland. Gorky's solution was that, since in his estimation none of them alone was capable of producing a masterpiece, they should pool their talent and create a collective work of art. Although the project never materialized, Gorky and his friends eventually found the courage to paint their own masterpieces; after the moment of crisis passed they gained confidence in their own abilities to take up where the School of Paris left off.

Although there were few links between the first wave of American modernists and the painters of the fledgling New York School, Gorky's friendship with Stuart Davis constituted one such point of contact. Davis, who had exhibited several small watercolors in the Armory Show as a nineteen-year-old prodigy, was the first American artist programmatically to set out to master the formal basis of Cubism, as opposed to merely imitating its surface look, and to marry it to specifically American subjects. Disenchanted with Ashcan School realism and with the teaching of Robert Henri with whom he had studied, Davis rejected Henri on the grounds that he had brushed aside the old academic practices without laying the groundwork for a new tradition. This was an important realization because the search for a tradition within which to work was the great quest for all American artists during the thirties, including Davis. An outspoken maverick, Davis, however, refused to take the easy way, to work either within the by that time firmly established Ashcan School approach as it was being updated by John Sloan, Kenneth Hayes Miller and Yasuo Kuniyoshi at the Art Students League; or to attempt, like the Regionalists, to create an eclectic style marrying illustrational subject matter to academic technique. Davis admitted he did not "spring into the world fully equipped" to paint as he wished. Even so, by the time America entered

Stuart Davis (1894-1964). Swing Landscape, 1938. (85½×173½")

World War I, the precocious Davis was already painting Cubist abstractions. Like so many Americans including abstractionists like Arthur Dove and Ad Reinhardt, Davis started out as a cartoonist and an illustrator. Because he was trained as a Henri student to wander about the city sketching his impressions, Davis developed a special feeling for urban subjects early in his life. For him, as for artists as wildly divergent as Joseph Stella and Franz Kline (as well as European painters like Léger), the city, with its bright lights, frantic tempo and powerful structures, was the modern theme par excellence.

Indiana University Art Museum, Bloomington, Indiana.

During the twenties, Davis painted a number of abstract paintings based on labels of commercial products, which in many ways were prototypes for pop art. Like the Precisionists, he sought to imbue unpretentious banal themes with a paradoxical monumentality. The flat, hard-edged forms of the work of Demuth surely influenced Davis during this period. In paintings like *Lucky Strike* (1921), an abstract arrangement based on the label of a package of cigarettes, Davis first used the numbers and letters he would eventually blow up as the dominant decorative motifs of his later paintings. Davis's first entirely abstract paintings,

however, were the "egg beater" series of 1927. In their flat planes, sharp silhouettes and clean mechanical angles and curves, they were clearly related to the purist abstractions of Léger and the geometric painters working in Europe. But in their brash boldness and directness, they have a quality one can begin to speak of as typically American.

In the years following the Armory Show, Davis became the most articulate American spokesman for abstract art. In 1935 the Whitney Museum daringly held an exhibition devoted to abstract painting in America; for the catalogue, Davis wrote an essay on the origins of abstraction in America. He credited the Armory Show with introducing abstract art to the country at large and with breaking the hold of the Academy over American artists, thus freeing them to express themselves in whatever idiom they chose. A dedicated abstractionist, Davis maintained that "Art is not and never was a mirror reflection of nature. All efforts at imitation of nature are foredoomed to failure." He described the relationship of art to nature as parallel lines that never meet. Abstract artists "never try to copy the uncopiable but will seek to establish a material tangibility in our medium which will be a permanent record of an idea or emotion inspired by nature." According to Davis, the most important question one could address to a painting was: "Does this painting, which is a defined two-dimensional surface, convey to me a direct emotional or ideological stimulus?" Davis had understood, as few if any American painters before him, the degree to which "the process of making a painting is the art of defining two-dimensional space on a plane surface." Most American artists were still vainly trying to capture the illusion of three dimensions, copying the natural world rather than seeing, as Davis had learned from the Cubists, that the painting itself represented an autonomous and self-referential reality.

In fact, the issue of painting from nature generally was somewhat confused at this time since the Regionalists and American Scene painters did not paint from nature at all, but instead derived their forms and compositions from older art or sometimes from photographs. Thus Benton copied Correggio and Michelangelo, Grant Wood looked to Holbein, John Steuart Curry created grotesque parodies of Rubens, and Ben Shahn got his inspiration from photographs and poster design. A score of other artists including the leading abstractionists worked from reproductions in European art journals like *Cahiers d'Art*. Only a very few "realists" like John Sloan, Edward Hopper and Milton Avery actually painted from nature, simplifying and editing their impressions to create a plastic unity missing in the randomness of nature. This is one reason their work stands apart in terms of its high quality and sense of conviction from the great majority of twentieth-century American realists.

Despite the greater popularity of realism with the public and with museums, Davis never swerved from his course as an abstract artist. On a trip to Paris in 1928-1929, he began using figurative elements again; but these were flattened now into two-dimensional decorative patterns. Returning from Paris to New York, he said he could "spike the disheartening rumor that there were hundreds of talented young modern artists in Paris who completely outclassed their American equivalents"; he thought now on the contrary that "work being done here was comparable in every way with the best of the work over there by contemporary artists." Davis's enthusiasm helped to keep up the flagging spirits of his friends in New York like his young neighbor Ad Reinhardt, and the Cubist painter David Smith, soon to renounce painting to become the greatest sculptor in the history of American art. In fact, Davis finally came to regard working in New York as a positive advantage, because New York was the commercial hub of modern life, the center of the incredible energy and dynamism that was fast making America one of the most powerful nations in the world.

Like many American artists during the thirties, Davis was politically active in liberal causes, but he found time to paint a number of large-scale public murals. His best known, a mural painted for radio station WNYC, gave him the opportunity to express his passion for jazz visually in a composition of musical symbols. Jazz, one of the great creative forces in American life, inspired not only Davis as well as Mondrian, who also responded to the "hot" rhythms of boogie-woogie, but artists of the forties and fifties as well, who saw their painterly improvisations as in some way related to the musical improvisations of "cool" jazz.

Andrew Wyeth (1917). April Wind, 1952. (20×26″)
Wadsworth Atheneum, Hartford, Connecticut.

Perhaps the most accurate way to describe Davis is as an abstract American Scene painter. His jagged shapes, loud colors and syncopated rhythms were visual equivalents for the sights and sounds of urban life in America. In the forties, probably under the inspiration of Matisse, Davis brightened his palette and created even bolder and more complex decorative patterns, culminating in his highly sophisticated abstractions of the fifties and sixties, in which popular imagery is combined with a highly refined sense of color and form.

Davis's example that American subjects could be painted in an advanced modernist style was an important one for many younger artists, who were on the verge of despairing that such a union was possible. Davis was very much present on the scene in downtown New York in the late thirties. With his loud sportshirts, didactic style, and lively intelligence, he was a constant inspiration to younger artists like Gorky, who wrote an article about him in 1931, naming him among those creating "the distinctive art of this century." Significantly, Davis was the single American in the list which included Léger, Picasso, Kandinsky and Miró—clearly the idols of the intense young painters setting out to create their own painting culture with which they hoped to challenge the achievement of the European titans.

According to Davis, the Armory Show was the most decisive moment in his career. He was, of course, not the only American artist to be affected by exposure to Cubism in the

Philip Evergood (1901-1973). The Jester, 1950. (61 × 78″)
From the Collection of Mr. and Mrs. Sol Brody, Philadelphia, Pennsylvania.

Armory Show, although its impact on his work is more evident than it was on the work of other American artists like Walt Kuhn, George Bellows, Guy Pène du Bois and Edward Hopper, who like Davis also exhibited in the Armory Show. Although none became an abstract artist, all began to simplify forms, reducing them to pure geometric volumes, by means of which heads became spheres, arms and legs cones, houses boxes, and trees cylinders. Yet these simplifications had but passing relationship to the formal transforma-tions of Cézanne with his flat faceted planes because they retained their sculptural sense of three-dimensionality. For Davis, as for Dove, O'Keeffe, Hartley, Marin and Maurer, reality was a point of departure; whereas, for the more earthbound realists, unwilling or unable to give their imagination free play, it remained a terminal point as well.

Indeed one of the most prominent features of American taste appears to be its literal-mindedness. The intuitive and subjective were often scorned in favor of the factual and the objective. To such a taste one might attribute the enormous vogue of a painter like Andrew Wyeth, whose photographic style literally reproduces the natural world, down to the last fine hair and blade of grass. Like Hopper and Burchfield, Wyeth paints themes of loneliness and desolation, but his work depends far more on literary anecdotes than on their more poetic images. Because his detailed style requires a high degree of skill not possessed by the

ordinary layman, it has been much applauded and appreciated by the general public, whose respect for the evidence of hard work amounts to an aesthetic prejudice in America.

Other painters whose styles are little more than illustrational reformulations of academic painting are Jack Levine and Philip Evergood. Both artists, like Ben Shahn, achieved a great deal of recognition in the forties while the best American painting, completely unknown to the general public, was being done in sordid lofts below Fourteenth Street. That same public which applauded Wyeth's dry technical art in the fifties and sixties also enjoyed the rich story-telling content of Levine's and Evergood's work. Both Levine and Evergood were livelier and juicier painters than Wyeth; but like him and like so many of

Jack Levine (1915). The Three Graces, 1965. (72×63″)
The Honorable and Mrs. William Benton, Southport, Connecticut.

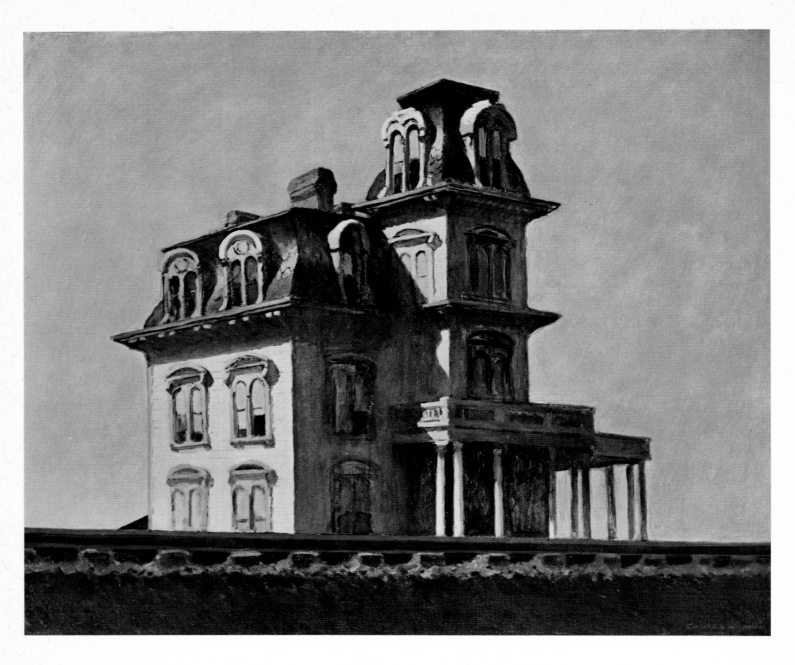

Edward Hopper (1882-1967). House by the Railroad, 1925. (24×29″)
Collection, The Museum of Modern Art, New York.

their contemporaries, they also tried to base their work on art historical precedents. Levine's *Three Graces* is a lumpish proletarian reformulation of the great classical pagan theme that occupied so many aristocratic Renaissance and Baroque artists. Evergood's religious symbolism created a complex iconography with Surrealist overtones, although his style was considerably modernized under the influence of the German Expressionist Max Beckmann, who, like the Dada master George Grosz, came to live and work in America where they inspired many socially conscious artists like Evergood.

One group of artists active in the thirties turned realism inside out to create highly eccentric images in a style allied to American Scene painting, Precisionism and ultimately to academic Surrealism. The bizarre style of such artists as Peter Blume, Ivan Albright, Louis Guglielmi, Eugene Berman and George Tooker came to be known as Magic Realism. Carrying their personal fantasies to extremes in weirdly distorted images, Albright painted rotting and decaying figures and still lifes and Blume depicted strange juxtapositions in various forms of oddly suspended animation in works like *South of Scranton*. Other painters who created an idiosyncratic personal version of reality with few external references to the

actual world in a style that was nominally realistic were Edwin Dickinson and Morris Graves. Although Dickinson's technique, like that of the magic realists, was related to the academic surrealists like Dalí who had great skill in recording visual data but little ability to transform it formally, his images were intensely romantic in an almost nineteenth-century sense. Like Albright's scabrous creatures, Dickinson's misty figures looking as if they were covered with cobwebs evoke a sense of decadent morbidity. Morris Graves, on the other hand, a Northwest Coast painter interested in Vedanta, specialized in depicting mysterious birds who seem to serve as mystical metaphors for the secrets of nature. In some respects, one can see the development of such idiosyncratic styles and hermetic images as yet another consequence of the isolation in which the American artist traditionally worked.

Isolation *per se* is the dominant theme of Edward Hopper's work. But Hopper is a sufficiently profound artist to have been able to generalize the sense of loneliness and alienation felt by many Americans into a universal theme. Unlike the magic realists, Regionalists and American Scene painters, Hopper did not attempt to revive the techniques of past epochs like the Renaissance or the Baroque; instead he set his mind to developing a severe laconic style compatible with his homely imagery and content. Like the magic

Edward Hopper (1882-1967). Tables for Ladies, 1930. (48¼×60¼″)
The Metropolitan Museum of Art, New York. George A. Hearn Fund, 1931.

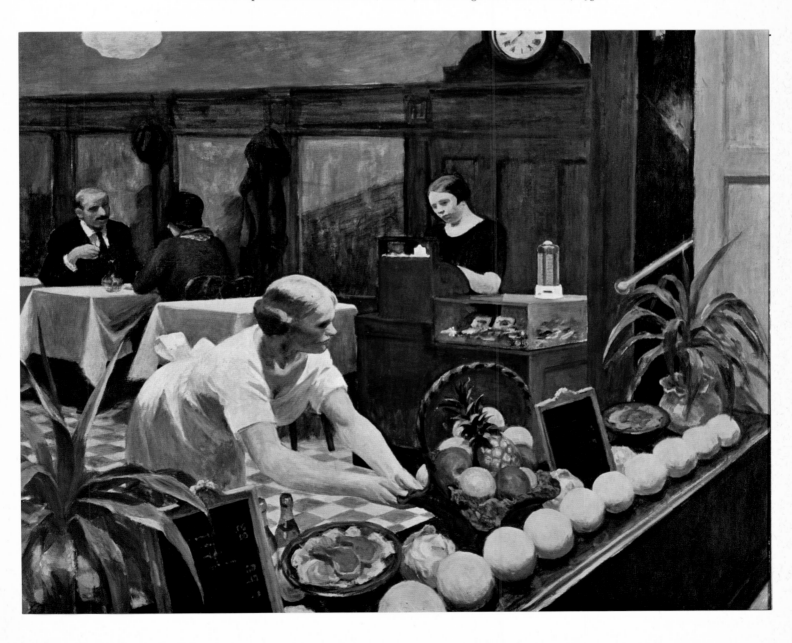

realists, however, Hopper often casts a chill over his figures, frozen as if for eternity in their rigid fixed poses. In Hopper's work, each stroke counts, and serves to depict a form with economy and conviction. There is no surplus of effort, no surfeit of detail to please the literal minded. Hopper, unlike the majority of American realists of the thirties, would not compromise with the sentimental. His lonely office workers, aging couples and desolate filling stations speak of the depressing banality of the democratic experience; but they do so with a poignancy and compassion that elevate their subjects to dimensions far beyond their petty sufferings.

Hopper's painterly style, in which broad masses of light and shadow are juxtaposed to create a firmly constructed world of solid, massive shapes, distinguishes him as an outstanding American painter. His modest pictures, in renouncing any claim to the heroic, nonetheless create a very stable and permanent world. In Hopper's treatment of banality, however, there is none of the ironic mocking of the Precisionists, or even the double-edged treatment given American themes by Grant Wood, but a real feeling for the ordinary working people who eat in cafeterias and all-night snack shops and live in furnished hotel rooms, whose life is brightened by no great moments or dramatic climaxes, a genuine empathy for those who find their few moments of comfort or amusement sunning themselves on simple porches or taking in a movie. Even an empty room for Hopper can be a theme pregnant with meaning. In Hopper's painting, the American Scene at last achieves dignity and relevance to the human condition in general.

Hopper was, like all the best American artists of the twentieth century, acutely aware of the standard set by French art, but he was also committed to making a statement about America. Surely his art owes a debt to Manet, although he far preferred Eakins' art to that of any Frenchman. As a young man, Hopper had made several trips to Europe, but he recalled that when he was in Paris in 1906, he for the first time had heard of Gertrude Stein, but not of Picasso. After painting a series of pointillist pictures, he gave up what he deemed to be a French style. By the time he exhibited *Sailing*, a solidly constructed painting of a yacht, however, in the Armory Show, he was a committed realist, devoted to the reconstruction of the natural world through formal intelligence. "The question of nationality in art is perhaps unsolvable," Hopper wrote in the introduction to the catalogue of his 1933 retrospective at the Museum of Modern Art. Maintaining that "A nation's art is greatest when it most reflects the character of its people," he called for an end of the domination of American art by French art, which he felt was like the subservient relationship of Roman art to Greek culture. "If an apprenticeship to a master has been necessary," he announced, "I think we have served it. Any further relation of such a character can only mean humiliation to us. After all, we are not French and never can be and any attempt to be so is to deny our inheritance and to try to impose upon ourselves a character that can be nothing but a veneer upon surface."

Although Hopper preached independence from French art and a greater awareness of the American tradition, others took a more extreme position and demanded the total rejection of all foreign influences. The leader and most voluble member of this faction was surely Thomas Hart Benton whose populism, nationalism and isolationism made him the hero of all who would turn the clock back to earlier, simpler times, when America was a rural society not yet engaged in world politics, or in the search for an international style. Born in Neosho, Missouri, Benton eventually turned against urban culture, as well as modernist aesthetics on the grounds that they were both symptoms of decadence. He wished to create an epic style of bulging muscular forms based on the Old Masters, which would take as its great theme nothing less than the history of America. In order to make an authentic statement Benton felt the artist had to draw on his own experience; and the American experience, he believed, was tangibly different from that of the French. Painting the wheatfields and rolling hills of his beloved Midwest, Benton advised American artists to use subjects drawn from the regions where they were born, as Southern and Midwestern writers were devoted to the regions in which they lived.

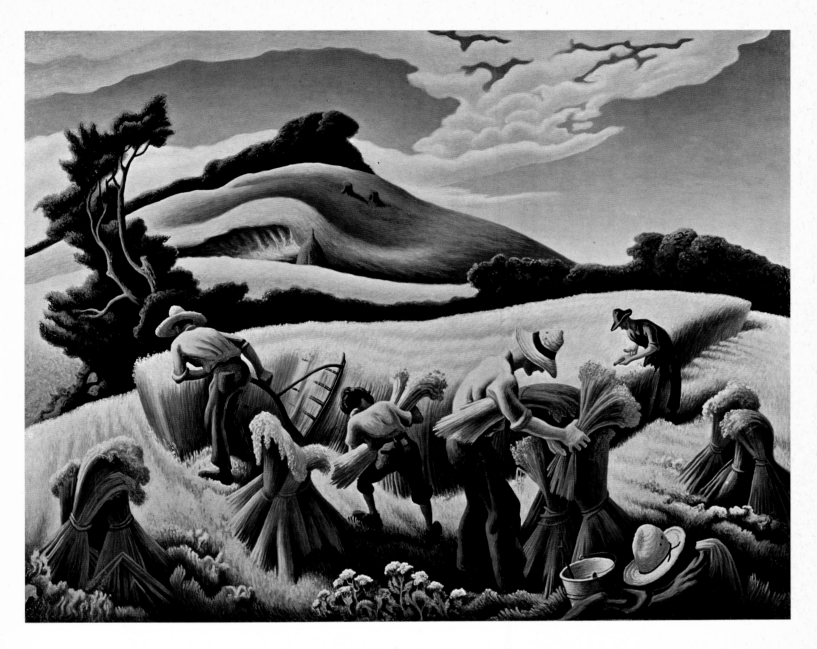

Thomas Hart Benton (1889-1975). Cradling Wheat, 1938. (31 × 38″)
Courtesy of City Art Museum, St. Louis, Missouri.

As the ranks of American artists swelled, it was natural that the East Coast monopoly on American culture could not last. Artists came out of the West, the Midwest and the South, and they brought with them new themes and new ways of looking at the world. Today these differences are often smoothed over as young artists from the interior of the country are quickly assimilated to the New York scene; even so, certain areas still continue to produce a strong regional style with characteristics recognizably different from the New York School. Examples of such current regional schools are the Chicago school of figure painters, the San Francisco funk artists, and the Los Angeles school of abstract artists includes some of the strongest and most original artists working in America today.

In the thirties, however, these regional schools had not developed, and the values of the East still dominated American art. Benton and other artists like Grant Wood and John Steuart Curry resented this domination. Calling themselves Regionalists, they set out to use the subject matter of American history to create a heroic, monumental, public style of painting. To this end they painted American heroes like John Brown, Paul Revere, and George Washington in works they believed proclaimed themselves as "made in USA."

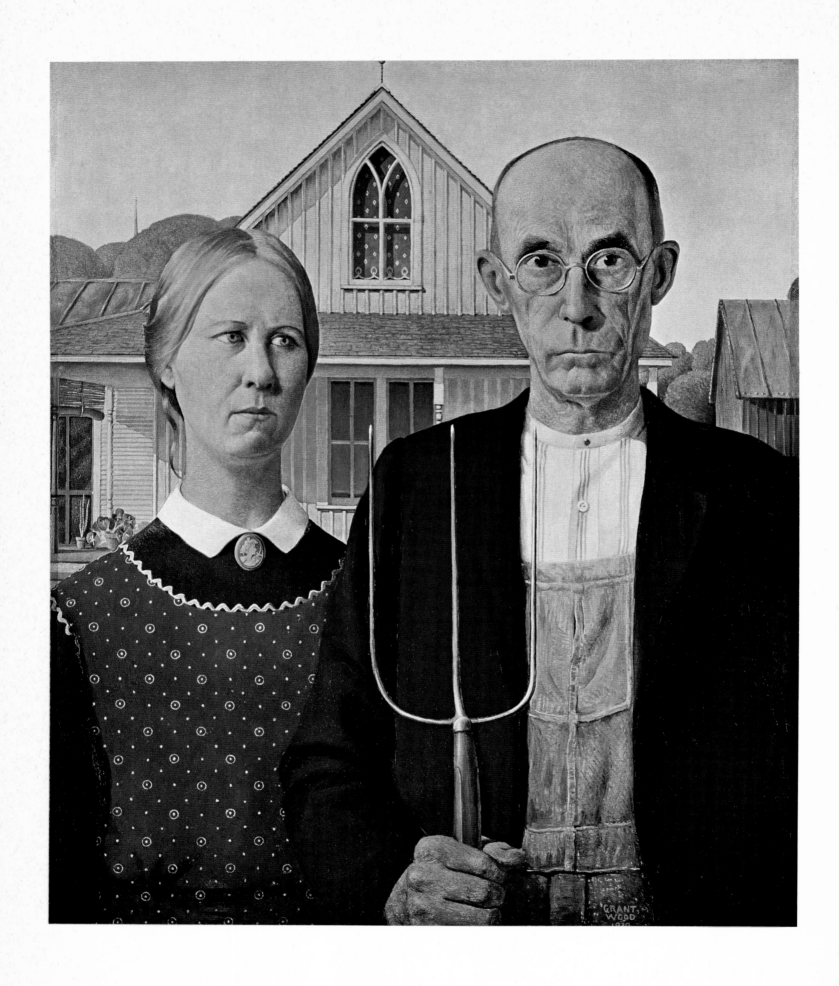

Grant Wood (1892-1942). American Gothic, 1930. (29×24″)
Courtesy of The Art Institute of Chicago, Chicago, Illinois.

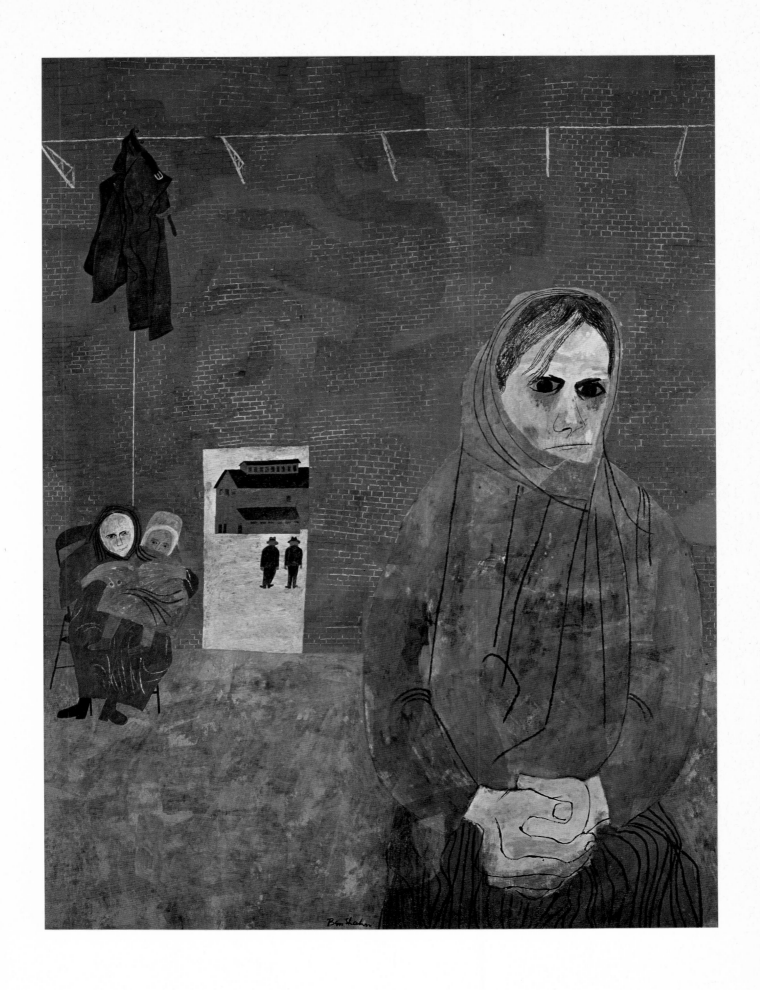

Ben Shahn (1898-1969). Miners' Wives, 1948. (48×36″)
Philadelphia Museum of Art, Philadelphia, Pennsylvania.

Most of the Regionalists, whose numbers were once quite substantial, have been forgotten, and for good reason, since they painted in a dead provincial manner that pandered to the worst elements of popular taste and did nothing to add to the development of American art. The three exceptions were Benton himself, Wood, and Charles Burchfield, a painter who never identified himself as a Regionalist, but whose paintings of the barren life of small towns in America became associated with Regionalism because of their themes.

Benton, a theoretician of some consequence, claimed that his aim was to achieve a "compact, massive and rhythmical composition of forms in which the tactile sensations of alternate bulgings and recessions shall be exactly related to the force of the line limiting the space in which these activities take place." Drawing, for Benton, was the foundation for painting; consequently he was not particularly sensitive to color, and he often created garish and discordant combinations of a flamboyant—and as the success of his paintings proved—popular vulgarity. Through the use of a bold contouring line, Benton hoped to achieve that sense of plasticity and sculptural volume he appreciated in the paintings of the past, which he accurately saw that Cubism, in its development of a shallow pictorial space, had discarded.

But Benton's anti-modernism and anti-intellectualism were deliberately cultivated; his rejection of modern art was not made in ignorance but in conscious awareness of the goals of the modernist, which he ultimately judged antithetical to the needs of a democracy. A former Synchromist who turned against abstractionism as an alien and imported style akin to treason in politics, Benton and his friend and apologist Thomas Craven feared the influence of Communists and homosexuals, which in some manner was associated in their minds with the decadence of modern art. Although it may seem extreme and even amusingly "camp" today, Benton's steadfast position summed up the serious feelings of many Americans who saw their old values and ways of life being swept away, and were determined to make a last stand against internationalism, whether in politics or in art.

Benton happily accepted the term Regionalism, first applied to a group of Southern writers who wrote about local affairs, as an accurate description of his goals. He saw his art and that of the other Regionalists as part of the countrywide revival of Americanism that ensued after the defeat of Woodrow Wilson and his internationalist policies. The new consciousness of American history brought about by the flood of historical writing that appeared during the thirties created a climate in which an art based on self-consciously American themes would flourish. In this context, Benton claimed that the art of the Regionalists "symbolized aesthetically what the majority of Americans had in mind—America itself." He claimed that "The fact that our art was arguable in the language of the street, whether or not it was like, was proof to us that we had succeeded in separating it from the hothouse atmosphere of an imported, and for our country, functionless aesthetics." Sick of what he termed "aesthetic colonialism," Benton attributed much of the success of the Regionalists to the fact that they worked all over the country. He himself, for example, returned to Kansas City to settle. Benton's most important public commissions, however, were painted in New York. They were a series of murals glorifying American life in its various aspects for the New School for Social Research and for the library of the old Whitney Museum of American Art. In these crowded paintings of the typical images of American popular culture, massive muscular figures create a space quite at odds with the flatness demanded by decorative mural art. In their hyper-plasticity, they seem about to burst forth from the compartments that contain them. As art, they are redeemed mainly by the energy and vitality which they express, rather than by any specifically pictorial values.

Grant Wood's slick surface and meticulously detailed technique differed considerably from Benton's style, with its broadly generalized forms, although Wood was as devoted to the depiction of deep space as Benton. Although they are always discussed in relationship to Regionalism, Wood's hard-edged works, his reduction of forms to geometric volumes, and his insistence on craftsmanship really relate his work more closely to Precisionism. The irony of paintings like *American Gothic* or his owl-eyed *Daughters of the American Revolution*

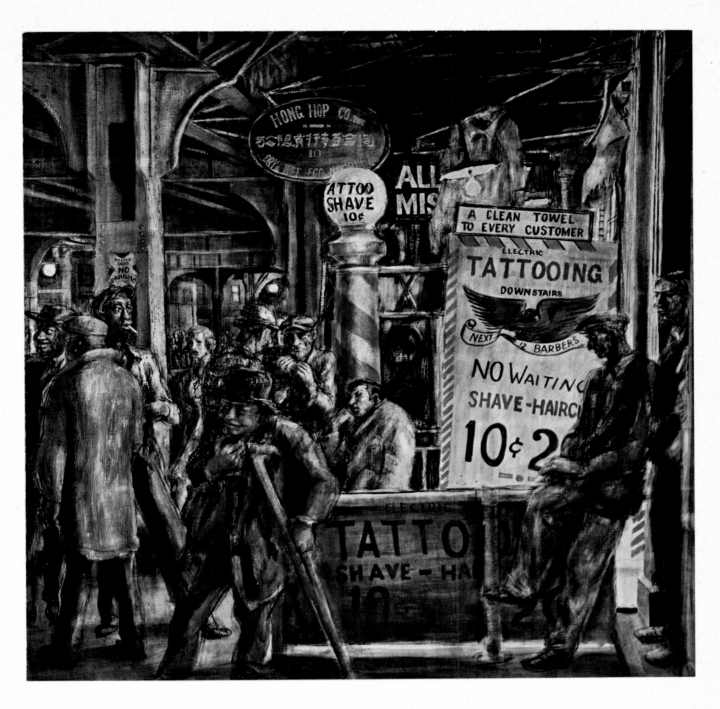

Reginald Marsh (1898-1954). Tattoo and Haircut, 1932. (46½×47⅞″)
Courtesy of The Art Institute of Chicago, Chicago, Illinois.

daintily and myopically sipping tea seems to have been missed by his contemporaries. But now in the light of pop art, one can see that there is already a certain satirical element present in Wood's treatment of American themes.

Charles Burchfield was a better painter than the Regionalists, but his view of life and choice of themes was related to theirs. In an essay on Burchfield's work, his friend Edward Hopper wrote that from "the boredom of everyday existence in a provincial community, he has extracted a quality that we may call poetic, romantic, lyric or what you will." Since Burchfield, like Hopper, wished to make poetry of the prosaic, it was natural that Hopper should feel close to Burchfield's art. Both rejected the hard surface and linear quality of the Regionalists and American Scene painters in favor of a fluid painterly style, in which edges are not drawn but created by broadly applied strokes of paint which model and define form. Their styles are quite different, however, in the contrast of Burchfield's drab color and dryness as compared with Hopper's appreciation of light and a rich surface.

Unlike Hopper, Burchfield did not confine himself simply to depicting what he saw objectively and with detachment. Burchfield's views of empty streets and deserted railroad stations always have something rather askew about them, as if the houses and towns were haunted or inhabited by restless spirits. Burchfield, whose early paintings were based on plant motifs, was primarily a landscape painter, and even somewhat of an expressionist in his exaggeration of fantasy and mood. Like Benton, Burchfield also lived in the Midwest (in Salem, Ohio), but as opposed to Benton's grandiose evocations of American history and his attempt to create an American myth out of rural life in America, Burchfield created a more modest introverted art based on his own private obsessions and fantasies about the ominous forces of nature in their more destructive aspect.

Although he painted brightly colored pictures in his youth, Burchfield's later paintings were characterized by a somber, almost monochromatic palette of greys and browns which seem totally in keeping with the dilapidated and decaying subjects he painted. In fact one might see the prevalence of decaying subjects in American art of the thirties as a symbolic acknowledgment that certain aspects of American life and the American landscape were literally decaying and disappearing, falling apart, as in a sense the society itself was changing under the economic pressure of the Depression.

While the Regionalists painted the countryside and small towns, the city was painted by the urban realists whose styles had much in common with theirs in that they, too, attempted to emulate Old Master technique but ended by having far more in common with popular illustration. Artists like Reginald Marsh, Raphael Soyer, Isabel Bishop and Ben Shahn continued the Ashcan School tradition of searching the city for picturesque themes. They painted tired office workers, street scenes, and Bowery bums in a style that revived many of the characteristics of academic painting, such as foreshortening, chiaroscuro, perspective. Some even attempted to use Renaissance techniques like tempera in the hope of making paintings as great as those of the Renaissance. Unfortunately, all they usually achieved was a pastiche of the styles of the past. The center for this academic illustrational painting was the Art Students League, where John Sloan was the director and Thomas Hart Benton was one of its most influential teachers.

It was here that a young painter from Cody, Wyoming, who was destined to revolutionize not only American painting but world art, came in 1929 to study with Benton. Yet even if one did not know that Jackson Pollock was Benton's student, one look at the raw vigor of Pollock's churning landscapes of the thirties would reveal his debt to Benton and to Benton's notion of Baroque realism. Pollock, however, did not fear French art as Benton did, and eventually his appreciation for Ryder gave way to an even greater love of Picasso. Although Pollock's purpose finally came to be the internationalization of American art, during the thirties he was closer to the American Scene ambiance at the Art Students League than to the growing enclave of experimenters who banded together for mutual encouragement and conversation at Greenwich Village hangouts like Romany Marie's or the Jumble Shop. Eventually Pollock did become part of the group that included de Kooning and Gorky through his friend, the mysterious Russian émigré, John Graham, and through his future wife, Lee Krasner, herself a gifted abstract painter who transmitted her early understanding of Picasso and Matisse to Pollock.

Although Graham left only a small body of work, during the late thirties he was a significant figure in New York avant-garde circles, because he seemed to understand Cubism better than anyone else. In a treatise on aesthetics written in 1937, called *System and Dialectics of Art*, Graham wrote: "No technical perfection or elegance can produce a work of art. A work of art is neither the faithful nor distorted representation, it is the immediate unadorned record of an authentic intellecto-emotional REACTION of the artist set in space." For Graham, the creation of space was the essence of painting: "This authentic reaction recorded within the measurable space immediately and automatically in terms of brush pressure, saturation, velocity, caress or repulsion, anger or desire which changes and varies in unison with the flow of feeling at the moment, constitutes a work of art."

Graham's text must surely have been known to Pollock, de Kooning and Gorky, all of whom were at formative stages in their work when it was published; in many respects it provides the key to the radical reformulation of pictorial values they were engaged in. Graham's dismissal of technique, the absolute *sine qua non* of academic painting, gave comfort to those still struggling to acquire the means they needed to make the paintings they wished to create. Furthermore, it seems clear in many respects, Graham's insistence on expressive content and the automatic record of gesture, his call for speedy execution and authentic reaction, set the stage for the initial "action painting" phase of Abstract Expressionism.

A brilliant, eccentric bibliophile and collector, Graham was a legendary figure who filled his East Hampton home with volumes of occult literature which also must have impressed young artists like Pollock. Along with Hans Hofmann, Josef Albers and Piet Mondrian, three great Europeans who escaped Hitler to take refuge in America, Graham was one of the main channels through which the mainstream of European painting flowed into the United States. Although he was a Picasso imitator in his Cubist works, unlike most, he understood what he imitated, and was able to teach what he knew to his young friends. Graham also understood what the Surrealists were doing in Europe. There are passages in his book which describe Surrealist automatism, a practice of spontaneous form or image creation based on free association, long before any Surrealists arrived in the United States. Graham's insistence on the psychological content of images, which caused him to announce that an artist's "reaction to a breast differs from his reaction to an iron rail or to hair or to a brick wall," surely influenced both Gorky and de Kooning, who were making ambiguous emotional images that could be interpreted in a number of different ways.

Unlike his young friends, however, who dedicated themselves with increasing conviction to the cause of abstractionism, Graham turned away from Cubism around 1940 to create a mystical representational art with academic Surrealist overtones. Gorky, de Kooning and Pollock, on the other hand, became yet more enthusiastic in their appreciation of Picasso, although they were just as wary as the American Scene painters of remaining true to their own experience, which they could see was qualitatively different from that of a European like Picasso.

Although even the early work of Pollock, de Kooning and Gorky looks radically unlike traditional art, all three were united in their desire to graft American art to the European mainstream, as part of a great tradition many centuries old. All studied the Old Masters and copied their drawings and paintings. From Benton, Pollock learned to appreciate El Greco and Michelangelo, making drawings after their work. In fact the flickering quality and loaded surface of Pollock's early work often recalls El Greco. De Kooning admired Ingres, and the agile graceful line he developed reveals how close in certain respects his drawing is to that of Ingres. Gorky, on the other hand, schooled himself by studying the modern masters like Cézanne as well as Ingres.

This attention to drawing is important to remark, because the early work of all three is dominated by the tension between painting and drawing, which are still quite separate entities in their respective works of the thirties. De Kooning's brilliant quicksilver line darts in and out, creating contours which model but sometimes lose the form they bound allowing it to seep through to adjoining areas. Gorky, too, begins to loosen the Cubist grid he has inherited from Picasso; influenced by Kandinsky, he starts to create loosely flowing contours, in which forms melt and bleed into one another and drawing becomes an element discontinuous from painting. Pollock, in his profound struggle to wrest order from chaos, begins to marry painting and drawing in tumultuous images of storm and holocaust, in which paint is thickly brushed on to a surface without regard to creating closed contours or shapes. At the same time, he was turning out endless pen sketches of monstrous personages contorted, superimposed and intertwined like the mythic beasts of some medieval manuscript.

For these artists, the American Scene was too narrow and parochial a theme for great painting. Their conception of the grand manner and a heroic style was not grounded in a

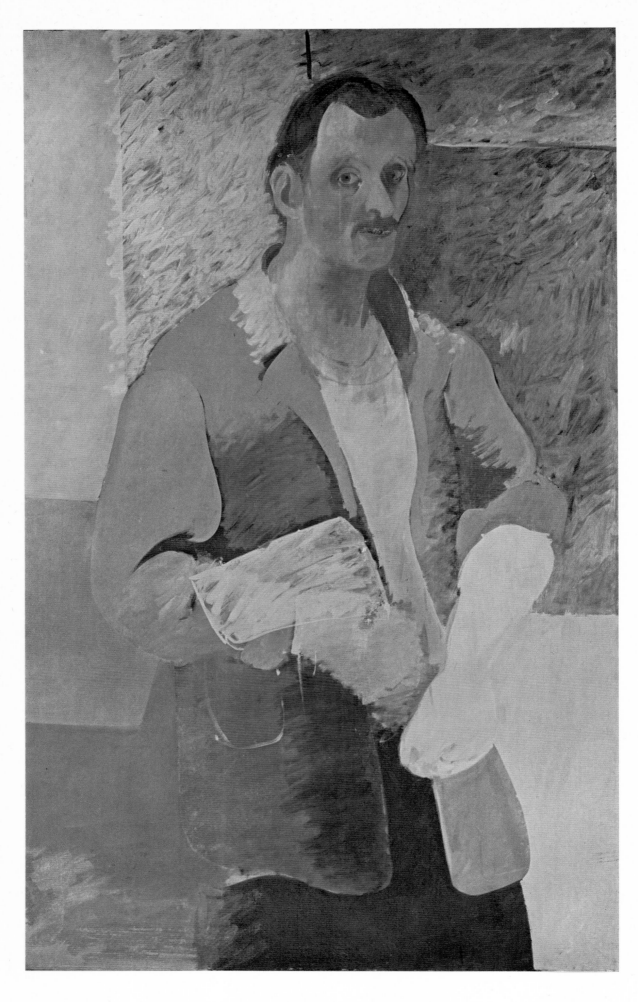

Arshile Gorky (1904-1948). Self-Portrait, 1929-1936. (55½×34″)
Courtesy M. Knoedler & Co., Inc., New York, Paris, London.

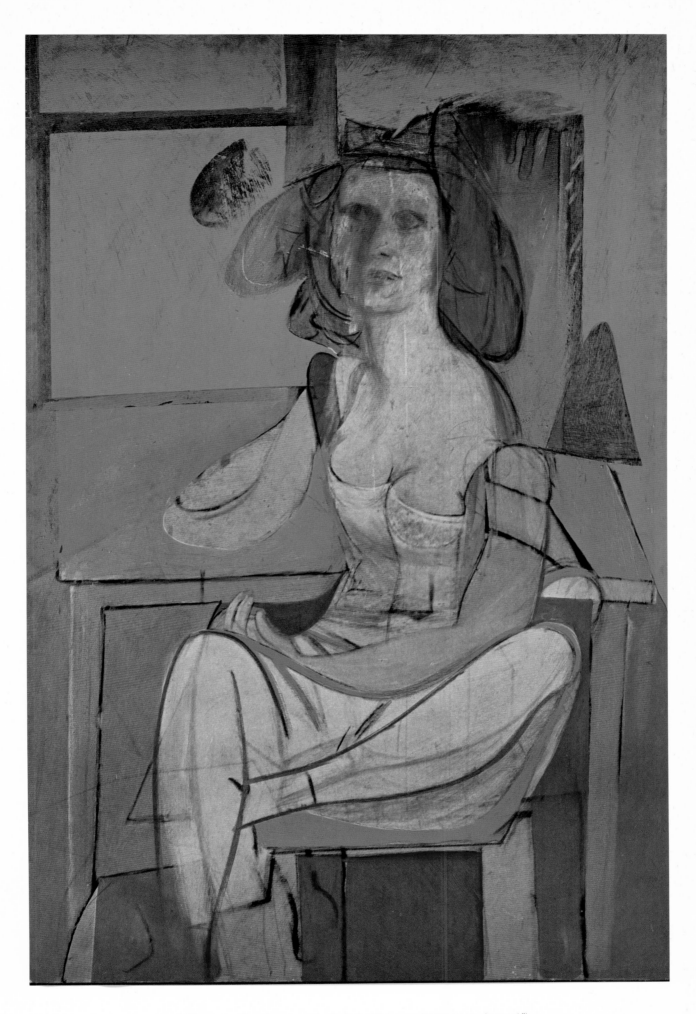

Willem de Kooning (1904). Seated Woman, about 1940. (54×36″)
Collection Mrs. Albert M. Greenfield, Philadelphia, Pennsylvania.

Milton Avery (1893-1965). Seated Girl with Dog, 1944. (44×32″)
Collection Roy R. Neuberger, New York.

sentimental notion of grandeur or in a nostalgic longing for the past, but in a genuine appreciation of the masters, old and new, whose art they wished to rival in terms of its plastic values and its universal content. They educated themselves in Cubism, but found the geometric style of late Cubism dominant in Europe in the thirties too narrow and constraining. And so they began to paint images that literally burst their linear confines, spilling over into one another and destroying the regularity of geometry. Their attempt to break down the rigid structure of Cubism in favor of a more fluid space and a broader, more painterly style affected other young abstract artists, too, like Richard Pousette-Dart, Giorgio Cavallon, George McNeil and John Ferren, who were also struggling to create convincing abstractions in the thirties.

The uphill battle of this group was greatly aided by the appearance of Europeans, either as visitors or as refugees. Matisse, Miró and Léger were all in America during the thirties and forties—Matisse to paint his murals for the Barnes Foundation; Miró to work at Stanley William Hayter's Atelier 17, an etching shop transferred from Europe to New York during World War II where Pollock and Motherwell also worked; and Léger to paint a never-completed mural for the French Line. The presence of the geometric painter, Jean Hélion, whose precise purist forms influenced Reinhardt, Ferren and conceivably Stuart Davis, was also an important stimulus to the development of abstract art in America.

Although Matisse apparently did not meet any of the younger American artists during his brief visit, his work became an important influence, even if that influence remained more or less underground until the fifties and sixties, when American painting became primarily a color art. The presence of an early Matisse of bathers in the lobby of the Valentine Gallery also made an impression on the small group of avant-garde artists because of its large scale, high color, and bold simplifications. It suggested the possibility of a decorative painterly style on a scale Americans were not ready to attempt for another decade.

In the thirties, however, Milton Avery at least seemed to be aware of Matisse's emphasis on color and decorative patterning, which he adapted into a highly personal and more intimate style of figure and landscape painting. Avery claimed to "strip the design to essentials." His attitude toward nature was somewhere in between that of Davis and that of Hopper, although he had no interest in specifically American or urban themes; his was a quiet bucolic style rather, although he asserted that "the facts do not interest me as much as the essence of nature." Avery's restrained landscape and figure studies, with their emphasis on color relationships and flatness were an inspiration to two young men destined to become perhaps the greatest colorists in the history of American painting, Mark Rothko and Adolph Gottlieb. When Avery died in 1965, Rothko reminisced about Avery's relationship with younger painters such as himself who often visited him in his studio. "We were, there, both the subjects of his paintings and his idolatrous audience," Rothko remembered. "The walls were always covered with an endless and changing array of poetry and light." Of Avery's limited repertoire of intimate themes, Rothko wrote that Avery painted "his living room, Central Park, his wife Sally, his daughter March, the beaches and mountains where they summered; cows, fish, heads, the flight of birds; his friends and whatever world strayed through his studio; a domestic, unheroic cast." Avery was an exception among American artists of his generation in his rejection of the public world of social art for the private world of the family. According to Rothko, Avery's seemingly modest arrangements of color and light "far from the casual and transitory implications of their subjects, have always a gripping lyricism, and often achieve the permanence and monumentality of Egypt."

Color and light, which would come to be the subject of Rothko's work, were also the basis for the art of Hans Hofmann and Josef Albers, two German-born artists who settled in the United States during the thirties. Both were great teachers as well as important painters, and their respective aesthetic theories informed several generations of American artists. In the art school he opened on Eighth Street in 1934, Hofmann continued the educational program he had taught in Munich. His method was based on his celebrated

Hans Hofmann (1880-1966). Cathedral, 1959. (74×48″)
Private Collection, Shaker Heights, Ohio.

"push-pull" opposition. According to Hofmann, the essence of painting was the balancing out of certain types of pictorial tensions caused by spatial pushing and pulling at the plane of the canvas, created by color and form relationship. Downgrading the purely intellectual and theoretical in favor of the intuitive and sensuous, Hofmann stressed the instinctual and the spontaneous—qualities that puritanical American painting had seldom been able to embrace. Hofmann's notion about the nature of pictorial space was far more complex than that of either a geometric painter like Davis or a realist like Hopper. He permitted an illusion of three-dimensional depth to be created, provided that an opposing force pulling the eye back to the surface plane could be created. If this balance between the assertion of the flatness of the surface plane and the illusion of depth could be sustained, then a complex and new kind of space that was neither like the bas-relief space of Cubism or the full relief of older art could be created.

Many artists who were not actually students of Hofmann's attended his lectures, where according to Clement Greenberg "you could learn more about Matisse's color . . . than from

Josef Albers (1888-1976). Homage to the Square: Ritardando, 1958. (40 × 40″)
Collection Roy R. Neuberger, New York.

Matisse himself." But none saw a painting of Hofmann's until his exhibition in 1944 when he showed intensely colored painterly abstractions. Since then, the work he did in the thirties has been seen; as one might have expected, Hofmann married Cubist forms to Fauve color in a series of still lifes. Another artist who mixed elements of Cubism and Fauvism in an original manner was Arthur B. Carles, whose rhythmic compositions seemed to anticipate the loose painterliness of Abstract Expressionism.

Although somewhat older than the Abstract Expressionists, Hofmann kept pace with their work, and often set that pace himself. In the fifties he showed billowing baroque abstractions or freely improvised gestural "action" paintings like his young colleagues. Beginning in the late fifties, however, Hofmann's painting flowered, and he painted in several manners at once. In one style, he freely improvised, creating gay linear motifs and bursts of paint which danced across loaded surfaces, illustrating his belief that a painting had to have movement above all if it was to live. In his alternate severely architectonic style, he covered the surface with thickly painted rectangles of pure color. Sometimes these flat areas were floated on an illusionistic ground; at other times they were locked together as in *Cathedral*, one of Hofmann's late masterpieces, to form an impassive opaque façade which stressed surface more than depth.

Although Josef Albers was a more methodical and less romantic painter than Hofmann, whose uninhibited style immediately found favor with the expressionists of the New York School, his influence was enormous as well. Albers, like the painter and designer Moholy-Nagy, and the architects Walter Gropius and Mies van der Rohe, fled Germany when the Bauhaus was closed. The first of the Bauhaus faculty to arrive in New York, Albers came to America in 1933, where he was determined to continue the radical program of art education propounded at the Bauhaus, which had sought to replace worn-out academic training with schooling that would not crush the free spirit of modernism. Toward this end, he founded the now famed Black Mountain College in the hills of Asheville, North Carolina, the same year that he arrived in America.

Black Mountain College was at the same time the most radical experiment in education undertaken in the United States until the present, as well as the most important art school, in terms of what developed out of the contacts that took place there, in the history of American art. Freer than the Bauhaus, Black Mountain had no structured curriculum, although Albers taught a "trial and error" method derived from the Bauhaus basic course which stressed color and design as abstract principles, to be organized by the artist in terms of their spatial and emotive relationships. Among the distinguished alumni of Black Mountain were Robert Rauschenberg and Kenneth Noland, two of the principal artists of the sixties, as well as the sculptor John Chamberlain. Other artists like Helen Frankenthaler often drove down from New York to visit. The Black Mountain faculty in the forties and early fifties had such distinguished members and visiting lecturers as Robert Motherwell, Willem de Kooning, Clement Greenberg, Merce Cunningham, John Cage and Buckminster Fuller. In fact it might not be going too far to maintain that virtually every creative idea that later emerged in American art of the sixties had its origin at Black Mountain.

The main thrust of Albers' teaching was that head, heart and hand had to be organized into a single unity. He wished to give his students a firm understanding of technique without destroying their creativity and spontaneity, however. He held that "knowledge does not destroy spontaneous work, rather it creates a solid base for it." It may in fact have been Albers' emphasis on knowledge, logic and thoroughness that allowed Rauschenberg and Noland to become the first of the younger or "second generation" New York School painters to react against the ambiguity and contradictions in Abstract Expressionism which could only be resolved by changing the formal basis of painting. Albers maintained he wished "first to teach the student to see in the widest sense, to open his eyes to the phenomena about him, and most important of all, to open his own living, being and doing." His wife, Anni Albers, taught the materials classes in which problems, mainly derived from Johannes Itten's original basic design course at the Bauhaus, were given to students

involving the combination of natural and synthetic materials. The purpose of these exercises was to see how "the material sets up its own limits for the task of the imagination." Rauschenberg's use of raw materials in his first audacious constructions as well as Noland's focus on the interaction of adjacent colors can perhaps both be traced back to approaches they learned as Black Mountain students.

After Albers left Black Mountain in 1950 to become the chairman of the Yale art department, the school soon closed, not only because Albers was no longer there to direct activities, but because New York had become too exciting, and artists did not want to live elsewhere.

Although in certain respects their teaching was related in its stress on form, color and materials, Hofmann and Albers differed in terms of their attitude toward discipline and fundamentals. Hofmann, who had never been at the Bauhaus, felt that the Bauhaus approach was too rigid and theoretical. He taught freedom of expression, speed of execution, and assertive paint application with an emphasis on surface, both as plane and as matter. His way won out for the fifties, but Albers' more methodical and logical approach finally triumphed in the sixties, after the gestural manner of Abstract Expressionism had played itself out. Obviously neither Hofmann nor Albers, as Europeans, was concerned with creating an "American" style; their schools were the very antithesis of the Art Students League, and their teaching a much needed corrective to that of John Sloan and Thomas Hart Benton, who were far better known in the thirties, however. This is not to say that Sloan and Benton were not important teachers; Sloan had an open mind and an understanding of Cézanne which he preached even if he himself did not quite practice it. And if only for what Jackson Pollock learned from him about the Old Masters, Benton was an important figure.

Thus one of the most important things that happened in America during the thirties was that a generation of American artists were being educated, both formally and informally, to understand a tradition they had as yet never possessed, except perhaps in the instances of isolated individuals like Eakins and Ryder. By the time World War II broke out, and scores of European artists arrived in New York, Americans had learned their lessons well and were willing and able to assimilate what further lessons the Surrealists, Cubists and Constructivists could teach them. Although many were still struggling with technique, color and the elements of design, others had begun to master their craft, and to raise it to a level few if any had achieved in America. Besides learning painting culture and achieving an understanding of the aesthetic basis of modernism, American artists were becoming more self-conscious about turning their limitations into assets. If American art had been crude, then they would cultivate directness; if it had been raw, then they would deliberately seek spontaneity and the "unfinished"; if it had been idiosyncratic, then they would insist even more forcibly on their own individualism. Although they might paint, like the early American modernists, a private inner vision, no longer would they be modest and humble in ambition like the Precisionists. For another crucial change that came about in the thirties was that not only was the level of painting upgraded, but the level of ambition ascended to heights it had never scaled in the history of American art. Rejecting American Scene painting as too narrow, provincial and particular, they were determined to create an art that could hold its own with the art of the museums as well as with that of the modern masters they admired and began by imitating. American artists faced the new challenge they had set before themselves with both trepidation and excitement. Before they could achieve their goal, however, they had to, as Barnett Newman put it, find a subject worth painting. Usually, that subject was their own sense of self, their own intensely personal conception of the world and nature and their own feelings and responses to that world.

Arshile Gorky (1904-1948). The Betrothal, II, 1947. (50¾×38″)
Collection Whitney Museum of American Art, New York.

The New York School

ALTHOUGH there is no specific hour one can point to as that of the nascence of the New York School, as the group of American painters who revolutionized world art came to be known, the opening of Peggy Guggenheim's Art of This Century gallery in 1942 constitutes one of the most important dates in its early history. When the war broke out in Europe, Miss Guggenheim, niece of the celebrated Kandinsky collector, Solomon R. Guggenheim, and later the wife of Surrealist Max Ernst, was forced to flee. She had already begun to collect in London many Cubist, Futurist, Constructivist and Surrealist paintings and sculptures toward the end of opening a museum of modern art. In Paris on the eve of the German invasion, she bought a work of art a day aided by Howard Putzel, an art dealer with a respected eye who later worked for her finding new talent in New York.

With the Germans literally on her heels, Miss Guggenheim transported across France her cache of works by artists such as Braque, Léger, Picasso, Severini, Delaunay, Brancusi, Arp, Miró and Schwitters—in short the leaders of every non-realist art movement of the twentieth century—which she had acquired for a modest $40,000. If she had done nothing but support Jackson Pollock for five years after the Federal Art Project folded, Peggy Guggenheim would have been one of the leading heroines of American art. But she accomplished far more than saving America's greatest innovator from poverty; her gallery, Art of This Century, was once again, like the Armory Show and Stieglitz' 291, a place where American and European modernists exhibited together. Only by this time, Americans who exhibited there, like Rothko, Still, Pollock, Motherwell, Baziotes, Hofmann and Gottlieb had absorbed a sufficient amount of European painting culture to compete with the modern masters on their own terms.

The opening of the gallery, held for the benefit of Red Cross war relief in October 1942, was, like the Armory Show, a sensation. Decor was by the eccentric avant-garde architect Frederick Kiesler, who created a startling environmental setting for paintings by the leading European modernists, which were suspended, unframed, in mid-air by means of rods. Kiesler, one of the original members of de Stijl, had also known Schwitters in Germany, and was an important and continuing link between early experiments in environmental art begun in Europe and those realized in New York in the fifties.

Her eye educated by Duchamp and Ernst, Miss Guggenheim was able to recognize the genius of the most radical young New York painters at a time when few, if any, had the slightest inkling of the meaning of the new art developing in the abandoned manufacturing lofts below Fourteenth Street. Of the European works exhibited at Art of This Century,

perhaps the most influential, in terms of their impact on the young Americans who also showed there, were the works of Kandinsky, Miró, Klee, Arp and Masson. During the thirties, abstract painters in America had been heavily indebted to the strict geometric abstraction of the purists and constructivists and to the hard-edged angular shapes of synthetic Cubism, especially as it was practiced by their hero, Picasso. But these generally "classical" styles, in their formality, restraint, closed forms and precisely delimited shallow relief space, did not satisfy the American appetite for a flamboyant all-out expression, a sense of physical presence and motion, and, probably most important of all, an intense romantic imagery. The freely improvised drawing and more ambiguously open space of Klee, Kandinsky and Miró provided the Americans with examples of liberated styles, which appealed to their instinct for individual self-expression and romantic gesture; on the other hand, their dislike of anything that seemed based on a preconceived and predictable formula drew them to Masson's early use of automatism to create spontaneously generated images drawn in paint. The final important ingredient in the initial phase of Abstract Expressionism was the vocabulary of bulbous organic forms based on nature known as biomorphic shapes originally developed by Arp.

This so-called "biomorphic" or surrealizing phase of Abstract Expressionism which took place during the forties encompasses the mature works of Gorky, Gottlieb's mysterious pictographs, Rothko's and Baziotes' viscous marine imagery, and Still's menacing personages. Most importantly of all, it includes Jackson Pollock's first mature works, the totemic paintings based on archetypal or mythic themes. Typical of these thickly painted and brightly colored works is *Pasiphae*, a densely painted work in which intense emotion, expressed through vehement paint application, is structured by rhythmically patterned linear elements. Although the title of this painting refers us to the legend of the abduction of the wife of King Minos by the mythical man-bull the Minotaur, it would be taking Pollock too literally to think that one could recognize the famous event in the mysterious calligraphy, suggestive of occult symbols, or the disembodied anatomical fragments emerging from the churning sea of paint in which they swim. In fact, it has been suggested that Pollock was so far from referring to a specific theme that this painting was originally entitled *Moby Dick*, after Melville's giant whale. Rather than illustrating any literary text, whether Greek or American, Pollock was intent on giving a general feeling about the immense power of the forces of nature which had previously been symbolized by such mythic beasts as the Minotaur and Moby Dick. It is, of course, interesting to speculate why Pollock, who had rejected American Scene painting in favor of modernism with its French sources, should have changed the title from an evocation of a great American symbol to the image, favored by the Surrealists and used extensively by Picasso, of the Minotaur, the name in fact of a review devoted to the art of the School of Paris widely read among avant-garde American painters as well.

Although Pollock's themes in the totemic paintings are closely related to those of the Surrealists, his linear passages recall Kandinsky's free drawing as well as Masson's calligraphy. The forms of Arshile Gorky, on the other hand, another American artist deeply indebted to Surrealism, were biomorphic shapes reminiscent of Miró and Arp. Gorky, who had already flattened bulging organic shapes in his synthetic Cubist works of the late thirties, was a complex artist whose imagery was alternately both florid and tortured.

Although his life was beset by tragedy and disappointment, Gorky was fortunate in having a number of good friends and influential supporters. He was spiritually adopted by the leader of the Surrealists-in-exile, the poet and redoubtable culture hero, André Breton. In Gorky's rich and ambiguous imagery, Breton saw analogies to the many-layered meanings of Surrealist poetry. Gorky had other important connections to the Surrealists, who accepted him as one of their group, as well. The art dealer Julian Levy, for example, who showed the Surrealists in his New York gallery, was introduced to Gorky's work by the ubiquitous John Graham, who had also arranged for the first public exhibition of Pollock's paintings in 1941 at the MacMillan gallery.

Reminiscing about Gorky's wartime activity as a camouflage painter, Julian Levy described Gorky's strange and colorful appearance: "From poverty, or of a piece with his camouflage, for he was a very camouflaged man, Arshile Gorky as long as I knew him wore a patched coat." From Levy's description, one gets a very vivid impression of Gorky's tattered appearance, while photographs and self-portraits reveal the intensity of the gaze of this ardent poet-painter, who once corrected a woman who mistook him for Jesus Christ by announcing, "Madam, I am Arshile Gorky."

Although the art of the New York School was identified early by the critic Robert Coates as "Abstract Expressionism," Gorky's and Pollock's interest in Kandinsky and Hofmann's free technique, loaded surfaces and brilliant color constituted the only points of contact between so-called "Abstract Expressionism" (a term first used by Alfred Barr to describe Kandinsky in the thirties) and German Expressionism. In fact, most of the artists to whom the name was applied considered it a misnomer. They preferred anything from "abstract impressionism," which would have acknowledged an obvious debt to the late Monet, to "intrasubjectivism," which would have made clear the emphasis on psychological content, as opposed to the emotional and empathic content of Expressionism. Many would have been happy with "abstract Surrealism"—by far a more accurate description of American art in the forties than "Abstract Expressionism," the title that stuck.

But any attempt to construct a group identity for a movement that never consciously existed as a movement was bound to fall short of correctness. For Abstract Expressionism, although it had certain common stylistic characteristics uniting its leaders, was never a homogeneous style; on the contrary, the so-called "first generation" New York School painters went so far in the direction of creating highly individualized personal styles that the result was a series of parallel styles, each of which was imitated by a host of younger painters.

Arshile Gorky was, of course, the first to arrive at such a mature manner. By the early forties, he was already painting works in a style so loose and fluid that it outstripped in sheer painterliness anything that had gone before. Having schooled himself first with the Old Masters and then with Cézanne and Picasso, Gorky was inspired by contact with Kandinsky and Miró, and to an extent with the Surrealist Matta, from whom he appears to have learned to embed sharply attenuated linear passages in an atmospheric space of undefined but shallow depth. A sensualist whose desires appear to have been repeatedly frustrated by experience, Gorky combined in his charged imagery the pleasure-loving and the possessed.

The first paintings by Gorky in which traces of the other modern masters have been so thoroughly assimilated that they have become merely aspects of Gorky's own style were done in 1942, the same year that Peggy Guggenheim opened her gallery. Beginning with the series based on his father's garden in Sochi, his works became progressively freer and full of random drips and transparent washes. Based on childhood memories, the Sochi theme focused Gorky's imagination on landscape. Probably inspired by Kandinsky's example of drawing on memories of past places and feelings with which the artist had many associations, Gorky began painting magically populated landscapes refulgent with personal meaning. Many of these, like Kandinsky's landscapes of the Russian countryside, were associated with specific images Gorky recalled from his childhood in Armenia.

Explaining the meaning of the paintings based on the *Garden of Sochi*, the subject of several works bearing the same title, Gorky wrote: "The garden was identified as the Garden of Wish Fulfillment and often I had seen my mother and other village women opening their bosoms and taking their soft and dependable breasts in their hands to rub them on the rock. Above all this stood an enormous tree all bleached under the sun the rain the cold and deprived of leaves. This was the Holy Tree. I myself do not know why this tree was holy but I had witnessed many people whoever did pass by that would tear voluntarily a strip of their clothes and attach this to the tree." In the painting, as in later paintings with explicitly sexual themes such as *The Betrothal*, swelling organic forms created

by fine hairbreadth lines bring to mind associations with sexual organs and breasts. And the tree is present, too; even if it is barely recognizable, we can still make out the fluttering forms standing ambiguously for the strips of clothing or for vaguely anatomical appendages.

The interest in landscape first evidenced in the Sochi paintings, which were based on memories of the past, was reinforced in the present by summer vacations in the country, where Gorky began to make many drawings based not on literal nature but on a variety of ambiguous organic forms. These drawings in turn became the basis for future paintings; for Gorky worked as academic artists had in the past, transferring his large-scale cartoons to canvas by drawing on a prepared grid. In these drawings, knife-sharp lines are threaded in and out of space with a nimble grace and an astonishing variety of inflated convex and subsiding concave contour. These "hybrid" forms, as André Breton called them, that Gorky created with his swift line were full of details allusive at one moment to human or animal anatomy, at others to plant or landscape forms. The paintings that ultimately resulted from these many studies were thinly painted, with frequently improvised passages of smudged or dripped paint suggestive of the soft billowing of clouds, the fluid movement of water, or the curving contours of a hillside. In their emphasis on flow and movement, these paintings offered an image as ephemeral as natural phenomena themselves.

Gorky's tragic suicide in 1948 coincided with the departure of Peggy Guggenheim and her entourage a year earlier to bring to an end the direct influence of Surrealism on American art. Of course the Surrealist legacy, in the form of automatism both as a process of formal invention and a technique for generating images continued to have importance.

Despite the degree to which Abstract Expressionism depended on earlier modern art movements such as Surrealism and Cubism, it would be inaccurate to imply that the new American painting developing in the shadow of World War II was merely an eclectic synthesis of these sources. Although its greatness lay in the fact that it did represent an extraordinary and seemingly impossible merger of diverse aspects of various modern movements that preceded it from post-Impressionism to Surrealism, the art of the New York School was above all else a highly original style. This originality was both personal and national. The artists who created the style, painters like Pollock, Gorky, de Kooning, Still and Motherwell, were extreme individualists, men whose lives and imagery testify to what they suffered in the sense of alienation and isolation that allowed their art to take on such a highly personal character.

Not only the isolation—both psychological as well as often geographical—of the individuals who created Abstract Expressionism, but also the many years American art was isolated as a provincial school divorced or cut off from the mainstream contributed to the originality of the New York School when it finally emerged in the forties. Like Spanish painting of the seventeenth century, which had served a protracted apprenticeship to Flemish and Italian mainstream styles, American painting, when it finally crystallized as an independent international force, burst forth with a highly particularized and identifiable character. Although it clearly developed from European models, American art was soon bigger, bolder, more literal and direct, more powerful in impact, and more devoted to speed and rawness of execution than European art had ever been. In fact, it happened that certain aspects of American provincialism, which had originally inhibited the development of a high style, were turned into positive factors. This was particularly true of those native-born painters of the first generation of Abstract Expressionists, who had assimilated the European tradition, not because it belonged to them by birth right, but only through a concentrated act of will.

Thus the crudeness of Still's and Pollock's early works and the awkwardness of Motherwell's forms speak of the enormous distance, both actually and figuratively, these non-East Coast painters had to travel to form a connection with the tradition of European painting. Earlier American artists from backwater areas, bogged down in a misunderstanding of the gradual evolution of modern art from older styles, had never succeeded as these men did in coming to grips with the high art tradition; instead like Benton, they had created

travesties of the old masters that were not only provincial and naive, but confused with popular illustration and academic attempts to revive the past *in toto*. By the time Franz Kline abandoned Ashcan School subjects in favor of abstractions of urban structures, however, all this had changed; and Kline was capable of expressing the crude American vigor of the Ashcan School without being condemned to express this energy in terms of second-hand or outdated pictorial conventions.

The success of American art has in some respects obscured the desperation of its origins. If a sense of struggle, both actual and metaphoric, was deliberately cultivated to expose both the difficulty of living as well as the difficulty of creating, then this pictured conflict was also to serve as an analogue of the struggle to create a tradition in which to paint. American artists of the thirties had labored to locate such a tradition within the various styles and cultures, American and European, of the past. But American artists of the forties were more realistic; they finally faced it that they would have to turn their attention from the past to the present, inventing their own myths and tradition wholecloth out of that present. In a journal entry, for example, Jack Tworkov described their dilemma: "The old world, the world of aristocratic dreaming has been shaken to bits... Nothing archaic can help us or set us an example. Everything in the world is new—like ourselves."

The need to create a style consistent with that newness spurred many New York artists to set off a series of innovational moves that exploded like a chain reaction during the extraordinarily creative decade of the forties. Fortunately, certain characteristically American ways of behaving and dealing with the world helped them in their determination to find new approaches to painting. For example, the pragmatic attitude helped sweep away notions of decorum and academic formulas, allowing anything to be used, providing it was

Jackson Pollock (1912-1956). Pasiphae, 1943. (56⅛×96″)
Courtesy Marlborough-Gerson Gallery, New York. Collection Lee Krasner Pollock.

available and served the purpose. Pragmatically, artists appropriated tools and materials that had never been utilized to make fine art: de Kooning used a fine sign painter's liner to create his rapidly executed arabesques and taught Gorky to do the same; Kline found house-painter's brushes practical in creating his wide swaths of paint, and later inspired Stella to paint his stripes with them, too; Gottlieb used a household sponge mop to apply large areas of color impersonally, which may have suggested to Noland the technique of rolling paint on evenly with wall-painting rollers. Pollock, of course, took the pragmatic attitude to its greatest extreme and devised a technique of spilling and pouring that eliminated the conventional tools of art altogether. Many others, too, used commercial house paints straight out of the can, discarding the notion of premixing on the palette as academic. Others bought the cheapest grade of enamel called Sapolin, which dried unevenly, producing novel surface effects alternating the glossy and the matte. The result of all this pragmatic improvisation was that at last the lack of a proper academic tradition had become an asset instead of a liability, permitting opportunities for experimentation, originality and innovation unlimited by conventional attitudes and norms.

Burgoyne Diller (1906-1965). First Theme, 1939-1940. (34×34″)
Property of Mrs. Burgoyne Diller.

During the thirties, Americans had put their greatest effort into locating a painting tradition in which to work; in the forties that tradition was at last solidly and firmly established. By the end of the fifties, it would harden into an academy in its own right. But for the time being, the presence of some of Europe's greatest artists living in the United States as refugees gave Americans heretofore undreamed-of possibilities for enlarging their vision. First Hofmann, Albers and the members of the Bauhaus faculty, then Peggy Guggenheim and the Surrealists, and finally Piet Mondrian, the leading geometric painter and theoretician of abstract art settled in the United States. Mondrian's influence, however, was at first confined mainly to his small circle of friends and admirers, which included Harry Holtzman, Charmion von Wiegand, Michael Loewe, Ilya Bolotowsky, and most importantly, Fritz Glarner and Burgoyne Diller.

Although there is little or nothing to distinguish Glarner's "relational paintings" as he called them, or Diller's classically architectonic arrangements of bands and bars of color suspended on a flat ground from contemporary paintings produced in Paris or London, both painters created formal arrangements of a quality that American abstraction had seldom if ever achieved earlier. Believing that art should express not the feelings or moods of the artist, but some impersonal and timeless absolute, the artists close to Mondrian painted pure nonobjective Cubist works whose static immobility was the very antithesis of the romantic Expressionist manner being developed by their colleagues.

Glarner, for example, subtly modifying the tricolor harmony of the primaries developed by neo-Plasticism, also altered the shape of his planes so that they were no longer regular rectangles, but irregular and slightly angled. His modifications of geometry were entirely typical of the American attitude toward geometric forms, which were seen as being as open to a personal and idiosyncratic interpretation as the vocabulary of organic forms inherited from Surrealism. Diller, on the other hand, was a much stricter classicist; he worked with increasing asceticism toward a reduced format which, by the time he died in the mid sixties, resembled the minimal paintings of far younger artists. Often using black as a dramatic foil and

Ad Reinhardt (1913-1967). Blue Painting, 1953. (75 × 28″)
The Museum of Art, Carnegie Institute, Pittsburgh, Pennsylvania.

background for brilliant red and blue or yellow bars, Diller, who was also a sculptor of the first order in his later years, created stark frontal arrangements of great dignity and monumentality.

But the geometric discipline of Mondrian and the constructivists in which such artists worked was precisely the tradition other painters like Gorky, de Kooning and Pollock were rejecting because they found it too conventional, constraining and unemotional. Although the geometric tradition re-emerged in the sixties with renewed vitality—in a form of course vastly altered because of its emphasis on color—during the forties and fifties it was a decidedly minor strain, for the Surrealists rather than the geometric painters captured the imagination of the most radical young Americans during the formative years of the New York School. The single exception was Ad Reinhardt, the only first generation "Abstract Expressionist" to begin and end his career as an abstract painter. Reinhardt's reductive format and color, however, are more appropriately discussed in relation to "minimal" art which he in large measure inspired. In this context, it should be remembered that with the exception of Reinhardt, Abstract Expressionism was only nominally an abstract style; in actuality landscape and figure elements stand behind all the work to a greater and lesser degree. And even in Reinhardt's case, the determination to create a Vitruvian image, as tall as a man and as wide as a man's outstretched arms, provides an implicit allusion to the figure, which might be inscribed within one of Reinhardt's blank cruciforms. Thus even for a maverick among the Abstract Expressionists like Reinhardt, man was always the measure.

Given the general distaste for the geometric tradition, it was altogether natural that the Surrealist conception of painting as a form of visual poetry had a great appeal for Americans with their Whitmanesque vision. Much more exciting to the young American avant-garde than the regular shapes, predictably if not inexorably echoing the framing edge of the various constructionist styles, was the more ambiguous and open, both literally and figuratively, space and forms of the Surrealists.

Paradoxically, American art had come full circle: Americans, who once held fast to the easily understood, the positive, the material and the literal, had acquired a taste for complexity and metaphor. The forms of the Surrealists, charged as they were with a variety of only vaguely definable associations, provided an example of an art of "content" as opposed to the merely decorative or formal art of late Cubism. Since American artists were rebelling against the purely formal in their determination to make a universally meaningful statement that would not only decorate but inform—if not ideally uplift—they felt they had a lot to learn from the Surrealists.

In Abstract Expressionism, then, American artists were at last able to realize their long maturing ambition for an art both of formal grandeur as well as spiritual significance. The literalism that limited American art for centuries was but a small portion of Abstract Expressionism; it was largely confined to making literal the flatness of the painting, and asserting the real qualities of the medium (i.e. that paint was fluid and surface was palpable). In all other respects, Abstract Expressionism was an art dedicated, above all, to transcending the mundane, the banal and the material through the use of metaphor and symbol.

As it had been for the Surrealists, the Unconscious became the field of most fertile exploration in terms of imagery for many Abstract Expressionists such as Gorky, Pollock, Motherwell, Baziotes, and the early Rothko and Gottlieb. Freud's stress on the sexual component of unconscious fantasies appears to have been a more important influence on Motherwell and Gorky, whereas the others were more drawn to Jung's theory of the collective archetypes. Pollock especially, who had executed many drawings for study with his Jungian analyst, was involved in excavating the buried content of the unconscious that linked modern man to his most ancient ancestors.

In opposition to the Jungian bias of the majority of New York painters, Robert Motherwell gave a decidedly Freudian orientation to his images. Motherwell, who came into contact with the Surrealists through Kurt Seligmann, a Surrealist painter who wrote a book

Robert Motherwell (1915). Elegy to the Spanish Republic, 1953-1954. (80×100″)
Albright-Knox Art Gallery, Buffalo, New York. Gift of Seymour H. Knox.

on magic widely read during the period, found his great theme of the forties and fifties in Freud's opposition of the life force and the death instinct. The numerous elegies to the Spanish Republic Motherwell began painting in 1949 are imagined as huge phallic configurations whose monumentality commemorates both man's courage and his impulse to self-destruction. Love and death alternate as the two dominant subjects of Motherwell's work. In the *Je t'aime* and *Chi amo crede* series, the life force triumphs; in the elegies and later paintings like *Africa* and the paintings commemorating Kennedy's assassination, the dark brooding forces of destruction crowd out the light. For Motherwell, automatism was the great principle of form creation, enabling him to create Rorschach-like configurations without inhibition. In his elaboration of the "paranoiac-critical" method of reading images, Salvador Dalí in a sense had predicted the manner in which Abstract Expressionists would present their ambiguous forms, with their loosely defined, perhaps even subliminal, multivalent associations.

It was true not only of Motherwell's and Gorky's sexually charged imagery, but of that of virtually all the first generation Abstract Expressionists, that their images evoked a whole

string of associations, of which the viewer might or might not be fully conscious. Thus Pollock's image might be thought reminiscent of the maelstrom or the primordial matter from which all life issued. Or Still's canyons and ravines might call to mind an Ice Age landscape as the bizarre mythic beasts of his early paintings conjured images of extinct creatures who inhabited the earth before man. More down to earth but not less romantic were the allusions to the contemporary industrial environment in the paintings of de Kooning and Franz Kline.

In the forties, Kline, who supported himself in this bleak period by drawing caricatures in Greenwich Village, painted small oils inspired by the same urban scenes depicted by his friend the American Scene painter, Reginald Marsh. A mural executed by Kline during this period still exists on the wall of a Greenwich Village tavern. Painted in the awkward illustrational style of provincial realism, it reveals that Kline's roots are within the tradition of the Ashcan School. However, many of the subway and elevated stations painted by Kline before his conversion to abstraction have real quality. Kline's gentle, delicate sense of touch, for example, reveals a refinement far beyond the crudities of Ashcan School realism.

For Kline to realize himself, however, it was necessary that he change his scale from that of a modest genre painter to one more expressive of the reality of the New York scene. Inspired by Pollock's and de Kooning's success in creating a broad gestural style, Kline began to experiment with improvising form in a series of calligraphic brush drawings on newsprint, or sometimes on the pages of the telephone book. According to legend, he was inspired to blow these drawings up to full scale paintings by seeing them through a stereopticon.

The year 1950 was decisive for Kline, as it was for many other New York painters. In that year he enlarged his scale, renounced color for black and white, and gave up painting Ashcan School subjects for bold abstractions which nevertheless continued to recall the great bridges and elevated railroads of his early works. Even their color—the dirty black and peeling white of the manufacturing loft area where Kline and his fellow artists lived and worked—evoked the urban landscape. And Kline was not adverse to the associations his paintings called up. "There are forms that are figurative to me, and if they develop into a figurative image it's all right," he said to an interviewer. "I don't have the feeling that something has to be completely non-associative . . . I think that if you use long lines, they become—what could they be? The only thing they could be is either highways or architecture or bridges."

Quite the opposite was true of the attitude toward form of painters like Rothko and Gottlieb, whose early ties were to Avery's nature image. Although Gottlieb's compartment-alized pictographs and Rothko's graceful biomorphic paintings of the forties emphasized color relationships, they were relatively undeveloped with regard to the sophistication both achieved after renouncing biomorphism and becoming fully abstract. Rothko's imposing image of rectangles floating in an atmospheric field and Gottlieb's explosive sunbursts have, like Kline's paintings, implicit landscape analogies. But their link is to the world of nature, not to the urban landscape that attracted Kline. The frontality and simplicity of their few large forms was as impressive as the originality of their color relationships. Having arrived at an image or format they merely varied but hardly changed after a point, in the fifties both Rothko and Gottlieb began to concentrate the burden of expression in their paintings on color. Each developed a highly individual palette, characteristic of their respective sensibili-ties and totally unlike the color range of any other painter. Rothko chose in the main to concentrate on deep resonant harmonies—red, blue or green color chords as sonorous as organ harmonies. Gottlieb on the other hand often contrasted intense blues and fiery reds with sputtering masses of shadowy black. At other times, he created unlikely combinations of pastel tints with dark shades, particularly those of the brown scale, to which he seemed especially attracted. Both Rothko and Gottlieb paid great attention to facture and surface. The many variations and modulations within their large rectangles and disks of color create subtle inflections that maintain the liveliness of their works.

Willem de Kooning (1904). Excavation, 1950. (80½ × 100⅛″)
Courtesy of The Art Institute of Chicago, Chicago, Illinois.

Explaining that he painted large not to create a public art but to make a more intimate statement, Rothko insisted, "To paint a small picture is to place yourself outside your experience, to look upon an experience as a stereopticon view or with a reducing glass. However you paint the larger picture, you are in it. It isn't something you command." Thus to create an image so large it would take up the viewer's entire field of vision and hence occupy his entire consciousness for the moment he was looking at it, became a general goal for the artists of Rothko's generation, who wished to make of art an experience as total, as engaging and as real as life itself.

The interest among the Abstract Expressionists in the unconscious must be seen as part of their determination to create a statement so broad and general that it would be universally meaningful. Partly the intensity of their determination to create such a universal statement must be seen as a reaction to, indeed a profound disgust at, the narrowness and parochialism of earlier American art. Beyond this, their stress on the elemental themes basic to human existence reflected a desire to regain for modern art some of the depth, dimension and fullness of expression of the great art of the past. For the

Jackson Pollock (1912-1956). One (Number 31, 1950). (8 ft. 10 in.×17 ft. 5⅝ in.)

Abstract Expressionists, however wild their art might have seemed at first, had no desire to break with tradition. Rather they wished to keep that tradition alive and moving; but to do so they were forced to alter its course.

This was hardly evident to the general public, however, nor even for that matter to critics or museums. Critics referred to their art as "Schmeerkunst"; Pollock was sufficiently notorious to attract attention as "Jack the Dripper" in the mass magazines; and the

museums, by and large, retained their double standard—abstract for European art and "realistic" for American. The situation became so desperate in fact that in 1951, a group of artists including Pollock, Kline, Motherwell, de Kooning, Tworkov, and Marca-Relli were forced, like the Eight nearly half a century before them, to organize their own exhibition, which they called the "Ninth Street show" because it was held in one of the store-front galleries on East Ninth Street.

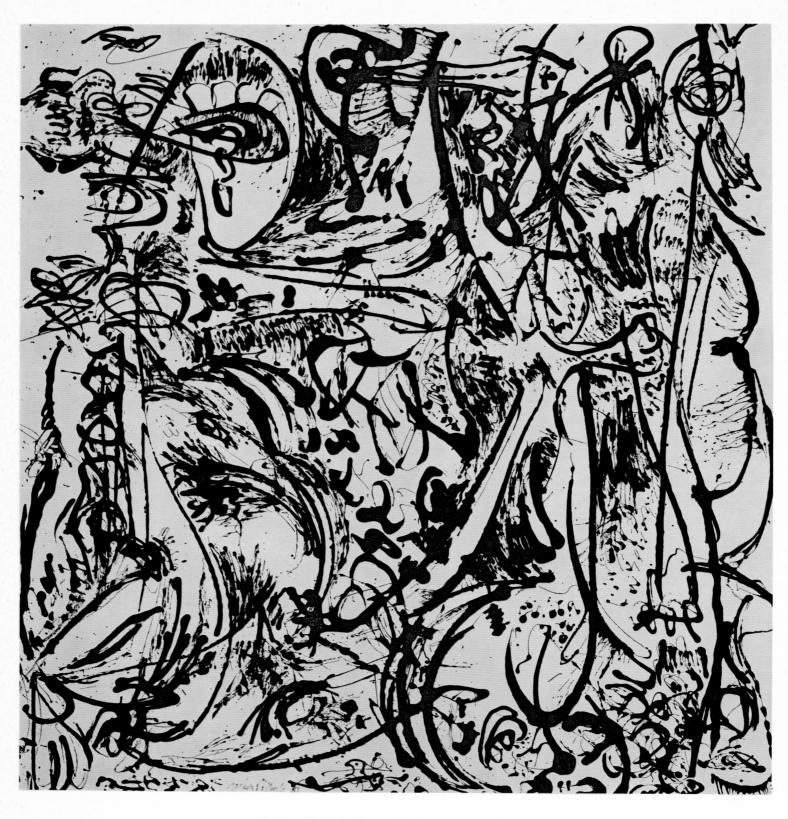

Jackson Pollock (1912-1956). Echo, 1951. (91⅞×86″)
Collection, The Museum of Modern Art, New York.
Acquired through the Lillie P. Bliss Bequest and the Mr. and Mrs. David Rockefeller Fund.

If the first phase of Abstract Expressionism was its psychological, mythic and bio-morphic phase, with its roots in the Surrealist interest in the unconscious as the locus for the most profound and universal content, then this phase may be seen as terminating in Gorky's last paintings and in de Kooning's brilliant series of black and white paintings (which set the fashion for the many dramatic black and white paintings of the period) done in the late

forties. The ultimate and perhaps finest statement of the biomorphic exists in de Kooning's astonishingly complex and sophisticated masterpiece of 1950, *Excavation*, a painting whose title seems to refer to the constant process of tearing down and rebuilding that characterizes Manhattan's distressed urban landscape.

In *Excavation*, de Kooning uses line to create a series of interlocking organic shapes, which often interpenetrate as well to share a common contour. By this time, rapidity of execution was an important part of de Kooning's style and expression; his whiplash-like line, now thick, now thin, now blotted, now erased altogether, weaves in and out, appearing and disappearing with mischievous agility. Spatial ambiguity as well as ambiguity of content is heightened to its utmost. Not only are we confused by the double image of a flesh-colored field of hills and valleys, referring equally to figure and landscape, but also the darting and skipping line does not create any entirely legible or closed contours either. Consequently, the loosely biomorphic shapes collide and flow into one another, creating a spatial organization that establishes neither a continuous nor precisely a discontinuous surface. This ambiguity of course was much desired and cultivated by de Kooning, who suggested that he wished to create a pictorial space that, in its slipping planes, lack of fixedness or recognizable referents, would be an analogy for the rootlessness and sense of disorientation of what he termed the contemporary "no environment." A deracinated immigrant, like a number of the other Abstract Expressionists who were born in Europe, living in a city in a constant state of crisis during and after a war which had overturned any semblance of world order, de Kooning was especially responsive to this sense of disorientation shared by many in mid-century America as well as elsewhere in the modern world.

In de Kooning's ultimate paintings in the biomorphic manner, fragments of the human anatomy—an eye, a mouth, or forms that suggest anatomical parts generally—are sandwiched into the densely packed shallow space he creates by means of line and value modulations. These detached anatomical fragments, the mark of a figure art totally out of context in a landscape image, are to be found in a similarly telescoped fashion in Pollock's, Gorky's, Rothko's and Gottlieb's paintings of the forties. Not only a Surrealist compression of metaphor, but the ending of a long development in painting brought about this strange superimposition of two genres that were formally distinct separate specialities in themselves. In a sense the projection of these fragments of the human figure into landscape contexts, which occurs also in Motherwell's elegies, might be seen as evidence of a telescoping process coming at the end of a great tradition of painting when the drive toward reduction and purification creates at the same time an unavoidable compression.

That tradition, of course, is the tradition of painterly painting initiated by the Venetians in the sixteenth century. The ensuing split between the linear and the painterly, outlined by Heinrich Wölfflin in *The Principles of Art History*, which began with the polarization of artists into partisans of Poussin (the linear classicist) and Rubens (the master of baroque painterliness), divided the art world again in the Ingres vs. Delacroix controversy that raged for most of the nineteenth century. The relationship of drawing to painting, or line to color, is one of the crucial questions that painters attempted to resolve in a number of radical ways in the forties in New York. Gorky's solution was virtually to disengage line from color, using the latter as autonomous patching and shading. To an extent de Kooning followed his example. And even those painters who did not use line as shape-defining contour, like Baziotes and Gottlieb, for example, created flat forms whose contours produced a legible edge, which could in some respects be considered "drawing."

Eventually, however, Pollock arrived at a way of absolutely marrying the linear to the painterly by drawing in paint. Moreover, this painterly drawing—prepared for by the hundreds if not thousands of pen and ink sketches he created throughout the late thirties and early forties—was executed in an automatic technique which allowed an even greater freedom of gesture than the freest painters in Western art had ever achieved. Others beside Pollock, including Gorky and Hofmann, probably under the influence of the "automatic" Surrealists, had allowed paint to run and drip in their paintings of the early forties. But

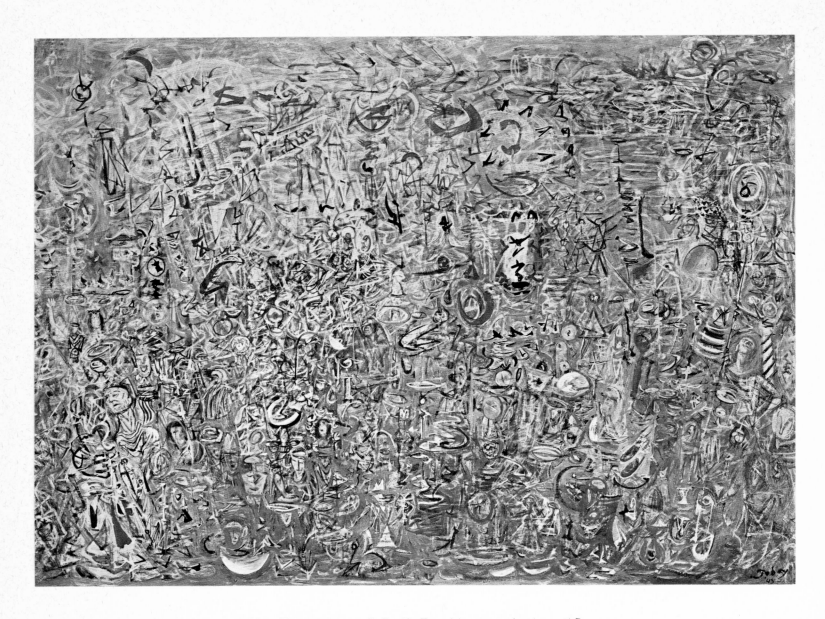

Mark Tobey (1890-1976). Pacific Transition, 1943. (23¹/₄ × 31¹/₄″)
Courtesy of City Art Museum, St. Louis, Missouri. Gift of Joseph Pulitzer, Jr.

beginning in small works done late in 1946, Pollock systematically used dripping from a stick or brush as an exclusively automatic technique throughout the work. In the paintings of 1947-1951, among which are Pollock's greatest masterpieces, the exclusive use of the drip technique creates a homogeneous surface, a fabric of densely woven and interwoven irregularly rising and falling loops and nets of paint. Because painting and drawing are compressed into a single technique by means of the overtly painterly quality of the dripped line, there is no discontinuity between the two, as there is in all painting, to a greater or lesser extent, before Pollock's. The resolution of the opposition between painting and drawing, like the compression and telescoping of landscape and figure into a single genre, is again indicative of a climactic moment in the history of Western painting. This was the moment in which painting attempted to reduce itself to essentials, to distill its own essence—a process initiated by the early modernists such as Kandinsky and Mondrian and still being carried on by painters working today.

By marrying painting and drawing in an automatic technique that did not record the small intimate maneuvers of the hand, but the big physical gestures of the wrist and arm, Pollock "broke the ice" for his colleagues, as de Kooning put it. If the biomorphic phase based largely on Surrealist precedents had been the first chapter in Abstract Expressionism,

then Pollock's drip paintings of the late forties inaugurated a second phase, which Harold Rosenberg christened "action painting" because of its emphasis on gesture and its record as the principal expression and emotion bearing element in painting.

Behind Rosenberg's formulation of the aesthetic of "action painting," which was apparently pieced together from talk at the Cedar Bar, the artists' meeting place, are notions drawn from currently fashionable existentialist thought as well as certain Dada notions concerning the relation of art and life. Such vaguely formulated existentialist metaphors did indeed influence many American painters after the war as the ideas of Camus and Sartre filtered into New York. At the Artist's Club on East Eighth Street, organized as a forum for aesthetic discussions late in 1949, painters spoke of deliberately leaving their works looking unfinished, so that the painting would appear in a transient state of "becoming," rather than in a final fixed state of absolute definition, which to them meant sterility and deadness.

Many New York painters felt that Pollock's drip paintings, with their automatic "handwriting" permitting rapid execution and their emphasis on physical gesture, their fluid space, lack of closed shapes or exclusively linear elements of conventional drawing, represented a way of transcending and superseding the restricting canons of Cubist space and structure. Especially important was Pollock's new manner of composing, which became known as the "all-over" style. Before Pollock created his drip paintings, the Pacific Northwest painter Mark Tobey, like Morris Graves a devotee of Eastern mysticism, had created a densely meshed all-over image. But the smallness of scale of Tobey's "white writing" paintings, the purely graphic quality of his line, and the presence of anecdotal details meant that Tobey's paintings, although they might represent a moving personal statement, could never revolutionize art history as Pollock's drip paintings would.

Misunderstanding the concept of all-overness, many artists and critics saw Pollock's compositions as nothing more than "apocalyptic wallpaper," a phrase used by Rosenberg in his historic essay on action painting. In actual fact, although Pollock's "all-over"

Bradley Walker Tomlin (1899-1953). Number 9: In Praise of Gertrude Stein, 1950. (49×102¼")
Collection, The Museum of Modern Art, New York. Gift of Mrs. John D. Rockefeller, 3rd.

style had certain things in common with purely decorative art such as Islamic tile work, which repeats the same pattern *ad infinitum* and without variation, his drip paintings are great precisely because of their fantastic degree of variation—of form, of contour, of rhythm and pressure. They are "all-over" only in that Pollock creates a homogeneous surface, without a single climax, every part of the canvas receiving equal emphasis. Pollock's intention in creating an all-over style was to diffuse any notion of focus or pictorial climax, forcing the eye to constantly travel and retravel the labyrinthine paths of his intertwining nets and skeins of paint. In creating an all-over style, Pollock had two precedents: the openness and opticality of Matisse's paintings like the *Blue Window*, and the atomized post-Impressionism and large mural scale of Monet's late paintings of waterlilies. Fortunately, he could see these works in the Museum of Modern Art, where the superb collection assembled by Alfred Barr served as an inspiration to the generations of New York painters who went there to study and to learn what they could not acquire from their own native tradition.

Thus Pollock united in perhaps the most complex—in the sense of the number of diverse elements it assimilated and reconciled—style of the century, the cohesiveness and denseness of pictorial incident of analytic Cubism with the openness and visual opulence of post-Impressionism. Others had explored one or the other of these elements; for example, Richard Pousette-Dart, in a series of paintings of enlarged pointillist dots assertively applied with heavy impasto, drew heavily on Monet, as did Milton Resnick later. By the same token, de Kooning's fragmented paintings done around 1950, such as *Excavation*, recapitulate the space and structuring of analytic Cubism in a larger format and a more painterly technique. That Pollock was able to unite these two great modernist traditions, marrying the structural integrity of Cubism with the purely "optical" and painterly art of post-Impressionism, testifies to his genius not only as an innovator, but as a synthesizer.

Pollock's drip paintings were significant in other respects, too. They established a new scale for American painting which was closer to the mural scale of older decorative art than to the more intimate scale of easel painting. Pollock's first large-scale work was a nearly 20-foot long mural commissioned by Peggy Guggenheim for her gallery entrance (it is now at the University of Iowa) which was painted in 1943. By 1950, Clyfford Still, Barnett Newman and Mark Rothko had all produced very large paintings. The size of these paintings in itself would not be exceptional; but in their work, as opposed to big paintings in earlier art, large size was coupled with a single image that could be read at a glance, and hence seemed to dominate the viewer with its imposing simplicity and wholeness. For this reason these large paintings by Pollock, Still, Rothko and Newman did not provoke the anecdotal "reading" required by the big paintings like the historical "machines" of the past; rather their immediate effect was like the overwhelming impact of Romanesque frescoes, which also dominated the viewer with their impressive grandeur and spiritual force. Although Motherwell and Kline, too, painted large pictures in the fifties, many Abstract Expressionists such as de Kooning and Guston stayed well within the bounds of easel painting. In the sixties, a size both physically larger and a scale that proclaimed itself, because of the lack of internal relationships within the painting, as grander than that of Abstract Expressionism even was adopted by color painters such as Noland, Stella and Olitski. These painters followed Pollock's example of creating a pictorial field larger than the field of vision; other artists, such as Allan Kaprow and pop sculptor George Segal saw Pollock's paintings as constituting visual environments, as if they physically surrounded the viewer, and began creating literal environments.

The other painter who came almost as close as Pollock to effacing any remaining disjunction between the linear and the painterly was Clyfford Still. Like Pollock, Still was an idiosyncratic if not actually eccentric individualist from America's heartland who mastered the technical aspects of painting with difficulty. Like Pollock, too, Still was able to turn this awkwardness into a positive factor, and to create an image of extreme intensity and originality. During the forties, Still lathered on thick passages of pigment, probably with a palette knife, which created a richly encrusted surface, as flat and opaque as a wall.

Clyfford Still (1904). Painting, 1951. (93¼×75¾″)
From the Collection of The Detroit Institute of Art, Detroit, Michigan.

Franz Kline (1910-1962). New York, 1953. (79×50½″)
Albright-Knox Art Gallery, Buffalo, New York. Gift of Seymour H. Knox.

Willem de Kooning (1904). Merritt Parkway, 1959. (89¾×80⅜″)
Collection of Mr. and Mrs. Ira Haupt, New Jersey.

Adolph Gottlieb (1903-1974). Pink Smash, 1959. (108 × 90″)
Estate of the Artist.

Mark Rothko (1903-1970). Red, White and Brown, 1957. (99¹/₂ × 81³/₄")
Öffentliche Kunstsammlung, Basel, Switzerland.

Barnett Newman (1905-1970). Ulysses, 1952. (132 × 50")
Collection Jaime del Amo, Los Angeles, California.

Still's shapes, with their irregular flame-like edges biting into the adjoining ground, because they did not appear as shapes *against* a background, but as a continuous surface, from which figure could not be separated from ground, affirmed the flat two-dimensionality of the canvas in a particularly convincing manner. That it was important for painting to affirm its actual identity, as opposed to attempting to create a sculptural illusionism, no matter how great the degree of optical illusionism it might set up, became one of the central tenets of American painting of the sixties.

But to discuss merely the formal implications of Still's contribution is to overlook the most obviously compelling aspect of his work: the sheer torrential power of his primordial landscape imagery, with its cruel aggressive forms hacked and clawed from their surroundings. Indeed, the harsh execution of Still's work represents a kind of conquest of spirit over matter through the intense struggle to create form from chaos.

Although they are the very opposite of Still's seething, violent images, Rothko's aloof, tranquil rectangles share one characteristic with Still's work; they, too, refuse to set up conventional figure-ground relationships, their hazy, indistinct and soft contours bleeding and melting into their atmospheric environment, seeming to float contiguously with their surroundings rather than be isolated against a background behind them.

By 1950, when Bradley Walker Tomlin, Franz Kline and Philip Guston abandoned representation to join the swelling ranks of abstract artists, certain principles were established for advanced art: these were large scale, a single image, open form, and "all-over" composition. Once the all-over had been established as canonical, it was but one step to altogether eliminate internal relationship within the painting, the primary formal element in Cubist composition, which Mondrian maintained was the heart of painting. This was accomplished by Barnett Newman around 1950.

Newman's arrival at a "non-relational" mode of composition, in which a single image was oriented with regard not to other shapes on a ground but exclusively with regard to the framing edge, may be seen as inaugurating the third and final phase of Abstract Expressionism.

This phase overlapped to an extent with "action painting," but survived it as a viable mode in the sixties when gestural abstraction had been abandoned by every major painter except de Kooning, who continued to paint small expressionist nudes that were gentler, more lyrical pastel versions of his "women" of the fifties. This final development of Abstract Expressionism has been termed color-field painting or chromatic abstraction to differentiate its emphasis on color from action painting's emphasis on surface and gesture. Turning its back on Surrealism, although its major practitioners—Gottlieb, Rothko, and even Newman himself—had been influenced by certain aspects of Surrealist thought earlier, color-field painting made an uneasy truce with the geometric tradition.

Newman's "non-relational" composition in which a field was divided rather than having forms silhouetted on it or against it was radical in several respects. Although there were no internal relationships in the conventional sense in Pollock's drip paintings, Pollock's web was constructed, as William Rubin noted, like the grid of analytic Cubism, so that pictorial incident was concentrated at the center and faded out at the edges. Newman, on the other hand, following the precedent of Monet, Matisse and Miró, carried color evenly throughout the painting, creating a field of color coextensive with the whole of the pictorial field.

The relationship of chromatic abstraction to action painting or gestural abstraction is complex. Where de Kooning, Kline and the other gestural abstractionists were still closely allied to Cubism in their reliance on value contrasts and internal relationships, Rothko, Newman and Reinhardt dealt solely with contrasts of hue, and were principally interested, not in a dynamic image evocative of speed, movement and flux, but in a static monumental icon inducive of contemplation. Gottlieb's main interest, on the other hand, was in creating unusual color relationships and a high style of pictorial decoration. Because theirs was a highly disciplined art, Gottlieb's, Rothko's, and Newman's color relationships were highly structured. Gottlieb's image was distilled from his earlier pictographs. Instead of the multiple symbols caged in compartments, Gottlieb chose two of his most charged symbols—a solar disk and a whirling burst of undifferentiated matter that might stand for the earth. Gradually, these forms were simplified still further until their symbolic value became subservient to their purely formal role.

Praising the value of a few large simple shapes, Rothko began to confine himself solely to rectangles, which, like Newman's bands, echoed the framing edge with relentless logic. Yet a romantic lyricism, not cold logic, is the basis of Rothko's statement. The halations caused by the subtle vibration of his edges where adjacent colors touch give the appearance of actually radiating light. And indeed, Rothko's is a literally radiant image.

The lack of internal relationships resulting from a single image being related, not to other analogous shapes on a field in the manner of Cubist "rhyming," but exclusively to the framing edge is a feature of chromatic abstraction carried over into the best painting of the sixties. As a structural principle, it is first noticeable in the pared-down banded paintings Barnett Newman exhibited at the Betty Parsons gallery in 1950. In the same manner, Newman's show at French & Co. in 1959 was a revelation for many young painters, like Larry Poons, who were forcibly impressed with the sheer optical brilliance of his vaporous fields of luxuriant color.

By the time of Newman's exhibition at French & Co., where the influential critic Clement Greenberg as director also organized shows of works of Gottlieb, Dzubas, Olitski, Noland and Louis, there was already revolt germinating among younger painters against the excesses of action painting, which they felt was pictorially as well as emotively exhausted. Although downtown in the cramped store-front galleries on East Tenth Street, second-generation Abstract Expressionists imitated de Kooning's impastoed surfaces and broad gestures, there were significant signs of a change in taste. The 1959-1960 French & Co. exhibitions organized by Greenberg, who had praised de Kooning in the early fifties only to damn his Tenth Street imitators later, and the Museum of Modern Art's "Sixteen Americans" held in 1959, which included Rauschenberg, Johns and Stella, raised the curtain on a new chapter of American art, just as Tenth Street closed an episode that was fast becoming history.

Roy Lichtenstein (1923). Okay, Hot Shot, Okay, 1963. (80×68″)
Collection R. Morone, Turin, Italy.

The Sixties

O N first appearance, Abstract Expressionism, like any genuinely innovative style, appeared to break with the past in a radical manner. Soon, however, it was clear that as art it was firmly rooted within a tradition. Yet that tradition was largely European. Consequently, the assimilation by its practitioners of the aesthetic of modernism —of the entire body of theory, forms and technique developed primarily by the French avant-garde from Manet to Picasso and Matisse—meant the suppression of a great deal that was central to the American tradition.

Unlike the European tradition, American art had no classical roots, for the Greeks and Romans had never been to America. In the main American art had been neither monumental nor decorative, but fundamentally popular and realistic, in keeping with the demands of democratic taste. Despite the primary debt of the Abstract Expressionists to European art, however, they managed to preserve, if not the naive forms of earlier American art, at least many of its unique and compelling qualities of expression. These included boldness of imagery, directness of technique, stress on the material physicality of medium and surface, and candor of statement.

Nonetheless, certain elements in American taste were necessarily submerged for the two decades during which Abstract Expressionism dominated American painting. These were the puritanical asceticism that had produced a strict inhibited style like Precisionism, the love of the bizarre and the fantastic that had created the topsy-turvy world of Magic Realism, as well as the delight in story-telling detail and democratic genre that brought American Scene painting and a photographic realist like Andrew Wyeth to the pinnacles of popularity. Such native tastes and preferences, not to say deep-rooted national needs, were to receive fresh expression in pop art (and its San Francisco offshoot "funk") and in minimal art.

Pop and minimal were two of the most important of the multiple styles of American art of the sixties. The third, in the eyes of many critics by far the most significant style to develop after Abstract Expressionism, was color abstraction. Baptized "post-painterly abstraction" by its foremost defender, Clement Greenberg, color painting has carried on the long tradition of "optical" or retinal art that has its roots in the bright-hued palette of neo-Impressionism, Fauvism, and orphic Cubism.

A continuation of the European tradition of a color-light art, itself descended from Venetian colorism, post-painterly abstraction (so called by Greenberg to distinguish it from the painterliness of Abstract Expressionism) was not, however, like the vogue for "op" art

that gained publicity in the early sixties, merely an extension of Bauhaus theories of color and design. It is true that the work of Noland, Stella, and Kelly, to name three of the most important American abstract artists in the sixties, had certain obvious links to the earlier tradition of geometric formalism. Their work, however, was decisively post-Cubist in its rejection of internal relationships of shapes depicted against a background, which was the basis of Cubist design.

A comparison of Noland's circles and Stella's tondos with Delaunay's disks quickly reveals two significant and crucial changes: the palette of Noland and Stella is extended far beyond the limits of the conventional palette of Delaunay, and their shapes are related, not internally to one another, but only as a central image is related to the frame. This *gestalt* or wholistic feature of their work, a central element in American painting in the sixties, makes it more precise to speak of pictorial structure, based on an indivisible wholeness, rather than of composition in the traditional sense. A similar comparison of Kelly's painting with neo-Plastic color and design would reveal that he deviates from his sources in exactly the same manner that Noland and Stella reject Cubism. Indeed, Noland's highly personal, intuitive use of color, Stella's arbitrary, irrational geometry, and Kelly's insistence on reality as a point of departure for his forms, which until recently were always abstracted from real objects or nature, reveal that any notion of classicism one might be tempted to associate with their work is contradicted by their subjective and individual uses of geometry, which have romantic, expressionist, or realist overtones. In addition, the development in the sixties of new types of pigments including transparent water soluble plastic-base paints of great brilliance, "dayglo" colors with fluorescent properties and metallic pigments that reflect light, widely used by artists like Noland, Stella and Kelly, clearly differentiates American abstract works of the sixties from earlier geometric styles as much as their large scale, a legacy of Abstract Expressionism.

Thus the re-emergence of geometric abstraction in America in the sixties occurred in a form decisively altered by certain technical developments and above all, by the experience of Abstract Expressionism, with its emphasis on the intuitive and the subjective. This was prophesied by Barnett Newman in his painting ironically titled *The Death of Euclid*, in which he symbolically killed off the father of geometry. Because Newman, Rothko, Motherwell, and Still were able to create highly structured works independent of geometry, American painters of succeeding generations were afforded many new options not open to earlier abstract artists.

In several respects the decade of the sixties was unlike any previous period in American art. First of all, many of the most decisive innovations were made by very young artists. Helen Frankenthaler, Jasper Johns and Frank Stella were all in their early twenties when they created some of their most inspired and radical works. This was possible because they did not have to spend a lifetime learning how to paint. They could look around them in New York and learn from the achievement of their elders. The new level of technical competence of American painting in the sixties resulted in the production of many more tasteful, well-made, intelligent works than were ever previously produced in America, or perhaps anywhere else in the world. But real originality was as rare, if not rarer, than it had ever been, although the ranks of painters and art lovers began to swell at an alarming rate.

During the sixties, the New York art world expanded to spill over into the universities and the mass media. President Johnson invited artists to the White House—an unprecedented honor for an American artist, whom John Sloan had likened to the unwanted cockroach in the frontier kitchen. Dealers, curators, critics, writers and collectors engaged in a frantic round of activity, while bewildered artists tried to adjust to the new situation in which Americans had at last begun to identify culture with salvation.

This millenium so eagerly awaited by Henri and Stieglitz, as they pursued their lonely missions early in the century, unfortunately did not produce the spiritual conversion they desired; it did, however, touch off a wave of speculation that continues to keep the American art world spinning at a dizzying rate. Some artists have reacted to society's

embrace with hostility and withdrawal; others keep upping the ante, making larger and larger works, harder and harder to accommodate in existing architectural contexts. These decorative monumental paintings appear to demand the possibility for a genuinely mural expression heretofore unavailable to the modern artist, who has never before contemplated the rapprochement between art and society that now seems open to contemporary American artists. Still others, like Andy Warhol, the self-styled sacred prostitute of the art world, have passively accepted the attention of the public and the media, allowing themselves to be consumed by it if need be.

Unlike the forties and fifties, when a style with more or less uniform aesthetic premises—despite the degree of individual interpretation it might receive—was the single repository of all avant-garde impulses, the sixties saw warring factions compete. Sometimes the competition was not so polite for the banner of vanguardism, already slightly bedraggled by the struggle of artists to create an art sufficiently extreme so as not to be immediately assimilable by the shock-proof middle class and the sensation hungry mass media. Acceptance by the media of the best (as well as the worst) of contemporary art rang down the curtain on the century-long opposition of the avant-garde to the established values of the Academy and bourgeois society. One hundred years after Courbet successfully flaunted Academy authority by opening his own Pavillon du Réalisme, Jackson Pollock's death in a violent auto accident established a world market for avant-garde art that today is being collected and consumed as fast as it is being created.

Whether the enormous influx of money, often in the form of investment speculation tied to the vicissitudes of the American economy, has had the desired effect predicted earlier in the century by Dana of producing an American Renaissance is the source of considerable debate. One thing, however, is certain: the history of world art in the second half of the twentieth century bears an unmistakably American stamp. The force, impact and power of contemporary art, its search for increasingly direct and candid means of expression, its pragmatic attitudes and techniques, its emphasis on immediacy and its frequent commerce with violence, either of imagery or content, reflect the dominance of values familiar to students of American history and culture.

In the sixties, American art, so long the plain provincial country cousin of world art, has become its glamorous and sought-after Cinderella. Sophisticated, colorful, ambitious, secure in its recognition and achievements, American painting today has taken its place as one of the outstanding creations of modern civilization.

Although the activity of younger American painters like Frank Stella, Roy Lichtenstein, Larry Zox, Darby Bannard, Larry Poons, Edward Avedesian was at first seen only as a rejection of Abstract Expressionism, it is clear now that the continued quality of American art in the sixties depends first and foremost on a reformulation and extension of the premises of Abstract Expressionism, rather than on the total reversal that their stringent reductiveness or blatant pop and hard-edged imagery originally seemed.

Yet there is no doubt that, around 1960, there was a widespread revolution in taste, not to say aesthetic standards in New York. One of the first indications that such a reversal of taste was taking place was that the reputations of followers of de Kooning and Kline, the so-called second-generation action painters, were beginning to decline, while the severe "minimal" art of Ad Reinhardt, the "black monk" and *advocatus diaboli* of Abstract Expressionism, was winning new respect among young artists, who agreed with Reinhardt that the more apocalyptic pronouncements of the "heroic" generation and its literary apologists were a lot of hot air. Refusing to espouse what Reinhardt had mockingly described as "divine madness among third generation Abstract Expressionists," many young artists found Reinhardt's clarity a refreshing antidote to the muddled romanticism of late Abstract Expressionism, especially in its anti-intellectual Tenth Street phase.

Many features in Reinhardt's work link him, despite his role in all of the history-making events of the Abstract Expressionists, to the art of the sixties, rather than to that of his own generation. He was always a conceptual rather than an improvisational

painter, and the only member of the New York School to begin and end his career as an abstract artist. The youngest member of the American Abstract Artists in the thirties, Reinhardt began his career as an admirer of Stuart Davis. In the forties he gave up his jagged geometric planes for atmospheric paintings filled with delicate calligraphic elements, reminiscent of misty Chinese landscapes. Tracery-like particles suspended in a shallow space were in turn renounced in the early fifties for a more structural method of composing, in which rectangles were locked together in a compact architectonic unity. These early compositions of meshed rectangles were painted in closely-keyed harmonies of first the red and then the blue scale.

Ultimately, Reinhardt rejected color itself as a purely decorative element. In the view of a moralist like Reinhardt, who insisted above all on the ethical content of art—like the original puritans who rejected the purely visual as merely hedonistic display—decorative painting was just another form of self-indulgence, too easy to like to be good. With this attitude, Reinhardt began in 1953 to paint black paintings that were virtually monochromatic. Matte-surfaced and recessed behind a black frame, these quiet works, with their light absorbing as opposed to light reflecting surfaces, seemed literally to retire in the presence of the viewer, requiring some special effort to make out their faintly discernible cruciform image at all.

Like the recent pearlescent disks of the California abstractionist Robert Irwin, and the diaphanous curtains of melting color of Jules Olitski, Reinhardt's black paintings appear to change as the viewer perceives them, their central image emerging from darkness only gradually, as the images of an Irwin and an Olitski also take time to bring fully into focus. The main emphasis of these three artists who in the sixties have made of the monochrome or near monochrome painting an experience of extreme subtlety, has been on the nuance of perceptual differentiation as opposed to the sharp contrasts and instantaneous impact of geometric art. In opposition to older art, their works look relatively devoid of pictorial incident, as does much of American abstraction in the sixties, since composition has become subservient to a color and light experience.

Reinhardt's reductive form and color anticipated minimal art, while his practice of working in series, a feature of Albers' attitude toward form also, became standard procedure in the sixties, as abstract art became increasingly self-conscious and concerned with articulating and solving a given set of formal problems. Other aspects of Reinhardt's work, however, are clearly related to Abstract Expressionism. Its barely disguised romanticism, its explicitly human scale and adherence to easel painting conventions make it clear that Reinhardt's painting is linked to that of his contemporaries. On the other hand, a crucial similarity with the art of the sixties that could be singled out is Reinhardt's creation of an image that is *literally* as opposed to illusionistically located behind the frame.

Reinhardt's reputation as a minimalist *avant la lettre* rose at the same time that pop art exploded, that is, around 1960. The first of the new styles to emerge, pop had been brewing longer and became public more rapidly and easily than any abstract style because it was immediately appealing to a mass public which found Abstract Expressionism unintelligible. Brash, audacious, jazzy, and best of all, familiar, pop brought art to a large public mystified by the aloofness and hermeticism of abstract painting. What the general public did not realize, however, was that pop art had the same sources and many of the same formal premises as abstract painting. For example, Lichtenstein's stylized comic strip and advertising images, their enlarged Ben Day dots looking like a Seurat under a microscope, barely masked the relationship of his work to Léger's machine forms and flat, hard-edged style.

Similarly, Rosenquist's past as a billboard painter was not as important for his art as Magritte's strange juxtapositions of images and creamy paint surfaces, or the space and composition of Cubist collage, which he imitates in the maquettes for such large and iconographically complex works as *Horse Blinders*. When these sketches, actually collages of magazine illustrations pasted together to create maximum space and scale discontinuities, are blown up as paintings, such discontinuities appear all the more bizarre and disquieting.

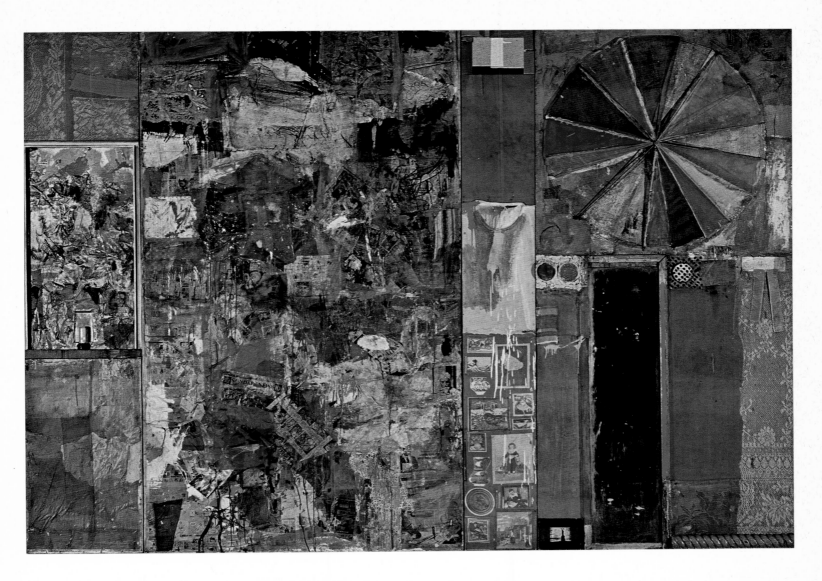

Robert Rauschenberg (1925). Charlene, 1954. (88½×126″)
Stedelijk Museum, Amsterdam, Holland.

By the same token, Warhol's career as a commercial illustrator was not nearly as decisive for his all-over images of soup cans and brightly colored flowers as Pollock's all-over style, which Warhol mistakenly or perhaps in deliberate irony interpreted as being literally all-over. Nor was commercial art as much a precedent for his colors and shapes as Gottlieb's cosmetic tinted bursts. Although their imagery overtly referred to popular culture, the works of the pop painters were as much art made out of art as the most self-conscious purely formal arrangement. Nevertheless, in the context of the lofty moral tone of Abstract Expressionism, the return of pop artists to representation was shocking, if not horrifying, to many artists and critics of the older generation. Instead of attempting to redeem the entire Greco-Roman, Judeo-Christian heritage, which the Abstract Expressionists often seemed to be attempting, the pop artists were painting Coke bottles, movie stars and soup cans, the icons of an entirely secular and materialistic culture. The irony of this mirror-image of the night-mare that the American Dream had become, in an age of rampant commercial exploitation and affluence, escaped most of the nouveau-riche collectors who rejoiced in owning the art that mocked them. But then, neither did Charles IV and his court realize what Goya was doing to their likenesses. Certainly Warhol's grotesque portraits of his patrons, playing up every feature of their vacuous narcissism, his grotesquely made-up Marilyn Monroe and tearful Jackie Kennedy will stand as an indictment of American society in the sixties as scathing as Goya's merciless portraits of the Spanish court.

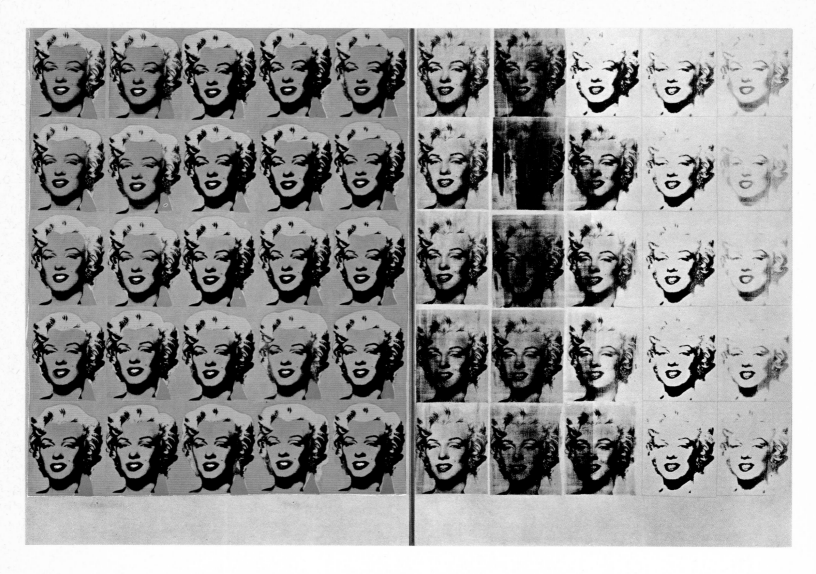

Andy Warhol (1925). Marilyn Monroe, 1962. (Two panels, 82×114")
Collection of Mr. and Mrs. Burton Tremaine, Meriden, Connecticut.

Although pop art had its greatest success in America, originally it was an English phenomenon named and promoted by the critic Lawrence Alloway, who had been associated with the pop culture oriented Independent Group in London in the fifties. Perhaps because they had never suffered from the cultural inferiority complex that plagued Americans, English artists and critics embraced American pop culture long before it was fashionable in the States to consider film as art or to discourse at length on the meaning of "camp."

Of course the painting of common objects had a long history in America, too. In the late nineteenth century, the *trompe-l'œil* still-life painters Peto and Harnett made strict formal arrangements of banal items. In the twenties, Stuart Davis copied the labels from commercial products like "Odol," and Gerald Murphy made simplified, stylized still lifes as clear and matter of fact as poster images. In the fifties, de Kooning had cut the "T-Zone" out of a Camel cigarette ad and pasted it on a grimacing, leering woman who seemed to epitomize the awful vulgarity and sexual travesty of the pin-up. And de Kooning, not Andy Warhol, first painted Marilyn Monroe.

In the fifties both Larry Rivers and Robert Rauschenberg had used images from popular culture, Rauschenberg clipping news items that recorded daily life and Rivers plumbing American history for themes like "Washington Crossing the Delaware." But the single painting that set off the greatest response, among artists and public alike, was Jasper Johns' American flag, painted in 1955 and first exhibited in 1958. Although Johns had also

painted the comic strip Alley Oop in the late fifties, the sudden explosion of comic strip imagery in the work of Lichtenstein, Warhol and others seems independent of the Johns work, which was not shown publicly. What all had in common, however, was the turn to discredited sources for imagery, yet another repetition of the search for freshness in "low" art and genre, when high art lapses into mannerism.

Although Clement Greenberg quickly relegated it to the never-never land of the "history of taste," pop art has already had a number of important consequences. It breathed new life into American art in the form of lively images at a period when Abstract Expressionism had lost its driving force. Pop brought closer the rapprochement between art and society, ending the split between the two embodied in avant-garde alienation, at least in a social and economic sense. Those who feel that art cannot retain its critical stance or purity without this alienation from society find this development appalling; others welcome the return of patronage and critical and institutional approval it has brought.

Perhaps the greatest boon of pop art was to critics, who had something to talk about again, and to art historians, happy to return to tracing familiar motifs after the vagaries of Abstract Expressionism, which to most academics, with the exception of Meyer Schapiro, one of its early defenders, was both formless and meaningless. It was Schapiro also who had first pointed out that Courbet and other important nineteenth century artists had drawn on popular sources for new subjects and as models for their simplifications of form. Acquaintance with this precedent in the early history of modernism quickly revealed that pop was only recapitulating the manner in which the first modernists had found popular imagery a fresh antidote to the staleness of academicism. This is not to say that Abstract Expressionism was dead in quite the way neo-classicism had died in the middle of the last century, but merely that it had become too familiar, and for one group of artists at least, simply too remote from life and the concerns of most people.

James Rosenquist (1933). Horse Blinders (fragment), 1968-1969. (Height, 120″)
Ludwig Collection, Wallraf-Richartz Museum, Cologne, West Germany.

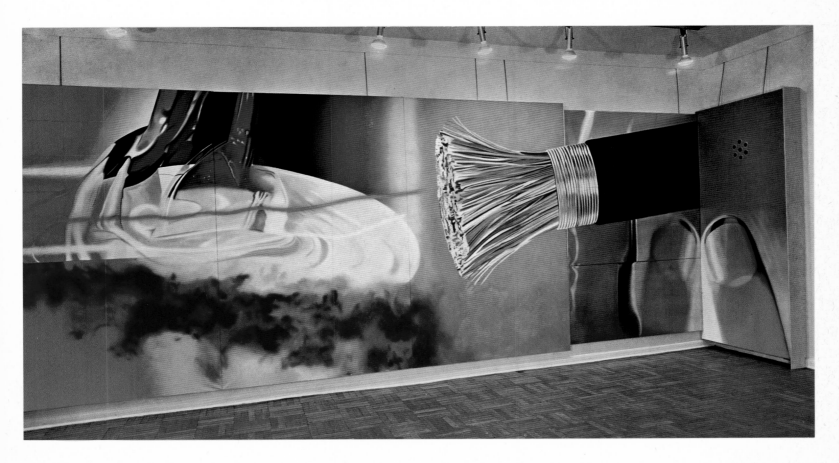

That their work can never have a large audience was taken for granted by the majority of modernists, and is still taken for granted by even the most popular abstract artists today, who deliberately work for an elite public of informed critics and connoisseurs, as Poussin, for example, worked in the seventeenth century. But like the seventeenth, the twentieth century is complex and oriented toward rapid change in the light of constant explosions of new knowledge and discoveries. As taste and patronage in the seventeenth century were broad enough to encompass Caravaggio's low-life genre and blunt populism along with Poussin's noble, lofty formalism, so today a multiplicity of styles co-exist, each with its own audience and apologists.

Pop art, however, was only one of the signs of revolt against the established canon that Abstract Expressionism was fast becoming, as it was increasingly accepted by critics, collectors, museums and art schools. This revolt ironically coincided with the very heyday of Tenth Street. While second-generation imitators of de Kooning and Kline were winning publicity and admirers, popular imagery, as we have seen, was being introduced by Rauschenberg and Johns. At the same time, Helen Frankenthaler, along with Morris Louis and Kenneth Noland, who were working in Washington, D.C. in virtual obscurity, began to see qualities in Pollock's art visible to few of their contemporaries.

In their view, the de Kooning style contained many vestiges of academic painting, especially in its reliance on drawing and value contrasts, as well as on Cubist space and composition. It was, in fact, toward the end of expunging the last vestiges of academic conventions that the most ambitious art of the sixties addressed itself. Eventually the scale of easel painting would be rejected in favor of the scale traditionally associated with mural painting and the grand manner, and its shallow relief space would be replaced by a new kind of pictorial space defined solely by contrasts in hue as opposed to traditional modeling and chiaroscuro.

Toward this end, also, representational elements, which had survived in the many semi-abstract compromise styles developed during the forties and fifties by artists like Larry Rivers were entirely rejected by the abstractionists of the sixties. Ambiguity of any kind, with regard to the location of an image in space, the loosely defined boundaries of an image, or the relationship of figure to ground became anathema in the sixties. Logic and clarity would replace ambiguity as the central value of sixties painting. In the sixties, artists drawn to representation began to make an explicitly figurative art, while those embracing abstraction purged their art of any concerns not vital to the purest, most rigorously consistent statement possible. The "crisis content"—that favorite reservoir of ambiguity for the Abstract Expressionists—was either forgotten or denied. No metaphorical allusion was hidden beneath the self-evident surface: painting was revealed in all its nakedness as an object in the world, as opposed to an allusion to any absolute. If an Abstract Expressionist like Barnett Newman had claimed in the forties that painting should embody nothing less than the "idea-complex that makes contact with mystery—of life, of men, of nature, of the hard, black chaos that is death, or the grayer softer chaos that is tragedy," an artist of the sixties like Frank Stella would flatly maintain that "what you see is what you see."

Signs of unrest in the late fifties became an issue of such importance that *Art News* offered a symposium on the subject "Is There a New Academy?" By this time, the art world was clearly divided into two polemical camps, one devoted to de Kooning and "action" painting, led by Harold Rosenberg, and the other, smaller and less noisy group who saw Pollock as the saviour of painting, revolving around Clement Greenberg. That both Greenberg and Rosenberg had originally been political writers did not lessen the vehemence of the polemic.

One of the contributors to the *Art News* symposium was Friedel Dzubas, a member of the small circle of painters including Sam Francis and Helen Frankenthaler who saw Pollock's automatism and all-over style as the basis for a post-Cubist abstraction. Echoing the feelings of this group, Dzubas pointedly asked, "Why is it that after an evening of openings on Tenth Street, I come away feeling exhausted from the spectacle of boredom and the

seemingly endless repetition of safe sameness?... There is an atmosphere of complacent kaffee-klatsch, one can find all the tricks of the current trade—the dragging of the brush, the minor accidents (within reason), the seeming carelessness and violence ever so cautiously worked up."

The possibility that the "crisis content" Harold Rosenberg had attempted to establish as a metaphysical criterion—to replace the purely formal values by which art had traditionally been judged—could be staged or simulated was bothering some others, too. Rauschenberg, for example, in his twin action paintings *Factum I* and *Factum II* duplicated every "spontaneous" splash and drip. Statements in *It Is*, the magazine published briefly by sculptor Philip Pavia, also hinted at a certain dissatisfaction with the official mystique. In 1959, Paul Brach, another of the group of second generation Abstract Expressionists who began to rebel against the excesses of the Tenth Street style, wrote of the necessity "to abolish choice and chance—to forbid autobiography and confession, to reject action and find precision." Other artists like Raymond Parker, Robert Goodnough and Al Held were also beginning to tighten their contours to produce legible shapes, once again considering discipline and control more important than broadness of gesture. Al Held, for example, observed that "the rigid logic of a two-dimensional esthetic binds us to the canvas surface making it an end in itself, not a means to an end." Like many American painters working around 1960, Held wanted to do more than simply bring the image up flush with the picture plane, he wanted to develop a spatial sense "not by going inwards toward the old horizon, but outward toward the spectator." Eventually, Held developed a kind of free expressionist geometry of boldly outlined forms with a sculptural ponderousness but no three-dimensional modeling. Asserting surface by building up a heavily impastoed crust, he attempted to create an illusion of forms not receding behind the frame, but being thrust aggressively forward.

In a certain sense, this illusion that the image was being projected in front of the picture surface—that, in other words, the entire canvas field is positive foreground as opposed to negative background on which positive forms are depicted—is also at work in Larry Poons' early paintings of brilliantly colored dots on dyed canvas fields. These dots, in their sharp contrast with the color and texture of the field obviously behind them, often appear to project forward, to hang suspended in the space between the canvas and the viewer. If Manet began the effect of pushing the background plane forward, telescoping depth into a new shallowness by squeezing illusionistic space out of painting through a variety of means, then this tendency received its most extreme formulation in American painting of the sixties, when a number of artists began treating the surface plane not as the foreground plane behind which space was illusionistically depicted, but the background from which an image either literally (in Rauschenberg's case) or illusionistically (in Held's and Poons' case) appeared to project.

This tendency to view the picture plane as background was marked in the sixties. It may be seen as part of the general drive to bring the image closer to the viewer—presumably toward the end of creating greater immediacy and impact—that it is one of the recognizable characteristics of the style of artists who apparently interpreted Pollock's web as appearing to spill forward into the spectator's space. Actually Pollock himself backed off from building up his image on top of the surface in the black and white paintings that immediately succeeded the classic drip works. And it was, as we shall see, these paintings done in Duco enamel on raw canvas, with their images clearly embedded within the surface, that were the point of departure for stained color paintings.

In addition to Held, other artists who created an original interpretation of geometry in the sixties included Agnes Martin, Alfred Jensen, Miriam Schapiro, and Alexander Liberman. The outstanding painter of the minimalist persuasion, Agnes Martin superimposed a grid of small, regular intervals over muted white and grey and shining gold backgrounds. Her works have a quiet strength and an intensity seemingly out of proportion to their restrained and economical means. Jensen, too, breaks up his loaded surfaces into small

Alexander Liberman (1912). Omega VI. (79¾×60″)
The Art Museum, Princeton University, Princeton, New Jersey.

Al Held (1928). Mao, 1967. (9½×9½ ft.)
Courtesy André Emmerich Gallery, New York.

regular units, which resemble the pieces of a mosaic in their colorful scintillation and emphasis on *matière*. Miriam Schapiro rotates simple geometric forms in space in order to create a complex illusionism, often stressing a tough enamel or metallic surface. In the early fifties, Liberman painted a series of precise black, red and white enamels of flat disks on a field which attracted considerable attention when they were first exhibited in 1960. Although he was one of the first to experiment with a freer painterly style in the late sixties, Liberman is best known for his series of elegant assured geometric abstractions executed earlier such as *Omega VI*.

Around 1960, it was clear from the emotionalism of the dialogue that it was difficult, if not impossible, for a young American painter not to take a stand in favor either of de Kooning's expressionist painterliness, which lacked a single characteristic image—unless one can call the obsessive motif of the "woman" such—or Pollock's all-over style, which offered a technique without an image that could be imitated without producing what could only look like a forged Pollock. So many artists were drawn to the flamboyance of the de Kooning manner that his circle, which included artists such as John Mitchell, Grace Hartigan, Alfred Leslie, and Michael Goldberg, virtually amounted to a school.

Paradoxically, de Kooning's example was more seductive because it did offer an adaptable manner, whereas Pollock, in the drip paintings, created an image so distinctly his own that to imitate it was to duplicate it. If Pollock had something to offer, therefore, it was not a surface look, but a way of working, an attitude that was, in its rejection of the conventions of easel painting, anti-academic and radical. Thus artists who imitated the rough, brushy unfinished look of a de Kooning ended up making paintings that resembled de Kooning's, but those who looked to Pollock's drip paintings were able to develop original images that were fundamentally dissimilar from drip paintings. Sam Francis, for example, created a rippling sheet of transparent islands of painting, which flowed across the entire canvas field with a gentle fluid movement. In his later work, large expanses of white canvas create a sense of spaciousness and light highly prized by color abstractionists in general. In Noland's paintings, simplicity of image contrasts with the complexity of color relationships.

Perhaps the first painter to grasp the full import of Pollock's message, however, was Helen Frankenthaler. Visiting Pollock in 1951 at his home in Springs, Long Island, she saw his works in progress. Apparently she understood immediately how important it was that Pollock worked, not on the wall, but on the ground, spreading his unprimed, unstretched canvas on the floor, standing over it, walking around it and elaborating it equally from all four sides. Late in 1952, she began staining diluted oil paint into raw duck, adapting Pollock's mechanical technique for applying paint without the use of the brush.

Frankenthaler's adoption of Pollock's method was crucial not only to the further development of her own art, but to color abstraction in general. As early as 1937, John Graham, in his prophetic book on aesthetics mentioned earlier, pointed out that a change in technique necessarily predicated a change in form. Consequently when Frankenthaler, following Pollock, gave up painting with the conventional brush and stopped applying the undercoating of priming that kept the canvas from absorbing pigment directly, it was inevitable that she would be in a position to create a fresh formal statement. Indeed, the originality of her flowing, expanding, unfolding and flowering images was the result of this approach.

Soaking and staining paint directly into the canvas fabric combined with working on the floor from all sides, as opposed to composing in advance, had many immediate repercussions. The effacement of the movements of the hand in favor of an automatic, mechanical and impersonal technique first accomplished by Pollock in his drip paintings, was eventually carried to its logical limits in the mechanically stained veils of Louis, the unmodulated circles, bands and chevrons of Noland, and the automatic spray paintings of Olitski. The look that resulted from such techniques was of uncontrived naturalness, of an image that had, so to speak, spontaneously created itself. This look, coupled with the sense of unity and immediacy of impact it afforded (because it made it impossible for the eye to focus on details), was desired if not demanded by the taste of the sixties.

The method of working on the floor, arriving at the framing edge last instead of first, gave Noland, for example, the habit of walking in circles around the periphery of his painting, which led him to begin making central images of concentric circles in the late fifties. In their symmetry, formal rigor and in the purity of their color, these paintings seem virtually burned into the canvas, their intensity and biting clarity utterly at odds with the records of successive "action painting" gestures that caused the muddy dullness of late Abstract Expressionism.

Helen Frankenthaler (1928). Blue Caterpillar, 1961. (117⅛×68½″)
Collection of the Artist.

Working on the floor also affected Frankenthaler's painting decisively. By cropping her images, Frankenthaler gained both the freedom to reconsider a composition and to revise in the process of creation, without resorting to the compositional juggling at the heart of Cubist painting. But the most important advantage gained by using this new technique was the resolution—or at least the staving off—of the double-edged crisis which ultimately compromised the works of so many lesser artists in the sixties unable to achieve a similar solution.

The nature of this crisis was so deep and pervasive, moreover, that Pollock himself was unable to create an entirely satisfactory new synthesis once he abandoned the drip technique in 1951. This dual crisis involved: (1) the rejection of the tactile, sculptural space of painting from the Renaissance until Cubism in favor of the creation of a purely optical space that did not so much as hint at the illusion of a third dimension; and (2) the avoidance, if not ideally the banishment of figure-ground or positive shape against negative background or for that matter any kind of silhouetted arrangements. Before Pollock, the artist who had come closest to getting rid of sculptural illusionism and depicted shape was Mondrian. But Mondrian had accomplished this in the context of the small scale of easel painting, and at the price of any kind of openness or spontaneity. In developing the drip technique, Pollock allowed himself far greater breadth and openness than Mondrian could ever achieve. And it is precisely in its insistence on breadth and openness that the art of Noland and Stella diverges from geometric abstraction.

As we have seen, the drip technique allowed Pollock to reconcile flatness with a purely optical illusionism by freeing line from its traditional function as a shape creating contour. In later works, Pollock further questioned the nature of figure-ground relationships by actually cutting holes out of his webs. In his paintings on glass, he went to the extreme of attempting to render the background neutral by literally suspending the image against a transparent ground.

This is something that the stain technique, as Frankenthaler developed it, was able to do. Essentially the great advantage of staining lay in its ability to render the background neutral by obviously sinking the image directly into it, identifying figure with ground, as Clement Greenberg has pointed out. Frankenthaler's early appreciation that the revolutionary aspect of Pollock's art was his *technique* and not his *image* gave her an enormous edge in overcoming the dual obstacles—sculptural illusionism and figure-ground opposition—impeding the development of a post-Cubist abstraction, based not on delimited shallowness and figure-ground exchanges, but on opticality and openness. Obviously, the seeds of such a style existed in Impressionism and the various post-Impressionist movements, especially in Matisse's art, which impressed many American artists in the sixties with its boldness and simplicity. Following Matisse's example, artists like Ellsworth Kelly, Jack Youngerman and Raymond Parker realized that a few simple large forms generously filling the canvas could have a greater impact than any number of fragmentary shapes. Like Louis, Noland, Olitski and Stella, these artists related the single wholistic image to the frame, rather than relating shapes depicted on the field to each other.

If one seeks to find a single common denominator in the heterogeneous styles of the sixties, that common denominator is probably a debt to the work of Jackson Pollock. Although other artists of the forties and fifties like de Kooning, Motherwell, Kline, Still, Newman, Rothko and Reinhardt made important innovations, Pollock's revision of the traditional approaches to technique, pictorial space, composition and form was the most radical and decisive. It was, in fact, as radical and decisive as the reformulation of Old Master form and techniques undertaken by Manet nearly a century earlier, which became the basis for Cubism. Manet rejected Renaissance modeling and perspective as academic; Pollock in turn was able to lay the basis for an art that went beyond Cubism in rejecting Cubist space and modeling. Paradoxically that art turned out to be primarily a color art, since the area in which Pollock's work was least developed was precisely that of color. Fortunately, color relationships had been explored by Hofmann, Albers, and the color-field

painters Newman, Rothko and Gottlieb, so that examples of paintings in which the burden of expression was on color and its luminous qualities were plentiful when the urge to develop a color art became dominant.

Frankenthaler's major contribution was not, as it has been widely held, that she invented the stain technique, but that she was able to turn Pollock's technique toward the end of creating an art of pure and vibrant light and color. If one compares Frankenthaler's paintings with de Kooning school works of the early fifties, one is immediately struck by how different they look. Because pigment is thinned down to watercolor consistency, the whiteness of the canvas ground is fully utilized for its light-reflecting potential, in much the same manner that the page reflects light beneath the transparency of a watercolor wash.

This was especially important for the last great American artist to die without achieving material success or fame, Morris Louis, whose death in 1962 cut short a brilliant and at that time virtually unknown career. Louis maintained that Frankenthaler was a bridge "between Pollock and what was possible." The historic occasion early in 1953 when he and Kenneth Noland were taken to Frankenthaler's studio by Clement Greenberg to see her recently completed *Mountains and Sea* changed the course of American painting in the sixties. In many respects, Louis's greatest paintings, his *Veils* of 1954 and 1958, are unthinkable without Frankenthaler.

A comparison between Frankenthaler and Louis is instructive as to the opposition in their intention, however. Whereas Louis superimposes successive transparent planes, creating misty, foggy, rainbow or otherwise weather-related atmospheric effects, Frankenthaler paints a landscape image, and tends to modulate a form from within, contrasting not only hue, but saturation and intensity. Frankenthaler's emphasis on *liquidity* of pigment is part

Morris Louis (1912-1962). Blue Veil, 1958-1959. (100½ × 149")

Courtesy of the Fogg Art Museum, Harvard University, Cambridge, Massachusetts. Gift of Mrs. Culver Orswell.

Sam Francis (1923). Red No. 1, 1953. (64⅛×45⅛″)
Collection of Mr. and Mrs. Guy Weill, Scarsdale, New York.

of Louis's drive as well, although his perhaps more masculine interest in rigorous structure and symmetry is another obvious divergence. Before Louis and Frankenthaler used such diluted pigments, Marin had attempted to translate a watercolor technique into oil. He was hampered from fully achieving his goal, however, because he continued to prime the canvas, with the result that he was painting on a hard rather than an absorbent ground in his oils. This was not true in the watercolors themselves, of course, since the paper absorbed pigment directly—probably the reason Marin's watercolors usually remain superior to his oils. In staining, however, Frankenthaler, Louis, Noland and Olitski in his pre-spray paintings, allowed the raw ground to soak up color directly, as the page absorbed watercolor. This enabled them to achieve in oil and plastic-base paints both a freshness and a luminosity previously available only in watercolor, an intimist medium inimical to a monumental statement.

In this connection it is interesting to note that some of the highest moments in American art had occurred in the landscape watercolors of Homer, O'Keeffe and Marin, while many of Demuth's finest works are also watercolors. In her more explicit use of landscape image, Frankenthaler shows a stronger link to an established native tradition than the majority of color painters. Frankenthaler's historic role has only begun to be acknowledged. She was the first to appreciate the manner in which Pollock's work reconciled the linear with the painterly. For the other artists who followed Pollock rather than de Kooning, painting and drawing were equally identified. And this is altogether natural, since Wölfflin's categories were based on the premises of old master painting, which were rejected one by one by the modernists, until Pollock accomplished their final demolition.

Frankenthaler often used bare canvas dramatically; and Louis and Noland were equally able to use unpainted areas as an expressive element. In his "unfurl" paintings, Louis apparently draped raw canvas over a trough, spilling rivulets of paint in diagonally spreading streams, leaving the center of the canvas dramatically bared. Because the naked, literally undressed, quality of the canvas as yielding fabric rather than hard ground is stressed, the viewer often has the acute physical sensation of being hurtled headlong through a space both mysteriously infinite and explicitly and concretely finite.

A similar spatial drama and tension is created in many of Kenneth Noland's "bulls-eye" paintings with circular motifs. It is also an important element in the series of monumental chevron paintings executed by Noland in 1964. In these, the interaction of adjacent warm and cool colors such as clear bold yellows, reds and blues creates, through the properties of colors to advance or recede, a sense of space in its purely optical quality entirely opposed to the tactile sculptural space of Cubism. Thus even if Pollock's momentous union of the linear and the painterly voids Wölfflin's classical distinction between these two pictorial polarities, there continues to be a split between an illusionism based on traditional value contrasts—the last vestiges of the modeling of form of representational art—and a purely optical or visual illusionism resulting exclusively from contrasts in hue.

For this type of purely optical illusionism, Hofmann's celebrated "push-pull" dynamic and Albers' experiments in color contrasts were vital precedents. Their method of balancing out spatial tensions through color advancement and recession is in many ways still the basis of the illusionism of the painting in the sixties. Indeed, the central feature of current American painting might be seen as the investigation of the nature of illusionism, and its relationship to the flatness demanded by modernism. For in the sixties, literalism—the demand for an end to illusionism or any kind of fiction whatsoever—led a number of pop and minimal artists who began as painters, such as Claes Oldenburg, Robert Morris, George Segal, Donald Judd, Larry Bell, Craig Kauffman and Sylvia Stone, to abandon painting altogether for the creation of literal three-dimensional objects existing in real space. Their work is so close to the painting of the sixties that it really should be seen for what it is, an extension of painting rather than a purely sculptural expression.

On the other hand, the final identification, not of *flatness*, but of an inescapable illusionism as the irreducible essence of painting led to a renaissance of illusionism in the paintings of many former minimalist painters in the late sixties. It was almost, in fact, as if

Kenneth Noland (1924). Via Blues, 1967. (7 ft. 6⅛ in.×22 ft.)

an artist had to choose between renouncing painting for real three-dimensional objects, or reformulating illusionism to be consistent with flatness. The group mentioned above took the first course, while painters like Noland, Olitski, Stella, Darby Bannard and Ronald Davis, took the latter, creating a kind of self-cancelling illusionism that consistently contradicted itself through a variety of devices.

Opposed to this redemption of illusionism through a space developed largely through color relationships, was the literalism of the object makers, which had earlier been felt by Rauschenberg, pop artists like Lichtenstein and Jim Dine (at least in his early works), and hard-edge painters like Al Held and Nicolas Krushenick. Rauschenberg had anticipated the drive toward literalism by refusing to create space behind the picture plane. Instead he regarded it as a background on which to affix objects literally spilled forward into the spectator's space. In his combine paintings of the early fifties, such as *Charlene*, magazine and newspaper photos, pieces of fabric and clothing, were patched together in a tightly structured formal arrangement enlivened by intermediary passages of painterly brushwork. This was a combination that essentially blew up Schwitters' Merz collages to American scale and married its Cubist composition to de Kooning's wide-open gesture. Soon Rauschenberg was piling common objects and detritus from the environment on paintings in which space and form were entirely literal, as opposed to illusionistic, and reproduced images, treated in an equally literal manner, were actually incorporated into the work as opposed to being depicted by the artist.

The Collection of Mr. and Mrs. Robert A. Rowan, Pasadena, California.

The drive toward literalism of image and space Rauschenberg prophetically felt in the late fifties was perhaps the single dominant development in American art in the sixties. The other significant development was, of course, the renewal of interest in color as a vehicle for expression. The distaste for illusion and metaphor, which took a variety of forms, must be seen as an essential aspect of the rejection of the ambiguity of Abstract Expressionism and the inevitable consequence of the resurgence of native tastes and modes of feeling and thinking after the European current had played itself out. It is this literalism in fact that makes pop a false or pseudo-representational art. Not only is pop painting flat, like the decorative styles, it deals almost exclusively in second-hand images—pictures of pictures. Lichtenstein, Warhol and Rosenquist always make it explicit that their images are derived from reproduced sources; since their billboard or magazine page or film origin is known, it is known also that these images are to begin with flat. Not the three-dimensional images of the natural world, but the flat images of the world of prints is drawn on by pop artists.

What is the source of the literalism endemic to American art of the sixties? When we consider the literalism implicit in Pragmatism, the only system of philosophic inquiry developed exclusively by Americans, we begin to understand that literalism may be the defining characteristic of the American mind. As Pragmatism identified moral and ethical truth with the bare facts as experienced, so large numbers of American artists began to find *any* contradiction between illusion and reality intolerable. For them, experience has to tally precisely with reality. If a painting was created on a two-dimensional surface, then that

Jules Olitski (1922). High A Yellow, 1967. (92½×150″)
Collection Whitney Museum of American Art, New York.

flatness had to be stated as boldly and plainly as possible. If a form was to look three-dimensional, then it had to be created in three dimensions, not two. Thinking this way, many concluded that shapes could no longer be drawn or pictured; they had to be actual. Ellsworth Kelly, for example, stopped depicting shapes against a background to create geometric canvases that were literally shaped. Earlier, Claes Oldenburg and George Segal, who began as expressionist figure painters, renounced painting for the creation of three-dimensional objects and figures, which often look as if they had rolled directly out of their paintings to stand on the floor. No longer content to remain behind a canvas screen, they demand actual confrontation by the viewer in his own space.

To an extent this drive toward literalism meshed with certain of the fundamental assumptions of modernism carried farthest by Mondrian. The Dutch master's theory of neo-Plasticism, well known and discussed among Americans, challenged the very basis of representation, Plato's concept of *mimesis*, according to which objects were considered merely imitations of abstract absolutes. Mondrian, by contrast, claimed that the art object was not an imitation of anything but an autonomous reality. The manner of insuring the reality of art was to cease creating a fictive, three-dimensional world on a surface that was literally two-dimensional, and to acknowledge that two-dimensionality as fully as possible.

Mondrian, of course, had no idea how far his doctrines would be carried in his adopted country. Although Mondrian lived and worked in New York during the War, his immediate influence was restricted to a small circle of admirers who imitated the geometric forms of neo-Plasticism with a fidelity that could not lead to the creation of very

original art. Of the group, only Burgoyne Diller, apparently through sheer intensity of spirit, created paintings of great distinction. However, Mondrian's own late painting, *Broadway Boogie Woogie*, with its tiny rectangles of color creating a brilliant optical dazzle, remained one of the shrines of pilgrimage for several generations of American artists in their frequent visits to the Museum of Modern Art, the only real art school many ever attended. (The most obvious reference to Mondrian, of course, is in Larry Poons' dot paintings with their optical flicker.)

Because the most complex ideas are also the most difficult to assimilate, it is not surprising that Mondrian's ideas were not understood any faster than Pollock's. Neither made any fundamental impact on the art of the fifties. In the sixties, however, their influence was decisive. Together with the flat shapes and high color of Matisse, whose exhibition of *collages découpés* at the Museum of Modern Art in 1960 rocked the New York art world, Mondrian and Pollock staked out between them virtually the entire territory explored by innovative artists in the sixties.

If one wished to adumbrate most succinctly the history of recent American art, one might hold that its course was set by three painters, a critic, and a composer-aesthetician.

Larry Poons (1937). Rosewood, 1966. (120×160″)
William Rubin Collection, New York.

The painters of course were Jackson Pollock, Piet Mondrian, and Henri Matisse; the critic was Clement Greenberg, whose power was enhanced by the appearance of strong artists such as Louis and Noland whom he could once again champion as he had championed Pollock; and the composer-aesthetician was the guru of pop and mixed-media, John Cage, whose mixture of Dada and Zen was compatible with certain aspects of Harold Rosenberg's Dada-derived conception of action painting. With Cage's benediction, the arena of art was permitted to merge with the arena of life, as actual gestures in Happenings, the theater of action, replaced the metaphorical gestures of action painting.

Greenberg and Cage, although not painters, decisively affected painting, not only because of the strength and originality of their ideas, and the clarity and insistence with which they articulated them, but because the time was ripe for Greenberg's classic taste for the grand manner as well as for Cage's anti-classicism and preference for anarchic self-expression and restless experimentation over any set of norms of aesthetic decorum. In 1961 both Greenberg's collected essays, *Art and Culture*, and Cage's lectures, *Silence*, were published. They became the bibles of the sixties. No artist or critic working in the period failed to be affected by one or the other or both. By the end of the sixties the New York art world was once again clearly polarized, this time around the aesthetic positions articulated by Greenberg and Cage, which were seen as diametrically opposed world views having unavoidable social, political and moral consequences as well.

Greenberg's insistence on the timeless authority of the classical systems of aesthetics, particularly in their modern reformulation by Kant and Lessing, defined the limits of art for color painters as stopping short of literalism and theater, the anathema respectively of transcendence and purity. Cage's affirmation of contemporary life blended elements of John Dewey with aspects of Duchamp's ironic stance, encouraging art to encroach upon the environment until the boundaries between art and life were effaced. His advice to artists to draw inspiration from the everyday environment in fact had been the original stimulus for the development of pop imagery. In the late sixties, artists disaffected with the commercialism of the art world took Cage's permissiveness as a signal to abandon creating objects entirely in favor of ephemeral theatrical gestures that could not be bought or sold or owned as private property. Cage's own definition of art as a kind of revolutionary behavior, as opposed to any specific conservative order of forms, was particularly attractive to the radical younger generation, many of whom interpreted Greenberg's insistence on quality as an attempt to impose an official authoritarian canon in the form of a rigorous definition of the limits, which quickly seemed the rules, of art.

The development of painting in the sixties from reductive minimalism to a complex illusionism can be observed in the works of a number of painters including Larry Zox, Darby Bannard, Larry Poons and Ronald Davis. But it is most clearly traced in the work of Frank Stella, whose monochrome shaped paintings, in their impassive, object-like literalness, became the touchstone of minimal art, to the extent that his conversion to the sophisticated illusionism of color abstraction in 1965 deprived the minimal sensibility of much of its energy and impetus. Like Noland, Louis, and most of the younger painters whose careers began in the late fifties, Stella painted loosely brushed Abstract Expressionist works early in his precocious career. The exhibition of a group of his first "stripe" paintings in 1959 at the Museum of Modern Art had an effect similar to Jasper Johns' first exhibition largely because, like Johns' targets and flags, Stella's black stripe paintings were a bold challenge to existing criteria of taste as well as images of an extreme if not arrogant originality. Like Johns' paintings of common objects—lowbrow themes in relation to the heroic ambition and rhetoric of Abstract Expressionism—Stella's black paintings were considered an insulting affront to the fine art of painting, not least because they were, like Johns' original flag, the work of a painter in his early twenties who achieved instant fame and recognition. This was virtually unprecedented in America, where artists usually waited until well into middle age before they sold a painting or showed in a museum, which made Stella's entry into the art world that much more dramatic.

Jasper Johns (1930). White Flag, 1955. (72×144″)
Collection of the Artist.

The connection between Stella's and Johns' work was hardly fortuitous. As Franken-thaler was the first to grasp the radicality of Pollock's technique, Stella was the first to understand the implications of Johns' attitudes toward space and shape, as opposed to the sensational aspects of his blatantly American imagery. Stella understood that Johns' importance as a formal innovator was far greater than his interest as merely a source of pop imagery. He saw first of all that Johns had resolved the contradiction implicit in the ambiguity of Abstract Expressionist space. Proclaiming the flatness of his surface by choosing images one knew in advance to be flat—e.g. flags and targets—Johns underscored that self-proclaimed flatness by identifying the image, in the case of the flag, with the shape and dimension of the entire pictorial field.

That Johns' attitude toward space and especially toward *shape* was radical has tended to become obscured because virtually everything else about his work, including its intimate scale, encaustic medium, and Cézannesque paint handling, was reactionary. The issue of the formal importance of Johns' paintings has been complicated, moreover, by the direction his work has taken in the sixties. Because his later paintings are looser and less clearly structured than the iconic flags and targets, the radicality of the early works is perhaps not as clear as it should be. Johns' flags and targets, however, represented an important turning point. Like Reinhardt's crosses, they were entirely preconceived images painted in a context of the improvisational excesses of late Abstract Expressionism.

Johns' choice of a form that could neither be revised, such as a standardized or stereotyped image like a flag, nor seen as a series of related details was crucial for the development of the conceptual art of the sixties.

The repetition of modular units repeating the horizontal axis of the frame in rhythmic progression in addition to the identification of image with the pictorial field, resulting in the elimination of positive shape vs. negative background arrangements, clearly link Johns' flags with Stella's early stripe paintings. Johns' assertion of surface, too, as hard and resistant as opposed to yielding and absorbent, with its echo of Still's sensuous impasto, is related to Stella's adoption of metallic pigments in the 1960 aluminum paintings, although Pollock's use of aluminum paint was probably foremost in Stella's mind. As opposed to the literal reflectiveness of Stella's metallic silver, bronze and purple shaped paintings, however, Johns' use of encaustic acted like the glazes in old master paintings to create a surface that was paradoxically hard but transparent. The use of the encaustic technique in which Johns' finest paintings are executed allowed him to maintain freshness while still using fine handwork and subsequent layers of overpainting.

Stella's decision in 1960 to cut out the corners of an aluminum painting such as *Marquis de Portago* because they appeared to him "left over"—that is they functioned as background with relation to a shape—had the effect of shifting the emphasis definitively from internal relations between shapes depicted on a field to an eccentric perimeter that was insistently if not obsessively reiterated by bands of equal width separated by channels of raw canvas.

Immediately such paintings set off a vogue for the shaped canvas which produced many works that appear obvious and contrived in retrospect. Besides Stella, however, Noland, in his elongated diamonds, Kelly in his intensely saturated geometric paintings, and most recently Ronald Davis in his highly illusionistic plastic paintings, have made important works in which shape is literal, identical with the limits of the pictorial field, instead of depicted as in older art.

Davis's work is especially interesting because of his development of a new technique. Painting directly with liquid plastic, he creates a hard surface, which is glossy and reflective, literally filtering and transmitting light from behind. In opposition to traditional art, which built up an image on top of the ground with layers of paint and glazes, Davis locates his image *literally* behind the surface. This entirely changes the nature of the illusionism he employs and makes it something quite different from traditional illusionism. Whereas traditional painting attempted to trick the eye into believing that a three-dimensional cavity existed behind the surface of the painting, Davis constantly reveals the artificiality of his illusionism by creating a hard reflective surface. Instead of the logical world of Uccello (who certainly influenced Davis), which confronted the viewer with an image that faces him frontally, one is confronted with a hallucinatory world of images which, as Davis presents them, are only visible if the viewer is flying in the air above them. Hence the sensation that one is looking down at an image.

It was Malevich, of course, who first suggested that painters in the modern world should imitate views as seen from airplanes; the frequency of such aerial views in recent American art like Davis's, however, is astonishingly prevalent.

The range of artistic activity in America at the end of the sixties is extremely broad. Its spectrum extends from the late works of Newman, Rothko and Motherwell, which grow increasingly grave, austere and monumental, much in the spirit of the late masterpieces of the greatest painterly painters, Titian, Caravaggio, and Velazquez. Action painting has re-emerged as pure theater in a performance oriented anti-formal art. Many young painters are rejecting the public image and role sought after by the most ambitious painters of the sixties in favor of a casual intimate art like the unstretched pieces of canvas of Richard Tuttle. Others continue to explore ways of extending color relationships and illusionism; many like Larry Poons and Dan Christensen, inspired by Olitski's success, are returning to the painterliness they previously had rejected, once again attracted to freedom of execution. A number of second-generation Abstract Expressionists, such as Alfred Leslie, having recognized the confusion in action painting attitudes regarding space and shape have returned to the figure, joining realists like Phillip Pearlstein and

Frank Stella (1936). Marquis de Portago, 1960. (93¼×71½″)
Carter Burden Collection, New York.

Jack Youngerman (1926). Black, Yellow, Red, 1964. (96×73″)
Collection The Finch College Museum of Art, New York. Gift of the Artist.

Jack Beal in creating a hard-edged explicitly sculptural realism, whose calculated coldness stands in stark opposition to earlier sentimental expressionist "returns to the figure."

Having survived the crisis of the late fifties, many Abstract Expressionists such as John Ferren, Adja Yunkers, Raymond Parker, and Jack Youngerman are creating large, simple shapes related to Matisse's late works, to which Adolph Gottlieb's recent decorative abstractions are also related. Color abstraction generally dominates the scene, although its split into two camps seems fairly obvious: one group of abstractionists creates an exclusively hard-edged industrial urban art and the other devotes itself to a more lyrical allusive abstraction tied to landscape. This, essentially, is the expressive difference between Stella's muscular arcs and interlaces and Noland's horizontal banded works, with their implicit reference to the horizon line of landscape painting. Nature metaphors are beginning to be increasingly prevalent in the work of many younger artists. The switch from a cold artificial style to a more open style with distinct landscape allusions is especially noticeable in a painter like Darby Bannard. But the clearest example of the presence of landscape allusions is probably Olitski's atmospheric abstractions, with their *repoussoir* framing elements and contrast of vast open expanses with small, scale-giving elements, both familiar devices in traditional landscape compositions. Once again, American painting has begun to reiterate the traditional opposition of nature to the city, of the urban landscape to industrial forms, that split not only American painting, but all of modern art down the center.

Ellsworth Kelly (1923). Two Panels. Yellow and Black, 1968. (92×116″)
Courtesy Sidney Janis Gallery, New York.

233

Although Bannard and a number of younger artists have reduced the size of their paintings, large scale continues to be an important characteristic of new American art, which seeks now for complexity on every level, as it once sought for simplicity. Yet because of the sophistication of the artistic and critical audience, this complexity is being sought after for the most part with the greatest precision, clarity and logic. Although many young artists feel that the signals from the Renaissance are getting weaker, considering Pollock's abandonment of the traditional forms and techniques as the end of painting, others view Pollock today as a new beginning, and continue to be inspired by the level of ambition and achievement of American painting in the sixties.

These radicals dream of an art finally free of those last vestiges of Renaissance space and drawing that lingered on in Cubism. Indeed, if on the basis of recent American painting, one were to decide the outcome of the debate raging for centuries between those who argued for the supremacy of color or design, one would have to conclude that Rubens and Delacroix have found their ultimate justification in a far-away country, never before noted for its love of pleasure and sensuality. Alive today, they might have an equally difficult time believing that the center of world art is no longer Rome or Paris, but New York.

Ronald Davis (1937). Disk, 1968. (55×136″)
From the Collection of Mr. and Mrs. Joseph A. Helman, St. Louis, Missouri.

The Seventies:
American Art Comes of Age

EMBARKING on its third century, American painting at the end of the nineteen seventies has emerged, independent at last of foreign models, as the leading force in world art: a fully mature tradition, heir to both the legacy of European modernism as well as to indigenous American modes of thought and expression. An informed synthesis of these two sources, undertaken on a new level of conceptual and technical sophistication, is the major achievement of American art in the seventies.

During the sixties, American painters consolidated the stylistic and formal revolutions of the Abstract Expressionists, the first painters successfully to challenge classical Cubist principles of strict geometric design. Both the spontaneous, subjective "painterly" style of action painters like Pollock and de Kooning, as well as the more formal structural art of the "color-field" or chromatic abstractionists like Newman and Rothko, were radical extensions of the parameters of painting. Inventors of a post-Cubist style, the Abstract Expressionists were at last totally original American painters; their works were the first paintings made in America to carry sufficient authority to hang beside the masterpieces of the past.

In a more traditional culture, one can imagine that such an accomplishment would have ushered in a period of increasingly refined, well-executed academic art. To some extent, it is true that the seventies, in comparison with the dramatic "breakthrough" years of postwar American art, have been a relatively academic period, characterized by the professionalization of art, the growth of art schools, and the gradual assimilation of art into a social context. Americans, however, have particular difficulty accommodating the idea of an end to progress in any area, including the arts. A country that prizes novelty and invention above tradition and stability—at least until the present moment—America has generally demonstrated little respect for or interest in historical precedent. In the seventies, however, American artists developed a surprising and unexpected sense of history. In the past, Americans considered novelty and innovation as ends in themselves; in the seventies, American artists returned to conventional materials and techniques and found inspiration in reconsidering the art of the old and modern masters.

Constantly mobile, volatile and changing, America is a geographically large country that continues to breed individual psychological isolation despite the continued growth of the transportation and communication industries. As we might expect, this isolation is reflected in its art. Because of the fundamentally egalitarian, democratic ideology of the United States, popular taste has always rejected the "mainstream" of modern art, descended from the alien School of Paris. We have seen how, by the middle of the nineteen fifties,

proto pop artists like Robert Rauschenberg and Larry Rivers began challenging the "high art" elitist principles of Abstract Expressionism, a hermetic symbolic style accessible only to a cultured minority. Although there was a relative diversity of styles in the sixties, essentially only three styles—pop, minimal and color-field abstraction—dominated American art during that explosive decade. At the same time, however, strong regional schools developed in Washington, D.C., Chicago, Los Angeles and San Francisco, although these local expressions continued to be tied to the dominant New York styles. In San Francisco and Chicago, for example, representational art, both surreal and realistic, flourished throughout the sixties and seventies. In Chicago, Peter Saul and Jim Nutt developed fantasy styles with a more biting edge of social criticism than pop art; figurative painting first received an enthusiastic reception in Chicago as well. Washington, D.C., where Louis and Noland began painting stained canvases in the fifties, remains today an active center of color-field painting. Veteran color-field painters like Tom Downing, Gene Davis, Howard Mehring and Alma Thomas have been joined by younger artists like Sam Gilliam, whose stained canvases extend the premises of Louis and Noland's abstraction further into the area of the literalist sensibility. In early paintings, Gilliam draped unstretched pieces of stained and dyed canvas against the wall or in environments, emphasizing that a painting is literally nothing more than a colored surface, a mere piece of cloth. Recently Gilliam has begun collaging areas of dappled color on to stretched paintings; the collage is a device for structuring color without resorting to conventional drawing or illusionism used earlier by Lee Krasner and Howard Mehring.

Ironically, the shift toward conservatism characteristic of the seventies manifested itself early in Los Angeles, the center of the most extreme anti-traditional art in the sixties. So total was the rejection of the past by Los Angeles artists in the sixties that Robert Irwin and Larry Bell abandoned painting entirely to pioneer a highly evocative art of minimal environments. Billy Al Bengston sprayed glittering automobile lacquer on to metal surfaces, and Ron Davis, Craig Kauffman and John McCracken experimented with glossy plastic surfaces. In the seventies, however, the best known painters of the Los Angeles School —Ron Davis, Billy Al Bengston, Ed Moses and Craig Kauffman—began working once again with oil paint on canvas. Moreover, a second generation of gifted Southern California abstract painters, whose works stress shimmering light effects inspired by the brilliant California skies, have also rejected the plastic pigments and other new media, so attractive to the sixties' taste for the ephemeral and the impermanent, in favor of conventional materials and techniques.

If the "cool" sixties reacted against the romantic expressionism of the New York School, the seventies in turn have rejected the slick surfaces, alienated objectivity, gigantism, and serial imagery reminiscent of the factory assembly line, as well as the mechanical hard edges and simplified graphic images of the sixties. For the art of the seventies is not only more heterogeneous, diverse and pluralistic than that of the sixties, it is also frequently more intimate, poetic and personal. Once again, painting has become, not a mass-produced product, but a unique, personal communication. This is reflected not only in the choice of politically or psychologically loaded imagery, but also in the return to painterly hand painting and to the reduced scale of easel painting, as opposed to the environmental scale of mural painting characteristic of the art of the sixties.

In the seventies, the impulse toward a public art has finally been afforded freedom to express itself in state commissions for large-scale works awarded to abstract painters like Al Held, Ellsworth Kelly, Helen Frankenthaler and Frank Stella; at the same time, the alternative of an intimate art has become more viable as a possibility for younger painters eager to work on a human rather than an architectural scale. We have seen how, in the sixties, native American attitudes and tastes, particularly the characteristically American love of genre and American Scene subjects, suppressed during the rise of Abstract Expressionism, began to surface once again. This tendency toward the assertion of American themes became even more pronounced in the seventies, as the memory of European art

receded in the face of a new consciousness of the roots of a distinctively American culture. Intensified by the 1976 celebrations marking the Bicentennial of the American Revolution, the search for American roots triggered a wave of popular sentiment that continues to gain ground, unleashing a general reaction against abstract art among middle-class patrons, paradoxically at precisely the moment that government and institutional patronage has begun to take up the cause of abstraction as monumental public art.

The idea that modernist abstraction is un-American is of course not new. We may recall that the initial American response to the introduction of modern European art early in the century was that this new art was the product of an "Ellis Island" alien mentality. Each time there is a surge of populist, regionalist sentiment in America, the reaction against modern styles manifests itself again. Thus in the thirties, popular taste applauded mediocre regional art and American Scene genre, while both museums and the public ignored the art of the American abstract artists who laid the groundwork for Abstract Expressionism. Although the W.P.A. federal art patronage program, inaugurated during the Depression years as a means of providing work for artists, may not literally have encouraged what Arshile Gorky termed "poor art for poor people", the program did emphasize regional and popular genre subjects. As a result of the establishment of the National Endowment for the Arts, an agency of federal art patronage founded in the sixties, popular taste is once again a critical factor, and realistic genre art is being encouraged, as is a greater participation by a greater number in the arts. Federal art patronage in democratic America supports pluralism, the widest possible spectrum of artistic activity, rather than exclusively patronizing "high art" or elitist modern styles. Indeed in the populist decade of the seventies, the very term "modernism" has become suspect because of its elitist connotations.

Current anti-modernism in America has other sources as well. The breakdown of authority in all areas of American life, resulting from the nightmare of a corrupt government, also affected American art. Challenges to authority in all spheres made it no longer possible for an authoritarian critic like Clement Greenberg to proclaim that valid important art could be made only in the area designated as the "mainstream" of modernism because of its direct descent from Cubism. Pop art was not, in its academic references to the art of the past and its ironic commentary on a cultural context of reproduced images, a genuinely popular style as much as it was a critical examination of the expansion of popular culture; but pop opened the doors to a revival of representational painting intentionally and aggressively directed at the common man.

Fifty years ago, Marsden Hartley pessimistically predicted that art could not take root in America until ninety million people had become aware of it. Hartley would probably have been astonished to find that through the blatant familiar imagery of pop art, such a goal was, for the first time in history, a real possibility. Suddenly, in America, an educated or semi-educated mass public, previously ignorant of the existence of the visual arts, began taking an interest in painting and sculpture, along with good wines, gourmet cooking and other appurtenances of the good life. By and large their taste was for an art that was understandable, accessible and direct in its address. Their biggest reception has been, not surprisingly, for Photo Realism, a leading seventies' style of *trompe-l'œil* illusionism that vies with photography itself in duplicating and documenting the external world. The heir apparent of pop art, Photo Realism (or Hyper-Realism or Super-Realism as it is sometimes called) bears the same relationship to photography that pop art did to graphic design, advertising and printmaking. Pop artists flattened and stylized the images derived from mass media, forcing them to conform with the pictorial principles of modernism, but the Photo Realists, whose labored academic style recalled Pre-Raphaelite precedents, feel no such necessity. Thus the slick, glossy surfaces of the paintings of Richard Estes, Robert Bechtle, Ralph Goings, Robert Cottingham et al. gleam with highlights that delight the viewer who has no previous knowledge of art and is gratified to recognize the familiar streets of city and suburbs. In its obsession with Americana, Photo Realism is but the latest incarnation of American Scene painting, a latter-day version of the Ashcan School, often replete with requisite ashcans and

Jasper Johns (1930). Untitled, 1972. (72 × 192″)

other industrial eyesores. A devotion to the unpleasant detail that reveals the vacuity of the consumer culture shows that Photo Realism has the same muckraking impetus that formed the spirit of the original Ashcan School. In both cases, a journalistic, story-telling element is expressed in a nominally objective style. However, the Photo Realist selection of scenes that are particularly tawdry and tasteless, the choice of showing empty streets devoid of human life, is not neutral but loaded with negative social comment regarding the deterioration of the American Scene into an urban and suburban wasteland of mass culture artifacts, careless litter and traffic jams—in short, the neon wilderness. The social commentary of a Photo Realist like Audrey Flack, who specializes in mechanically executed still lifes of vulgar objects of the lowest level of mass culture and plastic *kitsch*, is presented as documentary reportage, which is quite different from the ironic *double-entendres* of pop art. At the same time that the Photo Realists are specializing in dead-pan documentary, pop artists like Roy Lichtenstein, who has repainted the masterpieces of Cézanne, Picasso, Matisse, Mondrian, Léger and other modern giants in a cartoon style, or Andy Warhol, whose latest series of paintings of American Indians and hammers and sickles marked "Made in U.S.A." poke fun at politically volatile subjects, continue to engage in a clever dialogue with high culture, which emphasizes the irony of mass culture reproductions of the formerly high culture aristocratic objects of the past.

Am. 131

Because it so flagrantly embraced traditional academic modes of illusionism, rehabilitating the entire panoply of *trompe-l'œil* devices against which modernism originally rebelled, Photo Realism attracted immediate attention when it first began to be widely exhibited around 1970, about the time that photography itself was beginning to gain recognition as a fine art in America. We must remember, however, that *trompe-l'œil* painting has been popular in the past in America. The recent rediscovery of the *trompe-l'œil* still lifes painted by Peto, Harnett and Haberle in the late nineteenth century, as well as the photography craze, also helped stimulate the emergence of Photo Realism as a major style of the seventies. In any case, the popularity of Photo Realism, coupled with the renaissance of photography itself, has revived the possibility of representational art as a serious threat to the hegemony of abstraction in American art. However, no Photo Realist challenged the fundamental assumptions of both abstraction as well as representation in so incisive a manner as Jasper Johns, who has emerged as a figure perhaps even more critical for American art of the seventies than he was for the sixties.

Johns originally won fame with his paintings of American flags, early pop icons which he began painting in 1955. His later paintings, however, such as the enigmatic polyptych *Untitled*, 1972, are disquieting, disorienting, puzzling works which cause problems of inter-

pretation and even of recognition. Provoking much critical controversy, Johns' later works have been appreciated by a small group of artists, critics and *amateurs*—the traditional public for avant-garde art from Caravaggio to Duchamp, Johns' chosen mentor in his intellectual pursuits. Although their hermeticism is mitigated to some extent by the inclusion of some recognizable images, such as the parts of the human body, beginning with his first large polyptych *According to What* in 1964, Johns' paintings are based on an intricate, highly personal iconography as esoteric as that of any sixteenth-century Mannerist artist.

Like Mannerist painters who adhered to the doctrine of *ut pictura poesis* (as in poetry, so in painting), which demanded that the work of art illustrate a specific literary text full of philosophical and poetic references, so Johns has derived his iconography from a variety of written sources, ranging from Duchamp's *The Green Box*, the notes for the preparation of Duchamp's chef-d'œuvre, the so-called *Large Glass*, to Ludwig Wittgenstein's *Philosophical Investigations*, to poems by John Ashbery and the late Frank O'Hara, to treatises on visual perception by Ernst Gombrich and others. Because it is based on complex sources, on first encounter a painting like *Untitled*, 1972 immediately raises questions of interpretation. Indeed the nature of visual perception itself is called into question. For *Untitled*, 1972, in its symmetrical division into two similar but not identical halves, splits the visual field in a manner that seems to induce optical schizophrenia because of the problems which the focusing of such an arrangement creates for binocular vision.

Made up of four panels, each six feet high by four feet wide, bolted together to form a single horizontal surface, *Untitled*, 1972 is the first in an extended and interrelated series of paintings and prints derived from paintings exploring the relationship of parts to the whole. This theme has been Johns' central subject in the seventies. *Untitled*, 1972 also marks the introduction of motifs that, for the first time in Johns' career, appear to be purely abstract. Further examination of these elements, however, reveals that, like the dismembered parts of the human body which recall Johns' initial plaster casts of body parts in the 1955 *Target with Plaster Cast*, both the curious shapes resembling flagstones in the two center panels, as well as the linear pattern of intersecting strokes resembling cross-hatching also refer back to earlier works by Johns. The "flagstone" motif is derived from *Harlem Light*, a painting of 1967 said to have been based on the raised relief of a crudely painted stone wall in Harlem. That these stones, normally used to pave American garden walks and terraces, are known colloquially as "flags" must have appealed to Johns' sense of punning irony, since a wall or a floor is as explicitly flat as the American flag. Like the flag, walls and floors present only one surface to view, reinforcing the viewer's consciousness of their flatness. In the seventies, Johns became increasingly preoccupied with epistemological issues, constantly questioning preconceived ideas concerning cognition, precognition, recognition and their relationship to visual perception. Double and "decoy" images that may signify more than one meaning are typical in the works of the late sixties and seventies. Thus the "cross-hatching" in the left hand panel of *Untitled*, 1972, subsequently taken up as a motif in graphic works, resembles an enlargement of the rapid irregular scribble Johns has used in drawings and prints, particularly of the flag; this scribble in turn often referred to the natural anarchy of patches of growth in fields.

Johns' preoccupation with "fields" in earlier paintings like *Slow Field* and *Field Painting* is with the field of vision as opposed to the color field of abstract art. Indeed his entire effort of the sixties and seventies can be seen as a conceptual reaction against the hedonism of color-field abstraction. For like Duchamp, Johns maintains that art must be intellectually as well as visually arresting—an idea at odds with the aesthetics of pure visibility that dominated abstract color painting in the sixties. In that they provoke speculation and interpretation, Johns' works pose some difficulty for the viewer. In their steadfast commitment to an intellectual, cerebral, conceptual content, Johns' paintings redefine the idea of the difficult. Johns' involvement with philosophical questions connects his approach to the theoretical discussions of the Cubo-Futurists, the first artists to be fascinated by philosophical and conceptual problems early in the twentieth century. Bringing such theoretical preoccupations back into the

artistic dialogue, Johns has changed the nature of this dialogue, demonstrating the new found willingness and ability of American artists to enter into theoretical discussions, which in the past they had avoided in favor of direct emotional expression. In the sense that restraint from impulsive "action" and considered analysis are marks of maturity, Johns' recent works are yet another indication of the new sober, reflective spirit of American painting in the seventies.

At a moment when hand painting, conventional media and a stress on conceptual content are primary to painting in America, Johns has re-emerged as a key artist for the present period. His fragmentation of the pictorial field as well as his fragmenting of the human body into parts, and his final reconstitution of these parts into new wholes that are both more and less than the sum of their parts, posits a philosophical conundrum that has stimulated a revival in criticism, simply by supplying substance for intelligent analysis. In Johns' recent works, there is a curious symbiosis between painting and printmaking that also characterizes the art of the seventies. Motifs from paintings are elaborated upon in prints; these motifs are then taken up once again in subsequent paintings. For example, the "cross-hatch" pattern that is in itself a reference to the processes of printmaking, reappears in a series of later paintings and prints by Johns. Other artists such as Frank Stella, whose recent metal reliefs resembling giant subway graffiti are etched in acid baths in a manner derived from the aquatint process, have also borrowed from graphic techniques to create innovative paintings. And both Robert Rauschenberg, in the "Hoarfrost" series of paintings on silk, and Andy Warhol in portraits and still lifes of the seventies continue to use techniques derived from serigraphy.

That formal innovation could be achieved most easily through technical innovation was an idea John Graham had initially promulgated as long ago as the thirties. Essentially a surrealist notion, the idea of formal invention through technical change has remained an important possibility for American artists. In the seventies, although oil and canvas have regained popularity as the principal painting materials, translations of techniques from one medium to another continue to mean freedom for artists to borrow techniques from graphic art, photography, drawing and watercolor. Indeed, the displacement of techniques originated for works on paper into the area of works on canvas such as, for example, the use of an essentially watercolor technique of staining liquified pigment into an absorbent ground characteristic in the paintings of Frankenthaler and Noland, remains an important possibility even in the conventional seventies. Similarly, in the work of artists like Nancy Graves and Cy Twombly, graphic elements are charged with a gestural energy that appears more diagrammatic than spontaneous; the canvas ground is used like a page of paper—as the neutral area on which marks are deployed. In the case of both Graves and Twombly, the archaic quality of the markings implies that drawing might be a kind of secret handwriting, which might be deciphered if the code were broken. The implication of significance in mysterious traces and marks raises questions of interpretation reminiscent of the manner in which early Abstract Expressionism evoked myth and symbol in its allusion to preconscious signs and pictographs.

A renewed interest in content, and in the works of the first generation Abstract Expressionists generally, is typical of the maturing art of the seventies. Once again, the idea of an exclusively decorative art is being questioned, in much the same probing spirit that the Abstract Expressionists had once challenged the validity of geometric Cubism. The preoccupation with significance and the denial of an art that exists purely for its own sake are both historical American prejudices against formalism, which may be traced far back to the Puritan rejection of art that did not in some way instruct, elevate or edify. The current focus on the works of Abstract Expressionists who claimed that their work had transcendental metaphysical content is an indication that another group of fundamentally American attitudes, at odds with the materialism of the American Scene, is reasserting itself.

The death of Ad Reinhardt in 1967 and Barnett Newman and Mark Rothko in 1970 deprived American art of three exceptional leaders; however, in their absence, their reductive serial works were canonized, establishing more firmly a growing school of quiet, contem-

plative, so-called minimal paintings inspired by Newman's broad expanses of rich, luminous color light, Reinhardt's ascetic, nearly invisible paintings and Rothko's brooding, majestic late works. For all three, the goal was to create an environment for meditation rather than an object for decorative purposes. This goal was finally achieved by Rothko, who ended his own life, like a number of other American abstract artists, in a tragic suicide. At Rice University in Houston, Texas, a special chapel was erected to house an environment of Rothko's monochromatic paintings. The American equivalent of Matisse's chapel at Vence, the Rothko Chapel has become a pilgrimage site for younger artists, inspiring painters like Brice Marden and Jake Berthot to emulate Rothko's monochromatic diptych and triptych forms.

The widespread appreciation of Rothko's exquisitely sensitive surfaces and refined painterliness, which depends on the saturation of intense colors soaked into the canvas in repeated coats to create an inner glow rather than on thick impasto, is responsible for the revival of soft edge painterly painting in the late seventies. Curiously, although Rothko was an abstract artist, the example of his sensitive brushwork has had the biggest impression on representational artists like Jim Dine and Susan Rothenberg.

Dine, who won renown as a pop artist, has become increasingly reflective and introspective in his works of the seventies. He continues to paint images such as the bathrobe motif that originated in a pop self-portrait; but he no longer affixes objects to his surfaces. Now these generalized images are no longer references to popular culture, but pretexts for the creation of patterns of color and line. In a recent painting like *Cardinal*, Dine is clearly indebted to the refined surfaces and subtle modulation of Rothko's late paintings, rather than

Nancy Graves (1940). A B C, 1977. (44 × 96": each panel 44 × 32")
Courtesy André Emmerich Gallery, New York

to the images of the world of mass culture that originally inspired him. Although Dine's recent paintings allude to the human figure, and some are even figure studies, they are not as directly involved in a return to traditional figure painting as literal as that of Alfred Leslie, who has equated figure painting with a tradition of humanism he seeks to revive in America.

" I wanted to put back into art all the painting that the Modernists took out," Leslie has stated, " by restoring the practice of pre-twentieth-century painting... I wanted an art like the art of David, Caravaggio and Rubens, meant to influence the conduct of people." Beginning in the late sixties, Leslie, originally an abstract painter, was among the first to renounce abstract art in favor of a style more available and accessible to a large public. Leslie's early attempts to resurrect the heroic dimensions and naturalistic style of Caravaggio and David, whose works had captured the imagination of a popular audience in earlier epochs, were clumsy and naive. Slowly mastering the technical facility necessary for such an ambitious effort, Leslie went to such typically American literalist extremes as having a jeep put in his studio so that he could" paint from nature" one of the props in his painting *The Death of Frank O'Hara*. In one of several versions of his homage to O'Hara, the American poet whose life was prematurely cut short by a freak auto accident, Leslie based his composition so closely on Caravaggio's *Entombment* that the painting is virtually a copy of Caravaggio in modern dress, executed however in a style that has as much to do with billboard painting as with the old masters.

Emulating Caravaggio's candlelight studies and David's sculptural realism, Leslie has invented a contemporary form of Caravaggesque realism, a monumental genre painting suitable to the democratic American experience. In *The 7 A.M. News*, a solitary woman sits

Jim Dine (1935). Cardinal, 1976. (108 × 72″)
Courtesy The Pace Gallery, New York.

244

Alfred Leslie (1927). The 7 A.M. News, 1976. (84×60″)
Courtesy Allan Frumkin Gallery, New York.

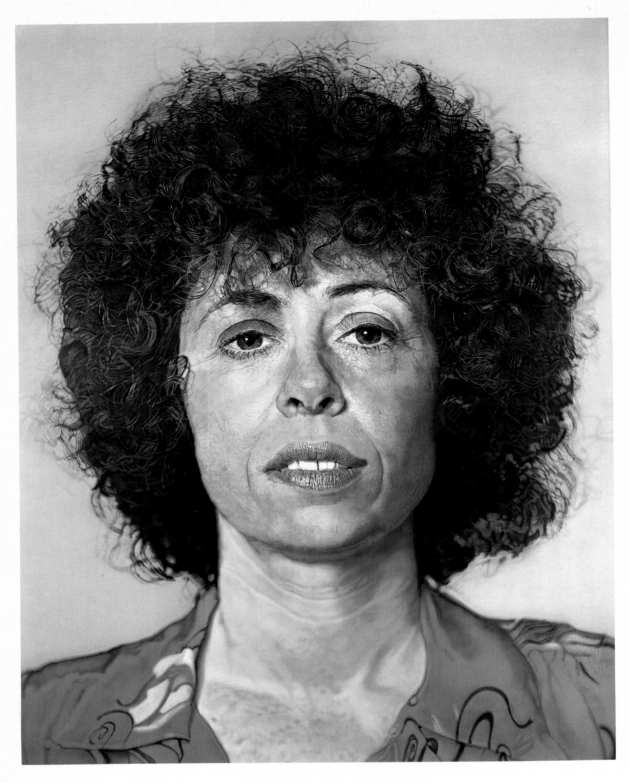

Chuck Close (1940). Linda, 1976. (108 × 84″)
Courtesy The Pace Gallery, New York.

reading a newspaper beside a table on which a television set flickers. Her face is illuminated by the harsh glare of the ubiquitous "tube" that has replaced both Caravaggesque candlelight and divine illumination. Her eyes, however, look away from the instruments of mass "communication" toward heaven, as if she were communicating rather with some mystical force that transcends the mundane reality of electronic technology. In her isolation, the woman reminds us of Edward Hopper's profoundly alienated figures sitting alone in cafeterias, bars and rented rooms.

Like Jim Dine, whose robes are far larger than life size, Leslie demands the viewer's attention by enlarging his images to heroic monumental scale. As large as the projections on

movie screens, Leslie's figures are seen in exaggerated close-ups influenced by cinematic images. With their curiously stupefied gaze, eyes often raised toward heaven like those of religious figures in Mannerist altarpieces, Leslie's portraits, like those of Chuck Close, have the theatrical drama of sheer colossal size. Close, however, does not deal with the figure at all, confining himself exclusively to immense portrait blow-ups based on photographs rather than on nature. Although they take photographs rather than people as models, Close's portraits like *Linda* are quite distinct from Photo Realist paintings in that they are based not on naive duplication of photographic images of reality, but on an abstract system of tiny dots arranged on a grid. At close range, these dots ultimately coalesce like the spots of color in a pointillist

Agnes Martin (1912). Untitled No. 8, 1975. (72 × 72″)
Courtesy The Pace Gallery, New York.

painting, into a recognizable image. This image in turn, at any point, depending on the viewer's focus, may once again break down into a series of abstract points. Thus in Close's work, there is a conscious engagement with the issues raised by modernist abstraction. That the faces are visible as both an abstract system of marks on the canvas as well as in the form of a recognizable image of uncanny force lends a tension and conceptual content to Close's work absent in Photo Realist painting. Like Leslie's over-size figures, Close's portraits involve the viewer in an intimate psychological confrontation with their subjects. This confrontation is particularly unsettling since Close's portraits, like those of Warhol as well as Leslie, are strangely inanimate and immobile: for all three, the human face has become a kind of still life—a searing commentary on the alienation of contemporary life.

Although America has been described, both at home as well as abroad, as the most materialistic country in history, another aspect of the American character, as fundamental as the empirical, pragmatic, literalist tendency, has begun to reassert itself in the seventies. This is the spiritual dimension that informed the work of Rothko, Newman and Reinhardt. We sense allusions to this spirituality in the trance-like expressions on the faces of Alfred Leslie's figures, which signify an altered state of consciousness. When we direct our attention to the notion of an altered state of consciousness, we realize that the impulse behind Reinhardt's black paintings, which demand an otherworldly state of mind to be visualized at all, was toward inducing such meditative states. A number of painters have followed Reinhardt in making nearly invisible images, but none has done so as successfully as Agnes Martin. For Martin's virtually monochrome square canvases like *Untitled No. 8* require a degree of concentration so intense from the viewer that, like Reinhardt's black paintings, they are oases of quiet in a tumultuous, over-stimulated environment. Superimposing a graphic grid-like linear network on her pale monochrome backgrounds, Martin has simplified her image to a bare minimum. Other artists like Robert Mangold, Robert Ryman, James Bishop and Jo Baer have also worked with minimal formats encouraging quiet contemplation, which are at the opposite pole of expression to the this-worldly art of Photo Realism. The presence of two such divergent types of painting in America in the seventies—one extremely material, the other extremely immaterial—is an indication of the broadness of the spectrum of artistic activity today, which ranges from the purest abstraction to a hyper-realism.

Like Agnes Martin, Jack Tworkov superimposes a linear network on a painterly background. Tworkov, however, often implies perspective with his network of lines which sets up a dynamic element in the work that is absent from the absolute frontality of Martin and the other minimal painters. A veteran Abstract Expressionist, Tworkov is among those American artists who, after years of searching, have found a truly distinctive personal style late in life. For one of the curiosities of American art in the seventies is that, possibly for the first time, the genuine innovations, the work of lasting value, are being made not by young artists like the *wunderkinder* of the sixties, but by mature painters well into their fifties, sixties and seventies such as Robert Goodnough, Friedel Dzubas, Giorgio Cavallon, Cleve Gray, Stephen Greene and other mature artists who, like Hans Hofmann in the sixties, have found unique stylistic identities at the end of long careers.

One such mature artist to have emerged as an important force in the seventies is Lee Krasner, whose recent series of collage paintings such as *Imperative* incorporate fragments of Cubist drawings which she made while a student of Hans Hofmann in the thirties. Krasner kept these drawings inspired by Picasso for nearly forty years. Finally, in the seventies, she cut them up into shapes in a manner suggested by Matisse's late *découpages*. Action now has been stilled; gesture is solidified into shapes that, although they continue to be informed by Krasner's inner sense of rhythm, have taken on a stable, monumental form. Krasner's willingness to delve back into her own personal history exemplifies the direction of the best recent American art, which has finally come to view the past not as a threat, but as a source of renewal and sustenance.

Another mature artist who has emerged as a painter of the first rank in the seventies is Richard Diebenkorn, whose return to abstract art after many years as a representational

artist reverses the direction of the many abstract painters like Philip Guston and Alfred Leslie who have recently turned to figurative subjects. In the fifties and early sixties, Diebenkorn was based on the Bay area around San Francisco, where he painted landscapes and figure studies. Even in his figurative work, however, Diebenkorn was concerned with pictorial structure rather than with specific detail. Impressed by Matisse early in his career, he came to a new appreciation of the Parisian master during a trip to Leningrad in 1965, which gave him the opportunity to study Matisse in greater depth. In 1966 Diebenkorn moved to Los Angeles to take a job as a professor. The following year he began his series of abstractions on

Lee Krasner (1911). Imperative, 1976. (50 × 50″)
Courtesy The Pace Gallery, New York.

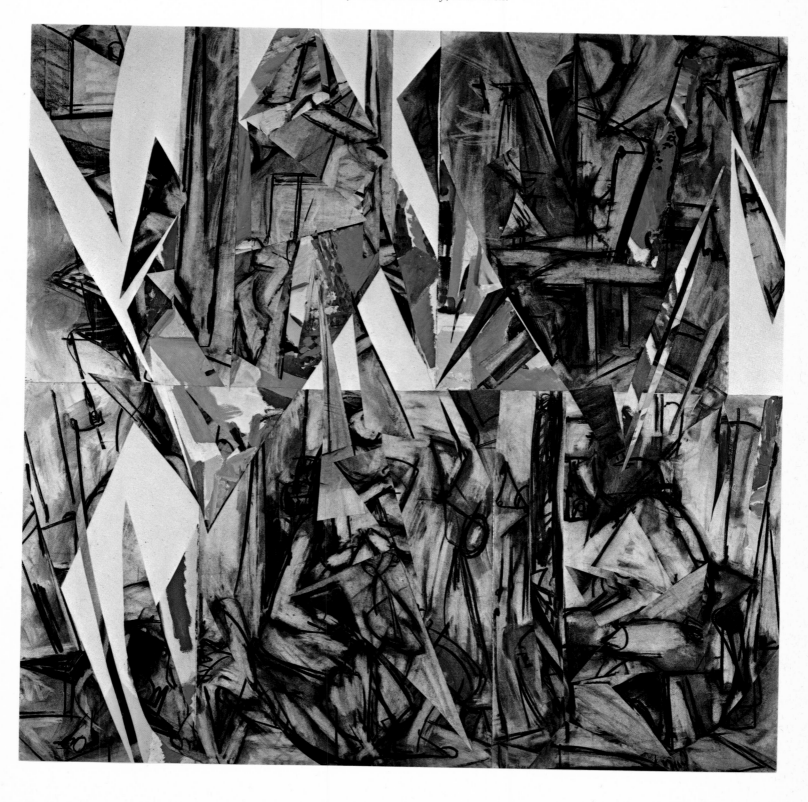

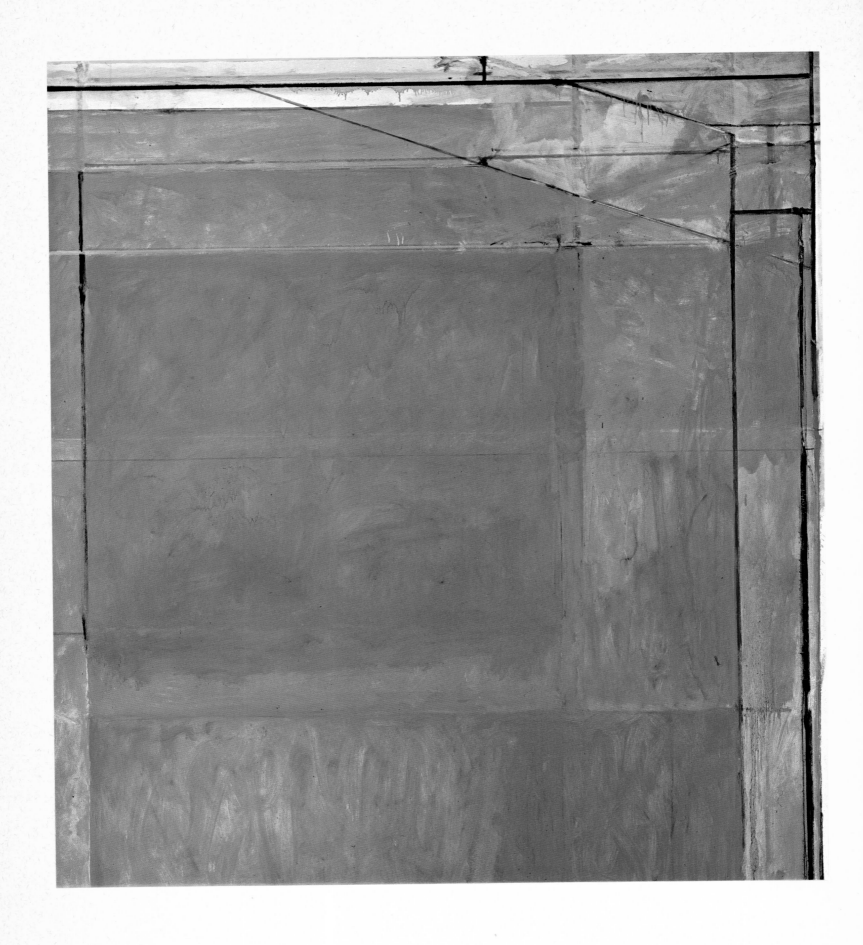

Richard Diebenkorn (1922). Ocean Park No. 60, 1973. (93×81″)
Albright-Knox Art Gallery, Buffalo, New York.

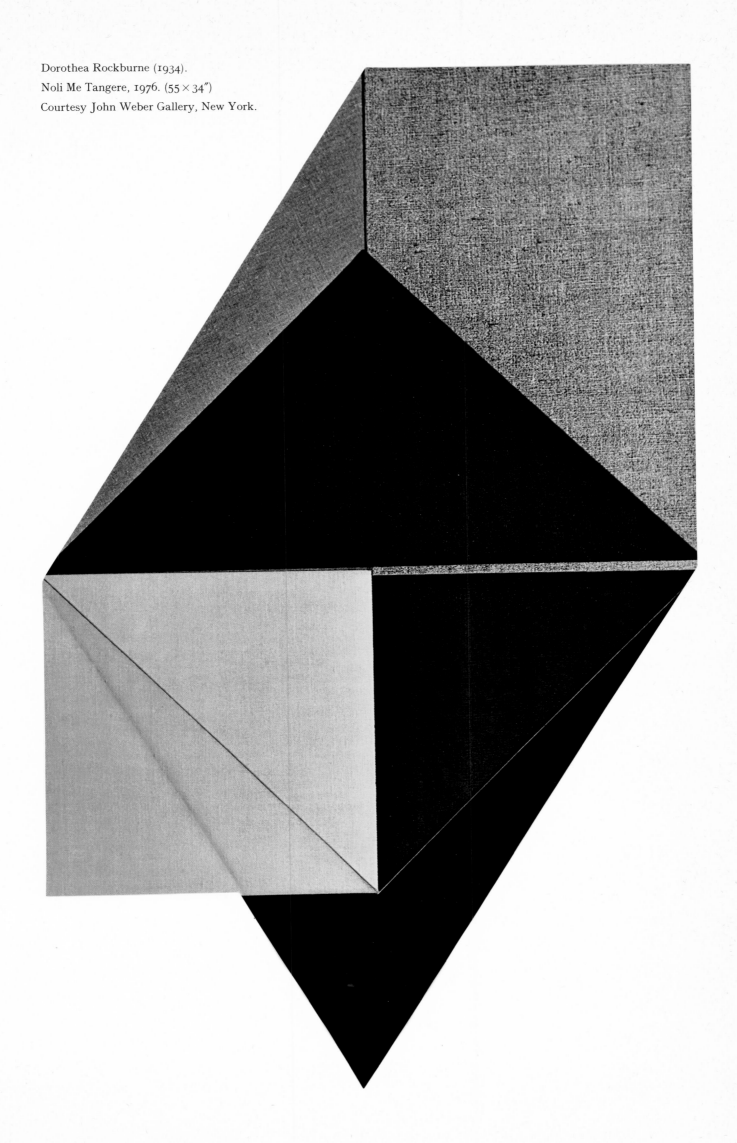

Dorothea Rockburne (1934).
Noli Me Tangere, 1976. (55 × 34″)
Courtesy John Weber Gallery, New York.

the theme of "Ocean Park" (the name of an amusement park in the beach community of Santa Monica where Diebenkorn keeps a studio). These paintings, like *Ocean Park No. 60*, are based on Matisse's most abstract oils. They employ drawing as a structuring element to contain areas of color that appear to reflect light. Like Motherwell, de Kooning and Still, who are continuing to paint some of their finest works in the seventies, Diebenkorn has devoted a lifetime to painting; the result is a mastery of technique unavailable to earlier American artists struggling to assimilate a painting culture that was essentially foreign.

In paintings like *Ocean Park No. 60*, Diebenkorn's approach to drawn geometry is intuitive rather than dogmatic or programmatic. This intuitive attitude toward geometry is typical of American artists who use geometry as a means of containing color rather than as an end in itself. For younger artists using geometry like Dorothea Rockburne, order is arrived at through empirical search rather than taken as an *a priori* point of departure; the result is a classicism with a particularly American inflection. In paintings like *Noli Me Tangere* Rockburne has turned to the harmonies of the Sienese masters like Duccio, whose art she has closely studied. Her complex technique as well is derived from a study of Renaissance methods. Covering a linen sheet with gesso, Rockburne folds her material into the form she wishes it to assume, much as one might fold paper. When the material, which she coats with varnish on the reverse side of the gessoed surface, dries, the linen hardens to become its own support, eliminating the need for a stretcher. With economy and elegance, Rockburne identifies surface with support—a step toward the unification of the painting as objective reality beyond the identification of image with ground that inspired both the stained canvas as well as shaped paintings in the sixties.

Rockburne's synthesis of elements taken from the historical past with characteristically American empirical methods and structure typifies the work of a new generation of American artists, who are taking the lessons of history not as restrictive dogma but as liberating precedent to be incorporated within a gradually maturing native tradition. After a crisis of confidence that echoed the historical crisis of a country on the verge of a second civil war over the issues of Viet Nam and racial integration, American artists have found their way back to a conviction in the worth of painting as a humanistic vocation and as a genuine means of communication. Within the eschatological context of recent years, the question" Is painting dead?" was seriously entertained. For American painters of the seventies, more and more of whom are returning to the traditional materials and concerns of their craft, and viewing innovation, not as an end in itself, but as part of a process reaching far beyond the brief span of America's short life as a civilization, the answer is a resounding NO.

Select Bibliography

List of Color Plates

General Index

Select Bibliography

Part One: From the Beginnings to the Armory Show

SOURCE WORKS

The most important general reference work for American art is GEORGE C. GROCE and DAVID H. WALLACE, *The New-York Historical Society's Dictionary of Artists in America, 1564-1860* (New Haven and London, 1957). This supersedes for the period prior to the Civil War such earlier compendia as RALPH CLIFTON SMITH's *Biographical Index of American Artists* (Baltimore, 1930) and MANTLE FIELDING's *Dictionary of American Painters, Sculptors and Engravers* (Philadelphia, 1926). — Useful information can be found in many biographical dictionaries, among which the *Dictionary of American Biography* and ULRICH THIEME and FELIX BECKER's *Allgemeines Lexikon der bildenden Künstler* stand out as the most useful. — The most comprehensive bibliography for the field is again found in GROCE and WALLACE's *Dictionary of American Artists*. — A valuable earlier effort is ELIZABETH McCAUSLAND's "A Selected Bibliography on American Painting and Sculpture from Colonial Times to the Present," *Magazine of Art* (November, 1946), pp. 329-349. — An especially good annotated bibliography of American art literature in terms of its relevance for the study of American history is WENDELL D. GARRETT and JANE N. GARRETT's "A Bibliography of the Arts in Early American History," *The Arts in American History* (Chapel Hill, 1965), pp. 35-170. — The *Art Index* is an essential guide to the periodical literature since 1929. Access to earlier material is more difficult, but Poole's *Index to Periodical Literature* (1802-1906) and GRIFFIN's *Writings in American History* (1906-1940) are useful. A number of twentieth century periodicals have concentrated on American art, especially *Antiques* (1922-), *Art in America* (1913-), and *Art Quarterly* (1938-).

GENERAL WORKS

Armory Show Fiftieth Anniversary Exhibition, Munson-Williams-Proctor Institute, Utica, and Armory of the Sixty-ninth Regiment, New York, 1963. — VIRGIL BARKER, *American Painting, History and Interpretation*, New York, 1950. — JOHN I. H.

BAUR, *Revolution and Tradition in Modern American Art*, Cambridge, 1951. — FRANK W. BAYLEY, *Five Colonial Artists of New England*, Boston, 1929. — WALDRON PHOENIX BELKNAP, Jr., *American Painting: Materials for a History*, Cambridge, 1959. — SAMUEL GREENE WHEELER BENJAMIN, *Art in America: A Critical and Historical Sketch*, New York, 1880. — Idem, *Fifty Years of American Art, 1828-1878*, Harper's New Monthly Magazine LIX, July, 1879, pp. 241-257; Sept. 1879, pp. 481-496; Oct. 1879, pp. 673-688. — Idem, *Our American Artists*, Boston, 1879. — YVON BIZARDEL, *American Painters in Paris*, New York, 1960. — MARY BLACK and JEAN LIPMAN, *American Folk Painting*, New York, 1966. — EDWIN BEACH BLASHFIELD, *Mural Painting in America*, New York, 1913. — THEODORE BOLTON, *Early American Portrait Draughtsmen in Crayons*, New York, 1923. — Idem, *Early American Portrait Painters in Miniature*, New York, 1921. — WOLFGANG BORN, *American Landscape Painting; an Interpretation*, New Haven, 1948. — Idem, *Still-Life Painting in America*, New York, 1947. — MILTON W. BROWN, *The Story of the Armory Show*, New York, 1963. — ALAN BURROUGHS, *Limners and Likenesses: Three Centuries of American Painting*, Cambridge, 1936. — CHARLES H. CAFFIN, *American Masters of Painting*, New York, 1902. — Idem, *The Story of American Painting*, New York, 1907. — JAMES T. CALLOW, *Kindred Spirits: Knickerbocker Writers and American Artists, 1807-1855*, Chapel Hill, 1967. — BENJAMIN CHAMPNEY, *Sixty Years' Memories of Art and Artists*, Woburn (Mass.), 1900. — ELIOT CLARK, *History of the National Academy of Design, 1825-1953*, New York, 1954. — ROYAL CORTISSOZ, *American Artists*, New York and London, 1923. — MARY BARTLETT COWDREY, *American Academy of Fine Arts and American Art-Union*, New York, 1953. — Idem, *National Academy of Design Exhibition Record, 1826-1860*, New York, 1943. — THOMAS S. CUMMINGS, *Historic Annals of the National Academy of Design*, Philadelphia, 1865. — MARSHALL B. DAVIDSON, *Life in America*, Boston, 1951. — HAROLD E. DICKSON, *Arts of the Young Republic*, Chapel Hill, 1969. — Idem, ed., *Observations on American Art: Selections from the Writings of John Neal*, State College (Pa.), 1943. — LOUISA

DRESSER, ed., *XVIIth Century Painting in New England*, Worcester (Mass.), 1935. — WILLIAM DUNLAP, *Diary of William Dunlap (1766-1839)*, ed. by Dorothy C. Barck, New York, 1930. — Idem, *History of the Rise and Progress of the Arts of Design in the United States*, 2 vols., New York, 1834. — Idem, *History of the Rise and Progress of the Arts of Design in the United States*, ed. by Frank W. Bayley and Charles E. Goodspeed, 3 vols., Boston, 1918. — Idem, *History of the Rise and Progress of the Arts of Design in the United States*, Introduction by William Campbell, ed. by Alexander Wyckoff, 3 vols., New York, 1965. — ALEXANDER ELIOT, *Three Hundred Years of American Painting*, New York, 1957. — CHARLES E. FAIRMAN, *Art and Artists of the Capitol of the United States of America*, Washington, 1927. — JAMES T. FLEXNER, *America's Old Masters: First Artists of the New World*, New York, 1939. — Idem, *First Flowers of our Wilderness*, Boston, 1947. — Idem, *The Light of Distant Skies, 1760-1835*, New York, 1954. — Idem, *The Pocket History of American Painting*, New York, 1962. — Idem, *That Wilder Image*, New York, 1962. — ALFRED V. FRANKENSTEIN, *After the Hunt: William Harnett and Other American Still-life Painters, 1870-1900*, Berkeley and Los Angeles, 1963. — ALBERT TENEYCK GARDNER and STUART P. FELD, *American Paintings*, New York, 1965. — SAMUEL M. GREEN, *American Art: A Historical Survey*, New York, 1966. — GEORGE C. GROCE, *New York Painting Before 1800*, New York History XIX, Jan. 1938, pp. 44-57. — OSKAR HAGEN, *The Birth of the American Tradition in Art*, New York and London, 1940. — NEIL HARRIS, *The Artist in American Society: the Formative Years 1790-1860*, New York, 1966. — SADAKICHI HARTMANN, *The History of American Art*, 2 vols., Boston, 1902. — ELLEN W. HENDERSON, *The Pennsylvania Academy of the Fine Arts and Other Collections of Philadelphia*, Boston, 1911. — SAMUEL ISHAM, *The History of American Painting*, New York, 1905. — *M. and M. Karolik Collection of American Paintings, 1815-1865*, Cambridge, 1949. — WILLIAM KELBY, *Notes on American Artists 1754-1820*, New York, 1922. — SUZANNE LAFOLLETTE, *Art in America*, New York and London, 1929. — OLIVER W. LARKIN, *Art and Life in America*, New York, 1960 (first edition 1949). — CHARLES E. LESTER, *The Artists of America*, New York, 1846. — *Life in America*, Metropolitan Museum of Art, New York, 1939. — JEAN LIPMAN, *American Primitive Painting*, New York, 1942. — Idem, *What is American in American Art*, New York, 1963. — Idem and ALICE WINCHESTER, *Primitive Painters in America 1750-1850*, New York, 1950. — NINA FLETCHER LITTLE, *American Decorative Wall Painting 1700-1850*, Sturbridge (Mass.), 1952. — STEFAN LORANT, *The New World*, New York, 1946. — JOHN W. McCOUBREY, *American Tradition in Painting*, New York, 1963. — Idem, *Painting*, The Arts in America: the Colonial Period, New York, 1966, pp. 149-249. — Idem, *American Art, 1700-1960: Sources and Documents*, Englewood Cliffs (N.J.), 1965. — HAROLD McCRACKEN, *Portrait of the Old West*, New York, Toronto and London, 1952. — RICHARD B. McLANATHAN, *The American Tradition in the Arts*, New York, 1968. — J. WALKER McSPADDEN, *Famous Painters of America*, New York, 1923. — FRANK JEWETT MATHER, Jr., CHARLES RUFUS MOREY, and WILLIAM JAMES HENDERSON, *The American Spirit in Art*, vol. XII, The Pageant of America, New Haven, 1927. — JEROME MELLQUIST,

The Emergence of an American Art, New York, 1942. — DANIEL M. MENDELOWITZ, *A History of American Art*, New York, 1960. — LILLIAN B. MILLER, *Patrons and Patriotism: the Encouragement of the Fine Arts in the United States 1790-1860*, Chicago and London, 1966. — EUGEN NEUHAUS, *The History and Ideals of American Art*, Stanford (Cal.), 1931. — *New England Miniatures 1750-1850*, compiled and edited by Barbara N. Parker, Museum of Fine Arts, Boston, 1957. — REMBRANDT PEALE, *Reminiscences*, The Crayon I-III, 1855-1856. — BERNARD B. PERLMAN, *The Immortal Eight: American Painting from Eakins to the Armory Show*, New York, 1962. — WILLIAM H. PIERSON, JR., and MARTHA DAVIDSON, ed., *Arts of the United States: a Pictorial Survey*, New York, Toronto and London, 1960. — J. HALL PLEASANTS, *Four Late Eighteenth Century Anglo-American Landscape Painters*, Proceedings of the American Antiquarian Society LII, Oct. 1942, pp. 187-324. — EDGAR P. RICHARDSON, *American Romantic Painting*, New York, 1944. — Idem, *Painting in America: The Story of 450 Years*, New York, 1956. — Idem, *A Short History of Painting in America: The Story of 450 Years*, New York, 1963 (an abridgement of the previous item, with some new material). — BARBARA ROSE, *American Art Since 1900: A Critical History*, New York and Washington, 1967. — Idem, ed. *Readings in American Art Since 1900: A Documentary Survey*, New York and Washington, 1968. — HENRY P. ROSSITER, *M. and M. Karolik Collection of American Watercolors & Drawings, 1800-1875*, 2 vols., Boston, 1962. — ANNA WELLS RUTLEDGE, *Cumulative Record of Exhibition Catalogues, The Pennsylvania Academy of the Fine Arts, 1807-1870, The Society of Artists, 1800-1814, The Artists' Fund Society, 1835-1845*, American Philosophical Society Memoirs XXXVIII, Philadelphia, 1955. — HOMER SAINT-GAUDENS, *The American Artist and His Times*, New York, 1941. — JOHN SARTAIN, *The Reminiscences of a Very Old Man 1808-1897*, New York, 1899. — CLARA E. SEARS, *Highlights Among the Hudson River Artists*, Boston, 1947. — Idem, *Some American Primitives*, Boston, 1941. — GEORGE W. SHELDON, *American Painters*, New York, 1879. — Idem, *Recent Ideals of American Art*, 8 vols., New York and London, 1888. — JAMES THRALL SOBY and DOROTHY C. MILLER, *Romantic Painting in America*, New York, 1943. — THOMAS SULLY, *Recollections of an Old Painter*, Hours at Home X, Philadelphia, 1873, p. 69 ff. — PAVEL PETROVICH SVIN'IN, *Picturesque United States of America 1811-1813*, ed. by Abraham Yarmolinsky, New York, 1930. — MABEL M. SWAN, *The Athenaeum Gallery 1827-1873*, Boston, 1940. — FREDERICK A. SWEET, *The Hudson River School and the Early American Landscape Tradition*, Chicago, 1945. — THOMAS BANGS THORPE, *New York Artists Fifty Years Ago*, Appleton's Journal VII, May 25, 1872. — HENRY T. TUCKERMAN, *Artist-Life: or Sketches of American Painters*, New York and Philadelphia, 1847. — Idem, *Book of the Artists*, New York and London, 1867. — JOHN WALKER and MACGILL JAMES, *Great American Paintings from Smibert to Bellows, 1729-1924*, New York, 1943. — HARRY B. WEHLE and THEODORE BOLTON, *American Miniatures 1738-1850*, New York, 1927. — JOHN FERGUSON WEIR, *The Recollections of John Ferguson Weir 1869-1913*, ed. by Theodore Sizer, New York and New Haven, 1957. — JOHN WILMERDING, *A History of American Marine Painting*, Boston and Toronto, 1968.

INDIVIDUAL ARTISTS

Washington Allston: JARED B. FLAGG, *The Life and Letters of Washington Allston*, New York, 1892. — EDGAR P. RICHARDSON, *Washington Allston: A Study of the Romantic Artist in America*, Chicago, 1948.

Ezra Ames: THEODORE BOLTON and IRWIN F. CORTELYOU, *Ezra Ames of Albany... 1768-1836*, New York, 1955.

Joseph Badger: LAWRENCE PARK, *An Account of Joseph Badger, and a Descriptive List of His Work*, Proceedings of the Massachusetts Historical Society LI, Dec. 1917, pp. 158-201. — LAWRENCE PARK, *Joseph Badger of Boston, and His Portraits of Children*, Old-Time New England XIII, Jan. 1923, pp. 99-109.

George Bellows: CHARLES H. MORGAN, *George Bellows*, New York, 1965.

George Caleb Bingham: E. MAURICE BLOCH, *George Caleb Bingham*, 2 vols., Berkeley and Los Angeles, 1967. — ALBERT CHRIST-JANER, *George Caleb Bingham of Missouri*, New York, 1940. — JOHN FRANCIS MCDERMOTT, *George Caleb Bingham*, Norman (Okla.), 1959.

Joseph Blackburn: LAWRENCE PARK, *Joseph Blackburn, Colonial Portrait Painter, with a Descriptive List of His Works*, Worcester (Mass.), 1923. — JOHN HILL MORGAN and HENRY WILDER FOOTE, *An Extension of Lawrence Park's Descriptive List of the Work of Joseph Blackburn*, Worcester (Mass.), 1937.

David G. Blythe: DOROTHY MILLER, *The Life and Work of David G. Blythe*, Pittsburgh, 1950.

Mary Cassatt: FREDERICK A. SWEET, *Miss Mary Cassatt, Impressionist from Pennsylvania*, Norman (Okla.), 1966.

George Catlin: LOYD HABERLY, *Pursuit of the Horizon: The Life of George Catlin*, New York, 1948.

Frederic Church: DAVID C. HUNTINGTON, *The Landscapes of Frederic Edwin Church: Vision of an American Era*, New York, 1966.

Thomas Cole: EVERETT PARKER LESLEY, *Thomas Cole and the Romantic Sensibility*, Art Quarterly V, Summer 1942, pp. 199-220. — LOUIS L. NOBLE, *The Course of Empire, Voyage of Life, and Other Pictures of Thomas Cole, N.A., with Selections from His Letters and Miscellaneous Writings, Illustrative of His Life, Character and Genius*, New York, 1853 (revised edition by Elliot S. Vesell, *The Life and Works of Thomas Cole*, Cambridge, 1964).

John Singleton Copley: MARTHA BABCOCK AMORY, *Domestic and Artistic Life of John Singleton Copley, R.A.*, Boston, 1882. — FRANK W. BAYLEY, *The Life and Works of John Singleton Copley*, Boston, 1915. — JAMES T. FLEXNER, *John Singleton Copley*, Boston, 1948. *Letters and Papers of John Singleton Copley and Henry Pelham, 1739-1776*, ed. by Charles Francis Adams, II, Guernsey Jones, and Worthington Chauncey Ford, Massachusetts Historical Society Collections LXXI, Boston, 1914. — BARBARA N. PARKER and ANNE B. WHEELER, *John Singleton Copley*, Boston, 1938. — AUGUSTUS T. PERKINS, *A Sketch of the Life and a List of Some of the Works of John Singleton Copley*, Boston, 1873. — JULES DAVID PROWN, *John Singleton Copley*, 2 vols., Cambridge, 1966; idem, *John Singleton Copley*, Catalogue of Exhibition at the National Gallery of Art, Metropolitan Museum of Art, and the Museum of Fine Arts, Boston, 1965-1966.

William Dunlap: ORAL SUMNER COAD, *William Dunlap, a Study of His Life and Works and of His Place in Contemporary Culture*, New York, 1917.

Asher B. Durand: JOHN DURAND, *The Life and Times of A. B. Durand*, New York, 1894.

Thomas Eakins: LLOYD GOODRICH, *Thomas Eakins: His Life and Work*, New York, 1933. Fairfield Porter, *Thomas Eakins*, New York, 1959.

Ralph Earl: LAURENCE B. GOODRICH, *Ralph Earl: Recorder for an Era*, Albany (N.Y.), 1967. WILLIAM SAWITZKY, *Ralph Earl, 1751-1801*, New York and Worcester 1945.

Louis M. Eilshemius: WILLIAM SCHACK, *And He Sat Among the Ashes*, New York, 1939.

Charles Fraser: ALICE R. H. SMITH and D. E. H. SMITH, *Charles Fraser*, New York, 1924.

Robert Feke: HENRY WILDER FOOTE, *Robert Feke: Colonial Portrait Painter*, Cambridge, 1930.

William Glackens: IRA GLACKENS, *William Glackens and the Ashcan Group*, New York, 1957.

John Greenwood: ALAN BURROUGHS, *John Greenwood in America, 1745-1752: a Monograph with Notes and a Checklist*, Andover (Mass.), 1943.

Chester Harding: CHESTER HARDING, *My Egotistography*, Boston, 1866.

Childe Hassam: ADELINE ADAMS, *Childe Hassam*, New York, 1938.

Martin Johnson Heade: ROBERT G. MCINTYRE, *Martin Johnson Heade*, New York, 1948.

George P. A. Healy: MADELINE CHARLES BIGOT, *Life of George P. A. Healy*, Chicago, 1913. — MARIE DE MARE, *G. P. A. Healy, American Artist*, New York, 1954. — GEORGE P. A. HEALY, *Reminiscences of a Portrait Painter*, Chicago, 1894.

Robert Henri: ROBERT HENRI, *The Art Spirit*, New York, 1923; new edition by Margery A. Ryerson, Philadelphia and New York, 1960. — HELEN APPLETON READ, *Robert Henri*, New York, 1931.

Edward L. Henry: ELIZABETH MCCAUSLAND, *The Life and Work of Edward Lamson Henry, N.A., 1841-1919*, New York, 1945.

Edward Hicks: ALICE FORD, *Edward Hicks, Painter of the Peaceable Kingdom*, Philadelphia, 1952.

Winslow Homer: PHILIP C. BEAM, *Winslow Homer at Prout's Neck*, Boston and Toronto, 1966. — WILLIAM HOWE DOWNES, *The Life and Works of Winslow Homer*, Boston, 1911. — JAMES T. FLEXNER and the Editors of Time-Life Books, *The World of Winslow Homer, 1836-1910*, New York, 1966. — LLOYD GOODRICH, *Winslow Homer*, New York, 1944. — Idem, *Winslow Homer*, New York, 1959.

William Morris Hunt: HELEN M. KNOWLTON, *Art-Life of William Morris Hunt*, Boston, 1899. — MARTHA A. S. SHANNON, *Boston Days of William Morris Hunt*, Boston, 1923.

George Inness: ELLIOT DANGERFIELD, *George Inness: the Man and His Art*, New York, 1911. — GEORGE INNESS, Jr., *Life, Art and Letters of George Inness*, New York, 1917. — LEROY IRELAND, *The Works of George Inness; an Illustrated Catalogue Raisonné*, Austin (Tex.), 1965. — ELIZABETH McCAUSLAND, *George Inness, an American Landscape Painter, 1825-1894*, New York, 1946.

John Wesley Jarvis: HAROLD E. DICKSON, *John Wesley Jarvis, American Painter, 1780-1840*, New York, 1949.

Eastman Johnson: JOHN I. H. BAUR, *An American Genre Painter: Eastman Johnson, 1824-1906*, Brooklyn, 1940.

Henrietta Johnston: MARGARET SIMONS MIDDLETON, *Henrietta Johnston of Charles Town, South Carolina, America's First Pastellist*, Columbia (S.C.), 1966.

Matthew Harris Jouett: E. A. JONAS, *Matthew Harris Jouett, Kentucky Portrait Painter, 1787-1827*, Louisville (Ky.), 1938.

John La Farge: ROYAL CORTISSOZ, *John La Farge: a Memoir and a Study*, Boston and New York, 1911.

Fitz Hugh Lane: JOHN WILMERDING, *Fitz Hugh Lane, 1804-1865, American Marine Painter*, Salem (Mass.), 1964.

Edward Greene Malbone: RUEL PARDEE TOLMAN, *The Life and Works of Edward Greene Malbone, 1777-1807*, New York, 1958.

Thomas Moran: THURMAN WILKINS, *Thomas Moran: Artist of the Mountains*, Norman (Okla.), 1966.

Samuel F. B. Morse: OLIVER W. LARKIN, *Samuel F. B. Morse and American Democratic Art*, Boston and Toronto, 1954. — CARLETON MABEE, *The American Leonardo: a Life of Samuel F. B. Morse*, New York, 1943. — EDWARD LIND MORSE, ed., *Samuel F. B. Morse, His Letters and Journals*, 2 vols., Boston and New York, 1914. — SAMUEL IRENAEUS PRIME, *The Life of Samuel F. B. Morse, LL.D., Inventor of the Electro-Magnetic Recording Telegraph*, New York, 1875.

William Sidney Mount: MARY BARTLETT COWDREY and HERMAN W. WILLIAMS, Jr., *William Sidney Mount, 1807-1868: an American Painter*, New York, 1944.

John Neagle: MARGUERITE LYNCH, *John Neagle's Diary*, Art in America XXXVII, April 1949, pp. 77-99.

William Page: JOSHUA C. TAYLOR, *William Page: the American Titian*, Chicago, 1957.

Charles Willson Peale: CHARLES COLEMAN SELLERS, *Charles Willson Peale*, 2 vols., Philadelphia, 1947. — Idem, *Portraits and Miniatures by Charles Willson Peale*, American Philosophical Society Transactions, XLII, part 1, Philadelphia, 1952.

Ammi Phillips: MARY BLACK, *Ammi Phillips: Portrait Painter 1788-1865*, New York, 1968.

Matthew Pratt: WILLIAM SAWITZKY, *Matthew Pratt, 1734-1805*, New York, 1942.

Maurice Prendergast: HEDLEY HOWELL RHYS, *Maurice Prendergast, 1859-1924*, Cambridge, 1960.

John Quidor: JOHN I. H. BAUR, *John Quidor, 1801-1881*, Brooklyn, 1942. — Idem, *John Quidor, 1801-1881*, Catalogue of an exhibition at the Whitney Museum of American Art, Munson-Williams-Proctor Institute, Rochester Memorial Art Gallery and Albany Institute of History and Art, 1965-1966.

William Ranney: FRANCIS S. GRUBAR, *William Ranney, Painter of the Early West*, Washington, D.C., 1962.

Theodore Robinson: JOHN I. H. BAUR, *Theodore Robinson, 1852-1896*, Brooklyn, 1946.

Albert P. Ryder: LLOYD GOODRICH, *Albert P. Ryder*, New York, 1959.

C. B. J. Fevre de Saint-Mémin: FILLMORE NORFLEET, *Saint-Mémin in Virginia: Portraits and Biographies*, Richmond, 1942. — Idem, *The St.-Mémin Collection of Portraits: Consisting of Seven Hundred and Sixty Medallion Portraits, Principally of Distinguished Americans*, New York, 1862.

Robert Salmon: JOHN WILMERDING, *Robert Salmon, Painter of Ship and Shore*, Boston, 1968.

John Singer Sargent: EVAN CHARTERIS, *John Sargent*, New York, 1927. — WILLIAM HOWE DOWNES, *John S. Sargent: His Life and Work*, London, 1926. — DAVID McKIBBIN, *Sargent's Boston*, Boston, 1956. — CHARLES MERRILL MOUNT, *John Singer Sargent, a Biography*, New York, 1955.

Sharples Family: KATHARINE McCOOK KNOX, *The Sharples: Their Portraits of George Washington and His Contemporaries*, New Haven, 1930.

John Sloan: VAN WYCK BROOKS, *John Sloan, a Painter's Life*, New York, 1955. — BRUCE ST. JOHN, ed., *John Sloan's New York Scene*, New York, 1965.

John Smibert: HENRY WILDER FOOTE, *John Smibert*, Cambridge, 1950. — Sir DAVID EVANS, JOHN KERSLAKE, and ANDREW OLIVER, *The Notebook of John Smibert*, Boston, 1969.

Gilbert Stuart: JAMES T. FLEXNER, *Gilbert Stuart*, New York, 1955. — JOHN HILL MORGAN, *Gilbert Stuart and His Pupils*, New York, 1939. — CHARLES MERRILL MOUNT, *Gilbert Stuart: a Biography*, New York, 1964. — LAWRENCE PARK, *Gilbert Stuart, an Illustrated Descriptive List of His Works*, 4 vols., New York, 1926. — WILLIAM T. WHITLEY, *Gilbert Stuart*, Cambridge, 1932.

Thomas Sully: EDWARD BIDDLE and MANTEL FIELDING, *The Life and Works of Thomas Sully, 1783-1872*, Philadelphia, 1921. — CHARLES H. HART, ed., *A Register of Portraits Painted by Thomas Sully, 1801-1871*, Philadelphia, 1909.

Abbott H. Thayer: NELSON C. WHITE, *Abbott H. Thayer: Painter and Naturalist*, Hartford, 1951.

Jeremiah Theus: MARGARET SIMONS MIDDLETON, *Jeremiah Theus: Colonial Artist of Charles Town*, Columbia (S.C.), 1953.

John Trumbull: THEODORE SIZER, *The Works of Colonel John Trumbull: Artist of the American Revolution*, New Haven, 1967 (first ed. 1950). — JOHN TRUMBULL, *The Autobiography of Colonel John Trumbull, Patriot Artist, 1756-1843*, ed. by Theodore Sizer, New Haven, 1953.

John H. Twachtman: ELIOT CLARK, *John Twachtman*, New York, 1924.

John Vanderlyn: MARIUS SCHOONMAKER, *John Vanderlyn, Artist, 1775-1852*, Kingston (N.Y.), 1950.

J. Alden Weir: DOROTHY WEIR YOUNG, *The Life and Letters of J. Alden Weir*, ed. with an Introduction by Lawrence W. Chisolm, New Haven, 1960.

Robert W. Weir: IRENE WEIR, *Robert W. Weir*, New York, 1947.

Benjamin West: GROSE EVANS, *Benjamin West and the Taste of His Times*, Carbondale (Ill.), 1959. — JOHN GALT, *Life, Studies, and Works of Benjamin West*, London, 1820 (first ed. 1816).

James A. M. Whistler: ELISABETH LUTHER CARY, *The Works of James McNeill Whistler*, New York and London, 1913. — ELIZABETH ROBINS PENNELL and JOSEPH PENNELL, *The Life of James McNeill Whistler*, 2 vols., Philadelphia and London, 1908 (revised ed. 1911). — DENYS SUTTON, *James McNeill Whistler*, London, 1966.

Worthington Whittredge: JOHN I. H. BAUR, ed., *The Autobiography of Worthington Whittredge, 1820-1910*, Brooklyn Museum Journal I, 1942, pp. 5-68.

Richard C. Woodville: *Richard Caton Woodville, an Early American Genre Painter*, Exhibition catalogue at The Corcoran Gallery of Art, Washington, D.C., April 21-June 11, 1967.

Select Bibliography

Part Two: The Twentieth Century

GENERAL WORKS

Art in America, LIII, No. 4, August-September 1965. Archives of American Art number. — VIRGIL BARKER, *Americanism in Painting*, in *Yale Review*, Summer 1936. — Idem, *A Critical Introduction to American Painting*, Whitney Museum of American Art, New York 1931. — Idem, *From Realism to Reality in Recent American Painting*, University of Nebraska Press, Lincoln, Nebraska 1959. — JOHN I. H. BAUR, *Revolution and Tradition in Modern American Art*, Praeger, New York 1967. — HOLGER CAHILL and ALFRED H. BARR, JR., *Art in America in Modern Times*, Reynal & Hitchcock, New York 1934. — ROYAL CORTISSOZ, *American Artists*, Scribner's, New York 1923. — HENRY GELDZAHLER, *American Painting in the Twentieth Century*, Metropolitan Museum of Art, New York 1965. — LLOYD GOODRICH, *American Genre*, Whitney Museum of American Art, New York 1935. — Idem, *Three Centuries of American Art*, Praeger, New York 1966. — LLOYD GOODRICH and JOHN I. H. BAUR, *American Art of Our Century*, Catalogue of the Whitney Museum of American Art, Praeger, New York 1961. — SAM HUNTER, *Modern American Painting and Sculpture*, Dell, New York 1959. — *Index of Twentieth-Century Artists*, College Art Association, New York 1933-1937. — WALTER PACH, *Modern Art in America*, Kraushaar Galleries, New York 1928. — BARBARA ROSE, *American Art Since 1900: A Critical History*, Praeger, New York 1967. — BERNARD ROSENBERG and NORRIS E. FLIEGEL, *The Vanguard Artist in New York*, in *Social Research*, XXXII, No. 2, Summer 1965, pp. 141 ff. — MONROE WHEELER, *Painters and Sculptors of Modern America*, Crowell, New York 1942.

THE ARMORY SHOW AND ITS AFTERMATH

America and Alfred Stieglitz, edited by W. Frank, L. Mumford, D. Norman, P. Rosenfeld and H. Rugg, Doubleday, Doran, New York 1934. — *An American Collection*, in *Philadelphia Museum Bulletin*, XL, May 1945. — EMANUEL M. BENSON, *John Marin,*

The Man and His Work, Museum of Modern Art, New York 1935. — THOMAS HART BENTON, *America and/or Alfred Stieglitz*, in *Common Sense*, IV, January 1935. — EDWARD BLASHFIELD, *The Painting of Today*, in *Century*, LXXXVII, April 1914. — CHRISTIAN BRINTON, *American Painting at the Panama-Pacific Exposition*, in *International Studio*, LXI, August 1915. — Idem, *Evolution Not Revolution in Art*, in *International Studio*, XLIX, April 1913. — MILTON BROWN, *American Painting from the Armory Show to the Depression*, Princeton University Press, Princeton, N.J. 1955. — Idem, *The Story of the Armory Show*, Joseph H. Hirshhorn Foundation, New York 1963. — HOLGER CAHILL, *Max Weber*, Downtown Gallery, New York 1930. — *Catalogue of the Forum Exhibition*, Anderson Gallery, Hugh Kennerly, New York 1916. — VAN DEREN COKE, *Taos and Santa Fe: The Artist's Environment, 1882-1942*, University of New Mexico, Albuquerque 1963. — *Collection of the Société Anonyme*, Yale University Art Gallery, New Haven, Conn. 1950. — A. W. DOW, *Talks on Art Appreciation*, in *The Delineator*, January 1915. — GUY PENE DU BOIS, *Artists Say the Silliest Things*, American Artists Group, New York 1940. — ARTHUR J. EDDY, *Cubists and Post-Impressionists*, McClurg, Chicago 1914. — CLEMENT GREENBERG, *John Marin*, in *Art and Culture*, Beacon Press, Boston 1961. — J. and G. HAMBIDGE, *The Ancestry of Cubism*, in *Century*, LXXXVII, April 1914. — MARSDEN HARTLEY, *Adventures in the Arts: Informal Chapters on Painters, Vaudeville and Poets*, Boni & Liveright, New York 1921. — Idem, *Art — and the Personal Life*, in *Creative Art*, II, June 1928. — SADAKICHI HARTMANN, *The Photo-Secession, A New Pictorial Movement*, in *Craftsman*, VI, April 1904. — MACKINLEY HELM, *John Marin*, Pellegrini & Cudahy, New York 1948. — *History of an American, Alfred Stieglitz: 291 and After*, exhibition catalogue. — WALT KUHN, *The Story of the Armory Show*, New York 1938; supplemented by an article in *Art News Annual*, 1939. — W. D. MACCALL, *The International Exhibition of Modern Art*, in *Forum*, L, July-December 1913. — ELIZABETH MCCAUSLAND, *A. H. Maurer*, Wyn, New York 1951. — Idem, *Marsden Hartley*, University of Minnesota Press, Minneapolis 1952. — JOHN MARIN, *A Few Notes*, in *Twice A Year*, No. 2,

1939. — Idem, *John Marin by Himself*, in *Creative Art*, III, October 1928. — Idem, *Letters of John Marin*, edited by H. J. Seligmann, Pellegrini & Cudahy, New York 1931. — Idem, *Selected Writings of John Marin*, edited by Dorothy Norman, Pellegrini & Cudahy, New York 1949. — FRANK J. MATHER, JR., *Newest Tendencies in Art*, in *The Independent*, LXXIV, March 1913. — JEROME MELLQUIST, *The Emergence of an American Art*, Scribner's, New York 1942. — Idem, *The Armory Show Thirty Years Later*, in *Magazine of Art*, XXXVI, December 1943. — JEROME MEYERS, *An Artist in Manhattan*, American Artists Group, New York 1940. — DOROTHY C. MILLER, *Lyonel Feininger and Marsden Hartley*, Museum of Modern Art, New York 1944. — WALTER PACH, *Queer Thing, Painting*, Harper, New York 1938. — DUNCAN PHILLIPS, *Fallacies of the New Dogmatism in Art*, in *American Magazine of Art*, IX, January 1918. — Idem, *Revolution and Reaction*, in *International Studio*, LI, November-December 1913. — DANIEL CATTON RICH, *Georgia O'Keeffe*, exhibition catalogue, Art Institute of Chicago, 1943. — Idem, *Georgia O'Keeffe*, exhibition catalogue, Worcester Art Museum, Worcester, Mass. 1960. — THEODORE ROOSEVELT, *A Layman's Views of an Art Exhibition*, in *The Outlook*, XXIX, March 9, 1913. — PAUL ROSENFELD, *Port of New York: Essays on Fourteen American Moderns*, Harcourt, Brace, New York 1924. — MEYER SCHAPIRO, *Rebellion in Art*, in *America in Crisis*, edited by Daniel Aaron, Knopf, New York 1952. — GERTRUDE STEIN, *The Autobiography of Alice B. Toklas*, Modern Library, New York 1933. — ALFRED STIEGLITZ, *Modern Pictorial Photography*, in *Century*, LXIV, October 1902. — Idem, *Six Happenings*, in *Twice A Year*, Nos. 14-15, 1946-1947. — Idem, *Stories, Parables and Correspondence*, in *Twice A Year*, Nos. 8-9, 1942. — Idem, *291*, edited by Alfred Stieglitz, Nos. 1-12, 1915-1916. — SIDNEY TILLIM, *Dissent on the Armory Show*, in *Arts*, XXXVII, May-June 1963. — MAX WEBER, *Chinese Dolls and Modern Colorists*, in *Camera Work*, No. 31, July 1910. — Idem, *The Fourth Dimension from a Plastic Point of View*, in *Camera Work*, No. 31, July 1910. — FREDERICK S. WIGHT, *Arthur G. Dove*, University of California Press, Berkeley 1958. — W. C. WILLIAMS, D. PHILLIPS and D. NORMAN, *John Marin*, memorial exhibition, University of California Press, Los Angeles 1955. — WILLARD H. WRIGHT, *An Abundance of Modern Art*, in *Forum*, LV, January-June 1916. — Idem, *The Aesthetic Struggle in America*, in *Forum*, LV, January-June 1916. — MARIUS DE ZAYAS and PAUL HAVILAND, *A Study of the Modern Evolution of Plastic Expression*, 291 Gallery, New York 1913.

THE CRISIS OF THE THIRTIES

WALTER ABELL, *The Limits of Abstraction*, in *Magazine of Art*, XXVIII, December 1935. — WILLIAM C. AGEE, *Synchromism and Color Principles in American Painting*, Knoedler, New York 1965. — *American Abstract Artists*, annual exhibition catalogue and checklist from 1937. — EDWARD D. ANDREWS and FAITH ANDREWS, *Sheeler and the Shakers*, in *Art in America*, LIII, No. 1, February 1965. — H. H. ARNASON, *Stuart Davis*, National Collection of Fine Arts, Washington 1965. — W. S. BALDINGER, *Formal Change in Recent American Painting*, in *Art Bulletin*, XIX, December 1937. — ALFRED H. BARR, JR., *Cubism and Abstract Art*, Museum of Modern Art, New York 1936. — JOHN I. H. BAUR, *The Machine and the Subconscious:*

Dada in America, in *Magazine of Art*, XLIV, October 1951. — Idem, *Charles Burchfield*, Whitney Museum of American Art, New York 1956. — Idem, *Joseph Stella*, Whitney Museum of American Art, New York 1963. — THOMAS HART BENTON, *An Artist in America*, revised edition, University of Kansas City Press, Twayne Publishers, Kansas City 1951. — PETER BLUME, *After Surrealism*, in *The New Republic*, LXXX, October 3, 1934. — ADELYN BREESKIN, *Milton Avery*, American Federation of Arts, New York 1960. — Idem, *Roots of Abstract Art in America, 1910-1950*, National Collection of Fine Arts, Washington 1965. — CHRISTIAN BRINTON, *Modern Art at the Sesqui-Centennial Exhibition*, Société Anonyme, New York 1926. — MILTON BROWN, *Cubist-Realism: An American Style*, in *Marsyas*, III, 1943-1945. — GABRIELLE BUFFET-PICABIA, *Some Memories of Pre-Dada: Picabia and Duchamp*, in *Dada Painters and Poets*, edited by Robert Motherwell, Wittenborn, Schultz, New York 1951. — CHARLES BURCHFIELD, *On the Middle Border*, in *Creative Art*, III, September 1928. — ALAN BURROUGHS, *Kenneth Hayes Miller*, Whitney Museum of American Art, New York 1931. — HOLGER CAHILL, *Art as a Function of Government*, Federal Art Project, Washington 1937. — Idem, *New Horizons in American Art*, Museum of Modern Art, New York 1936. — LAWRENCE CAMPBELL, *Paintings from WPA*, in *Art News*, September 1961. — MARTHA C. CHENEY, *Modern Art in America*, McGraw-Hill, New York 1939. — THOMAS CRAVEN, *Men of Art*, Simon & Schuster, New York 1931. — Idem, *Modern Art—the Men, the Movements, the Meaning*, Simon & Schuster, New York 1934. — Idem, *Naturalism in Art*, in *Forum*, XCV, January-June 1936. — Idem, *Thomas Hart Benton*, Associated American Artists, New York 1939. — ANDREW DASBURG, *Cubism—Its Rise and Influence*, in *The Arts*, IV, November 1923. — STUART DAVIS, *Abstract Art in the American Scene*, in *Parnassus*, XIII, March 1941. — Idem, *Abstract Painting*, in *Art of Today*, April 1935. — Idem, *Arshile Gorky in the 1930's, A Personal Recollection*, in *Magazine of Art*, XLIV, February 1951. — LILLIAN DOCHTERMAN, *The Quest of Charles Sheeler*, State University of Iowa Press, Iowa City 1963. — S. LANE FALSON, *Fact and Art in Charles Demuth*, in *Magazine of Art*, XLIII, April 1950. — MANNY FARBER, *Jack Levine*, in *Art News*, March 1955. — MARTIN FRIEDMAN, *The Precisionist View in American Art*, Walker Art Center, Minneapolis 1960. — A. E. GALLATIN, *Museum of Living Art*, A. E. Gallatin Collection, George Grady Press, New York 1940. — SIDNEY GEIST, *Prelude, The 1930's*, in *Arts*, XXX, September 1956. — LLOYD GOODRICH, *Pioneers of Modern Art in America*, Whitney Museum of American Art, New York 1946. — Idem, *Pioneers of Modern Art in America: The Decade of the Armory Show, 1910-1920*, Praeger, New York 1963. — Idem, *Edward Hopper*, Whitney Museum of American Art, New York 1964. — E. C. GOOSSEN, *Stuart Davis*, Braziller, New York 1959. — JOHN GORDON, *Geometric Abstraction in America*, Praeger, New York 1962. — ARSHILE GORKY, *Stuart Davis*, in *Creative Art*, IX, September 1931. — JOHN D. GRAHAM, *System and Dialectics of Art*, Delphic Studios, New York 1937. — CLEMENT GREENBERG, *Milton Avery*, in *Art and Culture*, Beacon Press, Boston 1961. — Idem, *New York Painting Only Yesterday*, in *Art News*, Summer 1957. — J. and G. HAMBIDGE, *The Ancestry of Cubism*, in *Century*, LXXXVII, April 1914. — GEORGE HEARD HAMILTON, *John Covert, Early American Modern*, in *College Art Journal*, XII, No. 1, Fall, 1952. — EDWARD HOPPER, *Charles Burchfield, American*, in *The Arts*,

XIV, July 1928. — LINCOLN KIRSTEIN and J. LEVY, *Murals by American Painters and Photographers*, Museum of Modern Art, New York 1932. — SAMUEL KOOTZ, *Modern American Painters*, Brewer and Warren, New York 1930. — HILTON KRAMER, *The Legendary John Graham*, in *The New York Times*, May 29, 1966, Sec. 2, p. 13. — JULES LANGSNER, *Man Ray*, Los Angeles County Art Museum, Los Angeles 1966. — OLIVER LARKIN, *Twenty Years of Paintings by Philip Evergood*, Whitney Museum of American Art, New York 1947. — ROBERT LEBEL, *Marcel Duchamp*, Grove Press, New York 1939. — HENRY MCBRIDE, *A Hero Worshipped*, in *The Dial*, LXIX, July-December 1920. — DOROTHY MILLER and ALFRED H. BARR, JR. (editors), *American Realists and Magic Realists*, Museum of Modern Art, New York 1943. — GEORGE L. K. MORRIS, *American Abstract Art*, exhibition catalogue, St. Etienne Galerie, New York, May 22-June 12, 1940. — GEORGE L. K. MORRIS and LINCOLN KIRSTEIN, *Life or Death for Abstract Art?*, in *Magazine of Art*, XXXVI, March 1943. — FRANCIS V. O'CONNOR, *Federal Art Patronage, 1933-1943*, University of Maryland Press, College Park, Md. 1966. — BRIAN O'DOHERTY, *Portrait: Edward Hopper*, in *Art in America*, LII, No. 6, December 1964. — WALTER PACH, *Modern Art in America*, Kraushaar Galleries, New York 1928. — RALPH PEARSON, *The Failure of the Art Critics*, in *Forum and Century*, XCIV, November 1935-January 1936. — *Plastique*, No. 3, Paris 1938, special issue devoted to American art. — ANDREW C. RITCHIE, *Abstract Painting and Sculpture in America*, Museum of Modern Art, New York 1951. — Idem, *Charles Demuth*, Museum of Modern Art, New York 1950. — CONSTANCE ROURKE, *Charles Sheeler: Artist in the American Tradition*, Harcourt, Brace, New York 1938. — WILLIAM RUBIN, *Man Ray*, in *Art International*, VII, No. 6, June 1963. — MEYER SCHAPIRO, *The Nature of Abstract Art*, in *Marxist Quarterly*, I, January-March 1937. — Idem, *Populist Realism*, in *Partisan Review*, IV, December 1937-May 1938 (review of Thomas Hart Benton's autobiography). — LEE SIMONSON, *No Embargos*, in *Creative Art*, VIII, April 1931. — JAMES T. SOBY, *Ben Shahn*, Museum of Modern Art, New York 1947. — JOSEPH STELLA, *The Brooklyn Bridge (A Page of My Life)*, in *transition*, Nos. 16-17, June 1929. — *The 30's: Painting in New York*, exhibition catalogue, Poindexter Gallery, New York 1957. — MONROE WHEELER, *Painters and Sculptors of Modern America*, Museum of Modern Art, New York 1942. — FREDERICK S. WIGHT, *Hyman Bloom*, Institute of Contemporary Art, Boston 1954. — EDMUND WILSON, *The American Earthquake*, Doubleday, New York 1958. — BEN WOLF, *Morton Livingston Schamberg*, University of Pennsylvania Press, Philadelphia 1963. — WILLARD H. WRIGHT, *American Painting and Sculpture*, Museum of Modern Art, New York 1932.

THE NEW YORK SCHOOL

JOHN I. H. BAUR, *Bradley Walker Tomlin*, Whitney Museum of American Art, New York 1957. — Idem, *Nature in Abstraction*, Whitney Museum of American Art, New York 1958. — RUDI BLESH, *Modern Art USA*, Knopf, New York 1956. — RUSSELL DAVENPORT (editor), *A Life Round Table on Modern Art*, in *Life*, October 11, 1948. — *Eleven Europeans in America*, Museum of Modern Art Bulletin, XIII, Nos. 4-5, 1946. — CLEMENT GREENBERG, *The Present Prospects of American Painting and Sculpture*, in *Horizon*, October 1947. — PEGGY GUGGENHEIM, *Out of This Century*, Dial Press, New York 1946. — Idem, *Confessions of an Art Addict*, Macmillan, New York 1960. — SAM HUNTER, *Jackson Pollock*, in *Museum of Modern Art Bulletin*, XXIV, No. 2, 1956-1957. — *The Ides of Art: The Attitude of Ten Artists*, in *Tiger's Eye*, No. 2, December 1947. — *Jackson Pollock*, exhibition catalogue, Marlborough-Gerson Gallery, New York 1964. — SIDNEY JANIS, *Abstract and Surrealist Art in America*, Reynal & Hitchcock, New York 1944. — SAMUEL KOOTZ and HAROLD ROSENBERG, *The Intrasubjectives*, exhibition catalogue, Kootz Gallery, New York, September 14-October 3, 1949. — ROBERT MOTHERWELL, *The Modern Painter's World*, in *Dyn*, VI, 1944. — Idem, *Painter's Objects*, in *Partisan Review*, XI, Winter 1944. — FRANCIS K. O'CONNOR, *The Genesis of Jackson Pollock: 1912 to 1943*, unpublished Ph. D. thesis, Johns Hopkins University, 1965. — FRANK O'HARA, *Jackson Pollock*, Braziller, New York 1959. — *The Peggy Guggenheim Collection*, exhibition catalogue, Tate Gallery, London, December 31, 1964-March 7, 1965. — *La Peinture aux Etats-Unis*, special issue of *Art d'Aujourd'hui*, June 1951. — I. R. PEREIRA, *An Abstract Painter on Abstract Art*, in *American Contemporary Art*, October 1944. — JACKSON POLLOCK, *Jackson Pollock*, edited by Bryan Robertson, Abrams, New York 1960. — HAROLD ROSENBERG, *Arshile Gorky*, Grove Press, New York 1962. — WILLIAM RUBIN, *Notes on Masson and Pollock*, in *Arts*, XXXIII, November 1959. — Idem, *Arshile Gorky, Surrealism and the New American Painting*, in *Art International*, VII, No. 2, February 25, 1963. — MEYER SCHAPIRO, *Gorky: The Creative Influence*, in *Art News*, September 1957. — ETHEL K. SCHWABACHER, *Arshile Gorky: Memorial Exhibition*, Whitney Museum of American Art, New York 1951. — Idem, *Arshile Gorky*, Whitney Museum of American Art, New York 1957. — WILLIAM C. SEITZ, *Abstract Expressionist Painting in America*, unpublished Ph.D. thesis, Princeton University, 1955. — Idem, *Arshile Gorky*, Museum of Modern Art, New York 1962. — Idem, *Mark Tobey*, Museum of Modern Art, New York 1962. — Idem, *Hans Hofmann*, Museum of Modern Art, New York 1963. — *Tiger's Eye*, Nos. 1-9, 1947-1949, edited by R. and J. Stephan. — *VVV*, Nos. 1-4, 1942-1944, edited by David S. Hare assisted by André Breton, Marcel Duchamp and Max Ernst.

THE SIXTIES

LAWRENCE ALLOWAY, *The New American Painting*, in *Art International*, III, Nos. 3-4, 1959. — Idem, *Sign and Surface: Notes on Black and White Painting in New York*, in *Quadrum*, No. 9, 1960. — Idem, *The Shaped Canvas*, Solomon R. Guggenheim Museum, New York 1964. — Idem, *Six Painters and the Object*, Solomon R. Guggenheim Museum, New York 1964. — Idem, *Systematic Painting*, Solomon R. Guggenheim Museum, New York 1966. — Idem, *Barnett Newman: The Stations of the Cross*, Solomon R. Guggenheim Museum, New York 1966. — *American Paintings: 1945-1957*, Minneapolis Institute of Arts, Minneapolis 1957. — *American Vanguard*, United States Information Agency, Washington 1961-1962. — H. H. ARNASON, *Abstract Expressionists and Imagists*, Solomon R. Guggenheim Museum, New York 1961. — *Artforum*, September 1965, special issue devoted to Abstract Expressionism. — DORÉ ASHTON, *Philip Guston*, Grove

Press, New York 1959. — Idem, *The Unknown Shore: A View of Contemporary Art*, Little, Brown, Boston 1962. — EDWARD BRYANT, *Jack Tworkov*, Whitney Museum of American Art, New York 1964. — JOHN CAGE, *Silence*, Wesleyan University Press, Middletown, Conn. 1961. — *Clyfford Still: Paintings in the Albright-Knox Art Gallery*, Buffalo, N. Y. 1966. — *Contemporary American Painting*, Columbus Gallery of Fine Arts, Columbus, Ohio 1960. — JOHN COPLANS, *John McLaughlin, Hard Edge, and American Painting*, in *Artforum*, II, No. 7, January 1964. — ELAINE DE KOONING, *Franz Kline*, memorial exhibition catalogue, Washington Gallery of Fine Art, Washington 1962. — *Expressionism 1900-1955*, Walker Art Center, Minneapolis 1955. — *The Face of the Fifties*, University of Michigan Art Museum, Ann Arbor, Michigan 1961. — MICHAEL FRIED, *Frank Stella's New Paintings*, in *Artforum*, V, No. 3, November 1966. — Idem, *Kenneth Noland*, Jewish Museum, New York 1965. — Idem, *Modernist Painting and Formal Criticism*, in *The American Scholar*, Autumn 1964. — Idem, *Three American Painters*, Fogg Art Museum, Cambridge, Mass. 1965 (Olitski, Noland, Stella). — B. H. FRIEDMAN (editor), *School of New York: Some Younger Artists*, Grove Press, New York 1959. — MARTIN FRIEDMAN, *Adolph Gottlieb*, Walker Art Center, Minneapolis 1963. — ROBERT GOLDWATER, *Reflections on the New York School*, in *Quadrum*, No. 8, 1960. — LLOYD GOODRICH, *Young America 1965: Thirty American Artists Under Thirty-Five*, Praeger, New York 1965. — E. C. GOOSSEN, *The Big Canvas*, in *Art International*, II, No. 8, November 1958. — Idem, *Clyfford Still, Painting as Confrontation*, in *Art International*, IV, No. 1, January 1960. — Idem, *The Philosophic Line of Barnett Newman*, in *Art News*, Summer 1958. — ADOLPH GOTTLIEB, *Artist and Society, A Brief Case History*, in *College Art Journal*, XIV, No. 2, Winter 1955. — Idem, *My Paintings*, in *Art and Architecture*, LXVIII, September 1951. — CLEMENT GREENBERG, *American-Type Painting* and *The Crisis of the Easel Picture*, in *Art and Culture*, Beacon Press, Boston 1961. — Idem, *After Abstract Expressionism*, in *Art International*, VI, No. 8, October 25, 1962. — Idem, *Louis and Noland*, in *Art International*, IV, No. 4, May 25, 1960. — Idem, *The "Crisis" of Abstract Art*, in *Arts Yearbook*, No. 7, 1964. — Idem, *Post-Painterly Abstraction*, catalogue of the Los Angeles County Museum, Los Angeles 1964. — GEORGE HEARD HAMILTON, *Josef Albers: Paintings, Prints, Projects*, Yale University Art Gallery, New Haven, Conn. 1956. — Idem, *Object and Image: Aspects of the Poetic Principle in Modern Art*, in *Object and Image in Modern Art and Poetry*, Yale University Art Gallery, New Haven, Conn. 1954. — THOMAS B. HESS, *Abstract Painting: Background and American Phase*, Viking Press, New York 1951. — Idem, *Willem de Kooning*, Braziller, New York 1959. — WALTER HOPPS, *Catalogue of the VIII Sao Paulo Biennial*, National Collection of Fine Arts, Washington 1966. — SAM HUNTER, *USA*, in *Art Since 1945*, Abrams, New York 1958. — Idem, *Art Since 1950*, catalogue, Seattle World's Fair, 1962. — Idem, *Larry Rivers*, Jewish Museum, New York 1966. — SAM HUNTER and LUCY R. LIPPARD, *Ad Reinhardt*, Jewish Museum, New York 1966. — *Is Today's Artist With or Against the Past?*, in *Art News*, Part I, Summer 1958, and Part II, September 1958. — ALLAN KAPROW, *The Legacy of Jackson Pollock*, in *Art News*, October 1958. — VYANTAS KAVOLIS, *Abstract Expressionism and Puritanism*, in *Journal of Aesthetics and Art Criticism*, Spring 1963. — MICHAEL KIRBY, *Happenings*, Dutton, New York 1965. — MAX KOZLOFF, *The Impact of de Kooning*,

in *Arts Yearbook*, No. 7, 1964. — Idem, *The Many Colorations of Black and White*, in *Artforum*, II, No. 8, February 1964. — LUCY R. LIPPARD, *Pop Art*, Praeger, New York 1966. — KYNASTON McSHINE, *Josef Albers*, Museum of Modern Art, New York 1964. — ROBERT MOTHERWELL, *The Painter and His Audience*, in *Perspectives USA*, No. 9, Autumn 1954. — ROBERT MOTHERWELL and AD REINHARDT (editors), *Modern Artists in America*, first series, Wittenborn, Schultz, New York 1952. — *New Abstraction*, in *Das Kunstwerk*, XVIII, Nos. 10-12, April-June 1965. — *The New American Painting*, Museum of Modern Art, New York 1959. — *New York School*, Los Angeles County Museum of Art, Los Angeles 1965 (Baziotes, De Kooning, Gorky, Gottlieb, Guston, Hofmann, Motherwell, Newman, Pollock, Pousette-Dart, Reinhardt, Rothko, Still, Tomlin). — FRANK O'HARA, *Robert Motherwell*, with selections from the artist's writings, Museum of Modern Art, New York 1966. — CLAES OLDENBURG, *The Artists Say*, in *Art Voices*, IV, No. 3, Summer 1965. — *Paintings by Clyfford Still*, Albright-Knox Art Gallery, Buffalo, N.Y. 1959. — *Richard Diebenkorn*, Gallery of Modern Art, Washington 1964. — HAROLD ROSENBERG, *The Anxious Object*, Horizon Press, New York 1964. — Idem, *Hans Hofmann's Life Class*, in *Art News Annual (Portfolio)*, No. 6, 1962. — Idem, *Tenth Street: A Geography of Modern Art*, in *Art News Annual*, No. 28, 1959. — Idem, *Tradition of the New*, Horizon Press, New York 1959. — ROBERT ROSENBLUM, *Abstract Sublime*, in *Art News*, February 1961. — Idem, *Morris Louis at the Guggenheim Museum*, in *Art International*, VII, No. 9, December 5, 1963. — WILLIAM RUBIN, *Adolph Gottlieb*, in *Art International*, III, No. 3-4, 1959. — Idem, *Younger American Painters*, in *Art International*, IV, No. 1, January 1960. — Idem, *Ellsworth Kelly: The Big Form*, in *Art News*, November 1963. — MEYER SCHAPIRO, *The Liberating Quality of Abstract Art*, in *Art News*, Summer 1957. — Idem, *The Younger American Painters of Today*, in *The Listener*, London, January 26, 1956. — WILLIAM C. SEITZ, *Spirit, Time, and Abstract Expressionism*, in *Magazine of Art*, XLVI, February 1953. — Idem, *The Responsive Eye*, Museum of Modern Art, New York 1964. — PETER SELZ, *Mark Rothko*, Museum of Modern Art, New York 1961. — TI-GRACE SHARPLESS, *Clyfford Still*, University of Pennsylvania Press, Philadelphia 1963. — *60 American Painters*, Walker Art Center, Minneapolis 1960. — ALAN SOLOMON, *Robert Rauschenberg*, Jewish Museum, New York 1963. — Idem, *XXXII International Biennial Exhibition of Art*, Venice 1964, *United States of America*, Jewish Museum, New York 1964 (Chamberlain, Dine, Johns, Louis, Noland, Oldenburg, Rauschenberg, Stella). — LEO STEINBERG, *Jasper Johns*, Wittenborn, New York 1963. — JAMES J. SWEENEY, *Recent Trends in American Painting*, in *Bennington College Alumnae Quarterly*, VII, No. 1, Fall 1955. — SIDNEY TILLIM, *What Happened to Geometry?*, in *Arts*, XXXIII, June 1959. — Idem, *Realism and the Problem*, in *Arts*, XXXVII, September 1963. — Idem, *Optical Art: Pending or Ending?*, in *Arts*, XXXIX, January 1965.

THE SEVENTIES

LAWRENCE ALLOWAY, *Agnes Martin*, Institute of Contemporary Art, Philadelphia 1973. — GREGORY BATTCOCK (editor), *Minimal Art: A Critical Anthology*, E. P. Dutton, New York 1968. — Idem, *Idea Art: A Critique*, E. P. Dutton, New York 1973. —

Idem, *Super Realism: A Critical Anthology*, E. P. Dutton, New York 1975. — E. A. CARMEAN, *The Great Decade of American Abstraction*, Houston Museum of Fine Arts, Houston 1974. — LINDA CHASE, *Photo Realism*, Eminent Publications, New York 1975. — JOHN COPLANS, *Ellsworth Kelly*, Harry N. Abrams, New York 1972. — MICHAEL CRICHTON, *Jasper Johns*, Whitney Museum of American Art, New York 1977. — *Richard Diebenkorn*, exhibition catalogue, Albright-Knox Art Gallery, Buffalo, N.Y. 1977. — JOHN ELDERFIELD, *Grids*, in *Artforum*, May 1972. — MICHAEL FRIED, *Morris Louis*, Harry N. Abrams, New York 1970. — SUZI GABLIK, *Progress in Art*, Rizzoli, New York 1977. — THOMAS B. HESS, *Barnett Newman*, The Museum of Modern Art, New York 1971. — Idem, *Feel of Flying*, in *New York Magazine*, February 28, 1977. — SAM HUNTER, *American Art of the 20th Century*, Harry N. Abrams, New York 1972. — LUCY LIPPARD, *Changing: Essays in Art Criticism*, E. P. Dutton, New York 1971. — Idem, *From the Center: Essays on Feminist Art*, E. P. Dutton, New York 1977. — ELLEN MENDELBAUM, *Insoluble Units, Unity and Difficulty*, in *Art Journal*, Spring 1968. — ROBERT M. MURDOCK, *Modular Painting*, Albright-Knox Art Gallery, Buffalo, N.Y. 1970. — PETER PLAGENS, *Sunshine Muse*, Praeger, New York 1974 (California art). — BARBARA ROSE, *The Vincent Melzac Collection*, Corcoran Gallery of Art, Washington, D.C. 1972 (Washington School color painters). — Idem, *Decoys and Doubles, Jasper Johns and the Modernist Mind*, in *Arts*, May 1976. — WILLIAM RUBIN, *Frank Stella*, The Museum of Modern Art, New York 1970. — IRVING SANDLER, *The Triumph of American Painting*, Praeger, New York 1970.

List of Color Plates

ALBERS Josef (1888-1976). Homage to the Square: Ritardando, 1958. Oil on board. (40 × 40″) Roy R. Neuberger Collection, New York . 177

ALLSTON Washington (1779-1843). Elijah in the Desert fed by the Ravens, 1818. Oil on canvas. (43³/₄ × 72¹/₂″) Museum of Fine Arts, Boston, Massachusetts. Gift of Mrs. Samuel and Miss Alice Hooper . 59

ANONYMOUS. Mrs. Elizabeth Freake and Daughter Mary, about 1674. Oil on canvas. (42¹/₂ × 36³/₄″) Worcester Art Museum, Worcester, Massachusetts. Gift of Mr. and Mrs. Albert W. Rice 12

— John Van Cortlandt, about 1731. Oil on canvas. (57 × 41″) Brooklyn Museum, Brooklyn, New York. Dick S. Ramsay Fund, 1941 . 18

— Mrs. Anne Pollard, 1721. Oil on canvas. (28³/₄ × 24″) Massachusetts Historical Society, Boston, Massachusetts . 20

— Meditation by the Sea, about 1850-1860. Oil on canvas. (13¹/₂ × 19¹/₂″) Museum of Fine Arts, Boston, Massachusetts. M. and M. Karolik Collection 71

AUDUBON John James (1785-1851). Purple Grackle, 1822. Watercolor (23⁷/₈ × 18¹/₂″) The New-York Historical Society, New York . 69

AVERY Milton (1893-1965). Seated Girl with Dog, 1944. Oil. (44 × 32″) Roy R. Neuberger Collection, New York . 174

BELLOWS George (1882-1925). Both Members of This Club, 1909. Oil on canvas. (45¹/₄ × 63¹/₈″) National Gallery of Art, Washington, D.C. Gift of Chester Dale 125

BENTON Thomas Hart (1889-1975). Cradling Wheat, 1938. Tempera and oil on board. (31 × 38″) City Art Museum, St. Louis, Missouri . 165

BIERSTADT Albert (1830-1902). Lake Tahoe, 1868. Oil on canvas. (13 × 16¹/₈″) Fogg Art Museum, Harvard University, Cambridge, Massachusetts. Gift of Mr. and Mrs. Frederic H. Curtiss . . . 65

BINGHAM George Caleb (1811-1879). Fur Traders Descending the Missouri, about 1845. Oil on canvas. (29 × 36¹/₂″) Metropolitan Museum of Art, New York. Jesup Fund, 1933 79

BLAKELOCK Ralph Albert (1847-1919). Moonlight, about 1885. Oil on canvas. (27¹/₄ × 32¹/₄″) Brooklyn Museum, Brooklyn, New York . 98

BRUCE Patrick Henry (1881-1937). Painting, 1930. Oil on canvas. (35 × 45³/₄″) Whitney Museum of American Art, New York . 153

BURCHFIELD Charles E. (1893-1967). Church Bells Ringing, Rainy Winter Night, 1917. Watercolor on paper. (30 × 19″) Cleveland Museum of Art, Cleveland, Ohio. Gift of Mrs. Louise M. Dunn in memory of Henry G. Keller . 150

CASSATT Mary (1845-1926). Little Girl in a Blue Armchair, 1878. Oil on canvas. (35 × 51″) Mr. and Mrs. Paul Mellon Collection, Washington, D.C. 114

CATLIN George (1796-1872). The White Cloud, Chief of the Iowas. Oil on canvas. (27³/₄ × 22³/₄) National Gallery of Art, Washington, D.C. Paul Mellon Collection 104

CHASE William Merritt (1849-1916). In the Studio, about 1880 (?). Oil on canvas. (28¹/₂ × 40¹/₄″) Brooklyn Museum, Brooklyn, New York. Gift of Mrs. C. H. DeSilver 116

CHURCH Frederick E. (1826-1900). Twilight in the Wilderness, 1860. Oil on canvas. (40 × 64″) Cleveland Museum of Art, Cleveland, Ohio. Mr. and Mrs. William H. Marlatt Fund 66

CLOSE Chuck (1940). Linda, 1976. Acrylic on canvas. (108 × 84″) The Pace Gallery, New York . . . 246

COLE Thomas (1801-1848). The Course of Empire: The Savage State, 1833-1836. Oil on canvas. (39¹/₄ × 63¹/₄″) The New-York Historical Society, New York 62
— Schroon Mountain, the Adirondacks, 1833. Oil on canvas. (39³/₈ × 63″) Cleveland Museum of Art, Cleveland, Ohio. Hinman B. Hurlbut Collection 63

COPLEY John Singleton (1738-1815). Thaddeus Burr, 1758-1760. Oil on canvas. (50⁵/₈ × 39⁷/₈″) City Art Museum, St. Louis, Missouri . 26
— Mrs. Humphrey Devereux, 1771. Oil on canvas. (40¹/₈ × 32″) National Art Gallery, Wellington, New Zealand . 29
— Watson and the Shark, 1778. Oil on canvas. (72 × 90¹/₈″) Museum of Fine Arts, Boston, Massachusetts. Gift of Mrs. George von Lengerke Meyer . 40-41
— The Death of Major Peirson, 1782-1784. Oil on canvas. (97 × 144″) Tate Gallery, London 42

DAVIS Ronald (1937). Disk, 1968. Fiberglass. (55 × 136″) Collection of Mr. and Mrs. Joseph A. Helman, St. Louis, Missouri . 234

DAVIS Stuart (1894-1964). Swing Landscape, 1938. Oil on canvas. (7 ft. 1¹/₂ in. × 14 ft. 5¹/₂ in.) Indiana University Art Museum, Bloomington, Indiana . 156-157

DEMUTH Charles (1883-1935). Buildings Abstraction, Lancaster, 1931. Oil on board. (27⁷/₈ × 23⁵/₈″) The Detroit Institute of Art, Detroit, Michigan . 146

DIEBENKORN Richard (1922). Ocean Park No. 60, 1973. Oil on canvas. (93 × 81″) Albright-Knox Art Gallery, Buffalo, New York . 250

DILLER Burgoyne (1906-1965). First Theme, 1939-1940. Oil on canvas. (34 × 34″) Mrs. Burgoyne Diller Collection, Atlantic Hills, New Jersey . 186

DINE Jim (1935). Cardinal, 1976. Oil on canvas. (108 × 72″) The Pace Gallery, New York 244

DOVE Arthur G. (1880-1946). Holbrook's Bridge, Northwest, 1938. Oil. (25 × 35″) Roy R. Neuberger Collection, New York . 142

DURAND Asher B. (1796-1886). Kindred Spirits, 1849. Oil on canvas. (46 × 36″) New York Public Library, New York. Astor, Lenox and Tilden Foundations 50

EAKINS Thomas (1844-1916). Will Schuster and Blackman Going Shooting for Rail, 1876. Oil on canvas. (22¹/₈ × 30¹/₄″) Yale University Art Gallery, New Haven, Connecticut. Bequest of Stephen Carlton Clark, B.A. 1903 . 89
— The Gross Clinic, 1875. Oil on canvas. (96 × 78″) Jefferson Medical College, Philadelphia, Pennsylvania . 91
— The Thinker (Louis N. Kenton), 1900. Oil on canvas. (82 × 42″) Metropolitan Museum of Art, New York. Kennedy Fund, 1917 . 110

EARL Ralph (1751-1801). Roger Sherman, about 1777. Oil on canvas. (64³/₄ × 49¹/₂″) Yale University Art Gallery, New Haven, Connecticut. Gift of Roger Sherman White, January 1918 30

EVERGOOD Philip (1901-1973). The Jester, 1950. Oil on canvas. (61 × 78″) Collection of Mr. and Mrs. Sol Brody, Philadelphia, Pennsylvania . 160

FEKE Robert (1705/10-after 1750). Isaac Royall and His Family, 1741. Oil on canvas. (56¹/₄ × 77³/₄″) Harvard Law School, Cambridge, Massachusetts . 23

FRANCIS Sam (1923). Red No. 1, 1953. Oil on canvas. (64¹/₈ × 45¹/₈″) Collection of Mr. and Mrs. Guy Weill, Scarsdale, New York . 222

FRANKENTHALER Helen (1928). Blue Caterpillar, 1961. Oil on canvas. (9 ft. 9¹/₈ in. × 5 ft. 8¹/₂ in.) Owned by the Artist . 219

GLACKENS William (1870-1938). Hammerstein's Roof Garden, about 1901. Oil on canvas. (30×25″) Whitney Museum of American Art, New York . 123

GORKY Arshile (1904-1948). Self-Portrait, 1929-1936. (55¹/₂×34″) M. Knoedler & Co., Inc., New York, Paris, London . 172
— The Betrothal, II, 1947. (50³/₄×38″) Whitney Museum of American Art, New York 180

GOTTLIEB Adolph (1903-1974). Pink Smash, 1959. (9 ft.×7¹/₂ ft.) Estate of the Artist 202

GRAVES Nancy (1940). ABC, 1977. Acrylic and oil on canvas. (44×96″: each panel 44×32″) André Emmerich Gallery, New York .242-243

HARNETT William M. (1848-1892). The Faithful Colt, 1890. Oil on canvas. (22¹/₂×19″) Wadsworth Atheneum, Hartford, Connecticut. Ella Gallup Sumner and Mary Catlin Sumner Collection . . . 101

HARTLEY Marsden (1877-1943). Portrait of a German Officer, 1914. Oil on canvas. (68¹/₄×41³/₈″) The Metropolitan Museum of Art, New York. The Alfred Stieglitz Collection, 1949 130

HASSAM Childe (1859-1935). Rainy Day, Rue Bonaparte, Paris, 1887. (40¹/₄×77¹/₄″) Harry Spiro Collection, New York . 117

HEADE Martin Johnson (1819-1904). Orchids, Passion Flowers and Hummingbird, 1880. (20×14″) Mr. and Mrs. Robert C. Graham Collection, New York 68

HELD Al (1928). Mao, 1967. Acrylic on canvas. (9¹/₂ ft.×9¹/₂ ft.) André Emmerich Gallery, New York 217

HICKS Edward (1780-1849). The Residence of David Twining 1787. Painted about 1846. Oil on canvas. (27×32″) Abby Aldrich Rockefeller Folk Art Collection, Williamsburg, Virginia 72

HOFMANN Hans (1880-1966). Cathedral, 1959. Oil. (74×48″) Private Collection, Shaker Heights, Ohio . 176

HOMER Winslow (1836-1910). Breezing Up, 1876. Oil on canvas. (24×38″) National Gallery of Art, Washington, D.C. Gift of the W. L. and May T. Mellon Foundation 83
— The Fog Warning, 1885. Oil on canvas. (30×48″) Museum of Fine Arts, Boston, Massachusetts. Otis Norcross Fund . 84
— The Gulf Stream, 1899. Oil on canvas. (28¹/₈×49¹/₈″) Metropolitan Museum of Art, New York. Wolfe Fund, 1906 . 85
— Right and Left, 1909. Oil on canvas. (28¹/₈×48¹/₂″) National Gallery of Art, Washington, D.C. Gift of the Avalon Foundation . 87

HOPPER Edward (1882-1967). House by the Railroad, 1925. Oil on canvas. (24×29″) The Museum of Modern Art, New York . 162
— Tables for Ladies, 1930. Oil on canvas. (48¹/₄×60¹/₄″) The Metropolitan Museum of Art, New York. George A. Hearn Fund, 1931 . 163

INNESS George (1825-1894). Indian Summer, 1894. Oil on canvas. (45¹/₄×30″) George M. Curtis Collection, Clinton, Iowa . 96

JOHNS Jasper (1930). White Flag, 1955. Encaustic and collage on canvas. (6 ft.×12 ft.) Owned by the Artist . 229
— Untitled, 1972. Encaustic and collage on canvas with objets. (6 ft.×16 ft.) Ludwig Museum, Cologne, West Germany .238-239

JOHNSON Eastman (1824-1906). Old Kentucky Home, 1859. Oil on canvas. (36×45″) The New-York Historical Society, New York . 81

KELLY Ellsworth (1923). Two Panels. Yellow and Black, 1968. Oil on canvas. (7 ft. 8 in.×9 ft. 8 in.) Sidney Janis Gallery, New York . 233

KLINE Franz (1910-1962). New York, 1953. Oil on canvas. (79×50¹/₂″) Albright-Knox Art Gallery, Buffalo, New York. Gift of Seymour H. Knox . 200

KOONING Willem de (1904). Seated Woman, about 1940. Oil and charcoal on composition board. (54×36″) Mrs. Albert M. Greenfield Collection, Philadelphia, Pennsylvania 173
— Excavation, 1950. Oil and enamel on canvas. (6 ft. 8¹/₂ in.×8 ft. 4¹/₈ in.) The Art Institute of Chicago, Chicago, Illinois . 191
— Merritt Parkway, 1959. (7 ft. 5³/₄ in.×6 ft. 8³/₈ in.) Collection of Mr. and Mrs. Ira Haupt, New Jersey 201

KRASNER Lee (1911). Imperative, 1976. Collage, paper on canvas. (50×50″) The Pace Gallery, New York . 249

KÜHN Justus Engelhardt (active 1708-1717). Eleanor Darnall, about 1710. Oil on canvas. (54×44¹/₂″) Maryland Historical Society, Baltimore, Maryland 19

LESLIE Alfred (1927). The 7 a.m. News, 1976. Oil on canvas (unfinished). (84×60″) Allan Frumkin Gallery, New York . 245

LEVINE Jack (1915). The Three Graces, 1965. Oil. (72×63″) The Honorable and Mrs. William Benton, Southport, Connecticut . 161

LIBERMAN Alexander (1912). Omega VI. Oil on canvas. (79³/₄×60″) The Art Museum, Princeton University, Princeton, New Jersey . 216

LICHTENSTEIN Roy (1923). Okay, Hot Shot, Okay, 1963. Oil and magma on canvas. (80×68″) Remo Morone Collection, Turin, Italy . 206

LOUIS Morris (1912-1962). Blue Veil, 1958-1959. Acrylic resin paint on canvas. (8 ft. 4¹/₂ in. × 12 ft. 5 in.) Fogg Art Museum, Harvard University, Cambridge, Massachusetts. Gift of Mrs. Culver Orswell . 221

LUKS George (1867-1933). The Miner. Oil on canvas. (60×51″) National Gallery of Art, Washington, D.C. Gift of Chester Dale . 124

MACDONALD-WRIGHT Stanton (1890-1973). Abstraction on Spectrum (Organization 5), 1914. Oil. (30×24″) Nathan Emory Coffin Memorial Collection, Des Moines Art Center, Des Moines, Iowa 135

MARIN John (1870-1953). Off Stonington, 1921. Watercolor on paper. (16³/₈×19¹/₂″) The Columbus Gallery of Fine Arts, Columbus, Ohio. Ferdinand Howald Collection 140

MARSH Reginald (1898-1954). Tattoo and Haircut, 1932. Egg tempera on canvas. (46¹/₂×47⁷/₈″) The Art Institute of Chicago, Chicago, Illinois 169

MARTIN Agnes (1912). Untitled No. 8, 1975. Acrylic, pencil and Shiva gesso on canvas. (6 ft. ×6 ft.) The Pace Gallery, New York . 247

MOTHERWELL Robert (1915). Elegy to the Spanish Republic, 1953-1954. Oil on canvas (6 ft. 8 in. ×8 ft. 4 in.) Albright-Knox Art Gallery, Buffalo, New York. Gift of Seymour H. Knox . . . 189

MOUNT William Sidney (1807-1868). The Painter's Triumph, 1838. Oil on panel. (19¹/₂×23¹/₂″) Pennsylvania Academy of the Fine Arts, Philadelphia, Pennsylvania 74
— Eel Spearing at Setauket, 1845. Oil on canvas. (29×36″) New York State Historical Association, Cooperstown, New York . 78

NEAGLE John (1796-1865). Pat Lyon at the Forge, 1829. Oil on canvas. (94¹/₂×68¹/₂″) Pennsylvania Academy of the Fine Arts, Philadelphia, Pennsylvania 53

NEWMAN Barnett (1905-1970). Ulysses, 1952. Oil on canvas. (11 ft. ×4 ft. 2 in.) Jaime del Amo Collection, Los Angeles, California . 204

NOLAND Kenneth (1924). Via Blues, 1967. Acrylic on canvas. (7 ft. 6¹/₈ in. × 22 ft.) Collection of Mr. and Mrs. Robert A. Rowan, Pasadena, California . 224-225

O'KEEFFE Georgia (1887). Black Cross, New Mexico, 1929. Oil on canvas. (39×30¹/₁₆″) The Art Institute of Chicago, Chicago, Illinois . 143

OLITSKI Jules (1922). High A Yellow, 1967. Acrylic on canvas. (7 ft. 8¹/₂ in. × 12 ft. 6 in.) Whitney Museum of American Art, New York . 226

PEALE Charles Willson (1741-1827). The Staircase Group, 1795. (89×39¹/₂″) Philadelphia Museum of Art, Philadelphia, Pennsylvania. George W. Elkins Collection 48

PEALE Raphaelle (1774-1825). After the Bath, 1823. Oil on canvas. (29×24″) William Rockhill Nelson Gallery of Art and Mary Atkins Museum of Fine Arts, Kansas City, Missouri 100

PHILLIPS Ammi (1788-1865), Attributed to. Portrait of Harriet Leavens. Oil on canvas. (56¹/₄×27″) Fogg Art Museum, Harvard University, Cambridge, Massachusetts. Gift, Estate of Harriet Anna Niel . 70

POLLOCK Jackson (1912-1956). Pasiphae, 1943. Oil on canvas. (56¹/₈×96″) Marlborough-Gerson Gallery, New York. Collection Lee Krasner Pollock 185
— One (Number 31, 1950). Oil on canvas. (8 ft. 10 in. × 17 ft. 5⁵/₈ in.) The Museum of Modern Art, New York. Gift of Sidney Janis . 192-193

— Echo, 1951. (7 ft. 7⁷/₈ in. × 7 ft. 2 in.) The Museum of Modern Art, New York. Acquired through the Lillie P. Bliss Bequest and the Mr. and Mrs. David Rockefeller Fund 194

POONS Larry (1937). Rosewood, 1966. Acrylic on canvas. (10 ft. × 13 ft. 4 in.) William Rubin Collection, New York . 227

PRATT Matthew (1734-1805). The American School, 1765. Oil on canvas. (36 × 50¹/₄″) Metropolitan Museum of Art, New York. Gift of Samuel P. Avery, 1897 34

PRENDERGAST Maurice (1859-1924). Ponte della Paglia, Venice, 1899. Oil on canvas. (28 × 23″) Phillips Collection, Washington, D.C. 120

— Central Park, New York, 1901. Pencil and Watercolor. (14¹/₈ × 21³/₄″) Whitney Museum of American Art, New York . 121

QUIDOR John (1801-1881). The Money Diggers, 1832. Oil on canvas. (16³/₄ × 21¹/₂″) Brooklyn Museum, Brooklyn, New York. Gift of Mr. and Mrs. A. Bradley Martin, 1948 77

RAUSCHENBERG Robert (1925). Charlene, 1954. Collage. (7 ft. 4¹/₂ in. × 10 ft. 6 in.) Stedelijk Museum, Amsterdam, Holland . 211

REINHARDT Ad (1913-1967). Blue Painting, 1953. Oil on canvas. (75 × 28″) Museum of Art, Carnegie Institute, Pittsburgh, Pennsylvania . 187

REMINGTON Frederic (1861-1900). A Dash for Timber, 1899. Oil on canvas. (48³/₄ × 84³/₈″) Amon Carter Museum of Western Art, Fort Worth, Texas. Ex Collection Washington University, St. Louis, Missouri . 103

ROCKBURNE Dorothea (1934). Noli Me Tangere, 1976. Gesso, varnish, glue and oil on linen. (55 × 34″) John Weber Gallery, New York . 251

ROSENQUIST James (1933). Horse Blinders (fragment), 1968-1969. Oil and aluminum on canvas. (Height, 10 ft.) Ludwig Museum, Cologne, West Germany 213

ROTHKO Mark (1903-1970). Red, White and Brown, 1957. Oil on canvas. (8 ft. 3¹/₂ in. × 6 ft. 9³/₄ in.) Öffentliche Kunstsammlung, Basel, Switzerland . 203

RUSSELL Charles Marion (1864-1926). Crippled But Still Coming, 1913. Oil on canvas. (30 × 48″) Amon Carter Museum of Western Art, Fort Worth, Texas. Ex Collection Judge James Bollinger, Davenport, Iowa . 102

RUSSELL Morgan (1886-1953). Synchromy in Orange: To Form, 1913-1914. Oil on canvas. (11 ft. 3 in. × 10 ft. 3 in.) Albright-Knox Art Gallery, Buffalo, New York. Gift of Seymour H. Knox 134

RYDER Albert Pinkham (1847-1917). The Dead Bird, 1890-1900. Oil on panel. Phillips Collection, Washington, D.C. 93

— The Race Track or Death on a Pale Horse, 1895-1910. Oil on canvas. (28¹/₄ × 35¹/₄″) Cleveland Museum of Art, Cleveland, Ohio. Purchase, J. H. Wade Fund 94

SARGENT John Singer (1856-1925). The Daughters of Edward Darley Boit, 1882. Oil on canvas. (87⁵/₈ × 87⁵/₈″) Museum of Fine Arts, Boston, Massachusetts. Gift of the daughters of Edward D. Boit in memory of their father . 112

SHAHN Ben (1898-1969). Miners' Wives, 1948. Egg tempera on board. (48 × 36″) Philadelphia Museum of Art, Philadelphia, Pennsylvania . 167

SHEELER Charles (1883-1965). Upper Deck, 1929. Oil. (29 × 21³/₄″) Fogg Art Museum, Harvard University, Cambridge, Massachusetts. Louise E. Bettens Fund Purchase 145

SLOAN John (1871-1951). The Wake of the Ferry, 1907. Oil on canvas. (26 × 32″) Phillips Collection, Washington, D.C. 126

SMIBERT John (1688-1751). Dean George Berkeley and His Party (The Bermuda Group), 1729. Oil on canvas. (69³/₄ × 94¹/₂″) Yale University Art Gallery, New Haven, Connecticut. Gift of Isaac Lathrop of Plymouth, Mass., 1808 . 22

SMITH Thomas (active last quarter of 17th century). Self-Portrait, about 1690. Oil on canvas. (24¹/₂ × 23³/₄″) Worcester Art Museum, Worcester, Massachusetts 16

STELLA Frank (1936). Marquis de Portago, 1960. Acrylic on canvas. (7 ft. 9¹/₄ in. × 5 ft. 11¹/₂ in.) Carter Burden Collection, New York . 231

STELLA Joseph (1877-1946). Battle of Lights, Coney Island, 1913. Oil on canvas. (6 ft. 3³/₄ in. × 7 ft.) Yale University Art Gallery, New Haven, Connecticut. Gift of the Société Anonyme 132

STILL Clyfford (1904). Painting, 1951. Oil on canvas. (7 ft. 9¹/₄ in. × 6 ft. 3³/₄ in.) The Detroit Institute of Art, Detroit, Michigan . 199

STUART Gilbert (1755-1828). The Skater, 1782. Oil on canvas. (96⁵/₈ × 58¹/₈″) National Gallery of Art, Washington, D.C. Andrew Mellon Collection . 45

— The Athenaeum Portrait of George Washington, 1796. Oil on canvas. (39⁵/₈ × 34¹/₂″) Museum of Fine Arts, Boston, Massachusetts. Courtesy of the Boston Athenaeum 47

SULLY Thomas (1783-1872). Lady with a Harp: Eliza Ridgely, 1818. Oil on canvas. (84³/₈ × 56¹/₈″) National Gallery of Art, Washington, D.C. Gift of Maude Monell Vetlesen 52

TOBEY Mark (1890-1976). Pacific Transition, 1943. Gouache on paper. (23¹/₄ × 31¹/₄″) City Art Museum, St. Louis, Missouri. Gift of Joseph Pulitzer, Jr. 196

TOMLIN Bradley Walker (1899-1953). Number 9: In Praise of Gertrude Stein, 1950. Oil on canvas. (49 × 102¹/₄″) The Museum of Modern Art, New York. Gift of Mrs. John D. Rockefeller, 3rd . . . 197

TRUMBULL John (1756-1843). The Declaration of Independence (detail), 1786-1797. Oil on canvas. Yale University Art Gallery, New Haven, Connecticut 32

TWACHTMAN John H. (1853-1902). The White Bridge. (30¹/₄ × 20¹/₄″) Minneapolis Institute of Arts, Minneapolis, Minnesota. Martin B. Koon Memorial Collection 118

VANDERLYN John (1775-1852). Marius Amidst the Ruins of Carthage, 1807. Oil on canvas. (87 × 68¹/₂″) M. H. de Young Memorial Museum, San Francisco, California. Gift of M. H. de Young 56

WARHOL Andy (1925). Marilyn Monroe, 1962. Acrylic on canvas. (Two panels: 6 ft. 10 in. × 9 ft. 6 in.) Collection of Mr. and Mrs. Burton Tremaine, Meriden, Connecticut 212

WEBER Max (1881-1961). Athletic Contest, 1915. Oil on canvas. (40 × 60″) The Metropolitan Museum of Art, New York. George A. Hearn Fund, 1967 137

WEIR J. Alden (1852-1919). The Red Bridge. Oil on canvas. (24¹/₄ × 33³/₄″) The Metropolitan Museum of Art, New York. Gift of Mrs. John A. Rutherford, 1914 119

WEST Benjamin (1738-1820). Agrippina Landing at Brundisium with the Ashes of Germanicus, 1768. Oil on canvas. (64¹/₂ × 106¹/₂″) Yale University Art Gallery, New Haven, Connecticut. Gift of Louis M. Rabinowitz . 36

— The Death of General Wolfe, 1770. Oil on canvas. (59¹/₂ × 84″) National Gallery of Canada, Ottawa, Ontario. Canadian War Memorials Collection . 37

WHISTLER James Abbott McNeill (1834-1903). Nocturne in Black and Gold: The Falling Rocket, about 1874. Oil on panel. (23³/₄ × 18³/₈″) Detroit Institute of Arts, Detroit, Michigan 106

— Arrangement in Gray and Black No. 2: Thomas Carlyle, 1872-1873. (67³/₈ × 56¹/₂″) Glasgow Art Gallery and Museum, Glasgow, Scotland . 109

— Arrangement in Flesh Color and Black: Portrait of Théodore Duret, 1883. Oil. (76¹/₈ × 35³/₄″) The Metropolitan Museum of Art, New York. Wolfe Fund, 1913 111

WILLIAMS William (about 1710-about 1790). Deborah Hall, 1766. Oil on canvas. (71¹/₄ × 46¹/₂″) Brooklyn Museum, Brooklyn, New York. Dick S. Ramsay Fund 25

WOOD Grant (1892-1942). American Gothic, 1930. Oil on panel. (29 × 24″) The Art Institute of Chicago, Chicago, Illinois . 166

WYETH Andrew (1917). April Wind, 1952. Tempera on masonite. (20 × 26″) Wadsworth Atheneum, Hartford, Connecticut . 159

YOUNGERMAN Jack (1926). Black, Yellow, Red, 1964. Oil on canvas. (8 ft. × 6 ft. 1 in.) The Finch College Museum of Art, New York. Gift of the Artist . 232

General Index

Abstract Expressionists 137, 178, 181-184, 188, 189, 191, 192, 194-196, 198, 204, 205, 207-211, 213-215, 218, 225, 228-230, 233, 235, 236, 241, 248.

Abstract painters and painting 141, 146-149, 152, 154, 155, 157-160, 168, 170, 171, 178, 179, 182, 187, 188, 190, 193, 204, 205, 207, 208, 210, 214, 217, 218, 220, 230, 233, 237.

Action painting 171, 178, 197, 205, 207, 209, 214, 215, 218, 228, 230.

ADAM Robert (1728-1792), *Ruins of the Palace of the Emperor Diocletian at Spalato* (1764) 43.

ADAMS John (1735-1826) 46, 51.

ADAMS Samuel (1722-1803) 28.

AINSLIE Thomas 27.

ALBANI Alessandro (1692-1779), Cardinal 37.

ALBERS Anni (1899) 178.

ALBERS Josef (1888-1976) 171, 175, 178, 179, 187, 210, 220, 223;
New York, Roy R. Neuberger Collection: *Homage to the Square: Ritardando* (1958) 177.

Albiquiu, New Mexico 142.

ALBRIGHT Ivan Le Lorraine (1897) 162, 163.

ALEXANDER Cosmo (c. 1724-1772) 43.

ALLOWAY Lawrence (1926) 212.

ALLSTON Washington (1779-1843) 58-61, 95;
Boston, Museum of Fine Arts: *Thunderstorm at Sea* (1804) 58; *Elijah in the Desert fed by the Ravens* (1818) 58, 59; Cambridge, Fogg Art Museum: *Diana in the Chase* 58;
Detroit Institute of Arts: *Belshazzar's Feast* 59, 60;
Philadelphia, Pennsylvania Academy of Fine Arts: *The Dead Man Revived by Touching the Bones of the Prophet Elisha* 58;
Literary works: *Sylphs of the Seasons* (1813), poem 61; *Monaldi* (1841), romance 61; *Lectures on Art* (1850) 61.

American Art Union (Apollo Association), New York 77-80.

American Revolution (1775-1783) 33, 35, 42, 43, 49, 55, 58.

American Scene painting 133, 147, 152-155, 158, 159, 162-164, 169-171, 179, 182, 190, 207, 236-238, 241.

Amsterdam, Holland, Stedelijk Museum 211.

Andover, Mass., Addison Gallery of American Art, Phillips Academy 85-87.

Annapolis, Maryland 17, 24, 46.

Anonymous masters:
Boston, Massachusetts Historical Society: *Mrs. Anne Pollard* (1721) 17, 20;
Boston, Museum of Fine Arts: *Meditation by the Sea* (c. 1850-1860) 71, 72;
Brooklyn Museum: *John Van Cortlandt* (c. 1731) 17, 18, 55, 71;
Hartford, Wadsworth Atheneum: *Elizabeth Eggington* (1664) 13, 14;
Worcester Art Museum: *Mrs. Elizabeth Freake and Daughter Mary* (c. 1674) 12, 14, 15, 22, 71.

ANSHUTZ Thomas Pollock (1851-1912) 122.

ARENSBERG Walter (1878-1954) 147.

Armory Show, New York (1913), later in Chicago and Boston 9, 127, 131-133, 136, 138, 141, 144, 147, 148, 152, 154, 155, 158, 160, 164, 181.

ARP Jean (1887-1966) 181, 182.

ASHBERY John (1927) 240.

Ashcan School 9, 92, 105, 107, 126, 127, 133, 136, 155, 170, 185, 190, 237, 238.

Asheville, North Carolina, Black Mountain College 178, 179.

AUDUBON John James (1785-1851) 67, 69, 87;
New York, New-York Historical Society: *Purple Grackle* (1822) 67, 69.

AULT George (1891-1941) 158.

AVEDESIAN Edward (1936) 209.

AVERY Milton (1893-1965) 158, 174, 175, 190;
New York, Roy R. Neuberger Collection: *Seated Girl with Dog* (1944) 174.

BADGER Joseph (1708-1765) 27, 71;
New York, Metropolitan Museum: *James Badger* 27.

BAER Jo (1929) 248.

Baltimore, Peale Museum 49;
Maryland Historical Society 17, 19.

BANNARD Darby (1931) 209, 224, 228, 233, 234.

Barbizon School (c. 1830-1880) 96.

BARLOW Joel (1754-1812), *The Columbiad* (1807) 55.

BARNES Dr. Albert C. (1878-1951) 122.

Baroque painters and painting 15, 17, 23, 24, 162, 163, 170, 178, 195;
Neo-Baroque 154.

BARR, Jr., Alfred H. (1902) 183, 198.

BARTRAM William (1739-1823) 67.

Basel, Switzerland, Öffentliche Kunstsammlung 203.

BAUDELAIRE Charles (1821-1867) 103, 108.

Bauhaus (Weimar 1919-1925, Dessau 1925-1932, Berlin 1932-1933) 152, 178, 179, 187, 208.

BAZIOTES William (1912-1963) 181, 182, 188, 195.

BEAL Jack (1931) 233.

BECHTLE Robert (1932) 237.

BECKMANN Max (1884-1950) 162.

BELL Larry (1939) 223, 236.

BELLOWS George (1882-1925) 126, 127, 133, 160;
Washington, Corcoran Gallery: *Forty-two Kids* (1907) 126;
Washington, National Gallery: *Both Members of This Club* (1909) 125-127.

BENGSTON Billy Al (1934) 236.

BENTON Thomas Hart (1889-1975) 147, 153, 154, 158, 164, 165, 168, 170, 171, 179, 184;
St. Louis, Missouri, City Art Museum: *Cradling Wheat* (1938) 165.

BERGSON Henri (1859-1941) 133.

BERKELEY George (1685-1753), Bishop of Cloyne 20, 21, 33, 43.

Berlin 139.

BERMAN Eugene (1899-1972) 162.

BERTHOT Jake (1939) 242.

BIDDLE George (1885-1973) 152, 153.

BIERSTADT Albert (1830-1902) 64, 65, 67, 75, 80, 97, 102;
Cambridge, Fogg Art Museum: *Lake Tahoe* (1868) 64, 65;
New York, Metropolitan Museum: *Rocky Mountains* 64;
Washington, Corcoran Gallery: *Last of the Buffalo* 64; *Mount Corcoran* 64.

BINGHAM George Caleb (1811-1879) 76, 79-81, 83, 95, 118, 122, 124;
Brooklyn Museum: *Shooting for the Beef* (1850) 80;
New York, Metropolitan Museum: *Fur Traders Descending the Missouri* (c. 1845) 79, 80;
St. Louis, City Art Museum: *Raftsmen Playing Cards* (1847) 80.

BIRCH Thomas (1779-1851) 60.

BIRCH William (1755-1834) 60.

BISHOP Isabel (1902) 170.

BISHOP James (1927) 248.

BLACKBURN Joseph (active 1753-1764) 27.

Black Mountain College, Asheville, N.C. 178, 179.

BLAKELOCK Ralph Albert (1847-1919) 97, 98, 100, 114;
Brooklyn Museum: *Moonlight* (c. 1885) 97, 98.

Bloomington, Indiana, Indiana University Art Museum 156, 157.

BLUEMNER Oscar (1867-1938) 138.
Blue Rider group (Der Blaue Reiter, 1911-1914) 139.
BLUME Peter (1906) 154, 162;
New York, Metropolitan Museum:*South of Scranton* (1931) 162.
BOIT Edward Darley (1840-1915) 114, 115.
BOLOTOWSKY Ilya (1907) 187.
Boston 14, 15, 17, 21, 23, 27, 28, 42, 46, 54, 55, 58, 80, 82, 115, 117;
Boston Public Library 115;
Isabella Stewart Gardner Museum 114;
Massachusetts Historical Society 20;
Museum of Fine Arts 40, 41, 47, 58, 59, 63, 71, 84, 93, 108, 112, 115.
BOYDELL John (1719-1804), *Shakespeare Gallery* (1786) 58.
BRACH Paul (1924) 215.
BRANCUSI Constantin (1876-1957) 133, 181.
BRAQUE Georges (1882-1963) 144, 149, 155, 181.
BRETON André (1896-1966) 182, 184.
BRIDGES Charles (active 1735-1740) 23, 24.
BROOK Alexander (1898) 149.
Brookline, Massachusetts, Henry L. Shattuck Collection 27.
Brooklyn, New York 95;
Brooklyn Museum 18, 23, 25, 77, 80, 98, 116.
BROWN John (1800-1859) 165.
BRUCE Edward (1879-1943) 152.
BRUCE Patrick Henry (1881-1937) 147, 149, 153;
New York, Whitney Museum of American Art: *Painting* (1930) 153.
BRUSH George De Forest (1855-1941) 96.
BRYANT William Cullen (1794-1878) 61, 63, 76;
Thanatopsis (1817) 63.
Buffalo, New York, Albright-Knox Art Gallery 93, 134, 189, 200, 250.
BUFFORD John H. (active 1835-1871) 82.
BURCHFIELD Charles (1893-1967) 147, 150, 160, 168-170;
Cleveland Museum of Art: *Church Bells Ringing, Rainy Winter Night* (1917) 150.
BURR Aaron (1756-1836) 55.
BURR Thaddeus 27.
BYRON Lord (1788-1824) 93.

CAGE John (1912) 178, 228;
Silence (1961) 228.
CAHILL Holger (1893-1960) 153, 154.
Cambridge, Massachusetts 82;
Fogg Art Museum 58, 65, 70, 145, 221;
Harvard Law School 23;
Harvard University 21, 42, 58;
Widener Library 115.
CAMPBELL Thomas (1777-1844) 93.
CAMUS Albert (1913-1960) 197.
CARAVAGGIO (1573-1610) 214, 230, 240, 243, 246.
CARLES Arthur B. (1882-1952) 138, 139, 178.
CARLYLE Thomas (1795-1881) 108.
CAROLUS-DURAND Charles-Emile-Auguste (1838-1917) 113.
CASSATT Mary (1845-1926) 7, 8, 33, 114-116;
Chicago, Art Institute: *The Bath* (c. 1891) 116;
Philadelphia Museum of Art: *Woman and Child Driving* (1881) 115;
Washington, National Gallery: *The Boating Party* 116, 117;
Washington, Paul Mellon Collection: *Little Girl in a Blue Armchair* (1878) 114, 116.
CATESBY Mark (1679?-1749) 67.
CATLIN George (1796-1872) 102-104;
Washington, National Gallery: *The White Cloud, Head Chief of the Iowas* 102-104.
CAVALLON Giorgio (1904) 175, 248.
CÉZANNE Paul (1839-1906) 138, 141, 149, 160, 171, 179, 183, 229, 238.
CHAMBERLAIN John (1927) 178.
CHARLES II, King of England (1660-1685) 15.

CHARLES IV, King of Spain (1788-1808) 211.
Charleston, South Carolina 23, 54, 55, 58.
CHASE William Merritt (1849-1916) 116, 117;
Brooklyn Museum: *In the Studio* (c. 1880?) 116, 117.
CHAUCER Geoffrey (1340?-1400), story of Constance (in the *Man of Lawes Tale*) 93.
Chicago, Art Institute 85, 86, 96, 108, 116, 122, 143, 166, 169, 191.
Chicago school of painting 165, 236.
Chinese painting 67, 139, 210.
CHRISTENSEN Dan (1942) 230.
CHURCH Frederick Edwin (1826-1900) 64-67, 75;
Cleveland Museum of Art: *Twilight in the Wilderness* (1860) 66;
New York, Metropolitan Museum: *The Heart of the Andes* (1859) 65;
Washington, Corcoran Gallery: *Niagara* (1857) 65, 66;
Cotopaxi, several views 65;
Our Banner in the Sky, lithograph 66.
Civil War (1861-1865) 66, 80-82, 88.
CLARKE Thomas B. (1848-1931) 93, 96.
CLAUDE LORRAIN (1600-1682) 61, 62.
Cleveland Museum of Art 63, 66, 94, 150.
Clinton, Iowa, George M. Curtis Collection 96.
CLOSE Chuck (1940) 246-248;
New York, Pace Gallery: *Linda (1976)* 246, 247.
COATES Robert M. (1897) 183.
Cody, Wyoming 170.
COLE Thomas (1801-1848) 60-64, 71, 76, 82, 93, 95, 96;
Boston, Museum of Fine Arts: *The Expulsion from the Garden of Eden* (1827) 63;
Cleveland Museum of Art: *Schroon Mountain, the Adirondacks* (1833) 62, 63;
Cooperstown, N.Y., New York State Historical Association: *The Last of the Mohicans* 61;
Hartford, Conn., Wadsworth Atheneum: *The Last of the Mohicans* 61;
New York, Metropolitan Museum: *Titan's Goblet* (1833) 61;
New York, New-York Historical Society: *The Course of Empire*, series of five canvases: *The Savage State, The Pastoral State, The Triumph of Empire, The Destruction of Empire, The Desolation of Empire* (1833-1836) 61, 62, 93;
Utica, N.Y., Munson-Williams-Proctor Institute: *The Voyage of Life*, series of four canvases: *Childhood, Youth, Manhood, Old Age* (1840) 63, 64.
COLERIDGE Samuel Taylor (1772-1834) 61.
Cologne, Germany, Ludwig Museum 213, 239.
Color abstraction (post-painterly abstraction) 207, 218, 220, 221, 228, 230, 233, 240.
Columbus, Ohio, Gallery of Fine Arts 140.
Constructivism 181, 182, 188.
COOPER James Fenimore (1789-1851) 61, 76;
The Last of the Mohicans (1826) 61.
Cooperstown, N.Y., New York State Historical Association 61, 78.
COPLEY John Singleton (1738-1815) 7, 26-29, 31, 33, 38-44, 49, 54, 78, 80, 81, 99;
Boston, Museum of Fine Arts: *Watson and the Shark* (1778) 38-41, 78;
London, Tate Gallery: *Death of Chatham* (1779-1781) 39, 43; *Death of Major Peirson* (1782-1784) 39, 42, 43;
Private Collection: *Boy with Squirrel* (1766) 28;
St. Louis, City Art Museum: *Thaddeus Burr* (1758-1760) 26, 27;
Wellington, New Zealand, National Art Gallery: *Mrs. Humphrey Devereux* (1771) 28, 29;
Whereabouts unknown: *Thomas Ainslie and Mrs. Ainslie* (1757) 27, 49.
COPLEY John Singleton, Baron Lyndhurst (1772-1863) 39.
COROT Camille (1796-1875) 96.
CORREGGIO (1494-1534) 57, 158.

CORTISSOZ Royal (1869-1948) 131.
COTTINGHAM Robert (1935) 237.
COURBET Gustave (1819-1877) 82, 108, 113, 133, 209, 213.
COVERT John (1882-1960) 152.
CRANE Stephen (1870-1900), *The Open Boat* (1898) 86.
CRAVEN Thomas (1889) 168.
CRAWFORD Ralston (1906) 144.
Cubism 131, 136-139, 141, 144, 148, 149, 152, 154-156, 158, 168, 170, 171, 175, 177-179, 181, 184, 187, 188, 197, 198, 204, 205, 207, 208, 210, 214, 220, 223, 224, 234, 237, 241;
Post-Cubism 208, 214, 220, 235.
Cubist-Realists 144, 148.
Cubo-Futurists 240.
CUNNINGHAM Merce (1915) 178.
CURRY John Steuart (1897-1946) 153, 158, 165.

Dada movement 147, 162, 197, 228.
DALI Salvador (1904) 163, 189.
DALTON Richard 21.
DANA John Cotton (1856-1929) 151, 154, 209.
DASBURG Andrew (1887) 147.
DAVID Jacques-Louis (1748-1825) 36, 38, 67.
DAVIES Arthur Bowen (1862-1928) 125, 127, 133.
DAVIS Gene (1920) 236.
DAVIS Ronald (1937) 224, 228, 230, 234, 236;
St. Louis, Mr. and Mrs. Joseph A. Helman Collection: *Disk* (1968) 234.
DAVIS Stuart (1894-1964) 132, 152, 154-160, 175, 177, 210, 212;
Bloomington, Indiana University Art Museum: *Swing Landscape* (1938) 156, 157;
New York, Museum of Modern Art: *Lucky Strike* (1921) 157;
New York, 1939 World's Fair: *History of Communication* (1939) 154.
Declaration of Independence (1776) 31.
DEGAS Edgar (1834-1917) 92, 115, 116.
DE KOONING, see KOONING.
DELACROIX Eugène (1798-1863) 7, 195, 228.
DELANOY Abraham (1742-1795) 34.
DELAUNAY Robert (1885-1941) 148, 181, 208.
Delaware 14, 38, 87.
DEMUTH Charles (1883-1935) 141, 144, 146-148, 157, 223;
Detroit Institute of Arts: *Buildings Abstraction, Lancaster* (1931) 146.
Depression 9, 147, 148, 151, 152, 154, 155, 170, 237.
DERAIN André (1880-1954) 139, 147.
Des Moines, Iowa, Art Center 135.
Detroit, Michigan 14;
Institute of Arts 59, 81, 93, 95, 99, 106, 146, 199.
DEWEY John (1859-1952) 133, 228.
DEWING Thomas Wilmer (1851-1938) 96.
DICKINSON Edwin (1891) 163.
DICKINSON Preston (1891-1930) 144.
DIEBENKORN Richard (1922) 248-250, 252;
Buffalo, N.Y., Albright-Knox Art Gallery: *Ocean Park No. 60* (1973) 250, 252.
DILLER Burgoyne (1906-1965) 186-188, 227;
Atlantic Hills, N.J., Mrs. Burgoyne Diller Collection: *First Theme* (1939-1940) 186.
DINE Jim (1935) 224, 242-244, 246;
New York, Pace Gallery: *Cardinal* (1976) 242-244.
DOUGHTY Thomas (1793-1856) 60.
DOVE Arthur G. (1880-1946) 136-138, 141, 142, 147, 156, 160;
Colorado Springs, Fine Arts Center: *Fog Horns* (1929) 141;
New York, Roy R. Neuberger Collection: *Holbrook's Bridge, Northwest* (1938) 142.
Dow Arthur Wesley (1857-1922) 138.
DOWNING Tom (1928) 236.
DREIER Katherine S. (1877-1952) 132, 147.

DREISER Theodore (1871-1945) 122.
Du Bois Guy Pène (1884-1958) 160.
DUCCIO DI BUONINSEGNA (active 1278-1319) 252.
DUCHAMP Marcel (1887-1968) 127, 144, 147, 181, 228, 240;
Philadelphia Museum of Art: *Chocolate Grinder* (1914) 147; *The Large Glass* (1915-1923) 240; *Nude Descending the Staircase* (1912) 127;
The Green Box (Edition Rrose Sélavy, Paris 1934) 240.
DUNLAP William (1766-1839), *History of the Rise and Progress of the Arts of Design in the United States* (1834) 60.
DURAND Asher Brown (1796-1886) 50, 60,61, 63, 96;
New York, New York Public Library: *Kindred Spirits* (1849) 50, 61, 63; *Ariadne*, engraving 60.
DURET Théodore (1838-1927) 113.
Düsseldorf, Germany 64, 80;
Academy 80.
Dutch colonial art 16, 17, 28.
Dutch painting 133.
DYCK Sir Anthony van (1599-1641) 15, 16.
DZUBAS Friedel (1915) 205, 214, 248.

EAKINS Thomas (1844-1916) 7-10, 81, 87-92, 95, 99, 103, 105, 113-115, 122, 124, 126, 133, 164, 179;
Fort Worth, Texas, Art Center: *Swimming Hole* (1882) 92, 126;
New Haven, Yale University Art Gallery: *John Biglin in a Single Scull* (1874) 88; *Will Schuster and Blackman Going Shooting for Rail* (1876) 88-90;
New York, Metropolitan Museum: *Max Schmitt in a Single Scull* (1871) 88; *The Thinker, Louis Kenton* (1900) 110, 113; Philadelphia, Jefferson Medical College: *The Gross Clinic* (1875) 89-91, 113, 124; Philadelphia Museum of Art: *William Rush Carving His Allegorical Figure of the Schuylkill River* (1877) 92; *Fairman Rogers' Four-in-Hand* (1879) 92, 115; *Crucifixion* (1880) 90.
EARL Ralph (1751-1801) 30, 31, 43, 60;
New Haven, Yale University Art Gallery: *Roger Sherman* (c. 1777) 30, 31; Worcester, Mass., Art Museum: *Landscape: Looking East from Denny Hill* 60.
Edinburgh, Scotland 20, 21, 43.
Eight, The 125, 127, 131, 133, 193.
EMERSON Ralph Waldo (1803-1882) 136.
EMMONS Nathaniel (1704-1740) 21.
England 9, 15, 27, 28, 33, 38, 39, 42, 46, 54, 55, 58, 60, 61, 67, 84, 96, 212.
English painting 17, 58.
Enlightenment 34, 35, 43, 57, 97.
ERNST Max (1891-1976) 59.
ESTES Richard (1936) 237.
European art and artists 8, 17, 24, 28, 39, 51, 60, 71, 96, 122, 127, 131-133, 136, 138, 144, 147, 151, 152, 155, 158, 159, 171, 181, 184, 187, 193, 207.
EVERGOOD Philip (1901-1973) 160-162;
Philadelphia, Sol Brody Collection: *The Jester* (1950) 160.
Expressionism 9, 10, 86, 141, 154, 171, 178, 179, 182, 183, 187, 205, 208, 215, 218, 226, 233.

Fauvism 131, 136, 139, 178, 207.
FEKE Robert (1705/10-after 1750) 21-23, 27, 31;
Cambridge, Harvard Law School: *Isaac Royall and His Family* (1741) 21, 23.
FERREN John (1905-1970) 175, 233.
FLACK Audrey (1931) 238.
Flemish painting 16, 184.
Florence, Italy 113.
Folk art 71-73, 98.
Fort Worth, Texas, Fort Worth Art Center 92;
Amon Carter Gallery of Western Art 102, 103.
France 8, 9, 33, 43, 55-67, 70, 82, 149, 181.
FRANCIS Sam (1923) 214, 218, 222;
Scarsdale, N.Y., Guy Weill Collection: *Red No. 1* (1953) 222.

FRANK Waldo (1889-1967) 137.
FRANKENSTEIN Alfred (1906) 99.
FRANKENTHALER Helen (1928) 10, 178, 208, 214, 218-221, 223, 229, 236, 241;
New York, Collection of the Artist: *Mountains and Sea* (1952) 221; *Blue Caterpillar* (1961) 219.
FRANKLIN Benjamin (1706-1790) 24, 33, 49.
Franklin, Missouri 79.
French colonial art 14.
French painting 58, 122, 133, 152, 154, 164, 170, 182, 207.
French Revolution (1789) 35, 55.
FRESNOY Charles-Alphonse du (1611-1665) 24.
FREUD Sigmund (1856-1939) 63, 188, 189.
FROST Arthur B. (1851-1928) 152.
FULLER R. Buckminster (1895) 178.
FULLER George (1822-1884) 96.
FULTON Robert (1765-1815) 55.
Funk artists 165, 207.
FUSELI John Henry (1741-1825) 35, 58.
Futurism 141, 144, 148, 181.

GAINSBOROUGH Thomas (1727-1788) 44, 54.
GAUGUIN Paul (1848-1903) 116.
GAUTIER Théophile (1811-1872) 107.
GEORGE III, King of England (1760-1820) 24, 36, 55.
GÉRICAULT Théodore (1791-1824) 7;
Paris, Louvre: *Raft of the Medusa* (1819) 38.
German expressionists 136, 139, 141, 162, 183.
German painting 16, 136, 141.
Germany 178.
GÉRÔME Jean-Léon (1824-1904) 10, 88, 90.
GIFFORD Sanford R. (1823-1880) 67.
GIGNOUX Regis (1816-1882) 96.
GILLIAM Sam (1933) 236.
GLACKENS William James (1870-1938) 122, 123, 125, 131, 133;
Chicago, Art Institute: *Chez Mouquin* (1905) 122;
New York, Whitney Museum of American Art: *Hammerstein's Roof Garden* (c. 1901) 122, 123.
GLARNER Fritz (1899-1972) 187.
Glasgow, Scotland, Glasgow Art Gallery and Museum 107, 108.
GLEIZES Albert (1881-1953) 144.
GLEYRE Charles (1806-1874) 107.
GOINGS Ralph (1928) 237.
GOLDBERG Michael (1924) 218.
GOMBRICH Sir Ernst (1909) 240.
GOODNOUGH Robert (1917) 215, 248.
GOODRICH Lloyd (1897) 92.
GORKY Arshile (1904-1948) 154, 155, 159, 170-172, 175, 180, 182-184, 186, 188, 189, 194, 195, 237;
Newark, N.J., Airport Administration Building: *Aviation: Evolution of Forms Under Aerodynamic Limitations* (c. 1936) 154;
New York, Knoedler & Co.: *Self-Portrait* (1929-1936) 172;
New York, Museum of Modern Art: *Garden in Sochi* (1941) 183, 184;
New York, Whitney Museum of American Art: *The Betrothal* (1947) 180, 183.
GOTTLIEB Adolph (1903-1974) 154, 175, 181, 182, 186, 188, 190, 195, 202, 205, 211, 221, 233;
New York, Adolph Gottlieb Collection: *Pink Smash* (1959) 202.
GOYA Francisco (1746-1828) 211.
GRAHAM John (1881-1961) 170, 171, 182, 218, 242;
System and Dialectics of Art (1937) 170, 218.
GRAVES Morris (1910) 163, 197.
GRAVES Nancy (1940) 241, 243;
New York, André Emmerich Gallery: *ABC* (1977) 243.
GRAY Cleve (1918) 248.
GRECO EL (1541-1614) 171.
Greece, classical 33, 35.
GREENBERG Clement (1909) 177, 178, 205, 207, 213, 214, 220, 221, 228, 237;

Art and Culture (1961) 228.
GREENE Stephen (1918) 248.
Greenwich Village, New York 147, 170, 190.
GREENWOOD John (1727-1792) 27, 28;
Brookline, Mass., Henry L. Shattuck Collection: *Greenwood-Lee Family* 27;
St. Louis, City Art Museum: *Sea Captain Carousing at Surinam* 27.
GROPIUS Walter (1883-1969) 178.
GROSS Dr. Samuel David (1805-1884) 89, 90.
GROSZ George (1893-1959) 162.
GUGGENHEIM Peggy (1898) 147, 181, 183, 184, 187, 198.
GUGGENHEIM Solomon R. (1861-1949) 155, 181.
GUGLIELMI Louis (1906-1956) 162.
GUSTON Philip (1913) 198, 204, 249.
GUY Francis (c. 1760-1820) 60.

HABERLE John (1856-1933) 99, 239.
Hague, The, Holland 80.
HALPERT Samuel (1884-1930) 138.
HALS Frans (1580/81-1666) 114, 115, 122.
HANCOCK John (1737-1793) 27, 28.
HARNETT William Michael (1848-1892) 99, 101, 105, 212, 239;
Hartford, Conn., Wadsworth Atheneum: *The Faithful Colt* (1890) 99, 101.
Harper's Weekly, New York 82.
Hartford, Conn., Wadsworth Atheneum 13, 38, 55, 61, 101, 108, 159.
HARTIGAN Grace (1922) 218.
HARTLEY Marsden (1877-1943) 95, 130, 136-139, 147, 148, 160, 237;
New York, Metropolitan Museum: *Portrait of a German Officer* (1914) 130, 139.
HASSAM Childe (1859-1935) 117-119;
New York, Harry Spiro Collection: *Rainy Day, Rue Bonaparte, Paris* (1887) 117, 118.
HAYTER Stanley William (1901) 57.
HEADE Martin Johnson (1819-1904) 67, 68, 71;
Boston, Museum of Fine Arts: *Spring Shower, Connecticut Valley* (1868) 71;
New York, Robert C. Graham Collection: *Orchids, Passion Flowers and Hummingbird* (1880) 67, 68.
HEATH James (1757-1834) 46;
George Washington (1800), engraving 46.
HEFFERNAN Joanna 108.
HELD Al (1928) 215, 217, 224, 236;
New York, André Emmerich Gallery: *Mao* (1967) 217.
HÉLION Jean (1904) 175.
HENRI Robert (1865-1929) 96, 122, 125, 126, 133, 136, 155, 156, 208.
HESSELIUS Gustavus (1682-1755) 24;
Philadelphia, Historical Society of Pennsylvania: *Tishcohan* and *Lapowinsa* 24.
HESSELIUS John (1728-1778) 24, 46.
HICKS Edward (1780-1849) 72, 73;
Buffalo, N.Y., Albright-Knox Art Gallery: *The Peaceable Kingdom* (c. 1833) 73;
Cooperstown, N. Y., New York State Historical Association: *The Peaceable Kingdom* (1840-1845) 73;
Williamsburg, Va., Abby Aldrich Rockefeller Folk Art Collection: *The Residence of David Twining* (c. 1846) 72, 73.
HIGHMORE Joseph (1692-1780) 22, 24.
HILLIARD Nicholas (c. 1547-1619) 15.
HITLER Adolf (1889-1945) 152, 171.
HOFMANN Hans (1880-1966) 171, 175, 177-179, 181, 183, 187, 195, 220, 223, 248;
Shaker Heights, Ohio, Private Collection: *Cathedral* (1959) 176.
HOKUSAI (1760-1849) 87;
Boston, Museum of Fine Arts: *Wave* (c. 1830) 87.
HOLBEIN the Younger, Hans (1497/98-1543) 15-17, 158.
Holland 9, 15, 27, 58, 114, 115.
HOLTZMAN Harry 187.
HOMER Winslow (1836-1910) 7-10, 81-87, 89, 92, 95, 115, 117, 118, 122, 223;
Andover, Mass., Addison Gallery of American Art: *Eight Bells* (1886) 85; *Kissing the Moon* (1904) 86, 87;

Boston, Museum of Fine Arts: *Fog Warning* (1885) 84-86, 95, 117;
Chicago, Art Institute: *After the Tornado* (1899) 86; *Herring Nets* (1885) 85;
New York, Metropolitan Museum: *Prisoners from the Front* (1866) 82; *The Gulf Stream* (1899) 85, 86;
Philadelphia Museum of Art: *Lifeline* (1884) 84;
Washington, National Gallery: *Breezing Up* (1876) 83, 85, 86; *Right and Left* (1909) 87, 89;
Williamstown, Mass., Sterling and Francine Clark Art Institute: *Undertow* (1886) 85;
Youngstown, Ohio, Butler Institute of American Art: *Snap the Whip* (1872) 82, 83.
HOPPER Edward (1882-1967) 158, 160, 162-164, 169, 170, 175, 177, 246;
New York, Metropolitan Museum: *Tables for Ladies* (1930) 163;
New York, Museum of Modern Art: *House by the Railroad* (1925) 162.
Houston, Texas, Rice University, Rothko Chapel 242.
HUDSON Thomas (1701-1779) 22,24.
Hudson River school of landscape painting (1825-1870) 60, 61, 64, 67, 82, 96.
Hudson River school of portrait painting (1720-1740) 17, 55.
Huguenots 13, 15.
HUMBOLDT Alexander, Baron von (1769-1859), *Cosmos* (1847) 64.
HUNEKER James (1860-1921) 139.
HUNTER William 43.
Hyper-Realism 237, 248.

Impressionism 7, 70, 113-119, 121, 122, 133, 138, 220;
Neo-Impressionism 148, 207;
Post-Impressionism 131, 133, 184, 198, 220.
INGRES Jean-Auguste-Dominique (1780-1867) 88, 171, 195.
INNESS George (1825-1894) 96;
Chicago, Art Institute: *Home of the Heron* (1891) 96;
Clinton, Iowa, George M. Curtis Collection: *Indian Summer* (1894) 96.
Iowa City, University of Iowa 198.
IRVING Washington (1783-1859) 61, 76;
Tales of a Traveller (1824) 76.
IRWIN Robert (1928) 210, 236.
Islamic art 198.
Italian painting 184.
Italy 9, 15, 20, 24, 31, 33, 34, 37, 61, 96, 141, 149.
ITTEN Johannes (1888-1967) 178.

JACKSON Andrew (1767-1845) 75.
JAMES Henry (1843-1916) 8, 113.
Jamestown, Virginia 13.
Japanese art 108.
Japanese prints 82, 86, 108, 115, 116, 138.
JARVIS John Wesley (1780-1839) 76.
JAY John (1745-1829) 46.
JEFFERSON Thomas (1743-1826) 43, 46.
JENSEN Alfred (1903) 215, 217.
JOHNS Jasper (1930) 147, 205, 208, 212-214, 228-230, 238, 241;
Collection of the Artist: *White Flag* (1955) 212, 229;
Cologne, Ludwig Museum: *Untitled* (1972) 238-240;
According to What (1964) 240;
Field Painting 240;
Harlem Light (1967) 240;
Slow Field 240;
Target with Plaster Cast (1955) 240.
JOHNSON Eastman (1824-1906) 80-82;
New York, New-York Historical Society: *Old Kentucky Home* (1859) 80, 81;
Syracuse, N.Y., Everson Museum of Art: *Corn Husking* (1860) 61.
JOHNSON Lyndon B. (1908-1973) 208.
JOHNSTON Henrietta (active 1708-1728/29) 23.
JUDD Donald (1928) 223.
JUNG Carl Gustav (1875-1961) 188.

KANDINSKY Wassily (1866-1944) 141, 155, 159, 171, 181-183, 196;

Concerning the Spiritual in Art (1910) 136.
Kansas City, Missouri 168;
Nelson Gallery-Atkins Museum 100.
KANT Emmanuel (1724-1804) 228.
KAPROW Allan (1927) 198.
KARFIOL Bernard (1886-1952) 149.
KAUFFMAN Craig (1932) 223, 236.
KAUFFMANN Angelica (1741-1807) 49.
KELLY Ellsworth (1923) 10, 208, 220, 226, 230, 233, 236;
New York, Sidney Janis Gallery: *Two Panels. Yellow and Black* (1968) 233.
KENNEDY Jacqueline (1929) 211.
KENNEDY John Fitzgerald (1917-1963) 189.
KENSETT John Frederick (1816-1872) 67.
KENT Rockwell (1882-1971) 153.
KENTON Louis 113.
KIESLER Frederick (1896-1965) 181.
Kingston, New York 55.
KLEE Paul (1879-1940) 182.
KLINE Franz (1910-1962) 156, 185, 186, 190, 193, 198, 200, 204,205, 209, 214, 220;
Buffalo, N.Y., Albright-Knox Art Gallery: *New York* (1953) 200.
KNELLER Sir Godfrey (1648-1723) 20, 24;
Lord Buckhurst and Lady Mary Sackville 17.
KOONING Willem de (1904) 10, 154, 155, 170, 171, 173, 178, 184, 186, 188, 190, 191, 193-196, 198, 201,205, 209, 212, 214, 218, 220, 221, 223, 224, 235, 252;
Chicago Art Institute: *Excavation* (1950) 191, 195, 198;
Philadelphia, Albert M. Greenfield Collection: *Seated Woman* (c. 1940) 173;
New Jersey, Ira Haupt Collection: *Merritt Parkway* (1959) 201.
KRASNER Lee (1911) 155, 170, 236, 248, 249;
New York, Pace Gallery: *Imperative* (1976) 248, 249.
KRUSHENICK Nicholas (1929) 224.
KÜHN Justus Engelhardt (active 1708-1717) 17, 19, 24;
Baltimore, Maryland Historical Society: *Eleanor Darnall* (c. 1710) 17, 19, 24; *Henry Darnall and his Colored Servant* (c. 1710) 17.
KUHN Walt (1880-1949) 133, 160.
KUNIYOSHI Yasuo (1893-1953) 133, 155.
KUPKA Frank (1871-1957) 141.

LACHAISE Gaston (1882-1935) 136.
LA FARGE John (1835-1910) 96.
LANE Fitz Hugh (1804-1865) 67.
LANSDOWNE, William Petty Fitzmaurice, 1st Marquess of (1737-1805) 46.
LAUTREC, see TOULOUSE-LAUTREC.
LAWRENCE Sir Thomas (1769-1830) 54.
LAWSON Ernest (1873-1939) 125.
Lebanon, Connecticut 42.
LECOQ DE BOISBAUDRAN Horace (1802-1897) 113.
LÉGER Fernand (1881-1955) 156, 158, 159, 175, 181, 210, 238.
LELY Sir Peter (1618-1680) 16.
LE MOYNE DE MORGUES Jacque (?-1588) 13.
LENIN Vladimir Ilyich (1870-1924) 152.
Leningrad 249.
LEONARDO DA VINCI (1452-1519) 149.
LESLIE Alfred (1927) 218, 230, 243, 245-249;
New York, Allan Frumkin Gallery: *The 7 A.M. News* (1976) 243, 245;
The Death of Frank O'Hara 243.
LESSING Gotthold Ephraim (1729-1781) 228.
LESSING Karl Friedrich (1808-1880) 80.
LEUTZE Emanuel (1816-1868) 80.
LEVINE Jack (1915) 161;
Southport, Conn., Hon. William Benton Collection: *The Three Graces* (1965) 161, 162.
LEVY Julien (1900) 182, 183.
LEWIS and CLARK expedition (1803-1806) 102.
LIBERMAN Alexander (1912) 215-217;
Princeton, N.J., Art Museum: *Omega VI* 216.

LICHTENSTEIN Roy (1923) 206, 209, 210, 213, 224, 225, 238;
Turin, Italy, R. Morone Collection: *Okay, Hot Shot, Okay* (1963) 206.
LINCOLN Abraham (1809-1865) 82.
LINNAEUS (Carl von Linné, 1707-1778) 49.
LOEW Michael (1907) 187.
London 8, 16, 20-24, 28, 31, 33, 34, 42-44, 46, 49, 58, 103, 107, 115, 181, 187;
Grosvenor Gallery 107;
Independent Group 212;
London War Museum 115;
Royal Academy 24, 38, 43, 44, 54, 108;
Society of Artists 28;
Tate Gallery 39, 42.
Long Island, New York 21, 76, 81, 218.
LORRAIN, see CLAUDE LORRAIN.
Los Angeles, Calif., school of painting 165, 235;
Jaime del Amo Collection 204.
LOUIS Morris (1912-1962) 205, 214, 218, 220, 221, 223, 228, 236;
Cambridge, Mass., Fogg Art Museum: *Blue Veil* (1958-1959) 221.
Lowell, Massachusetts 107.
LOZOWICK Louis (1894-1973) 148.
LUKS George Benjamin (1867-1933) 122, 124-127, 133;
Washington, National Gallery: *The Miner* 124, 125.
Luminism 60, 117.

McCAUSLAND Elizabeth (1899) 138.
McCRACKEN John (1934) 236.
MACDONALD-WRIGHT Stanton (1890-1973) 97, 135, 138, 148, 152;
Des Moines, Iowa, Art Center: *Abstraction on Spectrum (Organization 5)* (1914) 135.
McFEE Henry Lee (1886-1953) 149.
McNEIL George (1908) 175.
MADISON James (1751-1836) 46.
Magic Realists 152, 162-164, 207.
MAGRITTE René (1898-1967) 210.
MALBONE Edward Greene (1777-1807) 58.
MALEVICH Kasimir (1878-1935) 230.
MANET Edouard (1832-1883) 116, 122, 133, 164, 207, 215, 220;
Paris, Louvre: *Déjeuner sur l'herbe* (1863) 108.
MANGOLD Robert (1937) 248.
Mannerism 13-15, 240, 247.
MAN RAY (1890-1976) 139.
MARCA-RELLI Corrado (1913) 193.
MARDEN Brice (1938) 242.
MARIN John (1870-1953) 97, 115, 136-142, 160, 223;
Columbus, Ohio, Gallery of Fine Arts: *Off Stonington* (1921) 140.
MARIUS Caius (156-86 B.C.) 57.
MARSH Reginald (1898-1954) 153, 169, 170, 190;
Chicago, Art Institute: *Tattoo and Haircut* (1932) 169.
MARTIN Agnes (1912) 215, 247, 248;
New York, Pace Gallery: *Untitled No. 8* (1975) 247, 248.
MARTIN John (1789-1854) 61, 62;
Fall of Babylon (1819) 62.
MARY II, Queen of England (1689-1694) 15.
MASSON André (1896) 154, 182.
MATISSE Henri (1869-1954) 127, 138, 139, 147, 159, 170, 175, 177, 178, 198, 205, 207, 220, 227, 228, 238, 242, 248, 249, 252;
New York, Museum of Modern Art: *The Blue Window* (1911) 198;
Merion, Pa., Barnes Foundation: Mural decorations (1930-1939) 175;
Vence, French Riviera: Chapel of the Rosary (1948-1951) 242.
MATTA ECHAUREN Roberto (1911) 183.
MAURER Alfred (1868-1932) 136, 139, 147, 160.
MEDICI family, Florence 151.
MEHRING Howard (1931) 236.
MELVILLE Herman (1819-1891), *Moby Dick* (1851) 182.
MENGS Anton Raphael (1728-1779) 35.
Meriden, Connecticut, Burton Tremaine Collection 212.

Merion, Pennsylvania, Barnes Foundation 122, 175.
METZINGER Jean (1883-1956) 144.
Mexican painting 152-154.
MICHELANGELO (1475-1564) 54, 149, 158, 171.
MIES VAN DER ROHE Ludwig (1886-1969) 178.
MILLER Kenneth Hayes (1876-1952) 155.
Minimal art 147, 187, 188, 207, 209, 210, 215, 223, 228, 242, 248.
Minneapolis, Minnesota, Institute of Arts 118.
MIRÓ Joan (1893) 159, 175, 181-183, 205.
Mississippi River 14, 79, 83.
Missouri River 102.
MITCHELL John (1927) 218.
Modernism 133, 136, 138, 147, 148, 152, 155, 159, 168, 178, 179, 182, 207, 213, 214, 223, 230.
MOFFATT Dr. Thomas 21, 43.
MOHOLY-NAGY Laszlo (1895-1946) 178.
MONDRIAN Piet (1872-1944) 158, 171, 187, 188, 196, 204, 220, 226-228;
 New York, Museum of Modern Art: Broadway Boogie Woogie (1942-1943) 227.
MONET Claude (1840-1926) 117, 183, 198, 205.
MONROE Marilyn (1926-1962) 211, 212.
MOORE Thomas (1779-1852) 93.
MORRIS Robert (1734-1806) 31.
MORRIS Robert (1931) 223.
MORSE Jedidiah (1761-1826) 54, 55.
MORSE Samuel F.B. (1791-1872) 54, 55;
 New Haven, Yale University Art Gallery: The Dying Hercules 54;
 Invention of the telegraph (1832) 55.
MOSES Ed (1926) 236.
MOTHERWELL Robert (1915) 10, 175, 178, 181, 184, 188, 189, 193, 195, 198, 208, 220, 230, 252;
 Buffalo, N.Y., Albright-Knox Art Gallery: Elegy to the Spanish Republic (1953-1954) 189.
MOUNT William Sidney (1807-1868) 74-82, 95, 117, 122, 124;
 Cooperstown, N.Y., New York State Historical Association: Eel Spearing at Setauket (1845) 78-80, 117;
 Detroit Institute of Arts: Banjo Player (1858) 81;
 New York, Century Association: The Power of Music (1847) 78;
 Philadelphia, Pennsylvania Academy of the Fine Arts: The Painter's Triumph (1838) 74-76, 78.
MUMFORD Lewis (1895) 137, 144.
Munich, Germany 8, 117, 175;
 School of painting 133.
MURPHY Gerald (1888-1964) 152, 212.
MUYBRIDGE Eadweard (1830-1904) 92.

Nantes, Revocation of the Edict of (1685) 15.
Nantucket, Massachusetts 81.
NAPOLEON I (1769-1821), emperor of the French 57.
Narragansett, Rhode Island 43.
National Endowment for the Arts 237.
Naturalism 82.
NEAGLE John (1796-1865) 53, 54, 79, 124;
 Philadelphia, Pennsylvania Academy of the Fine Arts: Pat Lyon at the Forge (1829) 53, 54, 124.
Neo-classicism 7, 36, 38, 43, 55, 57-59, 67, 107.
Neo-Impressionism 148, 207.
Neosho, Missouri 164.
Newark, New Jersey, Museum 151;
 Airport Administration Building 154.
New Bedford, Massachusetts 92.
Newburgh, New York 96.
New Haven, Connecticut 55;
 Yale College 54;
 Yale University Art Gallery 22, 30, 32, 36, 43, 54, 55, 88, 89, 132;
 Yale University Art School 119.
NEWMAN Barnett (1905-1970) 10, 179, 198, 204, 205, 208, 214, 220, 221, 230, 235, 241, 242, 248;
 Los Angeles, Jaime del Amo Collection:

Ulysses (1952) 204;
 The Death of Euclid (1947) 208.
New Mexico 136, 139, 142, 143.
Newport, Rhode Island 20, 23, 43.
New York 10, 17, 24, 34, 44, 46, 49, 55, 57, 60, 61, 76, 78, 80, 82, 92, 95, 97, 122, 127, 140, 144, 147-149, 152, 158, 159, 165, 168, 170, 175, 178, 179, 181, 185, 190, 195, 197, 198, 208, 209, 226-228, 234;
 American Academy of Fine Arts 55, 60;
 Armory Show (1913) 9, 127, 131-133, 136, 138, 141, 144, 147, 148, 152, 154, 155, 158, 160, 164, 181;
 Art Students League 155, 170, 179;
 Artist's Club on East Eighth Street 197;
 Atelier 17 175;
 Century Association 78;
 Columbian Academy 55;
 Finch College Museum of Art 232;
 Galleries: Art of This Century 181, 183, 198; André Emmerich 217, 243; French & Co. 205; Allan Frumkin 245; Sidney Janis 201, 233; Knoedler & Co. 172; Julien Levy 182; Macbeth 125; Mac-Millan 182; Pace 244, 246, 247, 249; Betty Parsons 205; Valentine 175; John Weber 251;
 Gallery 291, Fifth Avenue (1905-1917) 133, 136-139, 152, 181;
 Gallery of Living Art, New York University 155;
 Lincoln Center 133;
 Metropolitan Museum of Art 27, 34, 61, 64, 65, 79, 82, 85, 88, 93-95, 110, 111, 115, 119, 130, 132, 163;
 Museum of Modern Art 154, 155, 162, 164, 192-194, 197, 198, 205, 227, 228;
 Museum of Non-Objective Painting 155;
 National Academy of Design 55, 60, 76, 79, 80, 82, 92, 97, 125-127;
 New-York Historical Society 62, 69, 81;
 New York Public Library 50;
 Ninth Street Show (1951) 193;
 Private Collections: Carter Burden 231; Adolph Gottlieb 202; Robert C. Graham 68; Roy R. Neuberger 142, 176; William Rubin 227; Harry Spiro 117; John Hay Whitney 108;
 Rockefeller Center 152;
 Society of American Artists 92;
 Tenth Street style 209, 214, 215;
 Whitney Museum of American Art 121, 123, 151-153, 158, 168, 180, 226;
 World's Fair (1939) 154.
New York school of painters 155, 165, 178, 181, 183, 184, 188, 210, 236.
NOLAND Kenneth (1924) 10, 178, 179, 186, 198, 205, 208, 214, 218, 220, 221, 223-225, 228, 230, 233, 236, 241;
 Pasadena, Calif., Robert A. Rowan Collection: Via Blues (1967) 224, 225.
NORRIS Frank (1870-1902) 122.
Northampton, Massachusetts, Smith College Museum of Art 99.
NUTT Jim (1938) 236.

OBREGÓN Álvaro (1880-1928) 152.
O'HARA Frank (1926-1966) 240, 243.
O'KEEFFE Georgia (1887) 97, 136-138, 141-144, 148, 160, 223;
 Chicago, Art Institute: Black Cross, New Mexico (1929) 142, 143.
OLDENBURG Claes (1929) 223, 226.
Old Masters 155, 164, 170, 171, 179, 183, 185, 220, 230.
OLITSKI Jules (1922) 10, 198, 205, 210, 218, 220, 223, 224, 226, 233;
 New York, Whitney Museum of American Art: High A Yellow (1967) 226.
Op art 207.
Oriental art 138, 140.
OROZCO José Clemente (1883-1949) 154.
Ottawa, Ontario, National Gallery of Canada 37.
Oyster Bay, Long Island 21.

Paestum, Italy, Greek temples 35.
PAGE William (1811-1885) 96.
Paris 8, 10, 38, 43, 55, 57, 58, 80, 88, 103, 107, 113, 115, 117, 138, 139, 147-149, 152, 158, 164, 181, 187, 234;

Academy Exhibition (1808) 57;
 Ecole des Beaux-Arts 55, 88;
 Exhibition of Japanese Prints (1890) 116;
 Louvre 55, 57, 58, 108;
 Palais du Luxembourg 108;
 Salon (1846) 103; (1863) 108; (1873) 108; (1883) 114; (1884) 115;
 Salon d'Automne (1907, 1908, 1909) 139;
 Salon des Refusés (1863) 108;
 School of Paris 147, 149, 155, 182, 235;
 Society of Independents 147.
PARKER Raymond (1922) 215, 220, 233.
Parma, Italy 115.
Pasadena, California, Robert A. Rowan Collection 224, 225.
PAVIA Philip (1912) 215.
PEALE Charles Willson (1741-1827) 34, 46, 48, 49, 55, 67, 99, 105;
 Baltimore, Peale Museum: Exhuming the Mastodon (1806) 49;
 Philadelphia, Pennsylvania Academy of the Fine Arts: George Washington (1779) 46, 49; The Artist in His Museum (1822) 49;
 Philadelphia Museum of Art: Staircase Group (1795) 48, 49, 67, 99.
PEALE Raphaelle (1774-1825) 49, 99, 100, 105;
 Kansas City, Mo., Nelson Gallery-Atkins Museum: After the Bath (1823) 99, 100.
PEALE Rembrandt (1778-1860) 49, 95, 105;
 Detroit Institute of Arts: Court of Death (1820) 95.
PEALE Titian Ramsay II (1800-1885) 49, 67, 105.
PEALE children: Titian Ramsay I, Angelica Kauffmann, Linnaeus, Franklin 49.
PEARLSTEIN Philip (1924) 230.
PEIRSON Major Francis (1756-1781) 37.
PELHAM Henry (1749-1806) 28.
PELHAM Peter (c. 1695-1751) 21, 27.
PENN William (1644-1718) 38, 73.
PETO John Frederick (1854-1907) 99, 212, 239;
 Detroit Institute of Arts: After Night's Study 99;
 Northampton, Mass., Smith College Museum of Art: Discarded Treasures 99.
Philadelphia, Pennsylvania 22, 24, 33-35, 44, 46, 49, 54, 55, 60, 79, 87-90, 92, 99, 102, 105, 113, 122;
 Columbianum Academy 49, 55;
 Historical Society of Pennsylvania 24;
 Independence Hall 38, 49;
 Jefferson Medical College 88, 89, 91;
 Pennsylvania Academy of the Fine Arts 49, 53, 57, 58, 60, 74, 87, 88, 90, 95, 115, 122, 139;
 Philadelphia Centennial Exhibition (1876) 90, 113;
 Philadelphia Museum of Art 38, 48, 58, 84, 90, 92, 108, 115, 127, 167, 179;
 Philadelphia Press 122;
 Private Collections: Sol Brody 160; Albert M. Greenfield 173.
PHILLIPS Ammi (1788-1865) 70;
 Cambridge, Mass., Fogg Art Museum: Portrait of Harriet Leavens 70.
PHILLIPS Duncan (1886-1966) 119, 132.
Photo Realism 237-239, 247, 248.
PICABIA Francis (1878-1953) 138, 144.
PICASSO Pablo (1881-1973) 138, 139, 144, 149, 154, 155, 159, 164, 170, 171, 181-183, 207, 238, 248.
Pilgrim Fathers 17.
PISSARRO Camille (1830-1903) 117.
Pittsburgh, Pennsylvania 115;
 Museum of Art, Carnegie Institute 187.
Plymouth, Massachusetts 13.
POE Edgar Allan (1809-1849) 8, 95;
 The Haunted Palace 93.
POLLOCK Jackson (1912-1956) 10, 81, 154, 155, 170, 171, 175, 179, 181-186, 188, 190, 192-198, 205, 209, 211, 214, 215, 218, 220, 221, 223, 227-230, 234, 235;
 Iowa City, University: Mural (1943) 198;
 New York, Marlborough-Gerson Gallery: Pasiphae (1943) 182, 185;

New York, Museum of Modern Art: *One (Number 31)* (1950) 192, 193; *Echo* (1951) 194.
Pomfret, Connecticut, Academy 104.
POONS Larry (1937) 205, 209, 215, 227, 228, 230;
New York, William Rubin Collection: *Rosewood* (1966) 227.
POOR Henry Varnum (1888-1970) 153.
Pop art 133, 144, 147, 157, 169, 198, 207, 210-214, 223-225, 228, 229, 236-238, 242.
Post-Cubism 208, 214, 220.
Post-Impressionism 131, 133, 184, 198, 220.
Post-painterly abstraction, see Color abstraction.
POUSETTE-DART Richard (1916) 175, 198.
POUSSIN Nicolas (1594-1665) 15, 195, 214.
PRATT Matthew (1734-1805) 34, 44;
New York, Metropolitan Museum: *The American School* (1765) 34.
Precisionists 144, 147, 148, 157, 162, 164, 168, 179, 207.
PRENDERGAST Maurice (1859-1924) 115, 120-122, 125, 133;
New York, Whitney Museum of American Art: *Central Park* (1901) 121;
Washington, Phillips Collection: *Ponte della Paglia, Venice* (1899) 120, 121.
Pre-Raphaelites 237.
Princeton, N.J., Battle of (1777) 49;
Art Museum, Princeton University 216.
Prout's Neck, Maine 84, 86.
PUTZEL Howard 181.

QUIDOR John (1801-1881) 76, 77;
Brooklyn Museum: *The Money Diggers* (1832) 76, 77.

RADCLIFFE Ann (1764-1823) 58.
RAEBURN Sir Henry (1756-1823) 44.
RAIMONDI Carlo (1809-1883) 115.
RALEIGH Sir Walter (1552-1618) 13.
RAPHAEL (1483-1520) 49, 54, 149.
RAUSCHENBERG Robert (1925) 178, 179, 205, 211, 212, 214, 215, 224, 225, 236, 241;
Amsterdam, Holland, Stedelijk Museum: *Charlene* (1954) 211, 224;
"Hoarfrost" series 241.
Realism and realist painters 7, 9, 38, 39, 42, 51, 55, 75, 76, 87, 90, 92, 95, 99, 105, 108, 113, 122, 125-127, 131, 133, 136, 152, 153, 155, 158, 160, 162-164, 170, 177, 185, 190, 193, 207, 208, 233.
REDON Odilon (1840-1916) 133.
REED Luman (1787-1836) 61.
Regionalists 153, 155, 158, 163, 165, 168-170.
REINHARDT Ad (1913-1967) 10, 154, 156, 158, 175, 187, 188, 205, 209, 210, 220, 229, 241, 242, 248;
Pittsburgh, Carnegie Institute: *Blue Painting* (1953) 187.
REMBRANDT (1606-1669) 15, 49, 88, 90;
The Hague, Mauritshuis: *Anatomy Lesson of Dr. Tulp* (1632) 90.
REMINGTON Frederic (1861-1909) 103;
Fort Worth, Amon Carter Gallery of Western Art: *A Dash for Timber* (1899) 103.
Renaissance 131, 137, 149, 152, 153, 162, 163, 170, 220, 234, 252.
RENOIR Pierre-Auguste (1841-1919) 116, 122.
RESNICK Milton (1917) 198.
REVERE Paul (1735-1818) 28, 165.
REVETT Nicholas (1720-1804) 35.
Revolution, see American Revolution.
REYNOLDS Sir Joshua (1723-1792) 28, 36, 44, 49, 54.
RIBERA José de (1591-1652) 88, 115.
RICHARDSON Edgar P. (1902) 119.
RICHARDSON Jonathan (1665-1745) 24.
RIVERA Diego (1886-1957) 152.
RIVERS Larry (1923) 212, 214, 236.
Roanoke 13.
ROBERTSON Archibald (1765-1835) 55.
ROBINSON Boardman (1876-1952) 153.
ROBINSON Theodore (1852-1896) 117.
ROCKBURNE Dorothea (1934) 251, 252;
New York, John Weber Gallery: *Noli Me Tangere* (1976) 251, 252.

Rococo style 24, 27.
RODIN Auguste (1840-1917) 138.
Romanticism 7, 10, 17, 38, 57, 58, 93, 95, 133, 138, 142, 148, 163, 169, 178, 182, 190, 205, 208-210.
Rome 33, 35, 57, 58, 113.
ROMNEY George (1734-1802) 44.
ROOSEVELT Franklin Delano (1882-1945) 152.
ROSENBERG Harold (1906) 197, 214, 215, 228.
ROSENFELD Paul (1890-1946) 137.
ROSENQUIST James (1933) 210, 213, 225;
Cologne, Ludwig Museum: *Horse Blinders* (1968-1969) 210, 213.
ROTHENBURG Susan (1945) 242.
ROTHKO Mark (1903-1970) 10, 154, 175, 181, 182, 188, 190, 191, 195, 198, 203-205, 208, 220, 221, 230, 235, 241, 242, 248;
Basel, Switzerland, Öffentliche Kunstsammlung: *Red, White and Brown* (1957) 203;
Houston, Texas, Rice University: Rothko Chapel 242.
ROUSSEAU Jean-Jacques (1712-1778) 35, 55.
ROYALL Isaac (1719-1781) 21, 23.
RUBENS Peter Paul (1577-1640) 15, 16, 58, 158, 195, 234, 243.
RUBIN William (1927) 205, 227.
RUSH William (1756-1833) 92;
Allegorical Figure of the Schuylkill River (1828) 92.
RUSKIN John (1819-1900) 107, 113.
RUSSELL Charles Marion (1864-1926) 102, 103;
Fort Worth, Texas, Amon Carter Gallery of Western Art: *Crippled But Still Coming* (1913) 102, 103.
RUSSELL Morgan (1886-1953) 97, 134, 148, 149, 152;
Buffalo, N.Y., Albright-Knox Art Gallery: *Synchromy in Orange: To Form* (1913-1914) 134.
RYDER Albert Pinkham (1847-1917) 7, 8, 10, 92-98, 115, 139, 170, 179;
Boston, Museum of Fine Arts: *Constance* (before 1876) 93;
Buffalo, N.Y., Albright-Knox Art Gallery: *The Temple of the Mind* (1885) 93;
Cleveland Museum of Art: *The Race Track or Death on a Pale Horse* (1895-1910) 94, 95;
Detroit Institute of Arts: *The Tempest* (before 1891) 93;
New York, Metropolitan Museum: *The Forest of Arden* (1877) 93; *Toilers of the Sea* (before 1884) 95;
Washington, National Collection of Fine Arts, Smithsonian Institution: *The Flying Dutchman* (1887) 93;
Washington, National Gallery: *Siegfried and the Rhine Maidens* (1875-1891) 93;
Washington, Phillips Collection: *Macbeth and the Witches* (1890) 93; *Dead Bird* (1890-1900) 93, 94.
RYMAN Robert (1930) 248.

Saint Louis, Missouri 103;
City Art Museum 26, 27, 165, 196;
Joseph A. Helman Collection 234.
Salem, Ohio 170.
San Francisco, California 207, 236, 249;
M.H. de Young Memorial Museum 56;
School of funk artists 165, 207.
Santa Monica, California 252.
SARGENT John Singer (1856-1925) 7, 33, 112-115, 117, 133;
Boston, Isabella Stewart Gardner Museum: *El Jaleo* (1880) 114, 115;
Boston, Museum of Fine Arts: *The Daughters of Edward Darley Boit* (1882) 112, 114, 115;
London, War Museum: *Gassed* 115;
New York, Metropolitan Museum: *Madame X (Portrait of Madame Gautreau)* (1884) 115;
Murals in Boston Public Library, Boston Museum of Fine Arts and Widener Library at Harvard 119.
SARTRE Jean-Paul (1905) 197.
SAUL Peter (1934) 236.

SAVAGE Eugene (1883) 153.
Scarsdale, N.Y., Guy Weill Collection 222.
SCHAMBERG Morton (1882-1918) 144, 147.
SCHAPIRO Meyer (1904) 213.
SCHAPIRO Miriam (1923) 215, 217.
SCHILLER Friedrich von (1759-1805), *The Robbers* 58.
SCHWITTERS Kurt (1887-1948) 181, 224.
SCOPAS (4th century B.C.) 57.
SEGAL George (1924) 198, 223, 226.
SEGANTINI Giovanni (1858-1899) 139.
SELIGMANN Kurt (1900-1962) 188, 189.
SEURAT Georges (1859-1891) 210.
SEVERINI Gino (1883-1966) 138, 148, 181.
SHAHN Ben (1898-1969) 136, 158, 161, 167, 170;
Philadelphia Museum of Art: *Miners' Wives* (1948) 167.
Shaker Heights, Ohio 176.
SHAKESPEARE William (1564-1616) 93.
SHEELER Charles (1883-1965) 136, 144, 145, 147, 148, 154;
Cambridge, Mass., Fogg Art Museum: *Upper Deck* (1929) 145.
SHERMAN Roger (1721-1793) 30, 31.
SHINN Everett (1876-1953) 122, 125.
Sienese masters 252.
SIQUEIROS David Alfaro (1896-1974) 154.
SISLEY Alfred (1839-1899) 117.
SLOAN John (1871-1951) 122, 125-127, 133, 136, 147, 155, 158, 170, 179, 208;
Washington, Phillips Collection: *The Wake of the Ferry* (1907) 126, 127.
SMIBERT John (1688-1751) 20-23, 27, 42, 49, 60;
New Haven, Yale University Art Gallery: *Dean George Berkeley and his Party (The Bermuda Group)* (1729) 20-22, 43.
SMIBERT Nathaniel (1734-1756) 27.
SMITH David (1906-1965) 154, 158.
SMITH Captain Thomas (active last quarter of the 17th century) 15-17;
Worcester, Mass., Art Museum: *Self-Portrait* (c. 1690) 15-17.
Sochi, Russia 183, 184.
Société Anonyme, New York 147.
Southport, Connecticut, Hon. William Benton Collection 161.
SOYER Raphael (1899) 170.
Spain 88, 114, 115, 211.
Spanish colonial art 14.
Spanish painting 133, 184.
SPENCER Niles (1893-1952) 148.
Springs, Long Island 218.
STEEN Jan (1626-1679) 76.
STEICHEN Edward (1879-1973) 138, 139.
STEIN Gertrude (1874-1946) 133, 139, 164.
STEIN Leo (1872-1947) 139.
STELLA Frank (1936) 10, 198, 205, 208, 209, 214, 220, 224, 228-231, 233, 236, 241;
New York, Carter Burden Collection: *Marquis de Portago* (1960) 230, 231.
STELLA Joseph (1877-1946) 127, 132, 141, 144, 147, 148, 156, 186;
New Haven, Yale University Art Gallery: *Battle of Lights, Coney Island* (1913) 127, 132, 148.
STERNE Maurice (1878-1957) 149, 153.
STIEGLITZ Alfred (1864-1946) 133, 136-139, 141, 181, 208;
An American Place 137;
Camera Work, review 133;
Intimate Gallery 136.
Stijl, De 181.
STILL Clyfford (1904) 10, 181, 182, 184, 198, 199, 204, 208, 220, 252;
Detroit Institute of Arts: *Painting* (1951) 199.
STONE Sylvia (1928) 223.
STRONG George Washington 78.
STUART Gilbert (1755-1828) 7, 34, 43-47, 54, 55, 59;
Boston, Museum of Fine Arts: *Athenaeum Portrait of George Washington* (1796) 46, 47;
Brooklyn Museum: *Lansdowne Portrait of George Washington* (third version, 1796) 46;
England, Earl of Rosebery: *Lansdowne Portrait of George Washington* (second version, 1796) 46;

Philadelphia, PennsylvaniaAcademy of
the Fine Arts: *Lansdowne Portrait of
George Washington* (first version, 1796)
46;
 Washington, National Gallery of Art:
 Vaughan Portrait of George Washington
 (1795) 46; *Mrs. Richard Yates* (1793)
 46; *The Skater*(1782) 43-45.
STUART James (1713-1788) 35.
SULLIVAN Louis (1856-1924) 138.
SULLY Thomas (1783-1872) 52, 54, 55, 79;
 Washington, National Gallery: *Lady with
 a Harp: Eliza Ridgely* (1818) 52, 54.
Super-Realism 237.
Surrealists 147, 152, 154, 162, 163, 171,
 179, 182-184, 187, 188, 194-196, 205.
SWEDENBORG Emanuel (1688-1772) 96.
Synchromism 148, 152, 168.
Syracuse, N.Y., Everson Museum of Art
81.

Taos, New Mexico, school of painters 97.
Tappan, New York 76.
Ten American Painters 119, 122.
TENNYSON Alfred (1809-1892) 93.
THEUS Jeremiah (1719-1774) 23;
 Brooklyn Museum: *Elizabeth Rothmaler*
 23.
THOMAS Alma (1891) 236.
THOREAU Henry David (1817-1862) 136.
TINTORETTO (1518-1594) 58.
TITIAN (c. 1488-1576) 49, 54, 57, 58, 230.
TOBEY Mark (1890-1976) 196, 197;
 St. Louis, City Art Museum: *Pacific
 Transition* (1943) 196.
TOMLIN Bradley Walker (1899-1953) 197,
 204;
 New York, Museum of Modern Art:
 Number 9: In Praise of Gertrude Stein
 (1950) 197.
TOOKER George (1920) 162.
TOULOUSE-LAUTREC Henri de (1864-1901)
 138.
Trenton, N.J., Battle of (1776) 49.
TRUMBULL John (1756-1843) 32, 34, 42,
 43, 54, 60;
 New Haven, Yale University Art Gallery:
 Death of General Warren at Bunker's Hill
 (c. 1785) 43; *Death of General Mont-
 gomery at Quebec* 43; *Declaration of
 Independence* (1786-1797) 32, 43.
Turin, Italy, Remo Morone Collection 206.
TURNER Joseph Mallord William (1775-
 1851) 9, 61, 62, 67.
TUTTLE Richard (1941) 230.
TWACHTMAN John Henry (1853-1902) 118,
 119;
 Minneapolis Institute of Arts: *The White
 Bridge* 118, 119.
TWAIN Mark (Samuel Langhorne Clemens,
 1835-1910) 79;
 Adventures of Huckleberry Finn (1884)
 79, 83;
 Adventures of Tom Sawyer (1875) 79, 83.
TWOMBLY Cy (1928) 241.
TWORKOV Jack (1900) 185, 193, 248.
Tynemouth, Northumberland 84, 85.

UCCELLO Paolo (1397-1475) 230.

VANDERLYN John (1775-1852) 55-59, 75;
 Hartford, Conn., Wadsworth Atheneum:
 The Death of Jane McCrea (c. 1804) 55.
 Philadelphia, Pennsylvania Academy of
 the Fine Arts: *Ariadne* (1814) 57;
 San Francisco, M.H. de Young Memorial
 Museum: *Marius Amidst the Ruins of
 Carthage* (1807) 56, 57;
 Washington, Capitol Rotunda: *The Land-
 ing of Columbus* 57;
 Portrait of Aaron Burr 55; sketches of
 Niagara Falls (1801-1803) 55; sketches
 of Versailles (1815) 57.
VANDERLYN Pieter (c. 1687-1778) 55.
VEDDER Elihu (1836-1923) 93, 96;

New York, Metropolitan Museum: *The
Lost Mind* (1864-1865) 93.
VELAZQUEZ Diego (1599-1660) 15, 88, 108,
 113-115, 122, 230.
Vence, French Riviera, Chapel of the Rosary
 (Matisse) 242.
Venetian painting 195, 207.
Venice 139.
VERONESE Paolo (1528-1588) 58.
Viet Nam 252.
VINCENT François-André (1746-1816) 55.
VUILLARD Edouard(1868-1940) 121.

WAGNER Richard (1813-1883), *The Flying
Dutchman* and *Siegfried* 93.
WALKOWITZ Abraham (1878-1965) 138,
 141.
WARHOL Andy (1925) 209, 211-213, 225,
 238, 241, 248;
 Meriden, Conn., Burton Tremaine Collec-
 tion: *Marilyn Monroe* (1962) 212.
WASHINGTON George (1732-1799) 42, 44,
 46, 49, 58, 165, 212.
WASHINGTON Martha (1732-1802) 46.
Washington, D.C. 46, 55, 80, 153, 214;
 Corcoran Gallery of Art 64, 65, 126;
 Freer Gallery of Art 108;
 National Collection of Fine Arts, Smith-
 sonian Institution 93, 103;
 National Gallery of Art 45, 46, 52, 83,
 87, 93, 102-104, 108,124, 125;
 Paul Mellon Collection 38, 114;
 Phillips Collection 93, 120, 126;
 White House 208.
Washington school of painters 236.
WATSON Brooke 38.
WEBER Max (1881-1961) 136-139, 141,
 144, 147-149, 151, 152;
 New York, Metropolitan Museum: *Ath-
 letic Contest* (1915) 137.
WEIR John Ferguson (1841-1926) 119.
WEIR Julian Alden (1852-1919) 119, 121;
 New York, Metropolitan Museum: *The
 Red Bridge* 119, 121.
WEIR Robert Walter (1803-1889) 119.
WELLINGTON, Arthur Wellesley, Duke of
 (1769-1852) 39.
Wellington, New Zealand, National Art
 Gallery 29.
WEST Benjamin (1738-1820) 7, 24, 27, 28,
 33-39, 42-44, 49, 54, 55, 58, 73, 79, 88, 95,
 107;
 Hartford, Wadsworth Atheneum: *Saul
 and the Witch of Endor* (1777) 38;
 New Haven, Yale University Art Gallery:
 *Agrippina Landing at Brundisium with
 the Ashes of Germanicus* (1768) 35, 36;
 Ottawa, National Gallery of Canada:
 Death of General Wolfe (1770) 36-38, 43,
 79;
 Philadelphia, Historical Society of Penn-
 sylvania: *Thomas Mifflin* (1758) 24;
 Philadelphia, Independence Hall: *Peace
 Treaty with the Indians* (1772) 38, 73;
 Philadelphia Museum of Art: *Death on a
 Pale Horse* (1802) 38, 58, 95;
 Philadelphia, Pennsylvania Academy of
 the Fine Arts: *Death on a Pale Horse* (final
 version, 1817) 95;
 Washington, Paul Mellon Collection:
 Cave of Despair (1772) 38.
West Point, N.Y., U.S. Military Academy
 107, 119.
WHISTLER James Abbott McNeill (1834-
 1903) 7, 33, 97, 106-109, 111, 113-115,
 119, 121, 122, 127, 133, 139;
 Boston, Museum of Fine Arts: *The Last of
 Old Westminster* (1862) 108;
 Chicago, Art Institute: *The Artist's Studio*
 (c. 1867-1868) 108;
 Detroit Institute of Arts: *Nocturne in
 Black and Gold: The Falling Rocket*
 (c. 1874) 106, 107, 113;
 Glasgow Art Gallery and Museum: *Ar-
 rangement in Gray and Black No. 2:
 Thomas Carlyle* (1872-1873) 108, 109;

Hartford, Conn., Wadsworth Atheneum:
 Coast of Brittany (Alone with the Tide)
 (1861) 108;
 New York, John Hay Whitney Collec-
 tion: *Wapping on Thames* (1861-1864)
 108;
 New York, Metropolitan Museum: *Ar-
 rangement in Flesh Color and Black:
 Portrait of Théodore Duret* (1883) 111,
 113;
 Paris, Louvre: *Arrangement in Gray and
 Black No. 1: The Artist's Mother*
 (1871) 108;
 Philadelphia Museum of Art: *Purple and
 Rose: The Lange Lijzen of the Six Marks*
 (1864) 108;
 Washington, Freer Gallery: *Rose and
 Silver: "La Princesse du Pays de la
 Porcelaine"* (1864) 108;
 Washington, National Gallery: *The White
 Girl (Symphony in White No. 1)* (1862)
 108.
WHITE John (active 1584-1593) 13.
WHITMAN Walt (1819-1892) 9, 92, 138,
 188;
 Leaves of Grass 9.
WHITNEY Gertrude Vanderbilt (1877-
 1942) 151.
WHITTREDGE Worthington (1820-1910) 80.
WIEGAND Charmion von (1899) 187.
Wilkes-Barre, Pennsylvania 102.
WILLIAM III, King of England (1689-1702)
 15.
WILLIAMS William (c. 1710-c. 1790) 24,
 25;
 Brooklyn Museum: *Deborah Hall*
 (1766) 24, 25.
Williamsburg, Virginia 154;
 Abby Aldrich Rockefeller Folk Art Col-
 lection 73.
Williamstown, Massachusetts, Sterling and
 Francine Clark Art Institute 85.
WILSON Alexander (1766-1813) 67.
WILSON Woodrow (1856-1924) 168.
WINCKELMANN Johann Joachim (1717-
 1768) 35.
WITTGENSTEIN Ludwig (1889-1951) 240.
WOLFE General James (1727-1759) 36, 37.
WÖLFFLIN Heinrich (1864-1945) 195, 223;
 Principles of Art History (1915) 195.
WOLLASTON John (active 1749-1767) 24,
 27.
WOOD Grant (1892-1942) 153, 154, 158,
 164-166, 168, 169;
 Chicago, Art Institute: *American Gothic*
 (1930) 166, 168, 169;
 Edward G. Robinson Collection: *Daugh-
 ters of the American Revolution* (1932)
 168, 169.
WOOD Robert (c. 1717-1771), *Ruins of
 Palmyra* (1753) and *Ruins of Balbec*
 (1757) 35.
Worcester, Massachusetts, Worcester Art
 Museum 12, 16, 60.
World War I (1914-1918) 139, 147, 156,
 195.
World War II (1939-1945) 147, 175, 179,
 181, 184, 193, 226.
WPA (Work Projects Administration, 1935-
 1943), Federal Art Project 152-154, 237.
WRIGHT Frank Lloyd (1869-1959) 97.
WRIGHT Willard Huntington (1888-
 1939) 148.
WYETH Andrew (1917) 159-161, 207;
 Hartford, Conn., Wadsworth Atheneum:
 April Wind (1952) 159.

YOUNGERMAN Jack (1926) 220, 232, 233;
 New York, Finch College Museum of Art:
 Black, Yellow, Red (1964) 232.
Youngstown, Ohio, Butler Institute of
 American Art 83.
YUNKERS Adja (1900) 233.

ZOX Larry (1936) 209, 228.
Zurich, Switzerland 147.

PUBLISHED SEPTEMBER 1977
PRINTED BY
IMPRIMERIE STUDER S.A., GENEVA

PHOTOGRAPHS BY

Lee Angle, Fort Worth, Texas (page 102), Henry B. Beville, Alexandria, Virginia (pages 18, 19, 22, 25, 30, 32, 36, 77, 85, 89, 93, 110, 111, 119, 120, 126, 132, 189), Geoffrey Clements, Inc., Staten Island, New York (pages 98, 116, 123, 226), George M. Cushing, Boston, Massachusetts (page 20), Fratelli Fabbri Editori, Milan, Italy (pages 173, 191), Sherwin Greenberg, McGranahan & May, Inc., Buffalo, New York (pages 134, 200), Johnson Photographers, Inc., Clinton, Iowa (page 96), Joseph Klima, Jr., Detroit, Michigan (page 106), Eric Pollitzer, New York (pages 229, 233), G. Rampazzi, Turin, Italy (page 206), Rupert Roddam, Glasgow, Scotland (page 109), Elton Schnellbacher, Pittsburgh, Pennsylvania (page 187), F.J. Thomas, Hollywood, California (page 234), Malcolm Varon, New York (pages 62, 69, 81, 117, 142, 161, 163, 174, 186, 202, 204, 212, 217, 219, 222, 224-225, 227, 231, 232), John Webb, FRPS, London (page 42); and the photographic services of the following museums and galleries: Amsterdam, Stedelijk Museum (page 211), Bloomington, Indiana, Indiana University Art Museum (pages 156-157), Boston, Museum of Fine Arts (pages 40-41, 47, 59, 71, 84, 112), Buffalo, New York, Albright-Knox Art Gallery (page 250), Cambridge, Massachusetts, Fogg Art Museum (pages 23, 65, 70, 145, 221), Chicago, The Art Institute of Chicago (pages 143, 166, 169), Cleveland, Ohio, The Cleveland Museum of Art (pages 63, 66, 94, 150), Cologne, Federal Republic of Germany, Ludwig Museum (pages 238-239), Columbus, Ohio, The Columbus Gallery of Fine Arts (page 140), Cooperstown, New York, New York State Historical Association (page 78), Des Moines, Iowa, Des Moines Art Center (page 135), Detroit, The Detroit Institute of Arts (pages 146, 199), Fort Worth, Texas, Amon Carter Museum of Western Art (page 103), Hartford, Connecticut, Wadsworth Atheneum (pages 101, 159), Kansas City, Missouri, The William Rockhill Nelson Gallery of Art and Mary Atkins Museum (page 100), Minneapolis, Minnesota, The Minneapolis Society of Fine Arts (page 118), New York, The Metropolitan Museum of Art (pages 34, 79, 130, 137), New York, The Museum of Modern Art (pages 162, 192-193, 194, 197), New York, The New York Public Library (page 50), New York, Whitney Museum of American Art (pages 121, 153, 180), New York, Leo Castelli Gallery (page 213), New York, André Emmerich Gallery (pages 242-243), New York, Allan Frumkin Gallery (page 245), New York, Sidney Janis Gallery (pages 177, 201), New York, Marlborough-Gerson Gallery (page 185), New York, Pace Gallery (pages 244, 246, 247, 249), New York, John Weber Gallery (page 251), Ottawa, The National Gallery of Canada (page 37), Philadelphia, The Philadelphia Museum of Art (pages 48, 91, 167), Philadelphia, Pennsylvania Academy of the Fine Arts (pages 53, 74), Princeton, New Jersey, Princeton University, The Art Museum (page 216), San Francisco, M.H. de Young Memorial Museum (page 56), St. Louis, Missouri, City Art Museum (pages 26, 165, 196), Washington, D.C., National Gallery of Art (pages 45, 52, 83, 87, 104, 114, 124, 125), Wellington, New Zealand, National Art Gallery and Dominion Museum (page 29), Williamsburg, Virginia, Abby Aldrich Rockefeller Folk Art Collection (page 72), Worcester, Massachusetts, Worcester Art Museum (pages 12, 16), and by courtesy of "Art News," New York (page 68).

PRINTED IN SWITZERLAND